The age of
REMBRANDT
and VERMEER

J. M. NASH

The age of REMBRANDT and VERMEER

Dutch painting in the seventeenth century

Phaidon

PHAIDON PRESS LIMITED, Littlegate House, St Ebbe's Street, Oxford
Distributed in the United States of America by E. P. Dutton, New York
First published 1972
Second edition (paperback) 1979
© 1972 by Phaidon Press Limited
ISBN 0 7148 2012 1 (hardback) ISBN 0 7148 1973 5 (paperback)
Library of Congress Catalog Card Number: 78-73078
Printed in Italy by Amilcare Pizzi SpA., Milan

Contents

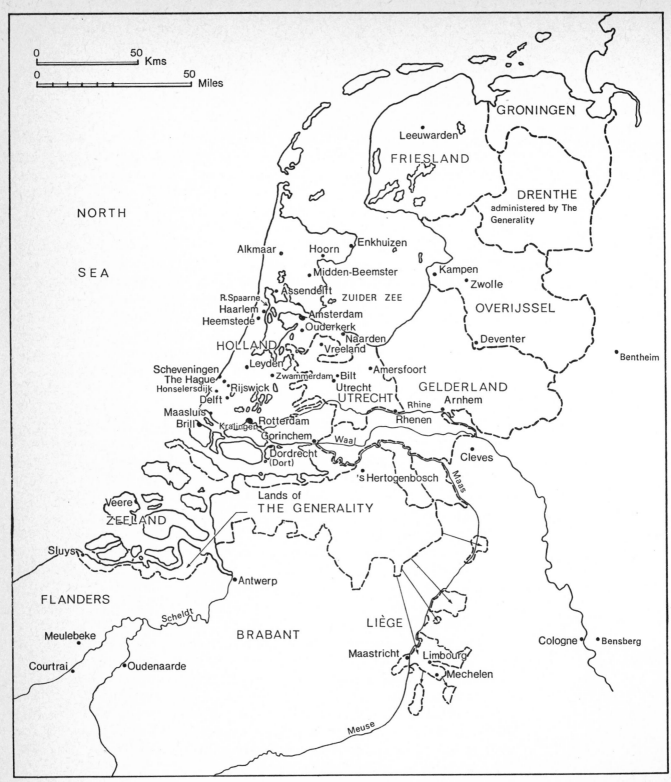

The United Provinces of The Netherlands in the seventeenth century

1. Introduction

IN 1556, the Low Countries of the North Sea coast of Europe became part of the great Spanish Empire. They were lands long accustomed to the domination of greater powers. By a series of dynastic marriages they had been transferred like heirlooms, descending down the line of the Dukes of Burgundy in the early fifteenth century, to the House of Habsburg in 1477. It was only after the Emperor Charles V had abdicated in favour of his son Philip in 1555, bestowing on him the following year the crown of Spain and all its territorial possessions, that the peoples of the Netherlands rebelled against foreign rule.

Philip II of Spain was a devout Catholic and a believer in the divine right of kings. His court was in Spain, and the remote and chilly Netherlands were no more to him than a source of spiritual concern and rich revenues. Calvinism was a heresy and he spared no effort to stamp it out. Flanders and Brabant were also the most amenable of his territories to heavy taxation. The Flemish merchants, and in particular those of Antwerp, were among the richest in the world, their wealth was accessible for taxation (unlike the wealth of the Spanish nobles and clergy) and they were in danger of becoming too powerful. Philip's rule of the Netherlands combined bloodthirsty extirpation of heresy, penal taxation, and total indifference to the wishes of his subjects. The combination of persecutions roused both Calvinists and Catholics alike, and soon they found a leader in William the Silent, Prince of Orange. The struggles which followed might have sapped the most fervent patriot. The Spaniards were efficient soldiers and strong in the richer southern provinces of Flanders and Brabant. The rebels often had to flee across frontiers or even across the sea. But the sea was their salvation, and their mastery of the sea their means of victory—as when, on 1 April 1572, Dutch pirates captured the port of Brill. Though the struggle endured until 9 April 1609, when Spain signed the Twelve Years' Truce acknowledging the independent existence of the commonwealth of the United Provinces of the Netherlands, that foothold at Brill marked the turn of the tide.

Hard fighting and the geography of the Low Countries made the provinces to the north of the Rhine free and strong, while those to the south remained subject and powerless. In fifty years, long historical traditions had been broken. The South, which had been rich, had become poor, and the North, by its mastery of the sailing routes, had become the richest trading nation in the world. The South, which had boasted for two centuries of the greatness of its painters, from van Eyck to Pieter Bruegel, would have been barren had it not been for the studio of the great and patriotic Peter Paul Rubens. The North, where few but minor masters and occasional patriotic eccentrics had worked before, suddenly produced, between 1609 and 1675, three generations of painters whose achievement was comparable to that of any period of the past.

2. Saenredam: an epitome of Dutch painting

AN EPITOME of the achievement of art in seventeenth-century Holland may be studied in the work of Pieter Janszoon Saenredam (Plates 14–16, 107, 108). It is an art rooted in Flemish tradition, flourishing in the atmosphere of a new national self-consciousness, but flowering as an abstract, even timeless, perfection, apparently transcending the contingencies of human affairs. Above all, this art may epitomize its time by its uniqueness: the painters of seventeenth-century Holland anticipated Cézanne in their obstinate devotion to a select number of personal motifs. Saenredam painted the interiors of churches. He was not the first to do that, but the earlier, Flemish, ecclesiastical interiors were flamboyant and theatrical, evoking pomp, pageantry and elaborated rituals. They were churches still loyal to the Roman Catholic faith. Saenredam's interiors display the whitewashed austerity of the Reformed church. There are no dramatic altarpieces or richly decorated side-chapels, no processions, no clusters of worshippers at shrines. Saenredam allows few people into his bare interiors, and they are as likely to be two boys playing marbles as anyone more obviously devout. As he presents them, his churches are occasions for contemplation.

Saenredam's career—the time, the place and the manner in which he entered upon his chosen domain—this, too, is exemplary. His father, Jan Saenredam, a professional engraver, had died in 1607, when Pieter Jansz. was only ten. Two years later, his mother had moved to Haarlem, where there lived a number of artists, such as Goltzius and van Mander, whose designs his father had engraved. A month before his fifteenth birthday, Pieter became the pupil of Frans Pietersz. de Grebber. He stayed with de Grebber for ten years and yet his mature art seems to owe nothing to this master, who painted history subjects and group portraits. The following year he entered the painters' guild in Haarlem. At this time the guild was still the organizing and controlling force in artistic life in Holland, and in Haarlem it was particularly important. The Guild of St Luke also included, in Haarlem at that time, box-makers, brassfounders, embroiderers, goldsmiths, lantern-makers, organ-makers, pewter-workers, plumbers, potters, printers, slate-layers, smiths, tinkers, and woodcarvers. They were a mixed lot, as the painters complained. Nevertheless, the Guild had its hierarchy, and the painters were at the top. During his life, Saenredam was secretary, steward, and even dean, of the Guild. His life was lived in the world of art throughout.

Yet everything else seems shrouded in mystery. There is no early work. Two scraps of paper (now in the Print Room, Berlin-Dahlem) are virtually all that has survived of his work before he was thirty. Neither sheet is larger than six inches by eight; each contains several minute, carefully detailed drawings; each drawing is identified and dated in precise calligraphy. On one sheet are drawings of 1617 and 1625, and on the other (of

plant studies), the dates are 1620 and 1641. Saenredam's temperament may be seen to have formed early: there is the scrupulous care, the pedantic concern for fact, the acute awareness of time, and the inability to discard finally the slightest scrap of work. These qualities became the ruling forces of his mature procedure; but of his mature art, these drawings give hardly a hint.

And then, in 1628, the year of his earliest dated painting—of a church interior—a book was published with illustrations by Saenredam, the only other known source of his work until then. The book was a history of Haarlem, *Beschryvinge ende Lof de Stad Haerlem in Holland*, by a native of the town, a preacher and poet, Samuel Ampzing. The book, with its illustrations, is an idiosyncratic product of this early period in the growth of the Low Countries' commonwealth, and deserves attention. Its full title was:

DESCRIPTION AND PRAISE OF THE TOWN OF HAARLEM IN HOLLAND: *in Rhyme: and with many old and new documents, not in rhyme, from various Chronicles, Charters, Letters, Memoirs or Recollections and such papers explained and corroborated.* BY SAMUEL AMPZING, *of Haarlem. Together with Peter Scriverius'* LAUREL-WREATH *for* LAURENS KOSTER *of Haarlem, inventor of* PRINTING. *The preface to the reader gives some tuition in our Low German tongue, and spelling, used here, under the Title or Heading of Dutch-Language-Information: deals also a little with the art of rhyming to the advantage and pleasure of those eager to learn.*

This title reveals the intense pride in its past and the search for a present national identity which stamped the culture of the early years of independence of the United Provinces of the Netherlands. By emphasizing his use of his native tongue, Ampzing shows that he sees himself among the creators of a new national literature. But nothing in the book shows the foundation of that new national pride more clearly than Saenredam's illustrations, especially the three maps or bird's-eye views. One over which he had taken particular care was a topographical reconstruction of the siege of Haarlem by the Spanish in 1572.

Haarlem had been among the first of the towns of Holland to join William of Orange in the uprising against Spanish rule. Orange forces had taken Brill on 1 April 1572, and on 3 July the burgomasters and corporation of Haarlem followed Dordrecht and Leyden and joined the revolutionaries. The Spaniards were at their walls before the end of the year. Haarlem held out for seven months, until July 1573. When they surrendered, the notorious Duke of Alva, the Spanish commander, was lenient and only killed the defending soldiers. When his five executioners were too tired to raise their sword-arms, they tied the remaining condemned men in pairs and threw them into the river Spaarne.

Saenredam's second map of sixteenth-century Haarlem was copied after a contemporary map bearing the legend: 'Haarlem destroyed by siege and fire: at the time she has come back under the government of the Prince of Orange, 1578.' Beneath the map, Ampzing composed quatrains which asked the reader to 'see here the good town of Haarlem as dead! See here the good town razed to the ground and totally destroyed by bloody sword and fire! What a plague war is, an all-destroying animal! But look again. What a delightful thing! How she has risen from her downfall and sorrow. Look at her prosperity and bloom and high standard, by God's blessing and fatherly hand!' Indeed the contrast between this map of 1578, with half the town devastated by siege and fire, and the map of modern Haarlem, which Saenredam made for the frontispiece, is vivid. A comparison shows that not less than two-thirds of the town had been newly built in the fifty intervening years. Saenredam had pointed his moral by leaving the fields around the earlier map blank but filling the surrounding fields of the modern town with plump, toy-like cows.

This was not propaganda; it reflected the truth that lay at the heart of the new country's strength. In those fifty years, the Province of Holland had become one of the richest and most powerful forces in seventeenth-century Europe. And while Amsterdam had become the greatest port and mercantile city in the world, Haarlem had developed industrially. She was famous for her breweries, her textiles, and her agriculture. She was the centre of the newly developing tulip-growing industry, at a time when tulip bulbs changed hands at astronomical prices. There was opportunity, energy, enthusiasm: all flourished in those early years of independence.

For the arts, it is clear that national sentiment and wealth were essential catalysts. Without wealth art could not exist, but the national sentiment, the pride in itself, which Holland discovered, gave the artist a new set of subjects, and gave the patron a new recognition of the values of the world around him. This can be seen clearly in the landscape etchings Saenredam provided for Ampzing. The frontispiece, in particular, is revealing, showing Haarlem bathed in the benign atmosphere of prosperity. The foreground is filled by the broad river Spaarne, busy with sailing ships and laden barges. On either bank are lush meadows with grazing cattle, windmills, and leafy coppices framing farms. The fortified town lies across the horizon, its spires, mingling with plumes of smoke, pointing to the high scudding clouds above. It is a prospect of the town, evoking rather than detailing its riches (the maps and the text did that). It used the special skills of the landscape artist to reflect the virtues of Haarlem, and in the foreground Saenredam placed prominently two travellers looking over the shoulder of an artist sketching the scene.

In his other landscape etchings Saenredam represents another aspect of national sentiment. He shows four monuments to Holland's glorious past, the ruins of four castles of the neighbourhood. These plates surpass mere topography and confirm that he was a master of the more subtle skills of landscape. He can move from the elegaic, classical dignity, with which he invested his representation of Brederode Castle, to a view of the old Castle of Assumburg, which was no more than four piles of overgrown masonry on a knoll surrounded by cattle. The latter plate celebrates the attractions of disorder and decay in a spirit which anticipates the paintings of Ruisdael (Plate 144) and Hobbema.

But this was not Saenredam's bent. The one plate in Ampzing's history which illuminates the artist's future is the unremarkable interior of the Great Church of St Bavo, Haarlem (Plate 15). In the year the book was published, Saenredam painted the first of no less than thirteen views of the interior of St Bavo. Of the fifty or so oil paintings by him which have survived, almost half show the interiors of only two churches, St Bavo and the romanesque Mariakerk in Utrecht (Plate 107).

Specialization became a necessity for many painters in seventeenth-century Holland. The open market and low prices encouraged the artist to repeat any motif he found saleable. Saenredam's specialization did not lead to repetition. He produced few paintings and little is known about his financial circumstances. It seems that the pressures that formed his art were internal as much as social. It has been suggested that he sought the solitude of church interiors because he was a hunchback. There may be truth in this, but he was always prepared to draw in public when necessary. But from his landscape drawings, he made almost no paintings. On the few occasions that he did do so, the paintings seem to be *tours de force* of re-creation: he painted the old town hall in Amsterdam after it was destroyed by fire and he painted the exterior of the Mariakerk in Utrecht (Plate 107) twenty-five years after his only visit, and the views he painted of Rome were from drawings made a hundred years earlier by Marten van Heemskerck. A sedentary temperament, an unease with open landscape, and a love of the past; these are the springs of his art.

It was an art of eye and memory, of observation and intellect. He must have discovered the science of perspective from his fellow pupil, the architect Jacob van Campen. He did not hesitate to modify or to rectify his drawings made from careful observation in the light of perspective. He would reject the evidence of his eyes to create the vistas he desired. Out of the contingencies and flux of time, all so exactly noted in his drawings, he composed an unchanging art. Within the great barrel of St Bavo, he found timeless harmonies. From his contemplation of those spaces, he invented an art for contemplation.

This exemplary career may illustrate two further points. Saenredam's uniqueness was obscured by a generation of imitators: Houckgeest, de Lorme and de Witte (Plate 86) were the most outstanding. Whatever the sources of this reticent art, it found its admirers. And whatever its sources in the temperament of Saenredam, his followers were not obviously kindred spirits. De Witte gained a reputation for drinking, gambling and insolvency which matched that of Frans Hals, yet his art, like Saenredam's, is sober, if not austere.

3. The arrival of the Mannerists in Haarlem

DUTCH PAINTING of the seventeenth century quickly developed a recognizable character. Yet its kinship to earlier, Flemish, art is no less apparent. It would be tempting to date the birth of an independent Dutch art from 1609—the year that Spain reluctantly made tacit acknowledgement that the seven rebel provinces of its Netherlands Dominion, united in arms for thirty years, were now an independent nation with whom she had signed a twelve years' truce. At all events it was only shortly after the signing of the truce that the first distinctively Dutch paintings were made. But the artists who produced this new art were the generation born about 1590: it is significant that this was the first generation to choose to live and work in the new commonwealth.

Until the final quarter of the sixteenth century, Holland and the other northern provinces had had no great school of painting to rival the centres of Bruges and Ghent, which had flourished in the fifteenth century, or Antwerp, which in the sixteenth century had become the centre to which every ambitious Netherlandish artist was drawn. Men of outstanding talent who stayed further north worked in provincial isolation: van Scorel worked mainly in Utrecht, Lucas van Leyden in his native town, Marinus van Reymerswaele in Zeeland and Marten van Heemskerck in Haarlem.

But the stirrings of rebellion, and the political and religious repression which followed, when Philip II of Spain inherited the Netherlands provinces in 1555, soon wrought changes. It is not certain that Pieter Aertsen left Antwerp for his native town of Amsterdam in 1556 for either religious or political reasons, but his going was the beginning of an exodus from the South. It was also important because he took to Amsterdam a form of earthy, sensuous realism which was a powerful influence on later Dutch art. He was joined, in 1562, by another prodigal son returning to his fatherland. This was Dirck Barendsz., a highly gifted painter, much admired in his day but now largely forgotten because so many of his works have been destroyed. Barendsz. had travelled to Venice, where he spent six years in Titian's studio, and he brought back to Amsterdam a thorough training in Venetian methods of painting.

With the return of Barendsz., there were two artists with a knowledge of Italy working in Holland. The other, Marten van Heemskerck, was an altogether larger figure. In his day, Heemskerck was more highly regarded than, for example, Pieter Bruegel the Elder. He was of an older generation than Barendsz., and had been to Rome in 1532, bringing back to his native Haarlem, five years later, a style influenced by Roman sculpture, Michelangelo, and Raphael's decorations for the Loggie in the Vatican. Heemskerck lived on in Haarlem until 1574 (he fled to Amsterdam during the siege) and for nearly forty years he produced a spate of pen drawings of biblical and other subjects, which were then engraved by an army of craftsmen, mostly in Antwerp, and the resulting

prints established his reputation throughout Europe. From Haarlem, Heemskerck shone like the Pole Star.

But to be seen, the Pole Star needs darkness. This came for Antwerp in 1585. After the capture of Brill by the rebel forces in 1572, William the Silent's campaign had looked like embracing all the Netherlands; even Antwerp had gone over in 1576. The tide began to turn in favour of Spain when Alexander Farnese, Duke of Parma, was made Governor of the Netherlands in 1578. Within a couple of years, he began a campaign that had subdued all Flanders and Brabant before 1586. But the catastrophe came with the fall of Antwerp to Spanish forces after a siege of twelve months on 17 August 1585.

The catastrophe was for the South. The fall of Antwerp was the making of the United Provinces. When Parma re-established Catholicism in Antwerp, the Protestants were given four years to wind up their affairs and leave. The exodus began. Then the 'Sea Beggars' of the rebel provinces blockaded the river Scheldt and cut off Antwerp from the sea. All trade was slowly brought to a stop. It was the death of Antwerp: even the Catholics turned north.

Whether it was Heemskerck's reputation which guided artists to Haarlem it is impossible to be sure, for Heemskerck died in 1574, and the first of the generation which was to establish Haarlem's place in the world of art arrived three years later, in 1577. This was Hendrick Goltzius from Gelderland. It is possible he was attracted to Haarlem by Heemskerck's reputation, because it was as an engraver, woodcut maker and designer of prints that Goltzius excelled.

Six years later, two other artists of considerable importance arrived in Haarlem. One, returning from Rouen and Antwerp where he had trained as a painter, was a native, Cornelis Cornelsz. van Haarlem; he was only twenty-one. The other, the oldest of the group, was Carel van Mander, who came from Meulebeke, near Courtrai in Flanders. But though these three, Goltzius, Cornelis van Haarlem and van Mander, brought lustre to the artistic life of Haarlem, their art was not obviously Dutch. Like their contemporaries in Utrecht, Bloemaert (Plates 4, 11) and Wtewael (Plate 2), they followed the style, now called International Mannerism, which they discovered in the art of the Antwerp artist Bartholomeus Spranger.

One of the three, certainly, showed a vivid sense of patriotism. This was van Mander, who as well as being a painter was poet, historian and theoretician. In 1604 he published, in Haarlem, his *Schilderboeck* (The Book of Painters), a prodigious compendium of information for artists, including among its six sections 'The Lives of the Excellent Netherlandish and German Painters' and the 'Foundation of the Painter's Art'. The very concept of writing a northern equivalent to Vasari, which is what van Mander's

'Lives' is, reveals his national pride. The 'Foundation of the Painter's Art' is also illuminating: it is written in Netherlandish couplets and addressed directly to the aspiring Netherlandish painter. Throughout, it shows a dilemma van Mander feels: 'Rome is the city where before all other places the Painter's journey is apt to lead him, since it is the capital of Pictura's [i.e. Painting's] Schools.' But he knows that the North has its own, distinctive, traditions. Unfortunately, he accepted the Italian valuation of those traditions. The Italians, he said, 'consider the Netherlanders excellent landscape painters. They may praise us for this but maintain they are superior in figure painting.' And earlier he had written to his ambitious readers: 'Be alert, my young friends, take courage, even though there will be many disappointments, apply yourself, so that we can achieve our goal—namely, that they [the Italians] can no more say, as is their custom: the Flemings cannot paint figures.' At times, van Mander is on the point of abandoning these Italian standards, and although he is too schooled in the Italian theory of art quite to do this, he is not afraid to praise, and even emulate in his own painting, one Netherlandish artist who ostentatiously ignored Italian art and Italian ideals, Pieter Bruegel the Elder.

Van Mander and his colleagues were still artists in exile, a generation unsure of its place. As an engraver and designer of engravings, Goltzius looked to an international audience. In his *Life* of Goltzius, van Mander praises his heroic strength as a draughtsman and the capacity of his engraver's burin, and goes on to tell a curious and revealing story. After completing in record time a set of six engravings, each in a different style, Goltzius decided to play a trick on the connoisseurs. He took a number of prints of two of these engravings—a *Circumcision* in the manner of Dürer, and an *Adoration of the Magi* in the manner of Lucas van Leyden—and disguised them, removing his signature and other indications of his authorship. Amateurs of prints were delighted to discover unknown prints by these revered masters. 'In this way', said van Mander, 'several people who tried to disparage or depreciate Goltzius's art, unwittingly put him above the best old masters and above himself.' The most significant detail in the story, however, is that the connoisseurs deceived by Goltzius were in 'Rome, Venice, Amsterdam and elsewhere'. Van Mander dreamed of a great school of northern painters rivalling that of Italy. For his 'Lives', he diligently searched out the most insignificant details of the lives of otherwise forgotten artists of the North and especially of his adopted town of Haarlem. He also wrote verses in which, after recalling the church spire of his native village in Flanders, he continued: 'But this is over. I will now deceive myself and consider all that country covered with salt sea. To have exchanged it for this is now no sorrow for me.'

Cornelis van Haarlem, as a good son of the town, received commissions from the corporation. He painted the *Massacre of the Innocents* and the *Wedding of Peleus and Thetis* and others that must be among the first pieces to be painted for museums. He also painted two group portraits, each showing the Company of St George Civic Guard at its annual banquet, in 1583 and again in 1599. Van Mander praised the earlier group as 'very effectively composed and all the people show their status or disposition by their actions'. But, as Constantijn Huygens remarked later, if Cornelis had been born thirty years later, he would not have gained the reputation he did. Cornelis, like Goltzius and van Mander, remained an exile from his artistic home of Antwerp. But a new generation discovered in Haarlem a rich and vital town with a thriving artists' guild, and there a new, Dutch, art was born.

4. Frans Hals

THE GREATEST GENIUS to arise in that first generation of independence in the United Provinces was also the least recognized, the most mysterious, the most inexplicable: Frans Hals. It is not known when or where he was born. His father was probably Franchoys Hals, from Mechelen, who was one of the six hundred cloth-workers and their families who arrived in Haarlem from Antwerp after 1585. The family was established in Haarlem by 1591, when Dirck, Frans's younger brother, also a painter, was baptized. Van Mander's anonymous biographer says that Hals was van Mander's pupil, but there is nothing to corroborate this. The first record we have of Frans is that of his entry into the Guild of St Luke in Haarlem in 1610. As he may have been thirty years old by then, and as the earliest known dated work—a portrait of 1611—is already the work of a mature genius, this makes the shadow over his youth appear even more impenetrable.

The few surviving documents concerning Hals are mainly records of debts and loans to repay debts. The only documents relating to a commission are curious. In 1633, he was commissioned to paint a group portrait of a company of Amsterdam militia; he was to be paid at the rate of sixty-six guilders a figure, which was a reasonable enough fee at the time and would have brought him a sum of over 1,000 guilders. But three years later, when the company summoned him to Amsterdam to complete the picture, Hals refused to travel and insisted that the guardsmen still involved should travel to Haarlem. They would not do so, and in the following year an Amsterdam painter, Pieter Codde, inserted their likenesses in their appointed places and completed the picture. The strange thing is that at the time Hals was refusing to travel the twelve miles to Amsterdam, he was being sued for debt by his landlord and his baker.

That Hals was not a neglected artist is proved by a most important body of evidence: his works. Over two hundred paintings by him have survived, and although this is not an immense number, almost all are portraits. Few things are less valued than the faces of a forgotten past, and Hals's only sitter whose reputation has survived independently was the French philosopher, René Descartes, who lived in Amsterdam for over twenty years. So it is probable that the surviving canvases are only a small part of Hals's actual production. Also, accident and recent research have discovered the identities of a sufficient number of his sitters to confirm that his reputation as a portraitist was high and remained high throughout his life. Jasper Schade van Westrum, Lord of Tull and 't Waal, was prepared to sit to Hals in 1645, and at the end of a very long career, when his brush-stroke was almost carelessly free, Hals still found sitters among aldermen and preachers, and the finished likenesses were published as engravings. The earliest literary reference to Hals is by Saenredam's patron, the Reverend Samuel Ampzing, in his

history of Haarlem. Ampzing praised Frans and his younger brother Dirck in a couplet:

> How nimbly Franz paints people from life!
> What neat little figures Dirck knows how to give us!

And in about 1630, Ampzing himself sat to Hals, for a picture on copper, hardly larger than a postcard. It is one of Hals's finest works, and although miniature in scale shows his usual free brushwork. This portrait has been identified because it was copied in two separate engravings.

Hals was, it seems, never short of commissions and his portraits were engraved for publication, yet it would be true to say that his genius went unrecognized. It went unrecognized because portraiture was not then thought a serious form of art. It was 'the kind of work that young painters, as well as others, most frequently find in this country', wrote Carel van Mander, adding 'for this reason, and in order to make money, many artists work primarily or exclusively as portraitists.' But it was, nevertheless, a low form of painting, to be avoided when possible. Hals did not avoid it. With the exception of a few portrait-like character studies, he painted only commissioned portraits. And, except for a dozen or so groups, his portraits are limited to a few simple formulas. He shows his sitters half-length, in one of three or four conventional poses against a plain background (Plates 22, 38). There are variations in pose and even, on occasion, in background, but one feature is invariable: the light always comes from the left (Plates 9, 159). It is hard to think of an artist who confined himself within so narrow a range of motifs, yet even if these portraits were the only things he had painted, Hals would unquestionably be a genius.

Hals had two gifts: he was a superb draughtsman with the brush; and he was a brilliant physiognomist. And both these gifts are fully mature in his earliest known works. Indeed, for Hals, these were not separable skills, but two aspects of the same faculty of portrait painting. His draughtsmanship is, nevertheless, an aspect which can be studied separately, simply by looking at the details of many of his works. In the handling of the embroidered sleeve of the *Laughing Cavalier* (Plate 39), for example, can be seen the mastery with which he could balance elaborate and accurately defined detail with broader, more summary handling.

His skill as a portrayer of character was, to a large extent, the result of his masterly draughtsmanship. Two points may be made, however. First, Hals represents his sitters with a lack of flattery which suggests that his patrons were either remarkably lacking in, or over-endowed with, self-love (Plates 51, 138). There is nothing in Hals's portraits of that subtle flattery visible in van Dyck's art. On the other hand, it looks, from other

portraits of the time, as if the Dutch accepted representations of their physical defects with remarkable equanimity. But Hals's literalness is usually without overtones of criticism or harshness; the shape of a nose, the oiliness of skin, or the sparseness of hair, these are matters of fact rather than the subject of comment (Plate 159). Hals's great skill was his ability to discover for each sitter that look which even the ugliest or most disagreeable person bestows on the objects of his affection.

The second point to note relates more directly to his draughtsmanship. In his recent monograph on Hals, Seymour Slive remarks that there is no known drawing by the artist, and he adds 'it is inconceivable that an artist who must have painted as easily as he breathed never put chalk or pen to paper.' But, as Slive also notes later, from the documents on the Amsterdam militia commission of 1633–6 it seems that Hals preferred to paint his portraits directly, while the sitter posed before him. He said that the guards would not have to pose for long while he painted them. That he proposed to paint directly on the final canvas seems implied by his adding that if some of the guards were unwilling to travel to Haarlem for sittings, he would make studies in Amsterdam which he would then include in his picture.

Hals's paintings *were* his drawings. If he avoided drawings and preliminary studies, as he probably did, it seems likely that this was not so much to preserve the freshness of his observations, but to ensure precision. Everything about Hals's procedure was limited: the lighting was invariable, his palette was limited to three or four pigments, even his brush-strokes are brusque and similar. What was not limited and predictable was the sequence of transformations wrought on these formulas by the uniqueness of the individual sitter. It was the precise quality of these transformations presented by each sitter that Hals caught precisely.

Hals's use of an invariable direction for the lighting is particularly significant here. The light falls evenly upon the uneven, mobile surfaces of the individual face: the light shimmers over these flexible, mobile surfaces: Hals paints the shimmer of light and shade. It is the crucial factor of his technique that he places exactly the spots at which the glossy skin reflects most brilliantly the beads and flecks of light. The attention to the skin's mobile surfaces as reflectors of light, and the ability to define these glossy planes with equivalent, flickering, strokes of the brush—these are the skills at the source of Hals's vital style. It is here that his art is based. This vision of light flickering over the expressive flesh of a face had to be drawn in paint. Other artists had used coloured chalks on tinted paper, but for Hals to have done this would have made laborious what was natural and spontaneous. And everything about Hals, both temperamentally and technically, would have avoided that.

Even if his art had consisted entirely of single portraits, Hals would still have been a genius; but fortunately he was given commissions for at least thirteen group portraits, and it is in these that his gigantic stature is fully revealed (Plates 8, 161). His individual portraits show him to be a brilliant and original draughtsman: his group portraits show that he is the equal of the greatest masters in the supreme skills of pictorial invention.

Five of the surviving commissions were from militia companies in Haarlem. Haarlem had two such companies, both with a long history. The older, the Company of St George (Plate 8), had been founded at the beginning of the fifteenth century as a civic guard of bowmen. The Company of St Hadrian had been founded in 1519 as a company of harquebusiers. Both companies had been disbanded after the capture of Haarlem by the Spanish in 1573, and had only been revived in 1580. But although they had the structure of military companies, their real function was social and civic. The annual banquet celebrated the end of the officers' year of duty. In 1609 the term of service, and therefore the interval between banquets, was extended to three years. In 1621 the banquets and attendant celebrations were limited to three or four days.

Hals was not the first to paint such a group portrait. Cornelis van Haarlem's banquet pictures had been followed by those painted by Frans de Grebber, Saenredam's teacher, and even earlier examples existed, notably by the Amsterdam painter, Dirck Barendsz. These earlier artists had recognized that the subject demanded more than a row of heads round a table, but only Cornelis's first banquet picture, of 1583, had really solved the problem. (De Grebber had, indeed, been faced with impossible tasks. His first commission had involved twenty-nine subjects, and his second, thirty-five.)

Hals did not merely solve the problem: he demonstrated that the task of painting between eleven and fourteen men, each individually a likeness, grouped round a table, could be done with a grandeur that rivalled the achievements of the greatest masters. It is clear, in fact, that Hals had learned from the greatest masters.

The motif of a group round a table had been a challenge for painters for at least two hundred years before Hals painted his first group. The greatest and most famous treatment was Leonardo's *Last Supper*, but Hals must also have seen engravings after the flamboyant canvases of the Venetian Paolo Veronese. Veronese had painted New Testament subjects—the *Last Supper*, the *Marriage at Cana*, *Christ in the House of Levi*—as almost indistinguishable from Venetian banquets. Even more pertinent to Hals's achievement were the designs of that Amsterdam painter who had worked in Titian's studio, Dirck Barendsz. Although his own group portraits were hardly more than rows of heads, Barendsz. had designed and published as engravings two biblical scenes of banquets, taken from the Gospel of St Matthew. These were powerful inventions. His *Mankind*

awaiting the Last Judgement, for which the drawing survives (in the Victoria and Albert Museum), anticipates Hals's portrait groups in the massing of its fourteen main figures into subsidiary groups; in pictorially linking figures on either side of a long table; in combining standing and seated figures to give further variety; and, perhaps most strikingly, in focusing on one end of the long table running across the picture, so that the head of the table, with its central figures, is shown foreshortened on the left of the canvas. Hals even has an open window behind the table in his earliest groups.

Cornelis van Haarlem had attempted all these devices, and Hals must have studied his banquet picture of 1583 very carefully. But Cornelis lacked the mastery of Hals: the works of Veronese do not come to mind when studying his picture, whereas Veronese and Tintoretto are necessary comparisons when considering the banquet pictures of Hals.

The apparent ease with which Hals could orchestrate a roomful of men, tableware, standards, and even a landscape through the window, is astounding, but it is easy to dismiss these marvellous works, simply because they do appear to lack seriousness. The two groups Hals painted when he was over eighty and within a year of his death are serious enough. These are the paintings of the *Regents of the Old Men's Alms House* (Plate 161) and the *Women Regents of the Old Men's Alms House* of about 1664. Time has given them an even deeper funereal gloom than they had initially, but they must always have been sobering in their austere blacks, greys and flashing whites. The five men regents and the four women regents, each group with its servant, sit with an air of endurance which is chilling and unforgettable. It results from the brooding expressions Hals has given his sitters, but most of all from his use of his great compositional skill to separate instead of unite the figures. In his great symphonies in praise of comradeship, Hals swept his brush across the canvas in long diagonal strokes that caught up in their weave nose and finger, collar and goblet, knife and bunting, near and far, matter and air, into a single, sensuous, promiscuous unity. But these men and women, guardians and actuaries of the dying, are small pyramids of laundered white and flesh, isolated in wastes of shadowy canvas. The brush-marks appear to have coalesced almost accidentally into smudgy patterns of hand and face: and each face stares stonily at the future with eyes that see only the past.

5. Early landscape and still-life

DUTCH LANDSCAPE PAINTING had its beginnings long before the birth of the Low Countries' commonwealth. As van Mander pointed out in the *Schilderboeck*, 'it is in this field that the Italians employ us though we are foreigners, for they consider the Netherlanders excellent landscape painters.' This was not an entirely flattering reputation, as van Mander knew. Michelangelo is supposed to have said that the Flemings were skilful at painting 'stuffs and masonry, the green grass of the fields, the shadow of trees, and rivers and bridges, which they call landscapes'. But all this, he said, was 'without symmetry or proportion . . . substance or vigour'.

Since the time of the van Eycks, at the beginning of the fifteenth century, the Flemings had developed a technical tradition which encouraged the representation of landscape. But for more than a century, landscape was employed only as an appropriate setting for a subject picture. The *Nativity*, the *Adoration of the Magi* and the *Flight into Egypt*, though among the most popular, were only three of the many subjects that gave occasion for elaborate landscapes; often the ostensible subject was lost in the vistas. One subject did become especially significant: the *Twelve Months of the Year*. Originally this was the *Labours of the Months*, represented on the façades of medieval cathedrals by single figures ploughing, sowing, reaping or performing other seasonal activities, to show Man's place in the divine order. During the fifteenth and early sixteenth centuries this subject provided themes for elaboration and variation in illuminated Books of Hours, commissioned by many wealthy men. In the *Months* as represented in those Books of Hours, the human activities became increasingly subordinate to extending vistas displaying the changing face of the countryside over the year. And for a few, at least, of those wealthy patrons, the countryside depicted so lovingly was their own property.

Early in the sixteenth century connoisseurs began to collect landscape paintings as a special category of picture. As early as 1521 the Venetian connoisseur Marcantonio Michiel noted that Cardinal Grimani owned 'many small landscape paintings' by Albert of Holland. Michiel also saw there other northern paintings: 'among them', he said, 'particular praise is given to the Twelve Months, and most especially to February, where one can see a boy who, urinating on the snow, makes it look yellow: the landscape is full of snow and ice.' In 1535 Federigo Gonzaga of Mantua bought 120 Flemish paintings, including 'twenty which represent nothing but landscapes on fire which seem to burn one's hands if one goes near to touch them'. Artist and connoisseur were discovering in landscape new sets of aesthetic values, and among them illusion, elaboration, variation, and nuance were becoming highly prized.

The Flemish tradition of landscape was brought north by the emigration that followed the fall of Antwerp in 1585. The undoubted master of the emigrés was Gillis van

Coninxloo, who left Antwerp in 1585 and, after some years near Frankfurt, settled in Amsterdam in 1595. With him were two other painters from Antwerp, David Vinckboons and Roelandt Savery. Together, these men transplanted the Flemish tradition of landscape to Holland, yet it was not their own work which had the most immediate influence. Vinckboons was primarily a painter of figure subjects. Savery favoured vistas of exotic terrain infested with an abundance of animal life; his favourite themes were *Noah preparing the Ark* and the *Garden of Eden*. Only Coninxloo was fundamentally a landscape-painter, and his magnificent primeval forests did not directly inspire the art of low horizons and bare skies which developed between 1612 and 1630.

Nevertheless, the first Dutch artist of distinctive talent was probably taught by one of these three Flemings (possibly Vinckboons), and that artist was Hendrick Avercamp. Avercamp, 'de stomme van Kampen' (the mute from Kampen), is a typically Dutch artist. His manner of painting, his drawing and ways of composing, remain very Flemish, but the quality of his art and the quality of his life are unmistakably Dutch. He was baptized in Amsterdam, on 27 January 1585, but seems to have passed much of his life in Kampen, a small town on the eastern side of the Zuider Zee. He appears to have discovered his own special theme early and devoted the rest of his life to it. And his development is obscure; the earliest dated work—of 1608, when he was twenty-three—is already in his mature vein.

Avercamp's art is easy to underestimate; it is limited, repetitious, and trivial: but it is also distinctive, witty, elegant, and always executed with a masterly touch. It is not even obvious that he is a landscape painter, for his speciality is crowds amusing themselves on the ice (Plate 1). The originals of this motif were two compositions by Pieter Bruegel the Elder: an engraving, *Skaters at the St George's Gate, Antwerp*, after a drawing of 1558; and an exquisite painting of a Flemish village in the snow, *Skaters with Birdcatcher*, of which many copies were made, the original probably being the panel now in the Delaporte Collection, Brussels. Avercamp must have seen that the motif of the winter fête was the epitome of Netherlandish exuberance. On the ice, outside the battlements that had secured them from the Spanish troops, the people of the new commonwealth, rich and poor, peasant and finely dressed bourgeois, could skate and slide and enjoy themselves. Over all there fluttered the tricolour of the new nation. Beyond the vertical surface of the panel, on the horizontal surface of ice, the small, neat figures spread themselves—nearer, larger and brighter; further, smaller and paler— among the veils of paint and snow.

The unique beauty of a Netherlandish winter, first represented by Pieter Bruegel, remained popular with later artists. But the invention of true Dutch landscape depended

on more than a national motif, it was the discovery of a style. And this, perhaps by chance, happened in Haarlem. Haarlem's magnetic power to attract talent is shown clearly here. Almost every Dutch painter of landscape of the first half of the century passed through the town, yet few were born or trained there, and few stayed long. The two artists who did most to establish the nature of seventeenth-century landscape, Hercules Seghers (Plate 46) and Esaias van de Velde (Plate 31), were both trained in Amsterdam, though Seghers was born in Haarlem. Both joined the painters' guild in Haarlem in 1612, but within two years Seghers was back in Amsterdam, and Esaias left for The Hague in 1618. Seghers exerted a decisive influence on Esaias. Esaias, in turn, influenced a number of other artists. These included Pieter de Molijn, who was born in London and joined the Guild of St Luke in Haarlem in 1616, and Jan van Goyen (Plates 5, 32, 33), of Leyden, who appears to have spent a year in Haarlem in 1617. He even left in Haarlem enough to impress an artist he never met, Salomon van Ruysdael (Plates 48, 113), who joined the Guild of St Luke there in 1623.

Seghers's influence is harder to assess, for only about fifteen paintings can safely be ascribed to him today. But there can be little doubt that his great genius had a profound effect on his contemporaries, even though few imitated his small landscapes of awesome mountains and panoramic vistas. Rembrandt, who owned eight of his works, was his one true heir as a landscapist (Plate 47). Rembrandt and Seghers shared an admiration for the work of the German painter Adam Elsheimer, whose work Seghers may have discovered in the studio of Coninxloo, his master. From Elsheimer and Coninxloo, Seghers developed a range of technical procedures which became the basis of the landscape painting of the early years of the seventeenth century.

The development of a style is always a difficult thing to account for. The growth of a national style of landscape in Holland seems to have depended on a number of factors: a vigorous professional tradition and professional competition; a prosperous open market, with little or no direct patronage; and in that market, a demand for a specific theme. All these elements were there in Haarlem in 1612. The theme was the Land, the Land of the newly independent United Provinces. The literature gives sufficient evidence of the national sentiment to prove the force of this motive. The significance of the lack of direct patronage is also clear. The painter was not in the position of the Limbourg brothers, working for the Duc de Berry, who demanded accurate representation of specific sites. The Dutch landscape-painter of the seventeenth century was representing his land for a potential purchaser from Holland, Zeeland, or any other of the seven United Provinces. Instead of the topographical, he represented the typical; he invented a series of subjects: winter scenes (Plates 1, 31), coastal scenes (Plates 76, 77, 90), sea-

scapes (Plates 93, 95, 97), country roads (Plates 112, 126), rivers and canals, and woods, as well as occasional topographical panoramas (Plate 49).

Nevertheless, the topographical basis of this art was crucial. The land with its specific physiognomy had existed long before the rise of the new nation, but artists had largely ignored its original features. Even Pieter Bruegel the Elder, the true inventor of Netherlandish landscape, had never made artistic use of the elementary fact that they were the Low Countries. He had always kept a high, panoramic viewpoint in his compositions. Yet the inevitable first discovery of any Netherlandish artist setting out to draw his native land was that it was low and flat: it was difficult to find a high vantage point from which to take a long view. The horizon was low and easily lost from sight; when prospects were extensive it was usually because they were empty. It was understandable that no one had earlier made an art out of this flat land. Even when directed by patriotic sentiment and his new market, the artist needed a particular richness of tradition to discover in the apparent visual barrenness of his native topography a new form of landscape art.

The art which developed in Haarlem after 1612 did spring from a rich confluence of traditions: with native skills descending from Bosch to Bruegel there blended the peculiarly Venetian achievements acquired by Elsheimer and inherited by Seghers. The result was an art of suprising originality, an art of great elegance, wit and restraint. It took the humblest motifs—an overgrown river bank, an uneven dune road, a derelict cottage and pale fence—and a technique of almost monochrome austerity and produced works of dandyish refinement (Plates 32, 33). That it was an art for connoisseurs there can be no doubt. The ostentatious triviality of the motifs, the virtuoso manipulation of the limited palette to create glowing light effects and rich textures, the dry brilliance of draughtsmanship which delighted in witty perspectives: all this speaks of an audience of *cognoscenti* appreciative of the skills concealed in every nuance of brushwork. As the patriot saw in his flat land virtues and significance hidden from the foreigner, so the professional and the connoisseur saw in this laconic style of landscape richness and skill hidden from the unfamiliar eye.

Still-life painting developed in a way that complemented rather than paralleled the growth of landscape art. It, too, appears to have grown from the Netherlandish skills of imitation. The religious paintings of fifteenth-century Flanders were heavy with objects: St Peter had his keys, St Paul his sword, St Bartholomew his knife and Mary Magdalene carried her pot of balm. To the informed contemporary, these objects were familiar: attributes of sainthood, their forms had had significance conferred on them by their sacred office. St Joseph had his saw, his hammer and his pincers and other carpenter's

tools, for that was his trade, but his hammer and nails reminded the devout of Christ's Passion on the Cross, and the mouse-trap Joseph made was another reminder that Christ's incarnation was a trap for the Devil. The Flemish painter gave these sacred emblems the forms of material existence. The first still-lifes were such objects, embedded in their context. The possibility of extracting them, of isolating them in a separate composition, was soon realized. The first independent still-lifes may have been an accidental result of the making of polyptychs. When the artist had spread a composition across several linked panels, with, perhaps, the vase of lilies or the ewer and towel needed for the Annunciation on a separate panel, as the van Eycks did in the Ghent altarpiece, then such a detail was easily detached and admired as a separate work. Another source of independent still-life was the decoration of walls and cupboard doors with *trompe l'oeil* objects, books on a shelf, the very objects concealed behind the cupboard door (Plate 36).

But the first truly independent still-lifes, painted in the third quarter of the sixteenth century, were a form of portraiture, or topography; they were flower-pieces. These bouquets of prize blooms, each of them defined accurately, clearly and minutely, were popular until the middle of the seventeenth century. They were not painted from life: the same bloom appears in different paintings and flowers that bloom at differing times of the year were freely put together. The significance of these pieces is uncertain. The frequent presence of sea shells, from the East and West Indies, the fruits of Holland's growing empire—taken with the growing obsession with horticulture and in particular the tulip cultivation which became a national mania—suggests that these bouquets combined the pleasures of amateur botany and natural history with delight in pictorial virtuosity and the pervading national pride. Whatever the interests, these pieces commanded high prices and provided an income, not only for Ambrosius Bosschaert, the principal artist of the form, but for a large number of his descendants and followers.

It was, once again, in Haarlem that the most significant developments in still-life took place during the first decades of the seventeenth century. A number of artists began to specialize in paintings of food laid out on a table. At first these were very Flemish in style; the viewpoint was high and the plates were spread out symmetrically, each dish and each object, fruit, biscuit, clearly displayed and minutely represented. The origin of the motif may have been such paintings as that by Pieter Aertsen of a laden table with Christ and the disciples in the background, representing the text 'Man shall not live by bread alone' (Luke 4 : 4), or that of another table piled high with rich food at which the *Prodigal Son* sits carousing, also by Aertsen. Whatever their origin, such pieces were popular. Then, about 1620, two great painters took up the theme of the breakfast piece

and transformed it. These were Willem Claesz. Heda and Pieter Claesz. From the sumptuous repasts, gaudy and luscious, spread out and waiting for the diner, these artists turned to a small corner of a table, a few utensils, a portion of food, perhaps already half-eaten, the place which an individual had just been occupying and to which he would return. These indications of possession and the proximity of the consumer confer new meaning on the still-life: it is no longer an invitation to all but has become an attribute of the appetite of one man.

Heda and Claesz. created a style which, though it recalls the landscapes of their contemporaries, is curiously opposite to that landscape art in its qualities. Like the landscapists, they worked in a low key, an almost monochrome palette, and like them they were concerned with the fall of light over their subject. But in this they are, perhaps, closer to Hals. The differences are fundamental: the landscapists made an art which is light, gay and laconic, the still-life masters, like Treck (Plate 72) and Kalf (Plate 73), one which is monumental, detailed and tranquil. They are complementary aspects of the same ideals.

The probability that the breakfast piece, apparently an ostentatious invitation to hedonism, had carried into the seventeenth century the admonition contained in Pieter Aertsen's earlier treatment of the subject may be questioned. But the still-life painters of Leyden, who followed the example of the Haarlem artists, were specialists in a subject that had undeniable moral implications, the *Vanitas* (Plates 74, 152). This was an emblematic reminder of the brevity of life and the folly of human ambitions. Its central image was often a skull, but a snuffed-out candle, a soap bubble, an hour glass or a watch served equally well. Placed in a still-life, any of these objects cast its shadow over even the most innocent or elevated of earthly activities. Figure subjects, too, take on a new connotation when these symbols of transience and human frailty are included (Plates 50, 128).

6. Early genre painters

'IN OUR NETHERLANDS, and especially at this present time, we have this lack, and this calamity, that there is little work to be done in figure composition that could provide our young people and our artists with the opportunity for such practice, through which they might achieve distinction in historical scenes, figures and nudes', lamented van Mander in the *Schilderboeck*. Receiving commissions to paint portraits from the life, Netherlandish artists continued on that 'bypath of the arts', he said, 'without having the time or the desire to look and search for the road of history or figure painting which leads to the highest perfection. Thus many a fine and noble mind has remained without fruit and quenched, to the great detriment of Art.'

Van Mander's complaint was justified. It would be hard to find more than a single painter of ability, beginning his career in Holland between 1610 and 1660, who persevered on that road to the highest perfection. Van Mander's generation of artists—Goltzius, Cornelis van Haarlem, Bloemaert (Plates 4, 11), Wtewael (Plate 2), Lastman (Plate 3) and a handful of others, almost all born before 1585—was the last to attempt the subjects and manners of the Italian Renaissance. The next generation, artists and public alike, seems to have totally rejected these ideals of art. This has, perhaps, not been sufficiently emphasized. The ultimate responsibility may lie, as has often been maintained, with the Reformed Church. But hostility, in the United Provinces, was not limited to religious art; it extended to the secular themes of classical mythology and history. Almost the only form of figure painting, other than portraiture, that was admired in the United Provinces in the seventeenth century was that of small scenes of contemporary life, and for the first half of the century it was largely restricted to a single theme: the *Merry Company*.

This was not a simple theme: it was complex both in its origins and in its manifestations, and there were very few subjects painted in the 1620s and 1630s which did not reflect an aspect of it. The two most important forms the theme took were the Banquet and the Kermis—High Life and Low Life—though they were not always clearly distinct. Their history was one of inter-relationships. The Banquet was a motif with a peculiarly rich and confusing past. With the exception of the Last Supper, which was in formal terms a related motif, the traditional subjects showing a banquet had included the *Marriage at Cana*, the *Feast of the Gods* (usually to celebrate either the Marriage of Cupid and Psyche or of Peleus and Thetis), the *Prodigal Son* (being prodigal), or the related scenes of *Mankind before the Flood* and *Mankind awaiting the Last Judgement*. The *Love-Feast*, often with heavily allegorical overtones, was a theme with a long tradition in the North, and closely related, both formally and in spirit, was the *Music Party*. These themes, because of their many strong affinities, are confusingly similar: naked

figures at a table may be Olympian gods feasting, or the degenerate contemporaries of Noah about to be destroyed by the Flood; if clothed, they may be at Cana or awaiting the Last Judgement. Other possibilities exist, but in most of them the uncertainty of theme creates a moral ambiguity: feasting leads to gluttony; marriage feasts may lead the feasters to the opposite of marriage, fornication. The pleasures of the senses result in sin. Just as the earliest representations of the ordinary man, the peasant, in his relation to the physical world had been in the Labours of the Months, so some of the first representations of Everyman's social, and therefore moral, environment had been as examples of the Seven Deadly Sins.

The theme of the Merry Company, with its many overtones, was taken up in Haarlem and Amsterdam by a number of artists between 1610 and 1630. Even Frans Hals may have painted a small *Banquet in a Park*, once in the Kaiser-Friedrich Museum in Berlin but now destroyed. This motif, a modern version of the *Marriage of Peleus and Thetis*, as such painters as Cornelis van Haarlem had treated it (see also Plate 2), was very popular between 1610 and 1615. The variation of the theme showing a few gallants and elegantly dressed women round a table in a tavern, which proved even more popular, was established by an artist whose career was short and whose history is shadowy, Willem Buytewech, nicknamed 'Geestige (Witty) Willem'. Buytewech joined the Haarlem painters' guild in 1612, the same year as Esaias van de Velde and Hercules Seghers, and he, too, stayed only briefly, until 1617, before returning to Rotterdam. He died in 1624, and now only about ten paintings can be ascribed to him. This theme, which springs most directly from that of the Prodigal Son, was taken up by a number of Haarlem painters, notably Dirck Hals (Frans Hals's brother), Esaias van de Velde, Hendrick Pot, Isack Elyas and Jan Molenaer (Plate 50) and his wife, Judith Leyster. The scenes are always on a small scale, and show carefully detailed figures in the contemporary costumes of cavaliers and their mistresses or courtesans. They sing or play musical instruments (the lute or theorbo takes on an emblematic quality here), they drink and they smoke, apparently as a prelude to more obviously sexual pleasures. In Amsterdam, Willem Duyster and Pieter Codde presented the theme in a slightly different mode, specializing in barrack-room scenes. Usually the difference is very slight—Duyster excelled in subtle light effects and in rendering the textures of different materials—for the battles hinted at were between Mars and Venus.

The most interesting modulation of the theme was from Banquet to Kermis, from aristocratic idling to peasant debauch. Occasionally the same artist treated both, as did David Vinckboons, that Flemish artist of the older generation who had arrived in Amsterdam about 1590. A drawing by him in the British Museum is especially interesting,

because although it shows an open-air banquet in a formal garden, reminiscent of the Feast of the Gods, it is, nevertheless, a *Prodigal Son* scene, for the prodigal can be seen in the distance, fleeing home, penniless and repentant. But Vinckboons was better known for his renderings of peasants merry-making, in the tradition of Pieter Bruegel and, before him, Hieronymus Bosch.

Bosch had used scenes of daily life to represent the Seven Deadly Sins in a panel now in the Prado, Madrid. The pervasive, universal nature of the Sins was demonstrated by the familiarity of the figures and scenes representing them. 'Anger' was a brawl between peasants outside a Flemish cottage: 'Pride' was a Flemish woman at home in a typical bourgeois interior, admiring herself in the glass. Most interestingly, Bosch showed 'Lust' as the vice of the upper classes, in a parody of a scene of courtly love, in which richly dressed couples flirt in a pavilion, surrounded by food, drink, musical instruments and a Fool. But 'Gluttony' is the vice of a peasant household, where food is the only wealth. Bruegel developed his moral comedy out of the implicit contrast between moral ideals and the actual behaviour of his peasants. For the seventeenth century, Bruegel was the supreme painter of peasant life, accurate and biting in his observations. The themes specifically associated with him were the *Peasant Fair* and the *Peasant Wedding*, but any scene of peasant revelry—that is to say debauch—was conceived in the light of his achievement.

Only two Haarlem painters of the new generation specialized in peasant scenes, Adriaen Brouwer (Plate 44) and Adriaen van Ostade (Plate 125). Brouwer, an exact contemporary of Rembrandt, is usually listed as a Flemish artist. He is believed to have been born in Oudenaarde and certainly died in Antwerp, but the first certain record of him is in Amsterdam in 1626, where he was known as a painter from Haarlem. It is thought that he came to Holland at about the age of fourteen and may have been trained by Frans Hals. His manner of painting is far closer to Hals than to any other master. Like Hals, he acquired the reputation of a profligate, but this may have been simply because his favourite theme was drunken peasants, and, just as Pieter Bruegel was held to have been a peasant because he painted peasants, so Brouwer may have earned his reputation because of his subjects. Nevertheless, there was growing, in those years at the beginning of the seventeenth century, the tradition of the Bohemian artist, and Brouwer may be counted among the earliest of the breed. In his reputation and the quality of his work, which is a conspicuous display of virtuosity, there is the hint that he and others, notably Buytewech, took an attitude to art and life that two centuries later would be called dandyish. Both Rubens and Rembrandt admired and collected Brouwer's work, and it is clear that they admired it for its cool, effortless brilliance.

Adriaen van Ostade—four years younger than Brouwer but reputed also to have been a pupil of Hals at the same time as Brouwer—shows nothing of either Hals's or Brouwer's painterly *brio*. His art is charming rather than brilliant and his peasant scenes do not reveal that animal vitality or ferocity which distinguish Brouwer's often frightening scenes. Van Ostade is amusing, and his cluttered interiors are filled with comic incident. A lesser artist than either, he was a link between Bruegel and Jan Steen.

Van Mander's disappointment at the lack of opportunity for figure painting in the Renaissance tradition is worth recalling before looking at the achievements of the group of painters working in Utrecht roughly between 1620 and 1630. There were three principal members of the group, all born around 1590, Hendrick ter Brugghen (Plates 23, 25, 26), Gerrit van Honthorst (Plates 12, 13) and Dirck van Baburen (a fourth was the teacher of ter Brugghen and Honthorst, Abraham Bloemaert (Plates 4, 11), who was influenced by his own pupils when they returned from Rome). All three visited Rome for some time between 1610 and 1620, and all three were strongly influenced by the work of Caravaggio.

Caravaggio left Rome in 1606 and died in 1610, but as ter Brugghen may have been in Rome as early as 1604, it is possible that he knew Caravaggio personally. But knowledge of the man was clearly unnecessary, as Honthorst and Baburen, neither of whom ever met him, were both greatly influenced by his works. Caravaggio's canvases publicly displayed in the Roman churches of Sta Maria del Popolo, the Chiesa Nuova and S. Agostino, and especially the three canvases showing the story of St Matthew in the Contarelli Chapel of S. Luigi dei Francesi, were the school of modern painting for many artists in Rome after 1605. Certainly Rubens was profoundly influenced by them. A significant aspect of Caravaggio's appeal to the young Netherlandish artists may have been his own debt to the Flemish tradition. His art owed as much to Massys and Hemessen as it did to Giorgione, and the great *Calling of St Matthew* takes its tax-collecting motif almost directly from Marinus van Reymerswaele. Caravaggio's art, built as it was out of an integration of Flemish and Roman forms, must have excited the group from Utrecht, faced with the same problem. But it was Caravaggio's realism which made a profound impression on the Utrecht painters. It was the hallmark of his art, heard of by van Mander before 1604, that 'he will not do a single brush-stroke without close study from life which he copies and paints'. 'Surely this is no wrong way to achieve a good end,' van Mander added.

Ter Brugghen was the most individual of the three, the most aware of the northern traditions behind Caravaggio's art. His rendering of delicate, cloud-filtered light and

shade anticipates the subtle interests of Vermeer and the painters of Delft (Plates 104, 115). Honthorst, who so specialized in candle-light effects that he was nick-named 'Gherardo delle Notti', and Baburen both had successful careers painting biblical subjects in Italy before their return to Utrecht, the former in 1620, the latter in the following year.

It is very striking that although all these artists painted biblical subjects after their return, they also took up other subjects; they diversified. Honthorst and Baburen, in particular, rediscovered that form of the Merry Company first developed by such Netherlandish painters as Aertsen and Hemessen half a century earlier, from which Caravaggio's own early half-length compositions probably derived. It looks as if van Mander's complaint remained true, even in the ancient cathedral town of Utrecht. Nevertheless, it should be remembered that Honthorst had painted his most brilliant Merry Company, a *Banquet* (Plate 12), which was unmistakably a Prodigal Son in a brothel (a canvas now in the Uffizi, Florence), while still in Italy. Whatever the reasons, ter Brugghen and Honthorst painted a number of single, half-length, life-size figures of musicians and drinkers wearing either vaguely arcadian or theatrically picaresque clothing (Plate 26). These figures, which are similar in spirit to some of those painted by Frans Hals, take up a form Caravaggio had painted for the open market of collectors, when he was still young and before he found serious patronage. They are to the Merry Company canvases what the paintings of individual Saints were to the biblical scene or the altarpiece.

The achievements of the Utrecht School are hard to assess. Perhaps, like its contemporary parallel in Haarlem, the painters of Merry Companies, it was the result of a speculative search for a new iconography that failed to capture the public's imagination; perhaps it was a brief fashion. It is hard to decide, because the movement disintegrated. Baburen died in 1624, ter Brugghen died in 1629, and only Honthorst, who left Utrecht for England in 1628 and later went to The Hague, lived on to become an international figure and a sadly deteriorated artist. Overshadowed by their great predecessor, Caravaggio, they are usually remembered for their influence on Rembrandt.

7. Rembrandt

A SINGLE Dutch artist—a contemporary of that generation, born between 1600 and 1610, of painters of Merry Companies and peasant scenes—stands out as a commanding genius. Born in 1606, about the same time as that other great talent, Adriaen Brouwer, he was the only painter to persevere on the road van Mander had indicated as leading to the highest perfection and, despite the lack of commissions for other than portraits from the life, to become and remain a history-painter: that was Rembrandt Harmensz. van Rijn of Leyden.

Leyden, at the beginning of the seventeenth century, was 'fairly seated in a delicate prospective, even in the heart of Holland, neatly built and fit for the muses to dwell in; for which cause the States of Holland in the year of our Lord 1575 after they were released of their long and dangerous siege [by the Spaniards] erected a university there, furnishing it with professions in all languages, giving them good and sufficient stipends, drawing to them the sufficient men of all professions than can be found in Christendome.' Rembrandt, who was the second-youngest child of a miller, was put to Latin school for seven years and then, in 1620 when he was fourteen, enrolled at Leyden University.

Rembrandt cannot have been at the university long, before his parents allowed him to begin his training as a painter. For perhaps three years he trained in Leyden, but there was no flourishing company of painters there, so about 1624 he went to Amsterdam for six months, to the studio of Pieter Lastman (Plate 3). Lastman was a not inconsiderable artist, who, because he was the teacher of a genius, has been unfairly treated by history. He also had as a pupil the other, even more precocious, Leyden painter, Jan Lievensz., who at the age of ten had gone to him for two years, between 1617 and 1619. Of those working in Holland at the time, Lastman was certainly the one painter able to teach Rembrandt the lessons of Italian art. A native of Amsterdam, he had gone at the beginning of the century to Italy, where he discovered the works of Caravaggio and, equally important, Adam Elsheimer. (The significance of that melancholy German who worked in Rome, producing far too few, small paintings on copper, and who died in 1610 at the age of thirty-two, is impossible to estimate. Without his example, neither the landscape painting of Haarlem nor the achievement of Rembrandt is conceivable.) Derivative though his art was, Lastman taught Rembrandt invaluable lessons. He taught him the fundamental skills of painting and draughtsmanship from which Rembrandt's art developed. Rembrandt remembered Lastman's example all his life. He carefully copied several of Lastman's compositions; at the age of 50 he was the owner of several of his paintings and drawings; and in his old age he was still basing works of his own on Lastman's inventions. Most important, perhaps, it was probably Lastman's example that encouraged Rembrandt to commit himself to the calling of history-painter.

Rembrandt's genius in this field was quickly recognized. Before he was 24, he was highly praised by a most discerning connoisseur and man of influence, Constantijn Huygens (Plate 29). An amateur of many arts, a polymath of formidable abilities and secretary to the Stadholder, Prince Frederik Hendrik of Orange, Huygens gave an interesting account of Rembrandt and Lievensz. in the autobiography he wrote about 1631. In particular he praised Rembrandt's painting of *Judas returning the Thirty Pieces of Silver* of 1629 (Plate 30). It was, he said, a work that could be compared with anything in Italy and with any of the beauties and marvels that have survived from remotest antiquity.

From this account, the young artists appear to have been very aware of their great talents and high destiny. Their histories, characters and conduct, as described by Huygens, approximate so closely to the archetypal figure of the Artistic Genius that it seems probable that the painters had quite deliberately presented themselves to their admirer in this role. Huygens stresses that both Rembrandt and Lievensz. are natural geniuses, owing nothing either to heredity or education, an exaggeration which is certainly unfair to their teacher, Lastman. He emphasizes their extreme youthfulness; 'nearer to childhood than to youth, to judge by their figures and their faces', he says. But although they had indeed been precocious, Lievensz. was at least twenty-three at the time about which Huygens was writing—some time after 1629—and Rembrandt a year older. Huygens observed (and this must have been the simple truth) that he had never seen such industry as shown by these two.

In this recital of these exemplary lives there are curious echoes of a *Life* which may indeed have been an exemplar to the Leyden artists: van Mander's account of their own great precursor, Lucas van Leyden. According to van Mander, Lucas had been amazingly precocious, uncomfortably industrious and 'all-encompassing and universal'. And, said van Mander, 'he never travelled abroad in order to learn his art, although Vasari writes differently and believes that all famous Netherlanders had to get their art from Italy and learn it from the Italians; but in this he errs. . . .' When Huygens asked Rembrandt and Lievensz. why they did not go to Italy 'to become familiar with Raphaels and Michelangelos' for then they would be able to 'bring the Italians to Holland, being as they are, men born to achieve the perfection of art', they answered that in the flower of their youth they had had no time to waste on travel, and added that the best of Italian pictures were then to be seen in northern collections.

Huygens admired both these young men greatly, but he believed that Lievensz., though a remarkable and excellent artist, would have difficulty in equalling Rembrandt's lively invention as a painter of histories. Until he left Leyden for Amsterdam, late in

1631 or early in 1632, Rembrandt painted little else but history subjects. And when he moved to Amsterdam, he painted a panel which may have been a specific declaration of his ambition. This was a *Descent from the Cross*, and it was accompanied by, or (more probably) followed by, a *Raising of the Cross*, on canvas. They were works of major ambition, and it cannot have been coincidence that when he moved to the town which had usurped Antwerp as the mercantile heart of the Netherlands Rembrandt painted the two subjects with which Rubens, admired by Huygens and many others as the greatest living Netherlandish painter, had established his reputation when he had settled in Antwerp, just over twenty years earlier. Moreover, Rembrandt's painting of the *Descent* was recognizably based on the engraving after Rubens's famous composition. And Rembrandt, too, published a reproduction of his composition, which (except for the etching after the grisaille *Christ before Pilate*, of 1636) was his only etched copy after one of his paintings. These two reproductive etchings were the only ones Rembrandt signed 'Rembrandt. f. cum pryvl°', which was a Flemish form of words to give copyright protection. Huygens must have admired Rembrandt's *Descent*, because he arranged a commission from the Stadholder for three further canvases, the *Entombment*, the *Resurrection*, and the *Ascension*, thus making the sequence of five works representing the *Passion of Christ*, now in Munich.

The commission occupied Rembrandt until 1639, but it remained the only one he received from the Stadholder (unless the Prince also commissioned the matching *Adoration of the Shepherds*, now also in Munich, which, with a lost *Circumcision*, he bought for 2,400 guilders in 1646, the year before he died). However, the year he moved to Amsterdam, Rembrandt received the momentous commission to paint *Dr Nicolaes Tulp demonstrating the Anatomy of the Arm* (Plates 42, 43) to members of the Amsterdam Guild of Surgeons. This was the painting which made his reputation and established the pattern of his career. There are few recorded commissions for history subjects by Rembrandt, although there is ample evidence for a long sequence of commissions for portraits, painted from the life, from professional men, especially preachers, lawyers and doctors. Rubens's *Descent from the Cross*, which Rembrandt had emulated, had been commissioned and donated to Antwerp Cathedral by the Antwerp Guild of Harquebusiers: when, shortly after Rubens's death in 1640, a company of Amsterdam harquebusiers gave Rembrandt a commission, it was simply for a group portrait. Even so, the monumental result may be called Rembrandt's last bid for the title of Rubens's successor as the great history-painter of the Netherlands, for no painting more clearly demonstrates his stature as a painter of histories than the portrait of the *Militia Company of Captain Frans Banning Cocq*, usually known as the *Night Watch* (Plates 66, 67). It should perhaps

be added that, like most artists, Rembrandt probably depended on the support and admiration, not of a nation or a generation, but of a single patron or a small circle of amateurs who understood and bought his work. In his case this seems to have been the small group of related professional men around Jan Six (Plate 88), who was Dr Tulp's son-in-law. Six himself owned a number of Rembrandt's works, but it is not known whether he or any of his circle commissioned paintings other than portraits.

As a history-painter, Rembrandt suffered throughout his life the fate described by van Mander in the *Schilderboek* (see p. 28). Yet it was out of this 'lack, and this calamity', as van Mander had called the absence of patronage for history painting, that, paradoxically, Rembrandt's own history painting flowered. The real paradox of course is that Rembrandt was never totally ignored as a history-painter. He was known and his works were collected all over Europe throughout his career. There were paintings by him in the collection of Charles I of England before 1633, and before he was 50 he was commissioned to paint an imaginary portrait of a philosopher for a patron in Sicily, the art collector Don Antonio Ruffo. His etchings and drawings brought high prices in 'Rome, Venice, Amsterdam and elsewhere'. He was the first genius to work for the open market, and it was from this that his art developed many of its distinctive features. Certainly, the commission from Sicily for an imaginary portrait was inspired by his excellence in that form, and nothing is more typical of his art than that series of Orientals, saints, prophets and other, more mysterious faces. Looking at the unique features and haunting expressions that Rembrandt gave to his *Officer* (Plate 20), *Flora* (Plate 54) or *Bathsheba* (Plates 133, 134), it is hard to realize that the imaginary portrait was a category of painting with a long tradition. Originally it was a devotional image, an icon, usually of a saint. It was a form which had already been established for two centuries when it was taken up in the Netherlands by the Utrecht School in the 1620s (see pp. 31–2). By that time the portrait might represent anyone or no one. That there was a market for such images is abundantly clear, and Rembrandt was encouraged to produce this form from the beginning. The French print-publisher Ciatres issued copies after several of Rembrandt's painted heads, arbitrarily identified as kings and heroes of antiquity and medieval legend. Even the form apparently so typical of Rembrandt, the real portrait in fancy dress, such as *Saskia as Flora* (Plate 54), was not his innovation but a device that can be traced back to the beginnings of portraiture itself.

Contemporary inventories show how popular Rembrandt's heads were; they also show that most collectors were indifferent to the subject, if any. 'Head, by Rembrandt' is the usual entry. The collector, presumably, wanted a Rembrandt, and Rembrandt was especially good at half-length figures and heads. Indeed, the complaint was that that was

all he was good at, as Don Antonio Ruffo, the Sicilian collector, was told, when he praised the half-length he had bought. Ruffo's commission, though, shows that Rembrandt took the subjects of his imaginary portraits seriously enough. Ruffo had asked for a 'philosopher, half-length'; Rembrandt provided a specific portrait, or even two, for it was the *Aristotle contemplating a Bust of Homer*, now in the Metropolitan Museum of Art, New York, in which the bust of Homer is an accurate representation of one in Rembrandt's own collection.

Rembrandt's collection of works of art, of which an inventory was made in 1656, was of an immense scope, containing—in addition to a large number of antique marbles or copies after them—paintings by a great many northern and Italian painters, and books and portfolios of engravings after the works of virtually all the great masters of the Renaissance. It provided Rembrandt, alone in Amsterdam, with an imaginary museum of the masterpieces of the world. His own works demonstrate the value of his collection to him. Without direct patronage, Rembrandt built his art out of competition with the masterpieces of the past. This is evident from the beginning, when he painted his own version of the *Descent from the Cross*. He took up Rubens's invention and re-created it in his own terms, and this remained a method of invention throughout his life. Throughout the thirties Rubens remained a potent force, and Rembrandt's inventions between 1632 and 1640, especially, are grounded in Rubens's achievement, filled with his forms, yet totally different in spirit and significance.

After Rubens's death, Rembrandt appears to have discovered Venetian painting and in particular that of Titian (there were important collections of Venetian art in Amsterdam after 1638). His painting acquired a new gravity and classicism; but it would be misleading to speak of his imitating Renaissance example, for in every instance where his source can be convincingly identified, Rembrandt's achievement appears to be a radical re-creation, which, though it often follows the general form of its model, has a totally new significance. This process of re-creation—in which, by meditating on an existing theme or on an earlier achievement, Rembrandt discovered new sets of values—was of special appeal to the new patronage of connoisseurs alert for the nuance, for the modulation of voice, the covert allusion.

In his variations on his theme, Rembrandt frequently used that Netherlandish literalness which saw the events of the Bible in contemporary terms, and so he made of the *Holy Family* a Dutch carpenter and his family (Plate 70). And in the *Christ and the Magdalen at the Tomb*, Mary mistakes Christ for a gardener because he carries a spade and wears a broad-brimmed straw hat (Plate 68). But that is not all. Rembrandt was never merely natural. The angels descending on the Holy Family, the Virgin herself,

are mixed a little with the Italian; the risen Christ appears in front of a landscape which is both exotic and medieval in its massive architecture.

But the Netherlandish literalness and the barbaric opulence between which Rembrandt seems to veer and which frequently exist together in a single work conceal the springs of his art. The richness and variety of Rembrandt's achievements are inexhaustible, but close to their centre is a curious duality of light and shadow, manifestation and concealment, matter and spirit.

The light and shade of his mature art is most striking; it fluctuates unaccountably, it hides what it might reveal. As light and shade alternate across the form of the painting, it is hard at first glance to perceive whether the shifts are caused by changing planes, varying textures, or some unregarded object casting its shadow. Yet the light and shade are expressions of a more profound duality.

From his youth, Rembrandt possessed the ability to create reality. Surfaces, in his paintings, exist; they invite the fingertips to experience their manifest textures. The differences between an ostrich feather and a steel gorget, between hair and lace, flesh and masonry—though his actual techniques altered dramatically over the years, these contrasts are at the heart of Rembrandt's art. And again, he builds his art out of the overlapping of surface on surface, collar over stomacher, hair upon collar, necklace against throat, leopard-skin against flank, scabbard against leopard-skin. In this way, Rembrandt creates a sense of physical presence which is overwhelming, but is itself a concealment. The clothing conceals the body as the body conceals the mind. Bathsheba's body is palpably present, her mind is absent, as she broods on the letter she has just read (Plate 133). This clearly physical image is about the impalpable, and depends for comprehension on knowledge of the body's history. The tender laying-on of hands which is the centre of the *Jewish Bride* (Plates 162, 165) is painted in broad strokes which leave the point at which the bride's fingers meet the back of the groom's hand unstated, inviting the eye to accept this invisible touch as the image of their union.

Throughout his life, Rembrandt remained a history-painter, reading his text and meditating deeply on the significance of what he had read, as a contemporary admirer said. It may have been this scrupulous reading of his text which led to the rejection of his last commissioned history painting. This was the enormous *Conspiracy of Julius Civilis: The Oath* (Plates 156, 157), originally intended for the Great Gallery of Amsterdam's new Town Hall. The subject—the rebellion of the ancient inhabitants of the Low Countries, the Batavians, against their oppressors, the Romans—had been described by Tacitus. It was from Tacitus that Rembrandt would have learned that the Batavian leader, Julius Civilis, was one-eyed, and so he painted him, a gaudily robed barbarian

among a group of primitives, taking the oath at a long table lit with a diabolical glow like an infernal Last Supper. But the Burgomasters of Amsterdam had chosen the Batavian fight for freedom as a historical parallel to their own recent war with Spain, and they saw Civilis as the precursor of their own late leader, William the Silent. Such a theme and such a hero required a more decorous, classical, *public*, treatment.

In the same year as the ill-fated *Conspiracy of Julius Civilis*, Rembrandt painted his last successful public commission, which was similar to that which Frans Hals was to paint two years later—a group of men round a table, the *Board of the Clothmakers' Guild of Amsterdam*, of 1662, now in the Rijksmuseum, Amsterdam.

8. Later genre: Vermeer and his contemporaries

LIGHT was Vermeer's subject: it fell through the window on his left, pale and insipid and unfailing: its clarity was never diminished by clouds: its calm was never broken by shafts from the sun (Plates 103, 104, 127). Night was an absence and offered no occasion for art. Into the light he inserted the things that lay to hand, a table and a chair, a Turkey carpet, a jug or a bowl of fruit, a map or a heavily framed picture, a woman, and, perhaps, other available objects. He placed them in the light with care, and the light bathed them impartially. But the objects were not indifferent to the light: their matter accepted or rejected it, turned towards it or away from it, absorbed, refracted and reflected it: its unity was metamorphosed into the diversity of colour.

The very paint of Vermeer's mature canvases is like condensations of light, dabs as fluid as quicksilver spilled from the tip of his brush. He must have used a lens to aid his observations of optical phenomena. A camera obscura would have projected an image of his model on to a flat surface, perhaps even the canvas on which he later painted the image, and he could have studied there those transformations of light peculiar to primitive lens systems that are such a striking feature of his art. He was born in 1632, at almost the same time as the Delft lens-grinder and scientist, Anthony van Leeuwenhoeck, and although there is no evidence that they were on familiar terms, Leeuwenhoeck was appointed executor of Vermeer's estate in 1675.

Little is known of Vermeer's life or career. He lived and died in Delft, a Catholic, father of eleven children, a picture dealer as well as a painter who worked slowly, left few works and died a bankrupt. Though he asked high prices for his canvases most were bought by a single collector, whose name is now lost, and were not widely known in his lifetime.

His greatness, though, does not lie in an obsession with optics: his canvases are not the precursors of chemical photography. There is in his remote images a charm, a poignancy and a beauty which accurate observation alone could not create. And the patterns into which his apparently insignificant models are arranged are strikingly limited and reminiscent of older paintings.

Since the early years of the seventeenth century, scenes of everyday life had become increasingly popular in Holland; the artists who painted them were numerous. Unmistakably, the Dutch delighted in recognizing themselves reflected in art—or, it would be truer to say, they delighted in an art grounded in the world of their senses. For the actual themes that were most popular did not represent the life around them in its diversity: there were, in fact, remarkably few themes and those carried disquieting reminiscences of earlier subjects. Indeed, in the Netherlands there was no single word to embrace all paintings of contemporary life, unless it was *beeldeken* for a picture with

small figures. Instead, there were words for specific subjects—*geselschapje* denoted the 'merry company', *buitenpartij* the 'open-air party' and *bordeeltjen* the brothel scene. Despite their apparent concern for the actual, Vermeer and those artists of his age— from ter Borch to de Hooch—who also painted scenes of contemporary life did not take their motifs haphazardly. Their art was a projection of older preoccupations on the world around them.

Northern art had shown a concern for the actual rather than the ideal since the Middle Ages. It had been the triumph of northern artists to discover the techniques by which the individual could be represented; the van Eycks, Dürer and Bosch, in their various ways, had contributed to the techniques of representing what was there. But— and this was no less important—they had seen that individuality could be representative: the unique, even the grotesque, might exemplify Mankind's common separation from the Ideal. For northern art did not simply represent the contingent, physical world: it portrayed the world of the senses, structured, as it was, by the opposed forces of appetite and morality. There was, at the centre of Netherlandish art, the terrible paradox of the Seven Deadly Sins that every pleasure and every anguish of the body and mind—every turbulence created by the appetites—was weighed in judgement.

The world of the senses was a world of appetites and interests, it was a world of values. The values of the appetites and morality were enriched with the values of culture. That is to say, of the many mere objects of the world, some acquired rich accretions of significance, from religion, profane myth, literature, art and folklore, and almost everything was available to the imagination as a support for new significance. A simple clay pipe, still a novelty in the early years of the seventeenth century, offered a delight to the senses of taste and smell, a temptation to the sin of Sloth (Plate 17). If nothing worse, it was an emblem of brooding melancholy, a reminder of the vanity of human desires, which, like smoke or soap bubbles (both products of pipes), pass rapidly away; it was suggestive of lovesickness, because 'fumo pascuntur amantes' (smoke is the food of lovers), or further proof of the rightness of the old proverb, 'veeltijds wat nieuws, selden wat goets' (often something new, but seldom anything good).

In the first years of the seventeenth century, the Dutch took up with relish the Italian game of inventing emblems and gave it a peculiarly Netherlandish form. The emblem, as developed by the Italians in the sixteenth century, was an exercise of wit which required ingenious combinations of word and image. The best known, even today, is the image of a dolphin twined about an anchor with the phrase *Festina lente* (make haste slowly). It is the perfect emblem because it is bizarre to the uninitiated but pleasingly apt to those who can understand it. Also, it suggests possible variations; the same

motto may be re-interpreted with the image of a crab and a butterfly. The Dutch form of emblem was, however, closer to the tradition, strong in the North, of proverbs. The inventive wit of Roemer Visscher, in his *Sinnepoppen* of 1614, was mainly concerned with the application of proverbs to new situations and objects in the world around him. *Rust ick zoo roest ick* (as you rest, so you rust) is represented by an axe left in a block of wood. Other proverbs, some of which were Latin but most of which were Netherlandish, allowed the artist Claes Jansz. Visscher to show a range of Netherlandish landscapes, utensils and domestic activities. In these images, published with the birth of the new nation, the values and essence of Dutch culture were made manifest for the first time.

This and the flood of books which followed suggest that though there was no single level at which a painting of daily life must be understood, the world around him was, for the Netherlander, rich with allusions, suggestions and reminiscences.

No artist was more ingenious in his play of wit and allusion in scenes of contemporary life than Jan Steen (Plates 45, 149, 150, 153). His own name has entered the Netherlandish language as a proverb: a 'Jan Steen household' calls to mind a quite specific variety of domestic disarray. No artist of his time was closer to the spirit of his great predecessor, Pieter Bruegel the Elder. Like Bruegel, Steen preferred the great ceremonial events of his society: a wedding, a christening or a saint's-day, at which the sprawling disorder of existence was brought into proximity with a sense of higher values. He fills his complex compositions with allusions to traditional rituals, sacred and profane, popular pastimes, proverbs and sayings and objects so familiar to his contemporaries that their significance called for neither explication nor comment. In the *Morning Toilet* (Plate 128) Steen shows a young woman rising in the morning drawing on her stocking. Though her skirts are above her knees, she pauses and stares unabashed through the open door straight into the eyes of the spectator. The open door and the bold stare are not incidental, as Steen indicates by various signs, literal and metaphorical. The bed has two pillows. The dog curled up by them recalls the spaniel curled up at the feet of the Venus Titian had painted, long ago, for the Duke of Urbino. Other details are equally suggestive, but the fundamental key lies in the gesture of the woman. Is she intending to draw up the stocking, or is she simply posing there provocatively? In a recent essay, E. de Jongh has pointed out that the Netherlandish for stocking, 'kous', was used in the seventeenth century in the same way as the word 'skirt' has been used in English in this century—as a term for a woman, especially a loose woman, and even for her sexual organs. Other verses and pictures of the time leave no doubt that a contemporary would have fully understood Steen's implication. But across the open threshold, barring the spectator from the woman, lies not only a lute (which itself was

used to signify, on different occasions, the pleasures of love and the follies of earthly pleasures), but also a skull. The world of the senses, the actual, which is the present, is impregnated with significance, which is the past and the future. Beauty and Pleasure, love and lust, Venus and whore, are framed by a foreboding of death.

Steen was a comic artist precisely because he was aware of the ideal dimension of life but did not represent it directly. The moral dimensions of the actual were his concern. He shows a *Wedding Party* (Plate 45) as a rich, rude feast, a mêlée of sacred and profane that is at once grotesque and beautiful. Although for the majority of the guests the holy sacrament of matrimony is a pretext for a leering debauch, the grand composition revolves round the group of a mother and child which is holy in its calm beauty. The force and splendour of the particular composition is proof that Steen was a comic artist on the highest level, and makes Sir Joshua Reynolds's regret, expressed in 1774, that Steen had not been taught by 'Michael Angelo and Raffaele' (see p. 52) appear perceptive, for this, and a handful of similar compositions by him, may be compared with all but the greatest masterpieces of the Renaissance.

If Steen's stature is revealed by the hints he gives of the ideal world of art, it was another artist who discovered that man did not have to be presented as comic if he were not to be made heroic: Gerard ter Borch made an art of the ordinary (Plates 124, 142, 145, 146). There is less mystery about ter Borch's career than about many other painters, yet his art is less explicit than that of any Netherlander except Vermeer himself. This is in part because ter Borch never stayed long among his fellow artists and possibly because of his age: he belonged to the generation between that of the painters of 'merry companies' and that of Vermeer, having been born in 1617. Part of his uniqueness derives from his training, both in Amsterdam, where he must have known the work of Willem Duyster, and in Haarlem, where he appears to have been trained by Pieter de Molijn. His early work owes much, both in subject-matter and in its treatment of textured surfaces, to the guardroom scenes of Duyster. But when he left Haarlem for England, in 1635, he seems never again to have lived in a town with a large artistic community. He travelled widely before he settled in Deventer, some time about 1654, where he remained for the rest of his life.

Ter Borch was a superb portraitist, who painted more portraits than any other type of picture. As a portraitist, he must be ranked only below Rembrandt and Hals, but unlike them he worked only on a scale approaching the miniature (Plate 142). And it was only when he was nearly forty that he began to paint a substantial number of those scenes usually associated with his name.

It is the very ordinariness, the lack of stylistic overtones, which is the most obvious

characteristic of those pieces (Plates 145, 146); and, subordinate only to that, the exquisite miniaturist's concern for textures. But when one looks at a sequence of ter Borch's works it becomes noticeable that these unremarkable people are not shown engaging in random activities of domestic and social life. His preferred themes are very limited: richly dressed and attractive young women write or receive letters, make music, alone or with young men, or drink glasses of wine, again accompanied by young men. The costumes are always rich, and consummately painted, the features of all the characters mobile and expressive, the backgrounds shadowy. Minor, enigmatic dramas, they retain undertones of military life and of the guardroom scenes with which he began his career. Ter Borch's authentic air is distracting; these are the ancient dramas, Mars and Venus, Samson and Delilah, the soldier and the lady, rediscovered in the world of his own time.

Did all Dutch artists, then, in taking up popular themes, see the world around them coloured by the past, permeated by inexplicit, even inexplicable, moods? It is far from certain. Indeed, many delightful works appear as hardly more than the repetition, skilfully executed, of an established theme (Plates 106, 115). There was, for such painters, a handful of themes, some taken from parables, some from proverbs, some from mythologies and yet others from the traditional feats of painterly skill recorded in the anecdotes of the painters of antiquity. Gerrit Dou (Plate 64) frequently painted faces lit by a candle, which, as a challenge to artistic virtuosity, may be traced back, beyond the Renaissance, to Pliny's description of Antiphilos, the Greek painter of the fourth century B.C., who painted a *Boy blowing on a Fire*. And in painting merry companies, Dutch painters no doubt remembered that Pausias of Sikyon had won immortal fame for his painting of *Drunkenness*, in which could be seen both the glass cup and the woman's face showing through it. For the seventeenth-century Netherlandish painter, these were simply the matter of painting. They were the subjects that were *schilderachtig*, picturesque.

Pieter de Hooch must have been such a painter. His subjects, domestic interiors (Plate 115) and courtyard scenes (Plate 122), have little drama and the traditional subjects are not emphasized. They are no more than a pretext for painting. Few artists who could reach the heights have been more uneven in their achievement than de Hooch and his worst paintings reveal clearly what his best paintings only hint at, that he was an artist with a system. His art depended on the manipulations of space. At his best he was a wonderful inventor of spacial effects. Nature and the laws of optical perspective were at his command. Planes, intervals, doors, shutters, corridors obey his will. Light falls at his command. Things are where they should be. The delight of a painting by de Hooch

is contained in surprise that the intractable stuffs of the experienced world can be conjured so effortlessly into inevitable, abstract harmonies.

But that is not the nature of Vermeer's art. In his concern for the values of light, he does not exclude other, human values. From his earliest dated work, the *Procuress* of 1656, now in the Gemäldegalerie, Dresden, he returned repeatedly to a handful of familiar motifs: music-makers, drinkers, and writers and readers of letters, and surrounded them with the attributes and symbols that were not less familiar. These images of worldly pleasure are made provocative by the very neutrality of his style. The eye contemplates them, and the mind is led to wonder on their potential significance.

A mosaic of glittering, blurred dabs of colour is a young woman reading a letter (Plates 98, 99). The crumbs of crystallized light group to form the textures of stuffs, glass, porcelain, wood, fruit, hair, and skin, the hardness of her brow, and the softness of her parted lips. Her pent breath and intense concentration are visible. She stands between curtains which are of two distinct styles. The crimson curtain, swept back to let in the light, has the colour and tight, sinuous swag of Caravaggio, the ancestor of Dutch realism. The other, pale, in crisper folds, recalls that linen curtain painted by the ancient Greek, Parrhasios, that his rival, Zeuxis, attempted to pull back to see the masterpiece beneath. It was Parrhasios who had discussed with Socrates the problem of representing the invisible soul through outward appearance. The curtains in Vermeer's picture have been withdrawn to reveal the focus where vision (that of the reader and of the spectator) generates the invisible motions of the human spirit.

Symbols given their power by the essentially visual qualities of chiaroscuro, obscurity and visibility, are at the centre of Vermeer's great *Art of Painting*, a title recorded by his widow, (Plates 103, 136). A curtain is lifted to reveal, not a self-portrait, but the *Artist*, in a curiously archaic, national costume, and his model robed as the personification of Fame. The key to the painting is almost invisible against the rafters: decorating the chandelier is the two-headed eagle of the Habsburgs, rulers of the Spanish Netherlands. But no light comes from this artificial source. The room and everything in it, including the map of the new Dutch Republic, is illuminated by Northern daylight. It is pure painting, pure vision, pregnant with meaning: an epiphany of the art of Netherlandish painting.

9. Landscape: Ruisdael and Hobbema

OUT OF national unity there flourished diversity. The generation born between 1625 and 1635 grew up in an established tradition of Dutch painting. Its masters and its techniques were around them. The men of this generation could go as far as Italy and yet preserve their sense of national achievement. Talent abounded and was no longer confined to Haarlem or Amsterdam; as the nation prospered, so young men dared to become painters, though their ambitions were often bitterly disappointed. The influence of Rembrandt was profound, though indirect. His first pupil, only seven years his junior, Gerrit Dou, learned the skills of Rembrandt's early, jewelled, miniature technique in Leyden (Plate 64) and when his master left stayed on to found a school of artists now known as *fijnschilders* (fine painters). Another pupil, Carel Fabritius, moved to Delft about 1650 and, until his death in 1654, profoundly influenced the growth of the Delft school of genre painting (Plate 120). New techniques and new pictorial ideals began to develop. Even in Haarlem, a new generation turned away from the dry elegant wit of Esaias van de Velde (Plate 31) and Jan van Goyen (Plates 32, 33) and discovered a more florid, colourful, picturesque, style. It was the golden age of Dutch painting, when every painter was a minor master, but of that proliferation of talents there was a handful of geniuses. Jan Steen and Vermeer have been discussed: a name to put beside them is Jacob van Ruisdael, the landscape-painter.

But unlike Steen and Vermeer, Ruisdael can, without incongruity, be compared to Rembrandt. His work has little direct resemblance to that of Rembrandt. In particular, Rembrandt's landscapes are of an older generation, being closely related to the achievement of Seghers and Esaias van de Velde. Ruisdael's canvases do have some slight similarity to the impasted works of Rembrandt's later years, but the real affinity is spiritual. He alone, of Dutch painters, has the range of Rembrandt, the ability to represent mood by pictorial means, and the exotic quality of his art. It is that exotic quality which is least obvious now. His work has come to epitomize Dutch landscape painting and it is easy to overlook how broad a range of landscape he commanded, far beyond the resources of his immediate environment (Plates 77, 143, 144). In particular, his rocky hillsides and waterfalls are, by the criteria of the north-western province of Holland, exotic. Though based in part on his experience of the German border, they are derived from Allart van Everdingen's Scandinavian landscapes and, through them, from the drawings of his master, Roelandt Savery, made in the Tirol at the beginning of the century.

The reminiscence of Savery is worth observing. It had been the achievement of the previous generation of Haarlem landscape-painters to break free from the formulas of the Flemish painters of the early seventeenth century, the followers of Jan Bruegel and

Savery in particular. Ruisdael rediscovered those conceptions of landscape construction; he needed formulas for constructing larger views than the principles of his uncle, Salomon van Ruysdael, for example, allowed. That the Mannerist schema is so little evident depends on a combination of factors: fundamentally, it is that Ruisdael's tonal sense, his sensitivity to the values of light, is so refined that this gives to the schema the cohesion and conviction of reality. A second factor is that his brush-marks totally lack the rhetorical flourish of Flemish Mannerism. On the contrary, the paint is applied in irregular splotches totally belying the linear rhythms to which they are applied but giving the objects they represent a rough-hewn touch that feels like reality.

This counterbalance of drawing and painting that is so remarkable a feature of Ruisdael's art is effective on another level, where, instead of using strong lines to give perspective, he has created depth by tonal change and judicious placing of discrete patches: a favourite use of this principle is seen in those still, black pools that fill so many of his foregrounds. There the surface is defined by abrupt dabs of pale pigment, leaves floating on the unseen surface, or a dog scurrying through the shallows breaking the water into scintillations.

In his invention, in his variety, in his extraordinary ability to convey mood, probably his only peer as a landscape artist is Nicolas Poussin. Certainly in Dutch art he is without rival. Yet two other names should be mentioned.

Aelbert Cuyp, of Dordrecht, was an artist of real range and exceptional refinement (Plates 97, 112). Eight years Ruisdael's senior, he was old enough to have learned the techniques of Seghers and van Goyen and then to have discovered from the work of Dutch painters returning from Italy the golden light of the Claudian Campagna. What might have proved nothing but a mannerism became, under Cuyp's hand, a visionary transformation of the true Dutch land. Cuyp, too, could be remarkably varied, but he was not afraid to repeat a favourite theme again and again.

Neither was Ruisdael's pupil, Meyndert Hobbema, afraid to paint the same theme more than once. His work is almost impossible to reproduce in quantity because it appears so repetitive. When Hobbema found a successful motif he would copy it and remake it with small variations. His formulas for building pictures were very limited: clumps of feathery trees, diverging perspectives, a shadow across a path, a cottage highlighted by a shaft of sunlight. Yet almost every picture is, individually, as fresh and thoroughly carried through as if it were a totally novel conception, and this ability is well brought out in his *Road on a Dyke* (Plate 126).

Writing at the end of the seventeenth century, the French critic, Roger de Piles, described the pleasures of landscape painting:

Among all the pleasures which the different talents of painting afford to those who employ them, that of drawing landskips seems to me the most affecting, and the most convenient; for, by the great variety of which it is susceptible, the painter has more opportunities, than in any of the other parts, to please himself by the choice of his objects. The solitude of rocks, freshness of forests, clearness of waters, and their seeming murmurs, extensiveness of plains and distant views, mixtures of trees, firmness of verdure, and a fine general scene or opening, make the painter imagine himself either a-hunting, or taking the air, or walking, or sitting, and giving himself up to agreeable musing. In a word, he may here dispose of all things to his pleasure, whether upon land, or in water, or in the sky, because there is not any production either of art or nature, which may not be brought into such a picture. Thus painting, which is a kind of creation, is more particularly so with regard to landskip.

It was this freedom to create that was the gift of the seventeenth-century painters of Holland to artists of later generations throughout the world.

10. Conclusion: the decline of Dutch painting

WHEN Jacob van Ruisdael died in 1682 the Golden Age of Dutch painting was virtually at a close. Berchem, de Heem, Netscher, Wijnants and Adriaen van Ostade died during the next three years and Philips Koninck, Cuyp, Kalf, Emanuel de Witte and Nicolaes Maes were all dead by the early nineties. Meyndert Hobbema survived until 1709, though he seems to have painted little after he took an appointment as a wine-gauger in 1668. Only two painters of the generation of Ruisdael and Vermeer carried their talent into the new century and they were both painters of marine subjects: Ludolf Bakhuizen and Willem van de Velde the Younger (Plates 89, 90)—elder brother of Adriaen van de Velde, who had died in 1672. Both were excellent artists. Van de Velde, in particular, preserved the taut, sweet clarity of those early Haarlem painters of the seas and estuaries, Jan van Goyen (Plate 33) and Jan Porcellis, and enriched their achievement with the mellow brilliance of Aelbert Cuyp's coastal scenes (Plate 97). Van de Velde and his father, who was also a marine artist, were taken into the service of Charles II of England in 1674 and thus left the way clear in Holland for Bakhuizen.

Of the succeeding generations, few artists can be compared to the originals of the seventeenth century. Jan Weenix (Plate 172) painted still-lifes of dead game in the Flemish tradition and foreshadowed the more oppressive creations of eighteenth-century French Rococo. Otherwise the successful style was a dilution of Gerrit Dou's fine Leyden manner (Plate 64) with the affectations of French court art. Godfried Schalken, who had studied with Hoogstraten (Plates 176, 178) and Dou, was one of the most successful in this style, and his work, though often cloying, has vitality as well as grace.

The most successful painter of the end of the century was probably Adriaen van der Werff (Plate 177). His early work was in the tradition of the Leyden fine painters but he quickly discovered the French classical style of the later years of the century. He was taken up with enthusiasm by the Elector Palatine, who appointed him court painter and made him a knight in 1703. He achieved greater fame and wealth than almost any other Dutch painter of the seventeenth or eighteenth centuries, and Houbraken called him the greatest Dutch artist. When compared with the work of the true Dutch artists of the century, however, his style appears derivative, superficial and unpleasant.

One artist of great appeal passed his entire working life in the eighteenth century and yet deserves a place beside the best of the minor masters of the seventeenth century, and that is the painter of flower-pieces, Jan van Huijsum (Plate 141). It is also fitting that a period which might be said to have opened with the flower-pieces of Bosschaert should end with those of Huijsum. Each was among the best-paid artists of his day, and it is well to remember that all the profundities of Rembrandt and the luminous mysteries of Vermeer were less admired in their time than a well-painted vase of flowers.

Appendix: Some attitudes to Dutch painting

As For the art off Painting and the affection off the people to Pictures, I thincke none other goe beeyond them, there having bin in this Country Many excellent Men in thatt Faculty, some att presentt, as Rimbrantt, etts, All in generall striving to adorne their houses, especially the outer or street roome, with costly pieces, Butchers and bakers not much inferiour in their shoppes, which are Fairely sett Forth, yea many tymes blacksmithes, Coblers, etts, will have some picture or other by their Forge and in their stalle. Such is the generall Notion, enclination and delight that these Countrie Native[s] have to Paintings.—PETER MUNDY, *Amsterdam, 1640*

We arived late at Roterdam, where was at that time their annual Mart or Faire, so furnish'd with pictures (especially Landscips, and Drolleries, as they call those clownish representations) as I was amaz'd: some of these I bought and sent to England. The reason of this store of pictures, and their cheapenesse proceede from their want of Land, to employ their Stock: so as 'tis an ordinary thing to find, a common farmer lay out two, or 3,000 pounds in this commodity, their houses are full of them, and they vend them at their Kermas'es to very great gaines.—JOHN EVELYN, *1641*

The masters to be studied for composition are Raphael, Rubens, and Rembrandt most especially, though many others are worthy notice, and to be carefully considered; amongst which Vandevelde [Willem van de Velde the Younger] ought not to be forgotten; who, though his subjects were ships, which consisting of so many little parts, are very difficult to fling into great masses, has done it, by the help of spread sails, smoak, and the bodies of the vessels, and a judicious management of lights and shadows. So that his compositions are many times as good as those of any master.—JONATHAN RICHARDSON, *1715*

With them [the Dutch] a history-piece is properly a portrait of themselves; whether they describe the inside or outside of their houses, we have their own people engaged in their own peculiar occupations; working, or drinking, playing, or fighting. The circumstances that enter into a picture of this kind, are so far from giving a general view of human life, that they exhibit all the minute particularities of a nation differing in several respects from the rest of mankind. Yet, let them have their share of more humble praise. The painters of this school are excellent in their own way; they are only ridiculous when they attempt general history on their own narrow principles, and debase great events by the meanness of their characters.

Some inferior dexterity, some extraordinary mechanical power is apparently that from which they seek distinction. Thus, we see, that school alone has the custom of representing candle-light not as it really appears to us by night, but red, as it would illuminate objects to a spectator by day. Such tricks, however pardonable in the little style, where petty effects are the sole end, are inexcusable in the greater, where the attention should never be drawn aside by trifles, but should be entirely occupied by the subject itself.

The same local principles which characterize the Dutch school extend even to their landscape painters; and Rubens himself, who has painted many landscapes, has sometimes transgressed in this particular. Their pieces in this way are, I think, always a representation of an individual spot, and each in its kind a very faithful but very confined portrait.—JOSHUA REYNOLDS, *The Fourth Discourse, 1771*

Among the Dutch painters, the correct, firm, and determined pencil, which was employed by Bamboccio and Jean Miel, on vulgar and mean subjects, might, without any change, be employed on the highest; to which, indeed, it seems more properly to belong. The greatest style, if that style is confined to small figures, such as Poussin generally painted, would receive an additional grace by the elegance and precision of pencil so admirable in the works of Teniers; and though the school to which he belonged more particularly excelled in the mechanism of painting, yet it produced many, who have shewn

great abilities in expressing what must be ranked above mechanical excellencies. In the works of Frank Hals, the portrait-painter may observe the composition of a face, the features well put together, as the painters express it; from whence proceeds that strong-marked character of individual nature, which is so remarkable in his portraits, and is not found in an equal degree in any other painter. If he had joined to this most difficult part of the art, a patience in finishing what he had so correctly planned, he might justly have claimed the place which Vandyck, all things considered, so justly holds as the first of portrait-painters.

Others of the same school have shewn great power in expressing the character and passions of those vulgar people, which were the subjects of their study and attention. Among those Jan Steen seems to be one of the most diligent and accurate observers of what passed in those scenes which he frequented, and which were to him an academy. I can easily imagine, that if this extraordinary man had had the good fortune to have been born in Italy, instead of Holland, had he lived in Rome instead of Leyden, and been blessed with Michael Angelo and Raffaelle for his masters, instead of Brouwer and Van Goyen; the same sagacity and penetration which distinguished so accurately the different characters and expression in his vulgar figures, would, when exerted in the selection and imitation of what was great and elevated in nature, have been equally successful; and he now would have ranged with the great pillars and supporters of our Art. — JOSHUA REYNOLDS, *The Sixth Discourse, 1774*

The account which has now been given of the Dutch pictures is, I confess, more barren of entertainment, than I expected. One would wish to be able to convey to the reader some idea of that excellence, the sight of which has afforded so much pleasure; but as their merit often consists in the truth of representation alone, whatever praise they deserve, whatever pleasure they give when under the eye, they make but a poor figure in description. It is to the eye only that the works of this school are addressed; it is not therefore to be wondered at, that what was intended solely for the gratification of one sense, succeeds but ill, when applied to another.

A market-woman with a hare in her hand, a man blowing a trumpet, or a boy blowing bubbles, a view of the inside or outside of a church, are the subjects of some of their most valuable pictures; but there is still entertainment, even in such pictures; however uninteresting their subjects, there is some pleasure in the contemplation of the truth of the imitation. But to a painter they afford likewise instruction in his profession; here he may learn the art of colouring and composition, a skilful management of light and shade, and indeed all the mechanical parts of the art, as well as in any other school whatever. The same skill which is practised by Rubens and Titian in their large works, is here exhibited, though on a smaller scale. Painters should go to the Dutch school to learn the art of painting, as they would go to a grammar school to learn languages. They must go to Italy to learn the higher branches of knowledge.

We must be contented to make up our idea of perfection from the excellencies which are dispersed over the world. A poetical imagination, expression, character, or even correctness of drawing, are seldom united with that power of colouring, which would set off those excellencies to the best advantage; and in this, perhaps, no school ever excelled the Dutch. An artist, by a close examination of their works, may in a few hours make himself master of the principles on which they wrought, which cost them whole ages, and perhaps the experience of a succession of ages, to ascertain. — JOSHUA REYNOLDS, *A Journey to Flanders and Holland in the Year 1781*

In appreciating the merits of Rembrandt . . . we may perhaps be enabled to determine what rank he is intitled to hold among the professors of the art. Disregarding, like the rest of his countrymen as well the forms of the antique, as the beautiful comments upon them discoverable in the works of the early Italian painters, he conceived in his own mind other ideas of the human figure, which he exemplified in an immense number of productions. In these pieces we are not to look for beauty of

form, nor always for truth of outline, yet we often observe a dignity of manner, which places him in this respect, far above a mere imitator of common nature, a Teniers, a Bega, or an Ostade. Among his historical pictures, we meet at times with pieces which the first painters of Italy might have been proud to own; and even among his prints, there may be found numerous examples of historical composition which impress the mind with ideas of grandeur, and of awe, of which the raising of Lazarus, and the beautiful little print of Christ with his Disciples at Emmaus, may serve as proofs. It is true his attempts at dignity of character are not always successful; and even his gravest subjects sometimes degenerate into buffoonery or absurdity. Who can forbear a smile when the cattle and their keepers, taking fright at the appearance of the angel who announces the nativity, overturn each other in their confusion to escape; or when Christ in the attitude of a mad-man, throws down the tables of the money changers, and furiously castigates the offenders with a tremendous bunch of cords? . . .

Even the ideas of grandeur and magnificence, which are at times discoverable in the works of Rembrandt, diminish in proportion as he approached to the representation of the naked figure. He was a painter of the human dress, rather than of the human form, and is indebted for a great part of his excellence to his furs, his mantles, his turbans, and his military accoutrements, of which he is said to have formed a large collection, which he assiduously studied. His academy figures are meagre, squalid, and vulgar, and his representations of the female character are disgusting in a high degree; the heads being in general disproportionally large, the limbs and extremities ill drawn, and diminutive and the skin appearing to hang in wrinkles over a corpulent and ill-formed mass of flesh. Yet there is reason to suppose, that in his judgment, these grotesque productions were preferable, as models of beauty, to the chaste and elegant representation of the Italian masters, with whose works he was not totally unacquainted, and whose prints he is known to have purchased with avidity.

The genius of Rembrandt as an historical painter, will be more accurately determined by comparing it with that of a great Italian master, whom he resembled in many striking particulars. The same grandeur of composition, the same powerful effect of light and shadow, the same freshness of tints which distinguishes the works of Titian, and which the hand of time rather improves than impairs, characterize also the productions of Rembrandt. Minute criticism might perhaps point out some distinctions between them. The pencil of Rembrandt had more spirit, that of Titian more softness. The works of the former require to be seen at a certain distance, those of the latter please from whatever point they are viewed; yet upon the whole the Dutchman need not shrink from a comparison with the Venetian. But when the productions of these artists are estimated by the standard of just criticism, what an astonishing disparity is perceived between them! The human form, under the plastic hands of Titian, bears the character of a superior race. The muscular strength of manly age, the just proportions, and delicious glow of female beauty, and the interesting attitudes, and rosy plumpness of infancy, excite approbation which will be as unchangeable as the principles on which it is founded. But surely some malicious sprite broke in upon the dreams of Rembrandt, and presented to his imagination, as the model of beauty, the perverse caricature of humanity, which, differently modified, appears in all his works. On this, the favorite object of his idolatry, he lavished all the graces of his exquisite pencil, and, infatuated by her allurements, suffered himself to be seduced from that simplicity of unadulterated nature, which is reflected to so much advantage in the mirror of art.

It has been remarked, that had Rembrandt studied in Italy, his drawing would have been more correct, from having the most perfect models constantly before his eyes. The observation is trite; this would have undoubtedly been the case, but in all probability there would only have been an exchange of qualities. Rembrandt shone in defiance of drawing, taste, and grace, and it is not unlikely, that if his principal attention had been directed to purity of outline, we should never have heard of

his name, except perhaps to an edition of the antique statues.

Let us however do justice to the talents of Rembrandt, and own that there are departments in which he appears to much greater advantage, than as an historical painter. Debarred by a vitiated taste from arriving at the first degree of eminence in works of imagination, he knew how to attain it when the actual model of his imitation was before his eyes, and he had only to transfer to the canvass the effect which he so well knew how to produce. Hence his portraits are deservedly held in the highest esteem, and in grandeur of character, as well as in picturesque effect, often rival the most celebrated works of Titian. . . .

From this slight inquiry into the merits of Rembrandt as a painter, it will sufficiently appear what rank he is intitled to hold among the eminent professors of the art. Excluded by the effects of a perverted and irremediable taste, from all pretensions to the first honours of his profession, he may be regarded as the most successful of those artists who have exercised great talents upon false principles, and who may not improperly be called the empirics of art.—DANIEL DAULBY, *1796*

Chiaroscuro is by no means confined to dark pictures; the works of Cuyp, though generally light, are full of it. It may be defined as that power which creates space; we find it everywhere, and at all times in nature; opposition, union, light, shade, reflection, and refraction, all contribute to it. By this power, the moment we come into a room, we see that the chairs are not standing on the tables, but a glance shows us the relative distances of all the objects from the eye, though the darkest or the lightest may be the farthest off—It has been said no man has enough of certain qualities that has them not in excess, so Rembrandt, of whose art chiaroscuro is the essence, certainly carried it to an extreme. The other great painters of the Dutch school were more artless; so apparently unstudied, indeed, are the works of many of them, for instance, Jan Steen and De Hooge, that they seem put together almost without thought; yet it would be impossible to alter or leave out the smallest object, or to

change any part of their light, shade, or colour, without injury to their pictures,—a proof that their art is consummate.

The landscapes of Ruysdael [Jacob van Ruisdael] present the greatest possible contrast to those of Claude, showing how powerfully, from the most opposite direction, genius may command our homage. In Claude's pictures, with scarcely an exception, the sun ever shines. Ruysdael, on the contrary, delighted in, and has made delightful to our eyes, those solemn days, peculiar to his country and to ours, when without storm, large rolling clouds scarcely permit a ray of sunlight to break the shades of the forest. By these effects he enveloped the most ordinary scenes of grandeur, and whenever he has attempted marine subjects, he is far beyond Vandervelde.

The subject [a picture by Ruisdael] is the mouth of a Dutch river, without a single feature of grandeur in the scenery; but the stormy sky, the grouping of the vessels, and the breaking of the sea, make the picture one of the most impressive ever painted. . . . An ordinary spectator at the mouth of the river which Ruysdael has here painted, would scarcely be conscious of the existence of many of the objects that conduce to the effect of the picture; certainly not of their fitness for pictorial effect.

This picture [a small evening winter-piece by Ruisdael] represents an approaching thaw. The ground is covered with snow, and the trees are still white; but there are two windmills near the centre; the one has the sails furled, and is turned in the position from which the wind blew when the mill left off work, the other has the canvas on the poles, and is turned another way, which indicates a change in the wind; the clouds are opening in that direction, which appears by the glow in the sky to be the south (the sun's winter habitation in our hemisphere), and this change will produce a thaw before the morning. The occurrence of these circumstances shows that Ruysdael *understood* what he was painting. He has here told a story; but in another instance he failed, because he attempted to tell that which is out of the reach of the art. In a picture which was known, while he was living, to be called 'An Allegory of the Life of Man' (and it may there-

fore be supposed he so intended it)—there are ruins to indicate old age, a stream to signify the course of life, and rocks and precipices to shadow forth its dangers;—but how are we to discover all this?

The Dutch painters were a *stay-at-home people*,—hence their originality. They were not, however, ignorant of Italian art. Rembrandt had a large collection of Italian pictures and engravings, and Fuseli calls the school of the Bassans the 'Venetian prelude to the Dutch school'. We derive the pleasure of surprise from the works of the best Dutch painters in finding how much interest the art, when in perfection, can give to the most ordinary subjects. Those are cold critics who turn from their works, and wish the same skill had been rendered a vehicle for more elevated stories. *They* do not in reality feel how much the Dutch painters have given to the world, who wish for more; and it may always be doubted whether those who do not relish the works of the Dutch and Flemish schools, whatever raptures they may affect in speaking of the schools of Italy, are capable of fully appreciating the latter; for *a true taste is never a half taste*. Whatever story the best painters of Holland and Flanders undertook to tell, is told with an unaffected truth of expression that may afford useful lessons in the treatment of the most sublime subjects; and those who would deny them poetic feeling, forget that chiaroscuro, colour, and composition, are all poetic qualities. Poetry is not denied to Rembrandt, or to Rubens, because their effects are striking. It does not, however, the less exist in the works of many other painters of the Dutch and Flemish schools who were less daring in their style.—JOHN CONSTABLE, *1836*

Although one has to keep in mind every part of the figure so as not to lose the proportions when they are hidden by drapery, I cannot think that this [the practice of drawing each figure in the nude before drawing it clothed] is a good method to follow in every case, but Raphaël seems to have conformed to it scrupulously, judging by the studies that are still in existence. I feel convinced that Rembrandt would never have achieved his power of rep-

resenting character by a significant play of gestures, or those strong effects that make his scenes so truly representative of nature, if he had bound himself down to this studio method. Perhaps they will discover that Rembrandt is a far greater painter than Raphaël.

This piece of blasphemy will make every good academician's hair stand on end, and I set it down without having come to any final decision on the subject. The older I grow the more certain I become in my own mind that *truth* is the rarest and most beautiful of all qualities. It is possible, however, that Rembrandt may not quite have had Raphaël's nobility of mind.

It may well be, however, that where Raphaël expressed this grandeur in his lines and in the majesty of each of his figures, Rembrandt expressed it in his mysterious conception of his subjects and the profound simplicity of their gestures and expression. And although one may prefer the note of majesty in Raphaël which echoes, as it were, the grandeur of some of his subjects, I think that without being torn to pieces by people of taste (and here I mean people whose taste is genuine and sincere) one might say that the great Dutchman was more of a natural painter than Perugino's studious pupil.—EUGÈNE DELACROIX, *1851*

But in the pastoral landscape we lose, not only all faith in religion, but all remembrance of it. Absolutely now at last we find ourselves without sight of God in all the world.

So far as I can hear or read, this is an entirely new and wonderful state of things achieved by the Hollanders. The human being never got wholly quit of the terror of spiritual being before. Persian, Egyptian, Assyrian, Hindoo, Chinese, all kept some dim, appalling record of what they called 'gods'. Farthest savages had—and still have—their Great Spirit, or, in extremity, their feather-idols, large-eyed; but here in Holland we have at last got utterly done with it all. Our only idol glitters dimly, in tangible shape of a pint pot, and all the incense offered thereto, comes out of a small censer or bowl at the end of a pipe. 'Of deities or virtues, angels, principalities, or

powers, in the name of our ditches, no more. Let us have cattle and market vegetables.'

This is the first and essential character of the Holland landscape art. Its second is a worthier one; respect for rural life.

I should attach greater importance to this rural feeling, if there were any true humanity in it, or any feeling for beauty. But there is neither. No incidents of this lower life are painted for the sake of the incidents, but only for the effects of light. You will find that the best Dutch painters do not care about the people, but about the lustres on them. Paul Potter, their best herd and cattle painter, does not care even for sheep, but only for wool; regards not cows, but cowhide. He attains great dexterity in drawing tufts and locks, lingers in the little parallel ravines and furrows of fleece that open across sheep's backs as they turn; is unsurpassed in twisting a horn or pointing a nose; but he cannot paint eyes, nor perceive any condition of an animal's mind, except its desire of grazing. Cuyp can, indeed, paint sunlight, the best that Holland's sun can show; he is a man of large natural gift, and sees broadly, nay, even seriously; finds out—a wonderful thing for men to find out in those days—that there are reflections in water, and that boats require often to be painted upside down. A brewer by trade, he feels the quiet of a summer afternoon, and his work will make you marvellously drowsy. It is good for nothing else that I know of; strong; but unhelpful and unthoughtful. Nothing happens in his pictures, except some indifferent person's asking the way of somebody else, who, by his cast of countenance, seems not likely to know it. For farther entertainment perhaps a red cow and a white one; or puppies at play, not playfully; the man's heart not going even with the puppies. Essentially he sees nothing but the shine on the flaps of their ears.

Observe always, the fault lies not in the thing's being little, or the incident being slight. Titian could have put issues of life and death into the face of a man asking the way; nay, into the back of him, if he had so chosen. He has put a whole scheme of dogmatic theology into a row of bishops' backs at the Louvre. And for dogs, Velasquez

has made some of them nearly as grand as his surly kings. . . .

Having determined the general nature of vulgarity, we are now able to close our view of the character of the Dutch school.

It is a strangely mingled one, which I have the more difficulty in investigating, because I have no power of sympathy with it. However inferior in capacity, I can enter measuredly into the feelings of Correggio or of Titian; what they like, I like; what they disdain, I disdain. Going lower down, I can still follow Salvator's passion, or Albano's prettiness; and lower still, I can measure modern German heroics, or French sensualities. I see what the people mean,—know where they are, and what they are. But no effort of fancy will enable me to lay hold of the temper of Teniers, or Wouvermans, any more than I can enter into the feelings of one of the lower animals. I cannot see why they painted,—what they are aiming at,—what they liked or disliked. All their life and work is the same sort of mystery to me as the mind of my dog when he rolls on carrion. He is a well enough conducted dog in other respects, and many of these Dutchmen were doubtless very well-conducted persons: certainly they learned their business well; both Teniers and Wouvermans touch with a workmanly hand, such as we cannot see rivalled now; and they seem never to have painted indolently, but gave the purchaser his thorough money's worth of mechanism, while the burgesses who bargained for their cattle and card parties were probably more respectable men than the princes who gave orders to Titian for nymphs, and to Raphael for nativities. But whatever patient merit or commercial value may be in Dutch labour, this at least is clear, that it is wholly insensitive.

The very mastery these men have of their business proceeds from their never really seeing the whole of anything, but only that part of it which they know how to do. Out of all nature they felt their function was to extract the grayness and shininess. Give them a golden sunset, a rosy dawn, a green waterfall, a scarlet autumn on the hills,

and they merely look curiously into it to see if there is anything gray and glittering which can be painted on their common principles.

If this, however, were their only fault, it would not prove absolute insensibility, any more than it could be declared of the makers of Florentine tables, that they were blind or vulgar, because they took out of nature only what could be represented in agate. A Dutch picture is, in fact, merely a Florentine table more finely touched; it has its regular ground of slate, and its mother-of-pearl and tinsel put in with equal precision; and perhaps the fairest view one can take of a Dutch painter, is that he is a respectable tradesman furnishing well-made articles in oil paint; but when we begin to examine the designs of these articles, we may see immediately that it is his inbred vulgarity, and not the chance of fortune, which has made him a tradesman, and kept him one.—JOHN RUSKIN, *1860*

As the point of view, so the style, and as the style, so the method. If you take away Rembrandt—an exception in his own country and everywhere else—you will see but one style and one method in all the studios of Holland. The object is to imitate that which *is*, to make what is imitated loved, to express clearly one's simple, strong, deep feelings. The style, then, will have the simplicity and clarity of the principle. Its law is to be sincere, its obligation to be truthful. Its first condition is to be familiar, natural, expressive; it follows from a concourse of moral qualities—*naïveté*, patient goodwill, and uprightness. We might almost call them domestic virtues, taken from private life and used in the practice of art, which serve equally to guide one aright and to enable one to paint well. If you take away from Dutch art that which might be called probity, you will no longer understand its vital element; and it will no longer be possible to define either its morality or its style. But just as there are in the most practical of lives motives and influences that en-

noble the behaviour, so in this art, held to be so positive, among these painters, held for the most part to be mere copiers of detail, we feel a loftiness and a goodness of heart, an affection for the true, a love for the real, that give their works a value the things do not seem to possess. Thence their ideal, somewhat misunderstood, somewhat despised, indubitable to all who are willing to grasp it, and very attractive to those who can enjoy it. At times a touch of warmer sensibility turns them into philosophers, nay, even into poets. . . .—EUGÈNE FROMENTIN, *1875*

SOURCES OF EXTRACTS

Mundy, Peter. *Travels in Europe, 1639–47*. The travels of Peter Mundy in Europe and Asia, 1608–1667, edited by Sir Richard Carnac Temple, vol. 4. London, 1925.

Evelyn, John. *The Diary of John Evelyn* (available in several editions), entry for 13 August 1641.

Richardson, Jonathan. 'The Theory of Painting', in *The Works of Jonathan Richardson*, edited by J. Richardson [the Younger]. London, 1773.

Reynolds, Joshua. *The Works of Sir Joshua Reynolds . . . containing his Discourses . . . [and] A Journey to Flanders and Holland . . .*, 2nd ed., 3 vols. London, 1798.

Daulby, Daniel. *A Descriptive Catalogue of the Works of Rembrandt . . .*, Liverpool, 1796.

Constable, John. Part of a lecture given to the Royal Institution on 9 June 1836. Quoted in C. R. Leslie's *Memoirs of the Life of John Constable*, edited by Jonathan Mayne. London & New York: Phaidon, 1951.

Delacroix, Eugène. *The Journal of Eugène Delacroix*, translated by Lucy Norton and edited by Hubert Wellington. London & New York: Phaidon, 1951. Entry for 6 June 1851.

Ruskin, John. *Modern Painters*, vol. 5. London, 1860. Pt. 9, ch. 6 (paras. 11, 12, 13) and ch. 8 (paras. 1, 2).

Fromentin, Eugène. *The Masters of Past Time*, translated by Andrew Boyle and edited by H. Gerson. London & New York: Phaidon, 1948. Pages 100–1.

List of plates

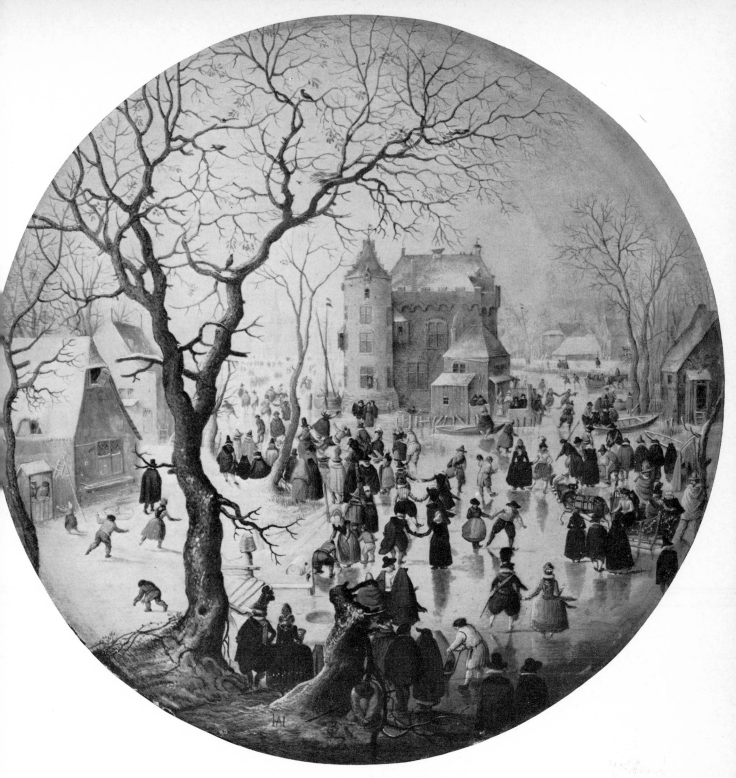

1. HENDRICK AVERCAMP (1585—1634): *A Winter Scene with Skaters near a Castle*. About 1609. Panel, diameter 16 in. London, National Gallery

In this early work, the artist stays close to the formulas of the Flemish followers of Bruegel. The round format was often used in representations of the *Twelve Months*. The marvellous castle, round which the celebrations revolve, may be an emblem of Dutch fortitude, but it is an invention of the artist and not an existing building.

2. JOACHIM WTEWAEL (1566—1638): *The Judgement of Paris.* 1615. Panel, $23\frac{1}{2} \times 31\frac{1}{8}$ in. London,
National Gallery

In the foreground, Paris, son of King Priam of Troy, makes his famous judgement between the goddesses:
Hera is on the left, Athena on the right and in the middle is the winner, Aphrodite. In the background is the
feast with which the Gods celebrated the marriage of Peleus and Thetis. It was then that Eris, the goddess of
strife, threw down the 'apple of Discord', inscribed 'for the fairest', and this was the cause of the contest. The
composition can be matched with similar works by Bloemaert and Cornelis van Haarlem, and typifies the
Mannerist style of the late sixteenth and early seventeenth centuries.

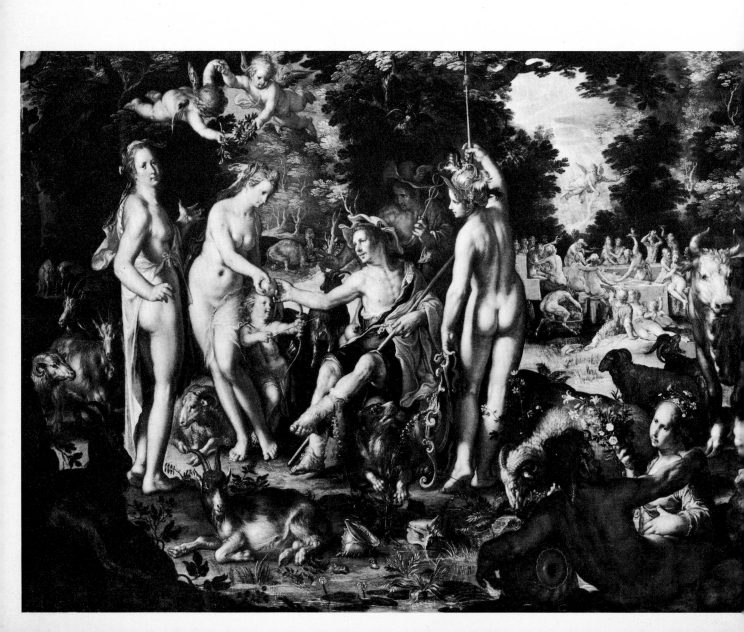

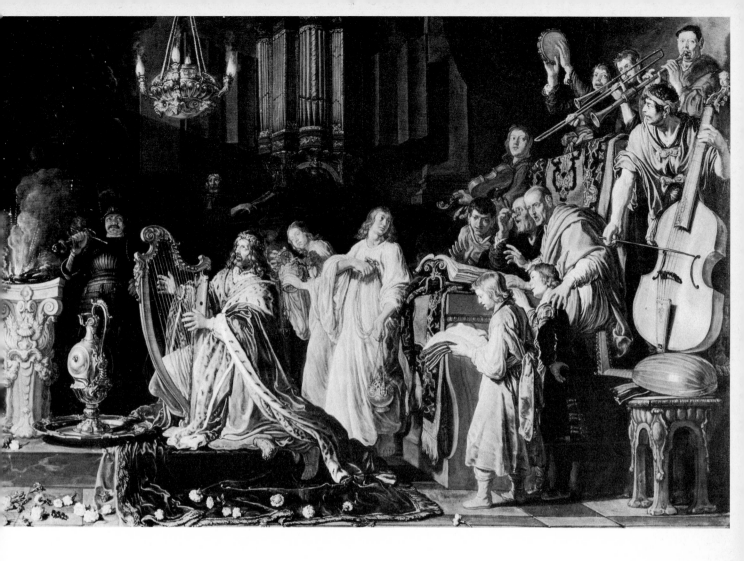

3. PIETER LASTMAN (1583—1633): *David in the Temple*. 1618. Panel, 31⅛ × 46 in. Brunswick, Herzog Anton Ulrich Museum

A comparison with Plates 19, 30, 40 and 41 reveals how much Rembrandt learned from Lastman and also how very quickly he transcended the achievements of his master. It was from Lastman that Rembrandt was able to learn the firm modelling and sense of solid forms on which his art was founded. And, as this example shows, Lastman must have been the source of his sometimes grotesque combinations of exactly considered and totally inappropriate details. Here, Lastman has taken great pains to characterize and animate the sixteen figures in his composition. In particular, he has carefully differentiated the five choristers, accepting a traditional challenge to the painter to show which part each singer has by the expression on his face. On the other hand, every detail of the setting—especially the magnificent organ pipes in the background—could only have originated in the Netherlands in the sixteenth century.

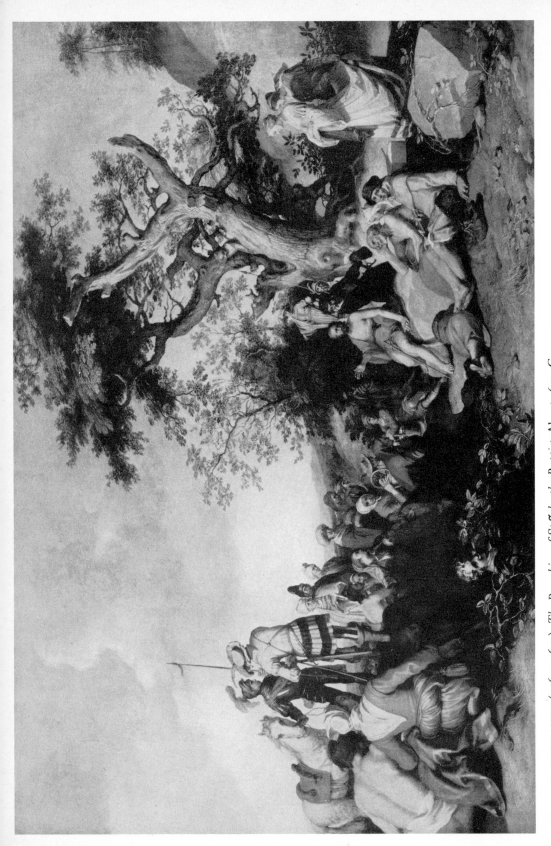

4. ABRAHAM BLOEMAERT (1564–1651): *The Preaching of St John the Baptist*. About 1630. Canvas, 49¼ × 75¼ in. Nancy, Musée des Beaux-Arts

The preaching of John the Baptist is described in most detail in the gospels of St Matthew and St Luke. It is St Luke who (3:14) says that soldiers were present, as Bloemaert shows on the left. It is St Matthew who (3:7) draws attention to the Pharisees and Sadducees (behind and to the right of the soldiers) whom John addressed as a generation of vipers. The tree may represent the metaphor in Matthew 3:10, 'every tree which bringeth not forth good fruit is hewn down, and cast into the fire.' The subject of John the Baptist preaching was popular in the Netherlands. Bruegel had treated it memorably in a painting of 1566, and Rembrandt also painted the subject about 1637.

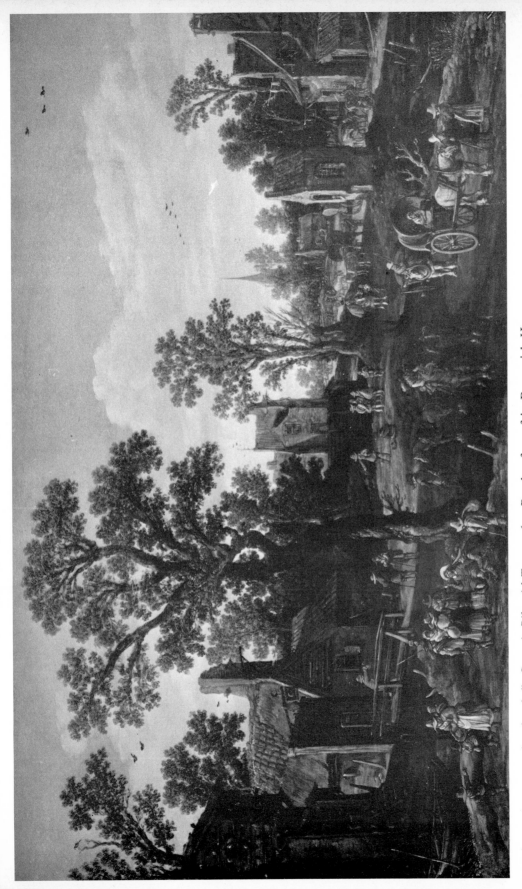

5. JAN VAN GOYEN (1596—1656): *Street in Bilt, with Troops*. 1623. Panel, $15\frac{5}{8} \times 27\frac{7}{8}$ in. Brunswick, Herzog Anton Ulrich Museum

In this small scene, probably painted in Leyden, van Goyen still uses the formulas of the Flemish school of landscape painters. The elaborate treatment of ground, broken up into contrasting areas of light and dark, with the intersections marked by trees, buildings or figures, is typical of Dutch landscape painting of this date. The format and the crisp, springy line with which the details are defined are derived from the Flemish tradition. Van Goyen's village has a certain quaint charm, but it does not convince the spectator that it is real. It may be filled with everyday rustic images but it totally lacks the sense of atmosphere which was to become the real subject of his later art. It was only gradually that a distinctive Dutch style evolved from its Netherlandish origins, as can be seen by comparing this plate with Plates 31, 32 and 33. In particular, it should be noted that Esaias van de Velde's *Winter Landscape* (Plate 31) was also painted in 1623.

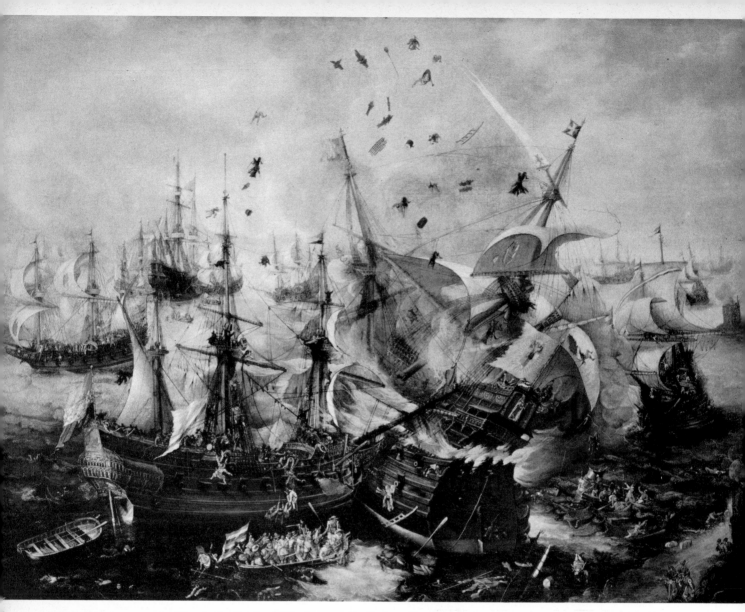

6. HENDRICK VROOM (1566—1640): *Battle of Gibraltar, 25 April 1607*. Canvas, $54\frac{1}{8} \times 74$ in. Amsterdam, Rijksmuseum

Vroom was the first great Dutch painter of sea-battles and maritime pageants. His work stems directly from a series of thirteen engravings designed by Bruegel and a painting, also by Bruegel, of the *Harbour at Naples*. The battle scene (above) celebrates a Dutch victory over the Spanish fleet. The vessel exploding in the foreground is the Spanish flagship. The men and debris hurled aloft recall the angels and demons that inhabit the skies of Hieronymus Bosch. Vroom's style is thoroughly sixteenth century and gives little hint of the feeling for atmosphere that was the dominant concern of later marine artists. As a portrayer of vessels, Vroom was, nevertheless, a master, as the detail (opposite) from a panoramic canvas reveals. This superb painting, which is, unfortunately, too rich in detail for the whole of it to be reproduced adequately on a small scale, represents an event in which the Dutch took a great interest and which led, ultimately, to the crises in Bohemia that precipitated the Thirty Years War.

7. HENDRICK VROOM: Detail from *The Arrival in May 1613 of Frederick V, Elector Palatine, at Flushing, with his Consort Elizabeth, Daughter of James I of England.* 1623. Haarlem, Frans Hals Museum

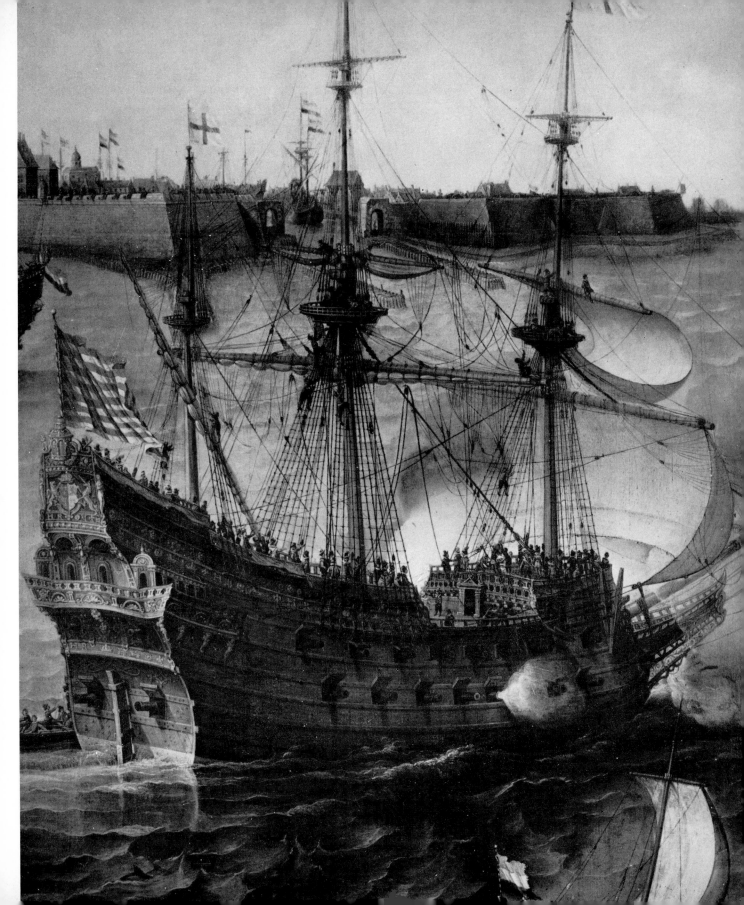

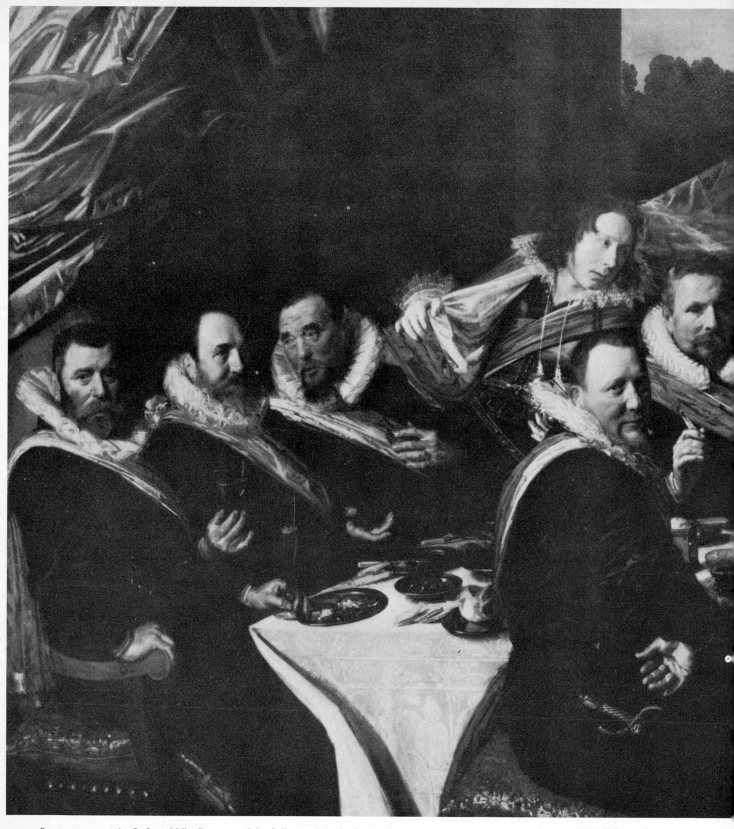

8. FRANS HALS (1580?—1666): *Banquet of the Officers of the St George Civic Guard Company*. 1616. Canvas, 69 × 127½ in.
Haarlem, Frans Hals Museum

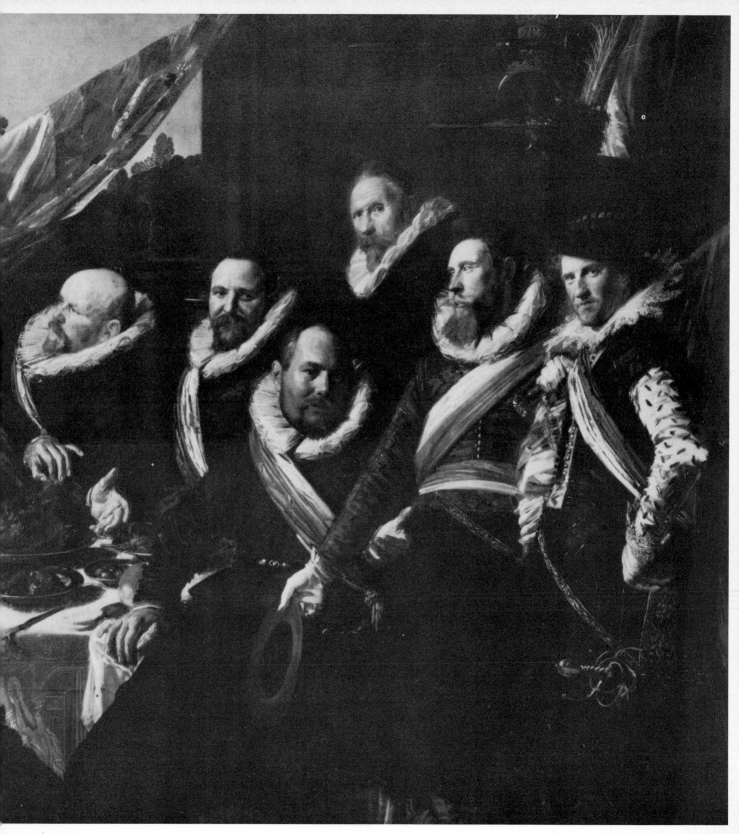

The St George Company (*St Jorisdoelen*) had been formed as a company of cross-bow men as early as 1402. The Colonel of the company sits at the head of the table and on his right is the Provost. Standing in the background is the company servant.

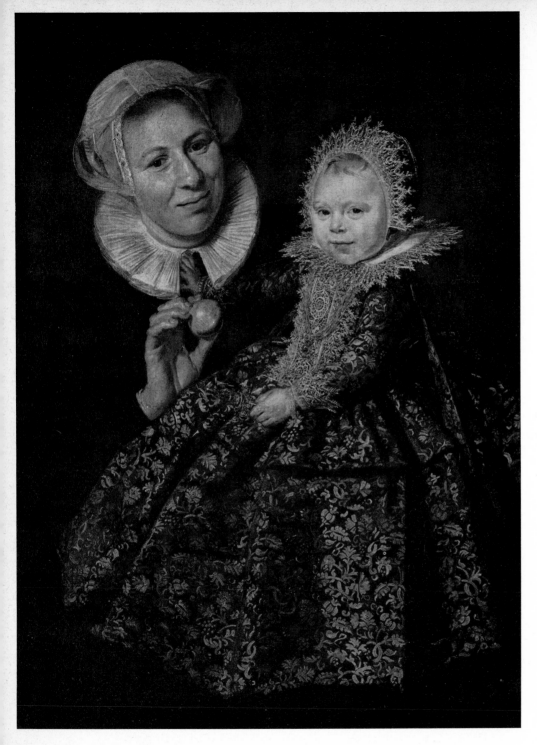

9, 10. FRANS HALS (1580?—1666):
Nurse and Child. About 1620.
Canvas, $33\frac{7}{8} \times 25\frac{5}{8}$ in. Berlin
-Dahlem, Staatliche Museen

Before the vivid immediacy of this
double portrait, it is a shock to realize
that nothing is known of the sitters.
Though the woman is always spoken
of as a nurse, this is not certain, and
the sex of the child is also not known.
The motif of offering an apple to a
child was common in Netherlandish
portraits and derives from representa-
tions of the Virgin and Child, in
which the apple that had caused
Man's Fall when given to Adam by
Eve signified his redemption when
given by the Virgin to her Son. For
this reason, Hals's picture may show
a mother and son.

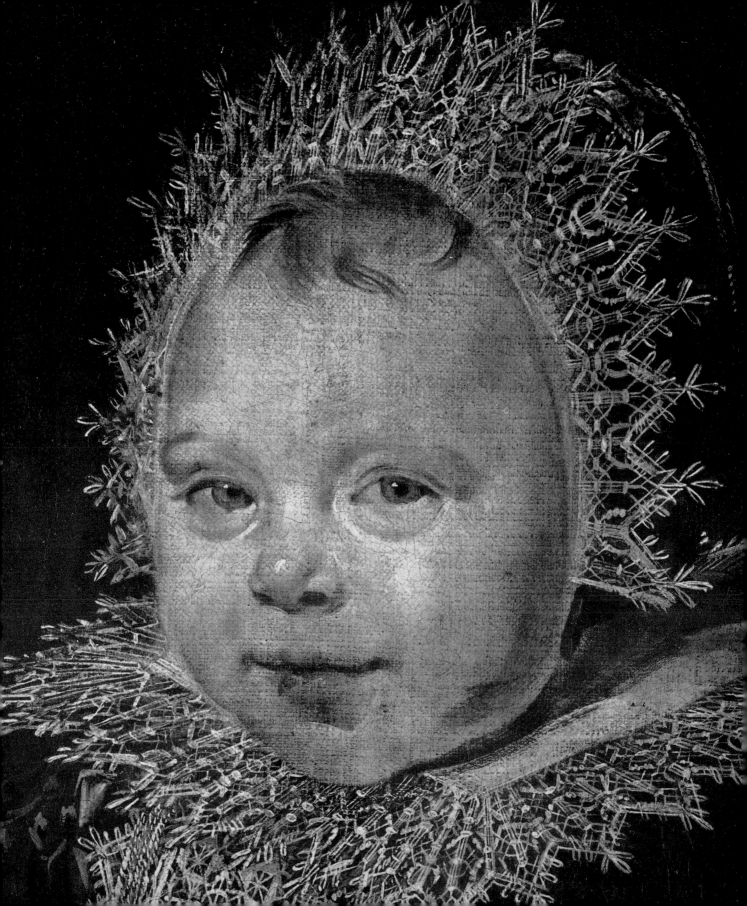

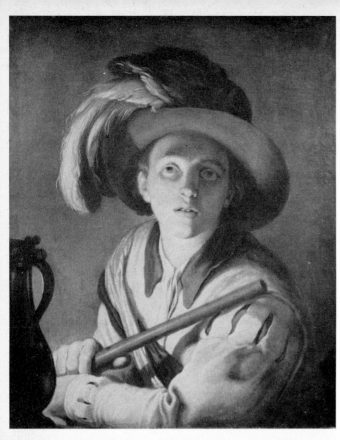

11. ABRAHAM BLOEMAERT (1564—1651): *The Flute-Player*. 1621. Canvas, 27⅛ × 22⅝ in. Utrecht, Centraal Museum

Bloemaert learned the secrets of Caravaggio's art from his pupils, ter Brugghen and Honthorst, when they returned from Rome. The half-length figure was often represented by ter Brugghen (see Plate 26) but Bloemaert's flute-player has none of his pupil's pungency. The criss-cross of flute and drapery, light and shade, anticipates one of Rembrandt's favoured devices.

12. GERRIT VAN HONTHORST (1590—1656): *A Banquet*. 1620. Canvas, 54½ × 80½ in. Florence, Uffizi

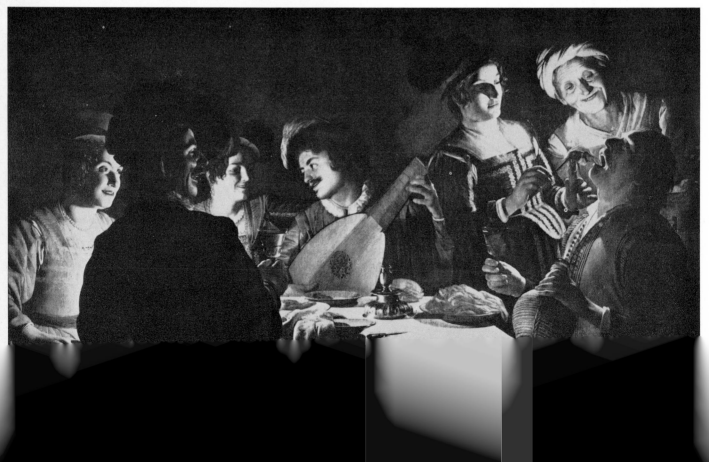

13. GERRIT VAN
HONTHORST:
*Christ before the
High Priest.*
About 1617.
Canvas, 106 ×
72 in. London,
National
Gallery

Both this and the
Banquet (opposite)
were painted in
Rome, where
Honthorst worked
between about
1610 and 1620.
*Christ before the
High Priest* is one
of the artist's
greatest works,
both for its drama-
tic delicacy and its
technical virtuosity
in representing the
naked flame of a
candle and the
controlled half-
tones of the rest of
the large canvas.
The *Banquet* is
coarser in spirit,
but its subject was
more favoured in
the Netherlands.

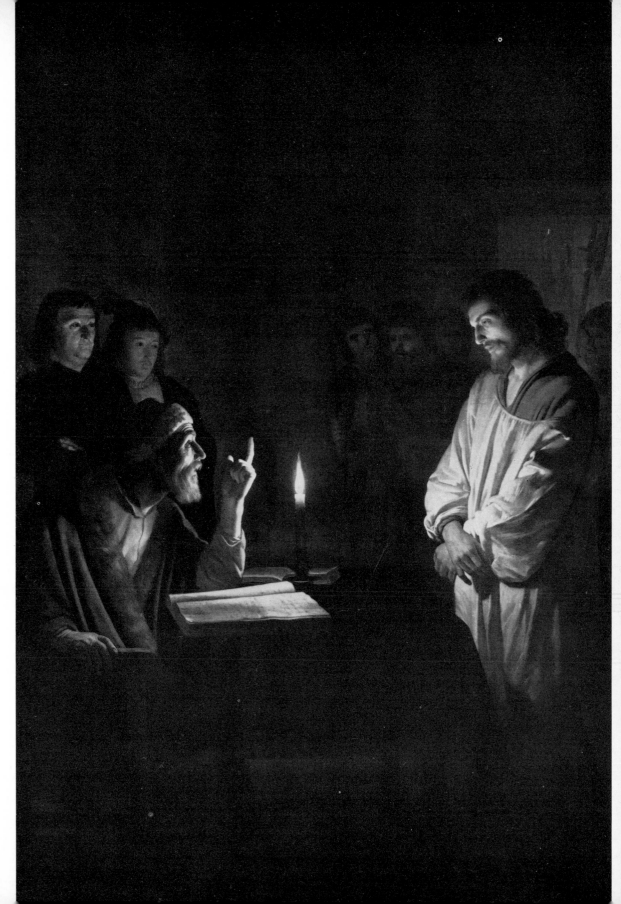

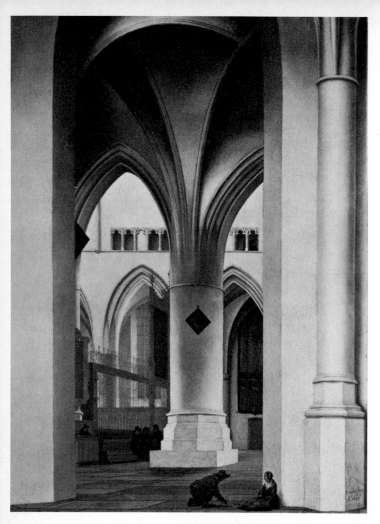

14. PIETER SAENREDAM (1597–1665): *St Bavo, Haarlem:
Interior from the Brewers' Chapel.* 1636. Panel,
19¼ × 14⅜ in. Paris, Fondation Custodia (Coll. F. Lugt)
Institut Néerlandais

15. PIETER SAENREDAM: *St Bavo, Haarlem: Interior of
the Choir and the Nave.* 1627. Pen and watercolour,
5⅝ × 9¼ in. Haarlem, Municipal Archives

Saenredam represented the interior of the Great Church
of St Bavo for the first time in this drawing, which was a
preparation for an etching to illustrate Samuel Ampzing's
History of Haarlem, published in 1628. As was his
practice, the artist carefully inscribed the drawing: 'this
drawn in 1627. in the great church in Haarlem, from life.'
The line marking the eye level, and the vanishing point,
to which all perspective lines lead, are clearly marked.
Saenredam painted many views of the interior of St Bavo
throughout his life. He found, in its intricate perspectives,
endless variations of those spacial harmonies which were
the substance of his art. Though he worked from careful
drawings and even from measured plans he was not afraid
to deviate from his drawing to create the effect he desired.

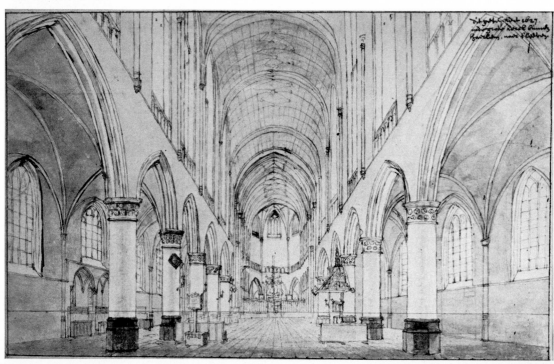

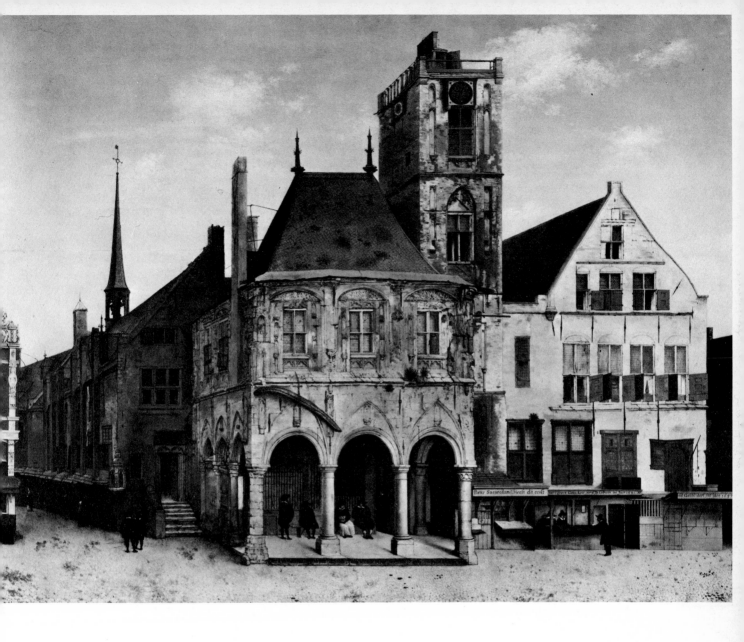

16. PIETER SAENREDAM: *Old Town Hall, Amsterdam*. 1657. Panel, 25⅜ × 32⅝ in. Amsterdam, Rijksmuseum

Saenredam made a careful drawing of the Old Town Hall in Amsterdam in 1641 and recorded his work on the drawing: 'Pieter Saenredam drew this on the 15, 16, 17, 18, 19, 20 July 1641.' Later he added the inscription: 'in the year 1652 the 7 July this old Town Hall in Amsterdam has burned down in three hours without more.' This finished painting, which closely follows the drawing made sixteen years earlier, is also carefully inscribed with similar records. Saenredam's inscriptions are like guarantees of his veracity.

17.
PIETER CODDE
(1599—1678):
'The Smoker'.
About 1635.
Panel,
$18\frac{1}{8} \times 13\frac{3}{8}$ in.
Lille, Musée
des Beaux- Arts

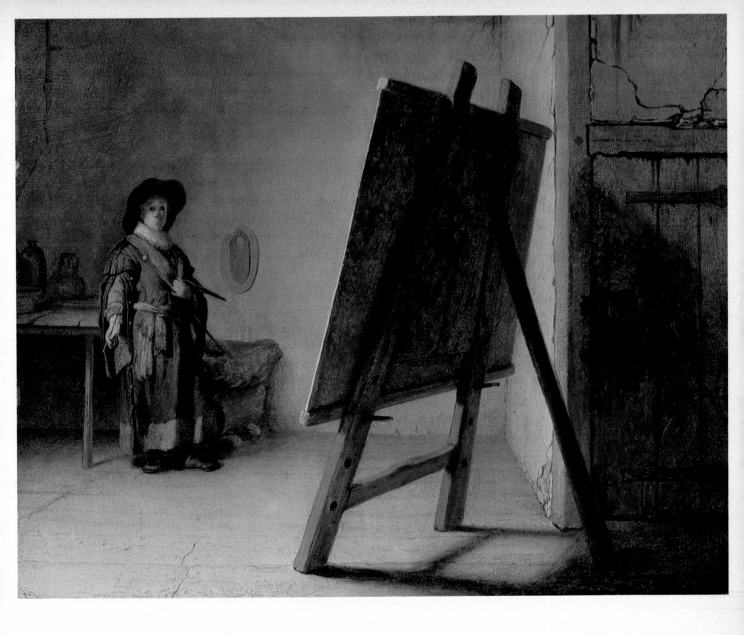

18. REMBRANDT (1606—69): *An Artist in his Studio*. 1628—9. Panel, $9\frac{7}{8} \times 12\frac{3}{8}$ in. Boston, Museum of Fine Arts

Both these paintings have the appearance of portraits. It has been suggested that Rembrandt portrayed himself or his first pupil, Gerrit Dou. But this is certainly not a simple self-portrait, faithfully recording what the artist saw in his mirror as he worked. We see an artist standing before a monumental panel, but Rembrandt has painted this scene on a panel not twelve inches square. It looks like a self-portrait rather than the *artist at work*, so often painted by Dou, by Ostade and by Steen (see Plate 153) because, instead of showing a craftsman slaving at his easel, Rembrandt shows a creator contemplating his creation, a work we can not see. It is Rembrandt's vision of the *art of painting*, to be compared with the later version by Vermeer (see Plate 103). Codde, too, paints a traditional subject in a modern personification. Here is *Melancholia*, to which scholars were prone. In the seventeenth century, Melancholia or Sloth had become associated with smoking, as the pipe in the student's pocket indicates.

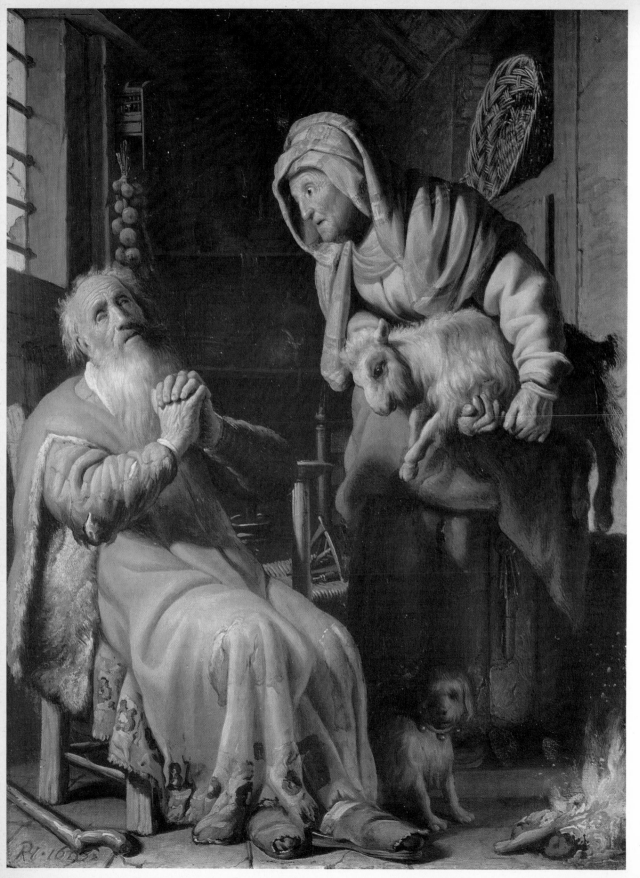

19.
REMBRANDT
(1606—69):
*Anna
accused by
Tobit of
stealing the
Kid.* 1626.
Panel, $15\frac{1}{2} \times 11\frac{3}{4}$ in.
Amsterdam,
Rijks-
museum (on
loan from
Baroness
Bentinck-
Thyssen)

In the
Apocrypha
Book of
Tobit, the
virtuous
Tobit tells
of his acci-
dental blind-
ing and how,
when his
wife came
home with a
kid given to
her by her
employers,
he, in his
blindness,
accused her
of stealing it.
The story of
Tobit at-
tracted
Rembrandt,
and he
represented
several
episodes in
paintings,
drawings
and etchings.

20.
REMBRANDT:
An Officer.
1629—30.
Panel,
$25\frac{5}{8} \times 20\frac{1}{8}$
in. Private
Collection

At one time
this was
thought to
represent
Rembrandt's
father, but
the model is
quite unlike
the one in
the only
probable
drawing of
Harmen
Gerritsz.
van Rijn
known to
exist, now
in the
Ashmolean
Museum.

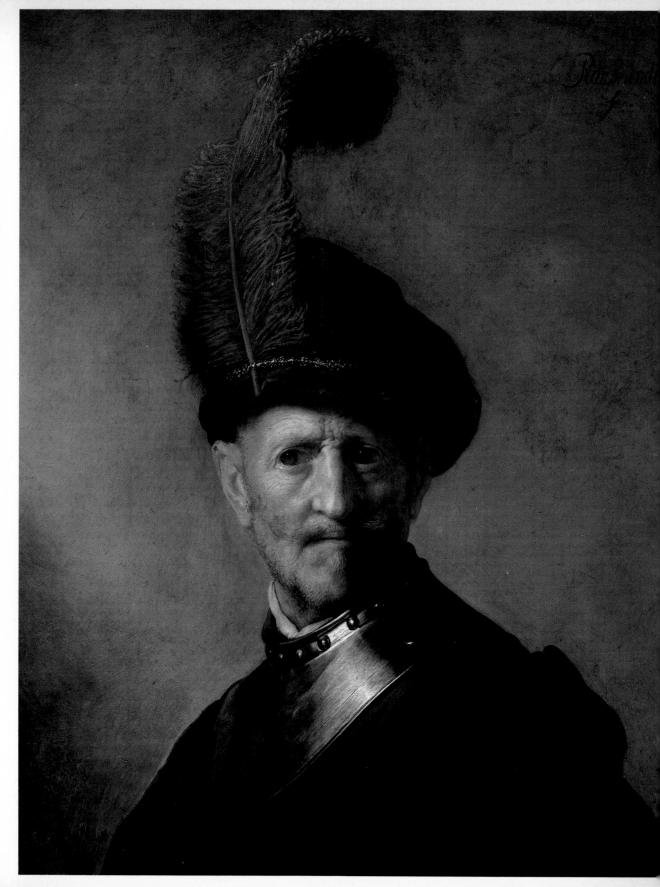

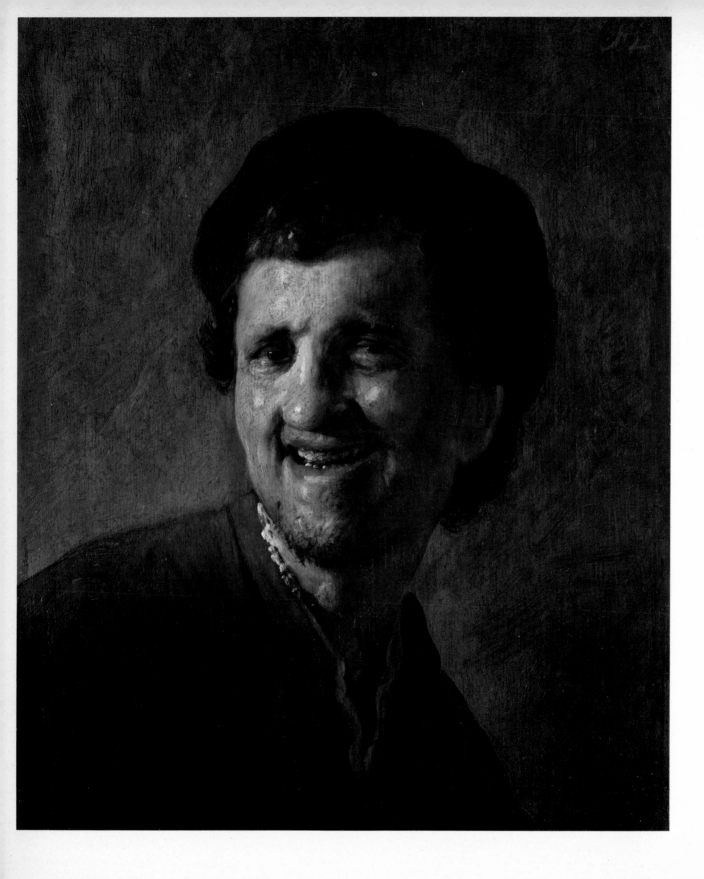

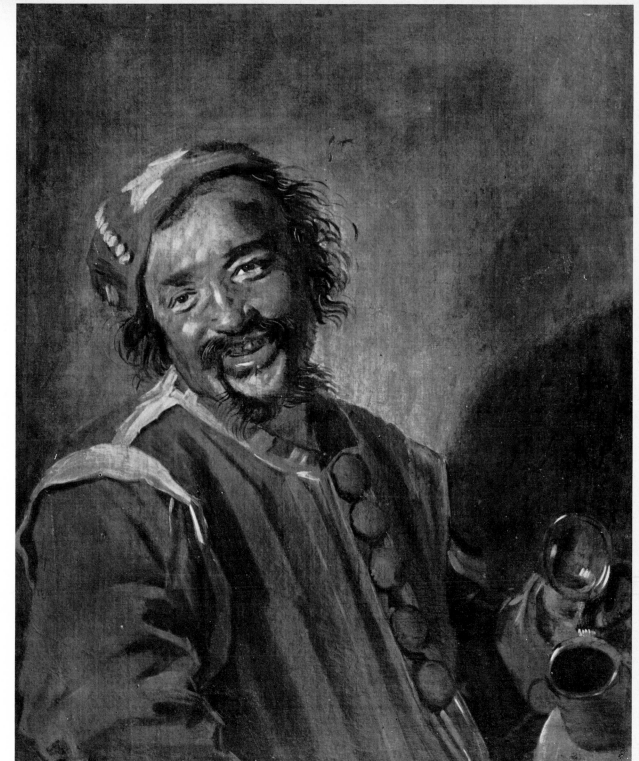

21 (*opposite*).
REMBRANDT
(1606—69):
Self-Portrait.
1629—30.
Panel, 16¼ ×
13¾ in.
Amsterdam,
Rijksmuseum

The young
Rembrandt
made a number of grimacing self-portraits,
which are
studies of
expression,
and recall the
story of the
Italian sculptor Bernini,
who studied
his reflection
while burning
his own leg in
order to be
able to portray the
martyrdom of
St Lawrence.

22. FRANS HALS (1580?—1666): *Peeckelhaering*. About 1628—30. Canvas, 29½ × 24¼ in. Kassel, Hessisches Landesmuseum

'Pickle Herring' was a theatrical character like Hans Wurst and Punchinello. This picture appears in Steen's '*The Physician's Visit*' (Plate 130), where the mocking, licentious character contributes a satirical note to the mood of the scene.

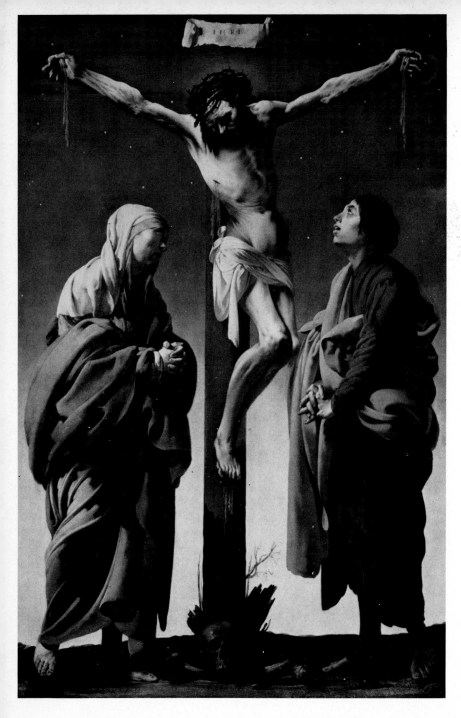

23. HENDRICK TER BRUGGHEN (1588?—1629): *The Crucifixion with the Virgin and St John*. Canvas, 61 × 40¼ in. New York, Metropolitan Museum of Art

24 (*opposite*). REMBRANDT (1606—69): *Christ on the Cross*. 1631. Canvas on panel, 39⅜ × 27¾ in. Le Mas d'Agenais (France), Parish Church

The contrast between ter Brugghen's strangely archaic image and Rembrandt's is dramatic. Ter Brugghen owed as much to northern art—and, in particular, to medieval Gothic carving and Grünewald—as to Caravaggio. His painting is unmistakably a devotional image, suitable for an altar. Rembrandt's early masterpiece, rediscovered only about ten years ago, is less easy to place. It may have been intended as one of the Passion series painted for the Stadholder between 1632 and 1639, now in the Alte Pinakothek, Munich, but it never joined the Stadholder's collection. Like the *Raising of the Cross* and the *Descent from the Cross* in that series, it appears to have been painted in emulation of Rubens.

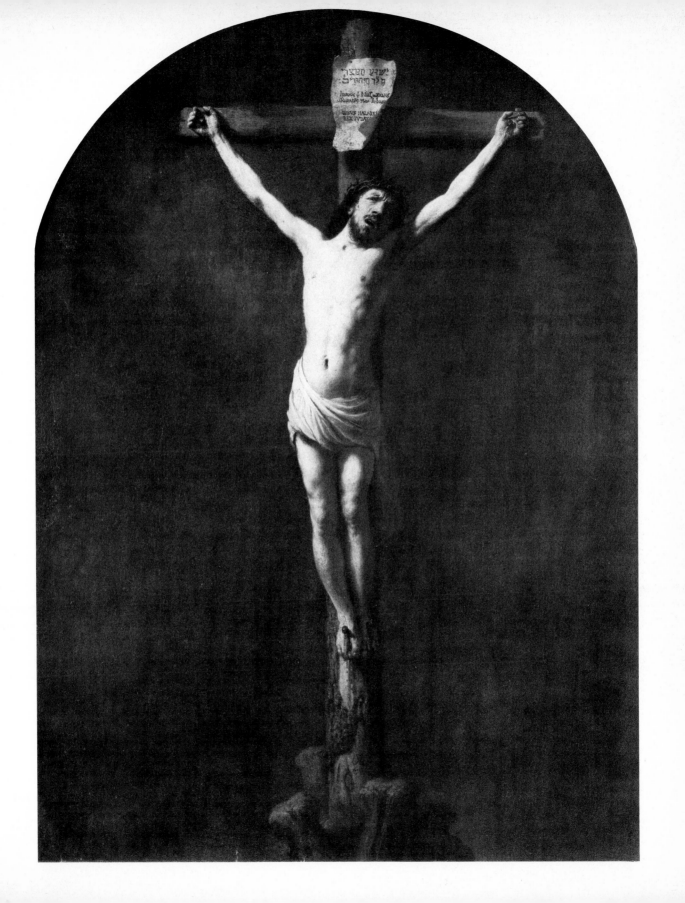

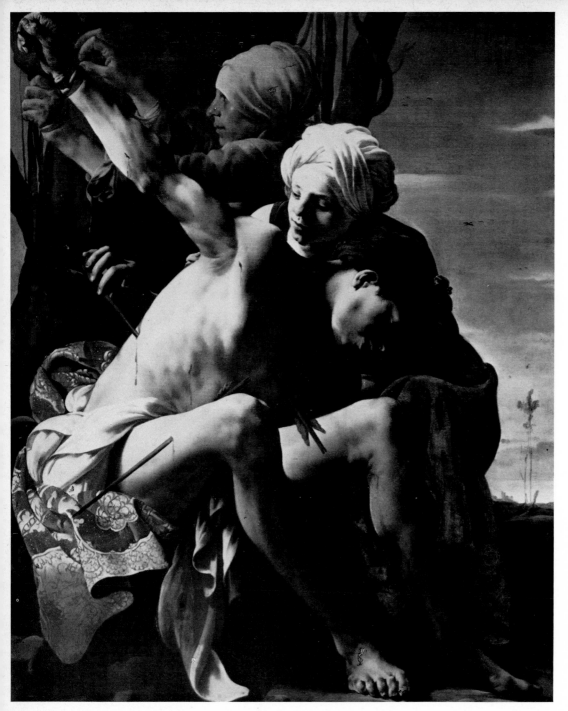

All the Utrecht painters who
followed Caravaggio painted
half-length figures of young
men playing instruments.
These musicians appear to
be dressed as actors or, like
actors, dressed to play a part.
Epitomizing the pleasures of
the senses, the subjects
clearly echo the early works
of Caravaggio, themselves
modelled on earlier northern
examples. The Utrecht
paintings in turn provided a
model for Hals and
Rembrandt.

25. HENDRICK TER BRUGGHEN (1588?—1629): *St Sebastian attended by St Irene*. 1625. Canvas,
 59 × 47¼ in. Oberlin, Ohio, Allen Memorial Art Museum

This is arguably ter Brugghen's masterpiece. The taut and complicated design of the three
figures—and even the powerful emotional effect created by the controlled expressions of the
two women as they efficiently tend to the Saint—may be recognized in a reproduction. The
masterful control of light is something that can only be fully appreciated in front of the original.

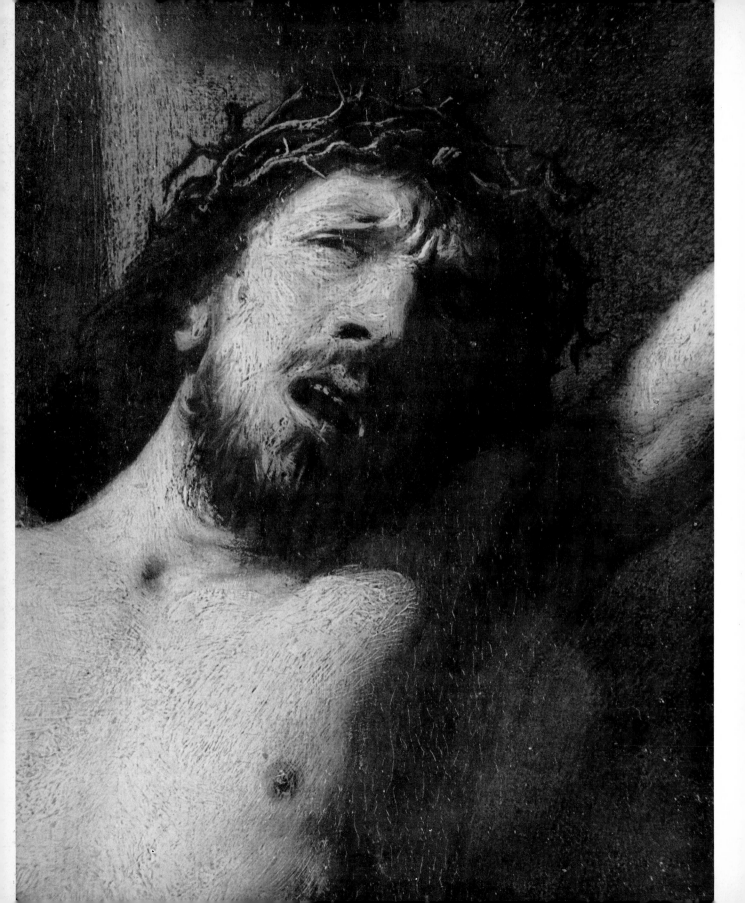

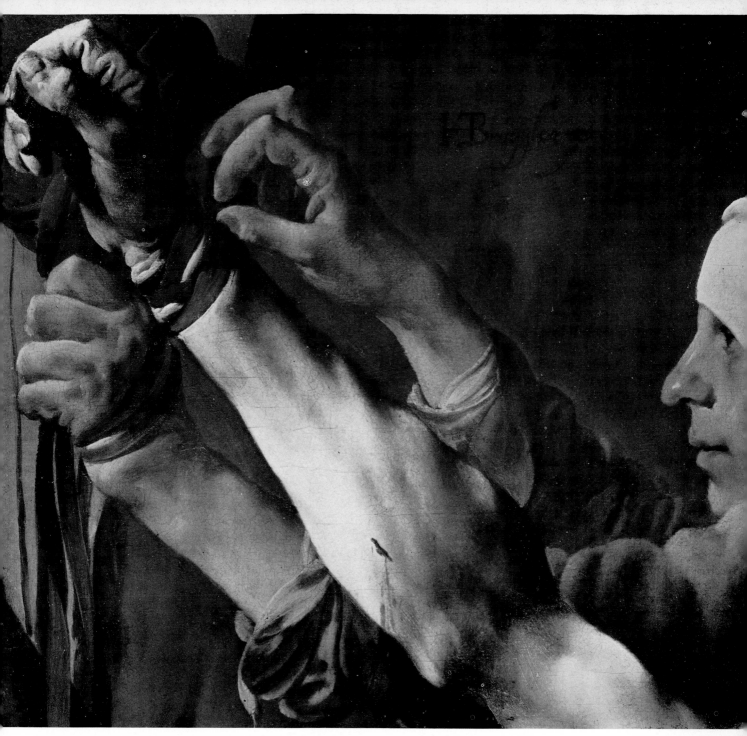

28. HENDRICK TER BRUGGHEN (1588?—1629): Detail from *St Sebastian* (Plate 25)

Ter Brugghen represents St Sebastian's suffering most vividly by showing the smooth thongs cutting deep into the almost lifeless flesh of the Saint's wrist. Rembrandt shows Christ's anguish in his face. St Sebastian's faith has made his pain merely physical: Christ is in torment of spirit. 'Eli Eli, lama sabachthani? that is to say, My God, my God, why hast thou forsaken me?' (Matt. 27:46)

27. (*opposite*). REMBRANDT (1606—69): Detail, enlarged, from *Christ on the Cross* (Plate 24)

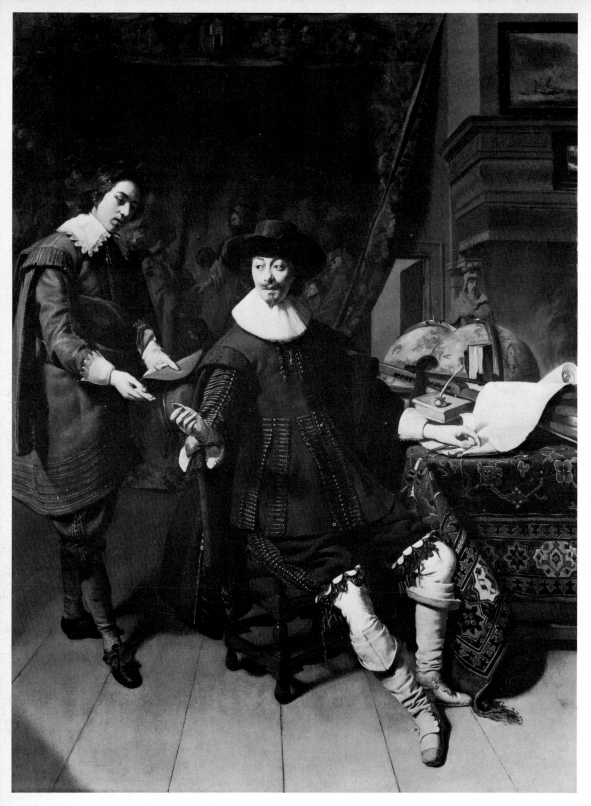

29. THOMAS DE KEYSER
(1596/7—1667):
*Constantijn Huygens
and his Clerk* (?). 1627.
Panel, $36\frac{3}{8} \times 27\frac{1}{4}$ in.
London, National
Gallery

Constantijn Huygens the
elder (1596—1687), Lord of
Zuylichem, was a man of
many talents. A poet who
translated Donne into his
own language, he was parti-
cularly interested in the fine
arts. He had been secretary
to the Dutch embassy in
Venice in 1620, and he held
the same appointment in
London from 1621 to 1624,
being knighted by James I.
On his return he was
appointed secretary to the
Stadholder, Frederik
Hendrik, Prince of Orange.

30. REMBRANDT (1606–69): *Judas returning the Thirty Pieces of Silver*. 1629. Panel, 29⅞ × 39¾ in. Private
 Collection

When Constantijn Huygens (see opposite) wrote an account of the two painters from Leyden, Rembrandt and
Jan Lievensz., in his autobiography, he singled out this painting and described it in detail. It could, he said, be
compared with anything in Italy and with any of the beauties and marvels that have survived from remotest
antiquity. 'To pass over so many marvellous beauties contained in a single work, the look of the desperate
Judas alone, of Judas in madness, crying out, begging pardon yet not expecting it and without hope in his face,
his hideous appearance, dishevelled hair, torn clothes and twisted arms, his hands wrung until they are bloody,
on his knees in a wild gesture, his whole body wretchedly contorted in agony; this I would oppose to all the
refinements of previous ages, and I wish that the ignoramuses . . . who think that nothing can be said or done
today that was not said or done already in antiquity could see it.' He concluded that not even the greatest
painters of Greek antiquity could rival this beardless son of a Dutch miller.

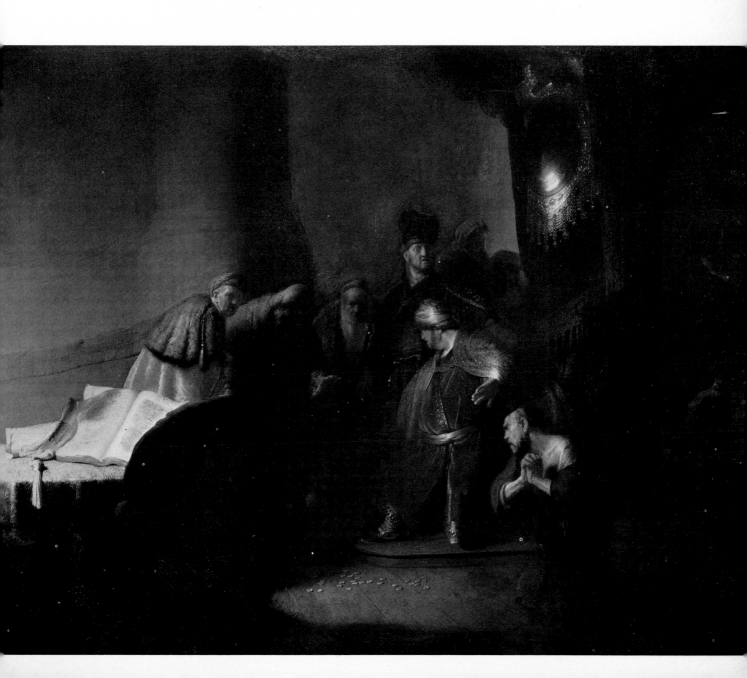

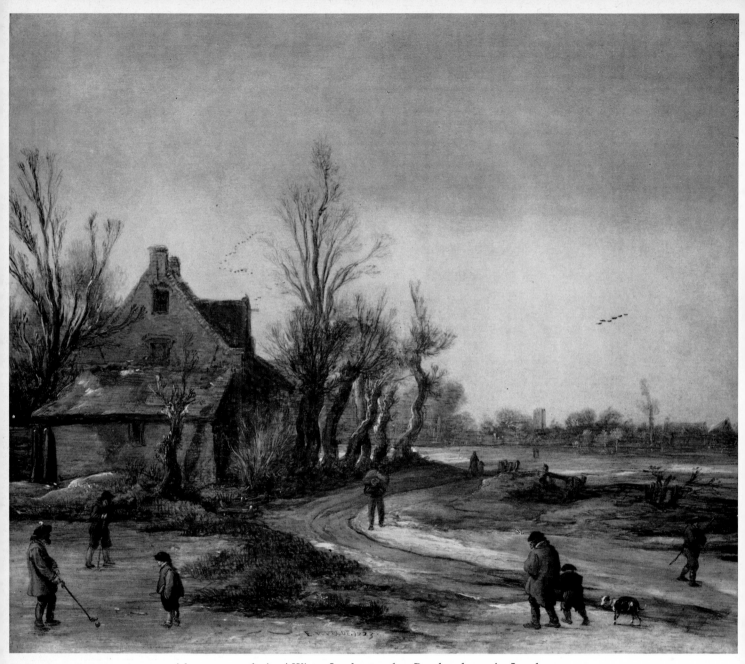

31. ESAIAS VAN DE VELDE (about 1590–1630): *A Winter Landscape*. 1623. Panel, $10\frac{1}{4} \times 12$ in. London,
National Gallery

Taken with Plate 5, these three landscapes exemplify the development of Dutch landscape painting from its
Flemish origins. Esaias van de Velde's *Winter Landscape* could never have been painted without the example
of Bruegel's winter scenes, yet it is already totally different from them, both in scale and in spirit. Van Goyen's
panels are superb examples of the Dutch art of the horizontal. Near-monochrome, reticent, they contain implied
vistas which evade the eye and tease the mind. The slightest gradation in a brush-stroke may represent a league.

32. JAN VAN GOYEN (1596—1656): *Landscape*. 1630. Panel, $15\frac{5}{8} \times 32\frac{1}{8}$ in. London, Victoria and Albert Museum

33. JAN VAN GOYEN: *Landscape with a Tavern*. 1646. Panel, $14\frac{1}{4} \times 24\frac{3}{8}$ in. Paris, Musée du Petit-Palais

34. JACOB DUCK (about 1600—after 1660): *Merry Company*. About 1630. Panel, 14¾ × 26¾ in. Nîmes, Musée des Beaux-Arts

This is unmistakably a brothel. The drinking, the smoking and the music have been abandoned, and now, on the floor, a drunken man, his eyes glazed, is being undressed by the women. He is their victim and they are stripping him of his finery and wealth. When they have taken all he has they will throw him out. His prodigality will receive the reward it merits in this world. This imagery was very familiar in the Netherlands in the sixteenth and seventeenth centuries. A very similar design was included in 'Emblemata of Sinne-werck', an emblem book devised by Johannis de Brune and published in Amsterdam in 1624. De Brune's Emblem 30 showed a young man sitting on a woman's lap while another woman took off his stocking. She had already removed his hat, ruff and sash. The motto was 'Iongh Hovelingh, oud schovelingh', that is to say, the young courtier will become an old beggar. The verses that followed warned of the inconstancy of fortune and of Woman's affections. The young man would repent womanizing, be thrown out and end up naked and in every kind of misery. On the wall, a painting of Salome with John the Baptist's head points this moral.

35. JUDITH LEYSTER (1609—60): *A Boy playing the Flute*. About 1630—5. Canvas, 28¾ × 24⅜ in. Stockholm, Nationalmuseum

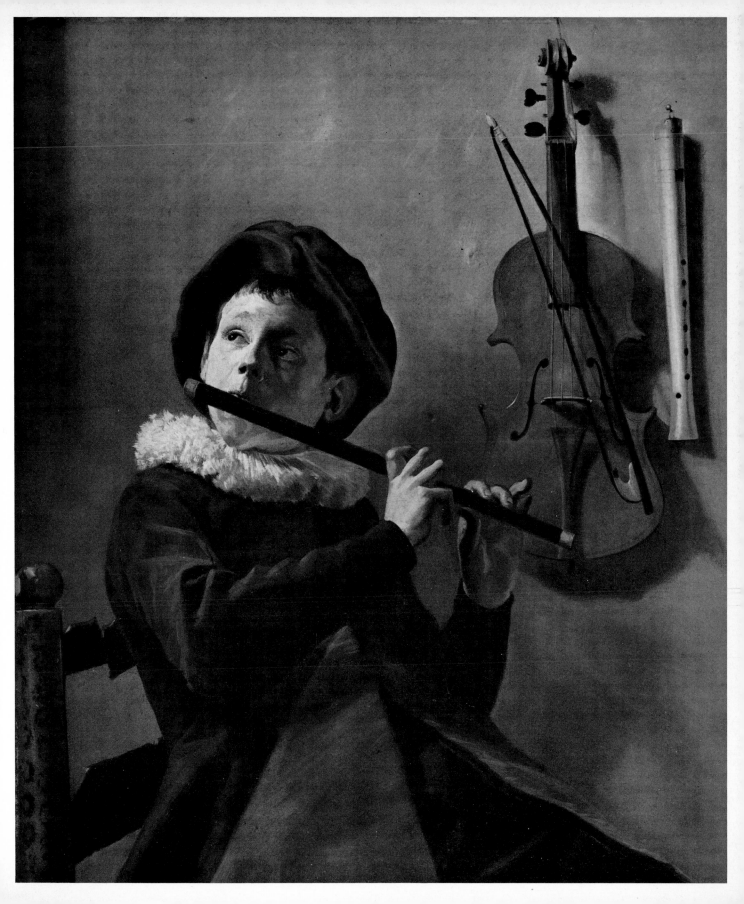

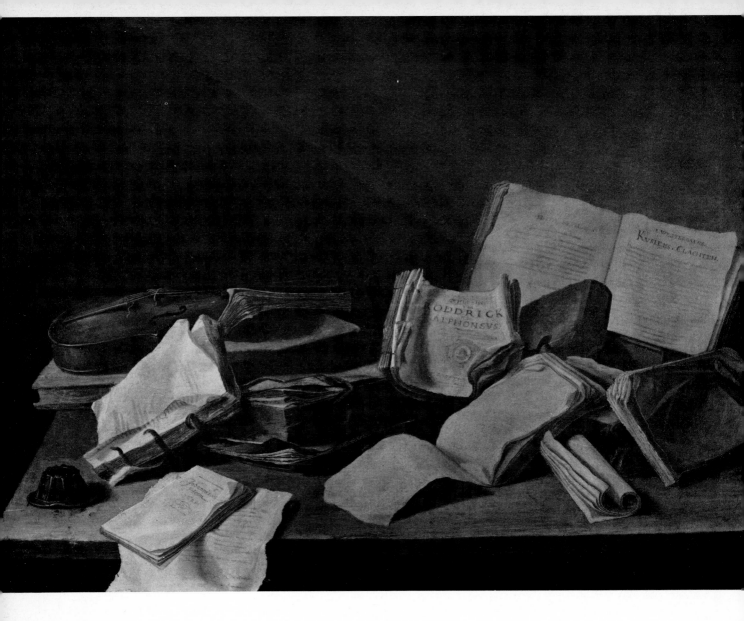

36. JAN DE HEEM (1605/6—1683/4): *Still-Life with Books*. 1628. Panel, 14¼ × 19⅛ in. The Hague, Mauritshuis

The still-lifes of books shown here have quite different meanings. Rembrandt paints the books (opposite) as the apparatus of learning used by his disputing scholars (Plate 40). De Heem simply paints his still-lifes in isolation, and at first sight provides no further indication of their significance, if indeed they are more than merely the occasion for a superb piece of painting. But the book in the centre without a cover bears the title-page of a well-known tragedy by the great playwright Gerbrand Adriaenszoon Bredero, *Roddrick ende Alphonsus*, first performed in 1611 and published in 1616. It was based on the Spanish epic *El Cid* and concerned the estrangement and reconciliation of King Alfonso VI and Rodrigo Diaz, the eleventh-century Spanish hero known as 'El Cid'. On the title-page was a couplet which said that friends were permitted to quarrel but must remain friends. The other book is open at a poem, 'Kisses and Complaints', by the poet Westerbaens. The presence of the violin suggests the value of reconciliation and harmony.

37. REMBRANDT (1606—69): Detail from *Two Scholars disputing* (Plate 40)

When the panel of which this is a detail (Plate 40)—or one very similar to it—was in the collection of the draughtsman and engraver Jacob de Gheyn in 1641, it was described as 'two old men disputing . . . there comes the sunlight in'. Although the title had been lost in the artist's lifetime, there is no doubt that it shows a biblical or historical scene and many suggestions have been made. *Elisha predicting the Attempt of the King against him, The Apostles Peter and Paul* or the Greek philosophers *Democritus and Heraclitus* are the most probable, with perhaps the first being most appropriate as the still-life of books and the snuffed candle are significant of man's mortality. The still-life might, otherwise, signify the folly of human knowledge and wisdom, though nothing could look less foolish than the expression of the old man who is making his point to the other. There is a superb preparatory chalk drawing for the figure on the left, now in Berlin.

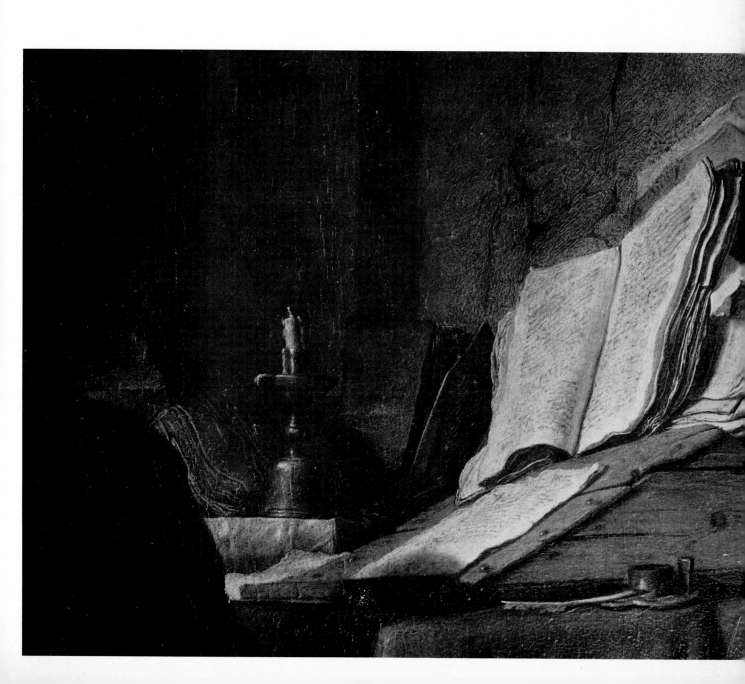

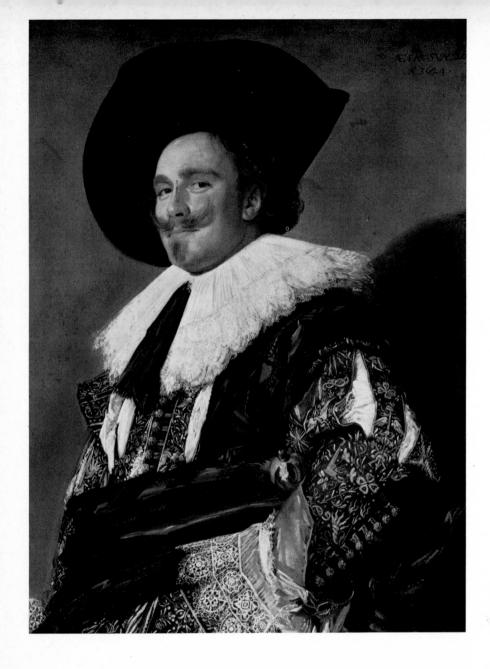

38, 39. FRANS HALS (1580?—1666): *The laughing Cavalier*. 1624. Canvas, 33¾ × 27 in. London,
Wallace Collection

Familiarity does not encourage observation. This is the best-known painting in Britain, yet,
as Seymour Slive pointed out in his recent monograph on Hals, no one has remarked on the
intricate embroidery on the sitter's sleeve, which represents strange devices, including Mer-
cury's cap and winged wand, bees, winged arrows, flames, flaming cornucopias and lovers'
knots. Slive comments: 'whether or not all the embroidered symbols were meant to be read
together as one gigantic emblem remains to be decided. Their presence, however, reminds us
how common such emblematic devices were in Hals' day, when they were found on clothing,
household furnishings, walls, ceilings and, of course, in books.' The detail illustrates Hals's
ability to paint precise detail without abandoning the appearance of total spontaneity.

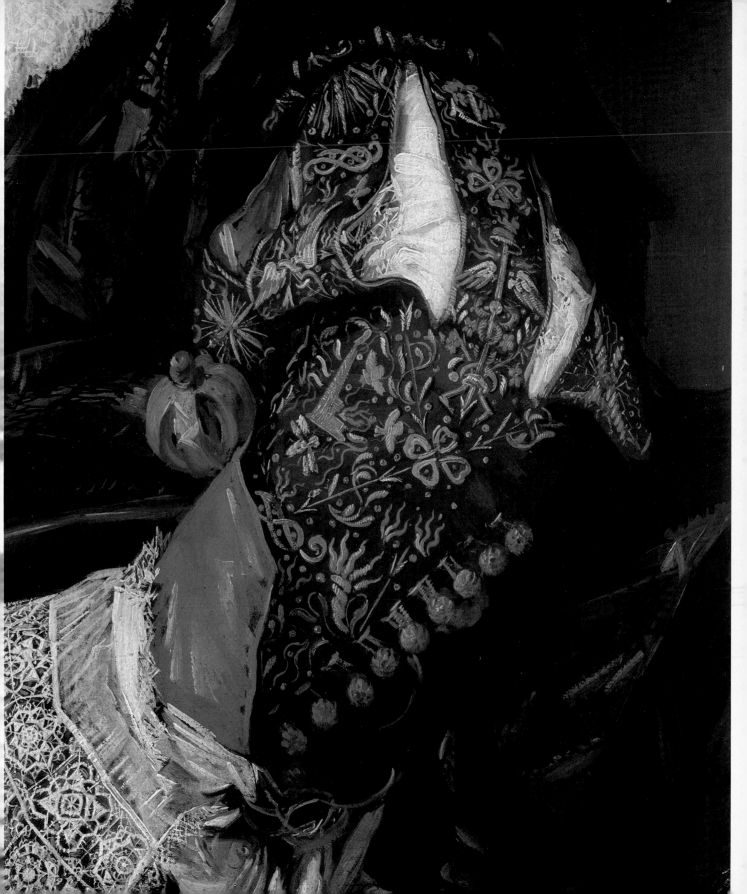

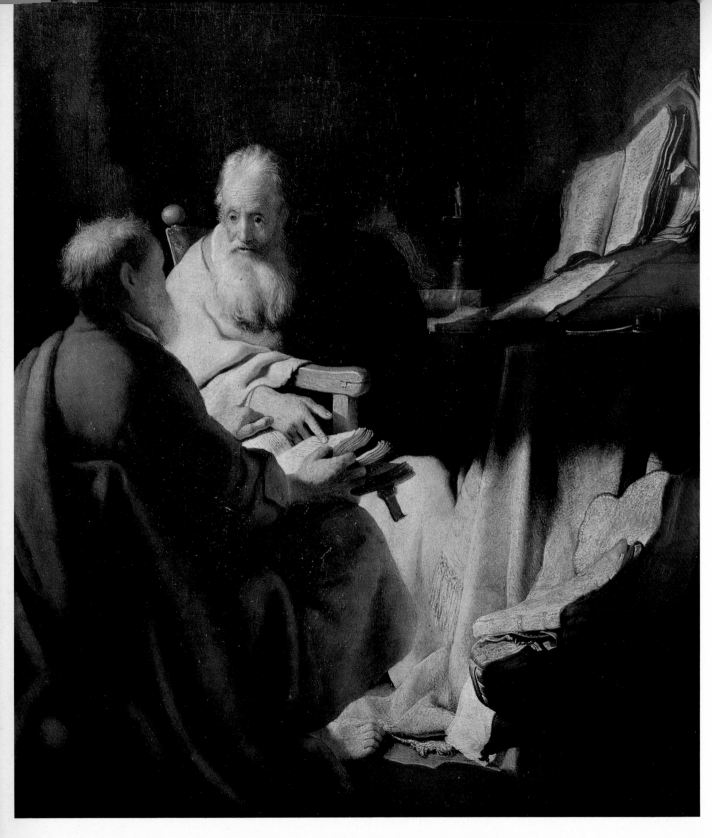

40. **REMBRANDT** (1606—69): *Two Scholars disputing.* 1628. Panel, 28⅛ × 23 in. Melbourne, National
Gallery of Victoria. See note to Plate 37

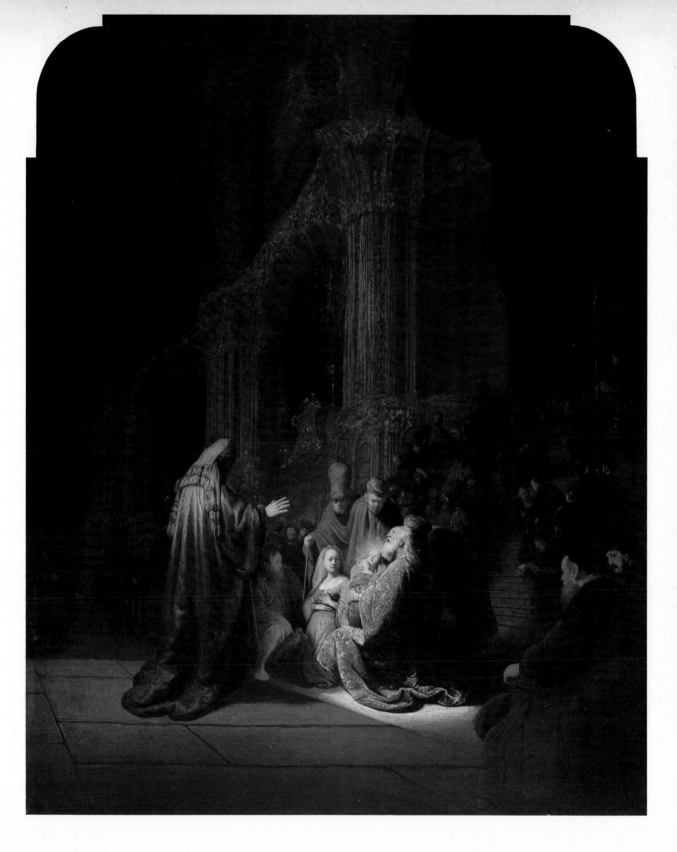

41. REMBRANDT: *The Presentation of Jesus in the Temple*. 1631. Panel, 23⅝ × 18⅞ in. The Hague, Mauritshuis

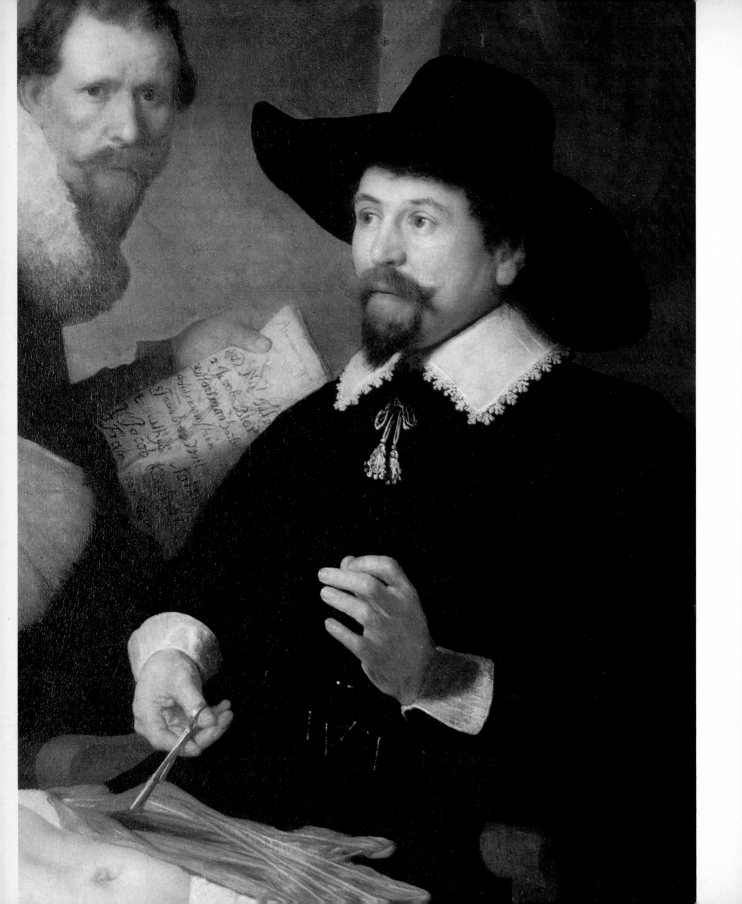

42, 43. REMBRANDT (1606—69): *Dr Nicolaes Tulp demonstrating the Anatomy of the Arm.* 1632. Canvas, $66\frac{3}{4} \times 85\frac{1}{4}$ in. The Hague, Mauritshuis

This was the canvas which established Rembrandt's reputation in the year he settled in Amsterdam. Dr Nicolaes Pietersz. Tulp (1593—1674) was a noted Amsterdam anatomist. He held the office of Praelector Anatomiae of the Amsterdam Guild of Surgeons and it was customary for a Professor of Anatomy, on the rare occasions that a corpse became available (and this was only when the body of an executed criminal was given over by the civic authorities), to perform a public autopsy in the 'Anatomy Theatre'. These performances used to attract big audiences and tickets were sold. Rembrandt, however, does not represent such an occasion, for Tulp is dissecting the forearm, whereas at public anatomies the entrails were always the first to be displayed, so as to prevent decomposition.

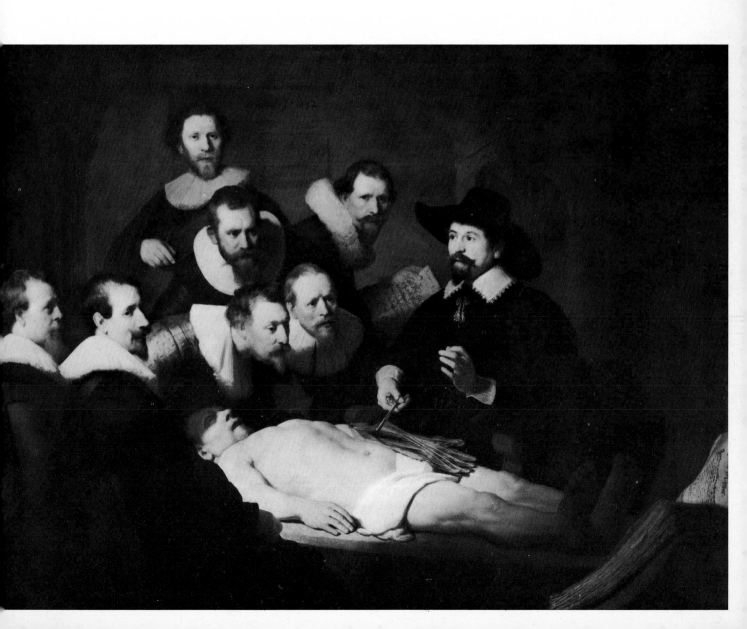

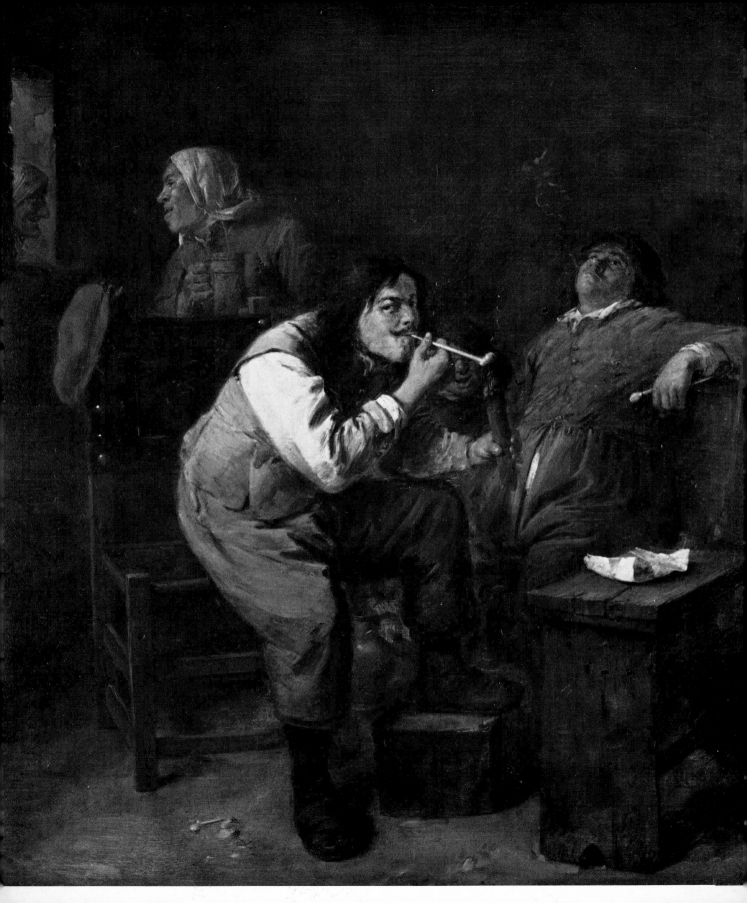

44. ADRIAEN BROUWER (1605/6—1638): *The Smoker*. Panel, 15⅞ × 14¼ in. London, Wellington Museum (Apsley House)

Nothing could demonstrate the elusive qualities of Dutch art better than these two works in the same collection. Both represent vulgar subjects, according to the criteria of orthodox art criticism of the period, in a quite unabashed way. Both, on closer examination, may be seen as representing larger themes than the obvious subject-matter. The Brouwer may represent the *Sense of Smell* or the *Sin of Sloth*. Jan Steen, echoing Pieter Bruegel's compositions, paints a morality by contrasting human ideals and human actuality. But each picture possesses more fundamental, pictorial qualities. The Brouwer is a brilliantly controlled piece of virtuoso painting, appealing to such *cognoscenti* as Rubens and Rembrandt, both of whom bought his work. Steen's composition is a hymn to the splendours of twilight, which embraces and transcends every single detail. The inventive power and the painterly vision revealed here make the traditional distinction between the heroic and the comic seem trivial and irrelevant.

45. JAN STEEN (1625/6—1679): *A Wedding Party*. 1667. Canvas, 38½ × 60⅜ in. London, Wellington Museum (Apsley House)

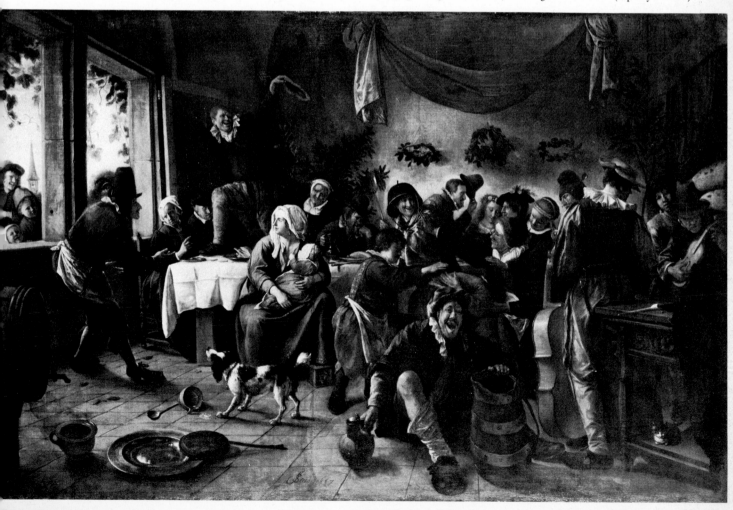

46. HERCULES SEGHERS (1589/90—after 1632): *River Valley with a Group of Houses*. About 1625. Canvas, $27\frac{1}{2} \times 34\frac{1}{8}$ in. Rotterdam, Museum Boymans—van Beuningen

Of the fifteen surviving paintings which can be ascribed with some certainty to Seghers, this is, perhaps, the most magical. It combines the rocky heights and panoramas which are such a feature of his inventions with the delicate, even intimate, details of the rooftops in the near distance. The particularity, the intrusion of human inconsequence, into the grandeurs of indifferent Nature is so convincing that it has led scholars to attempt to identify the place represented. When the picture was rediscovered, about 1910, Willem Bode believed it to represent the country bordering the Meuse between Limbourg and Maastricht. The rooftops bear a striking resemblance to those in a small etching Seghers made of a view through a window, and this painting is probably based on a number of drawings.

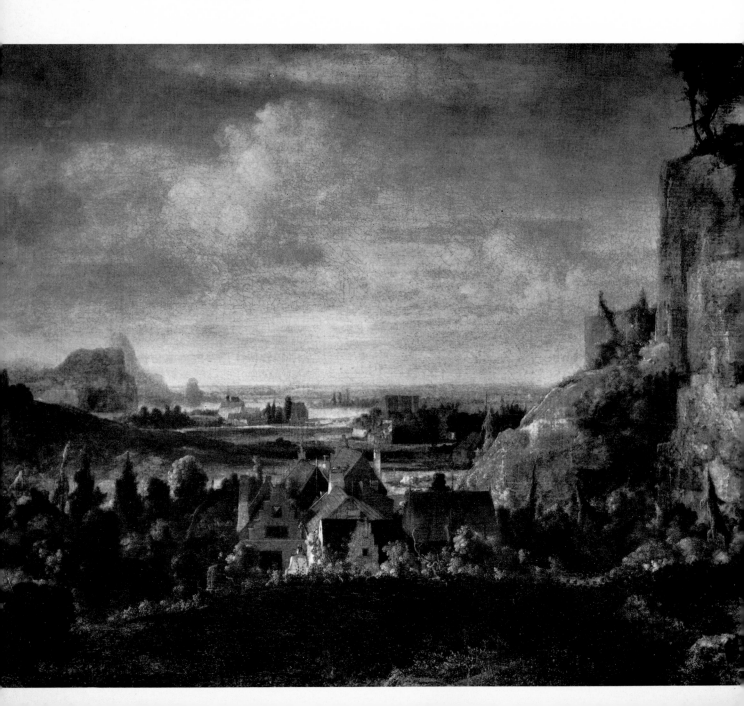

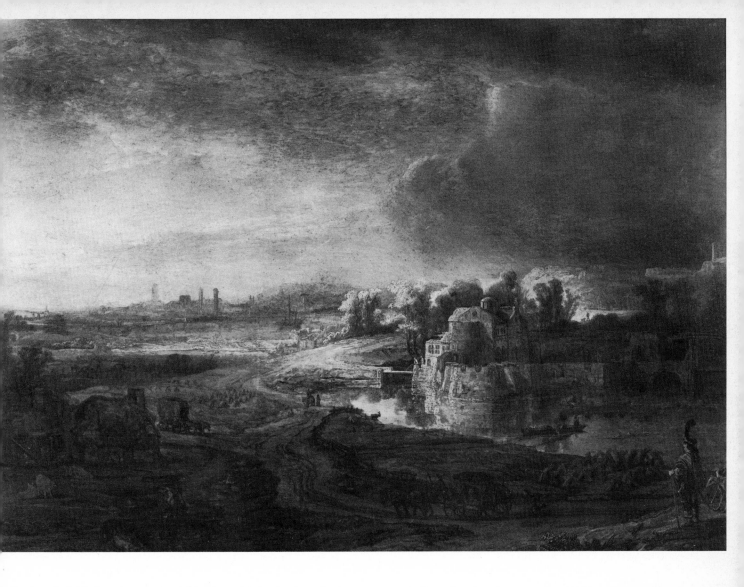

47. REMBRANDT (1606—69): *Landscape with a Coach*. 1640—5. Panel, $18\frac{1}{2} \times 26\frac{1}{4}$ in. London, Wallace
 Collection

Rembrandt admired and collected Hercules Seghers's works, and his own landscape paintings are very close
to them, both in spirit and in technique. Rembrandt painted few landscapes; just over a dozen can be confi-
dently attributed to him today, and this is one of the finest and most inventive. It combines features from the
unremarkable Netherlandish landscape to create a world of crepuscular mystery. The brooding gloom
is filled with innumerable details which enhance the poetic atmosphere as they suggest possible dramas
and romances. In creating this haunting work, Rembrandt has ignored the more modern forms of Dutch
landscape (see Plates 32 and 33). Neither does he give any hint of the experience of his own brilliant landscape
drawings and etchings, which he began to make about this time.

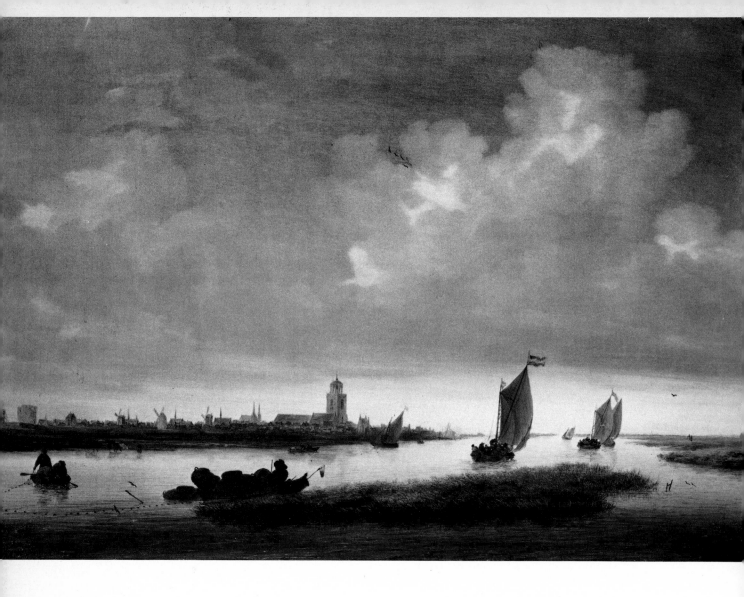

48. SALOMON VAN RUYSDAEL (1600/3—1670): *A View of Deventer*. 1657. Panel, $20\frac{3}{8} \times 30\frac{1}{8}$ in. London,
National Gallery

In his later works, Salomon van Ruysdael brought a new richness to the laconic style of Haarlem landscape. He
began to use thicker, juicier paint and a more colourful palette. Nevertheless, his instinct is still for the low view-
point and the bleak, unremarkable land of the polders—the tracts of low-lying territory reclaimed from the sea—
and the estuaries. In this he is old-fashioned, as comparison with the landscape by Philips Koninck (opposite)
makes clear. He is also old-fashioned in his adherance to a crisp method of applying paint. Here, as in the works of
Esaias van de Velde and Jan van Goyen (Plates 31, 32 and 33), the procedure is easily discernible; the brush-stroke
is clear, its direction obvious. The school of painting which had grown up round Ruysdael had discarded much of
this directness for a more complex, tonal system of painting. This later style, used to treat a comparable subject, can
be seen in Plates 76 and 77 and, very strikingly, in the work of Philips Wouwermans, in Plate 82. One artist whose
work may have influenced Ruysdael is Rembrandt. His paintings of the late 1630s, such as the *Christ and the
Magdalen at the Tomb* (Plate 68), and his landscape etchings of the later 1640s have obvious affinities.

49. PHILIPS KONINCK (1619—88): *Panoramic Landscape*. 1655. Canvas, 54¾ × 66¼ in. London,
National Gallery

Whether or not this is based upon an actual view (and that is unlikely) it is certainly based upon observation.
Koninck rediscovered the high viewpoint of the early Flemish landscapists but combined it with the concern
for the shape of the land which he learned from his immediate predecessors. He developed a type of com-
position—with a horizon running across the canvas, low down and unbroken by major incidents—in which the
interest was created by a contrast between the wide open skies and the infinite perspectives of the flat lands of
the North. Here he has been influenced by Rembrandt's landscape etchings in his drawing of the vistas
approaching the horizon.

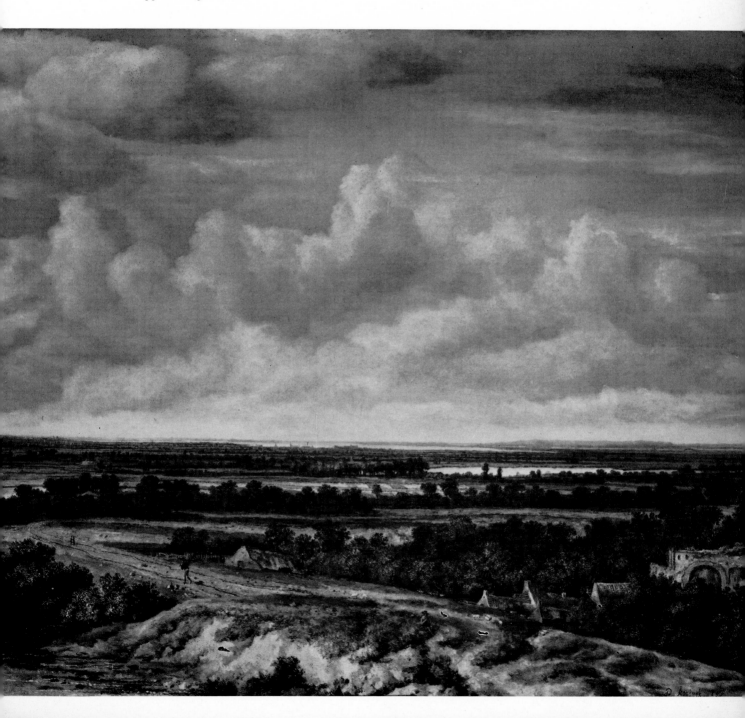

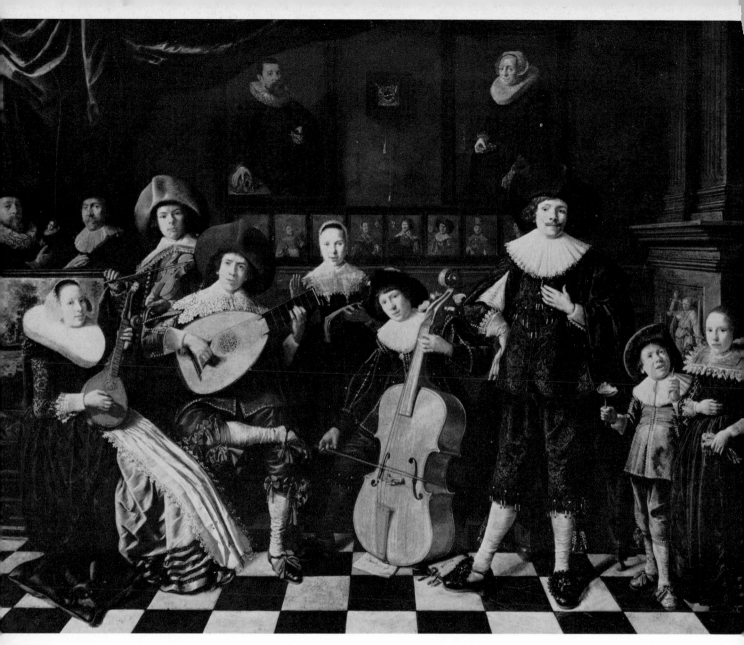

50. JAN MOLENAER (1609/10—1668): *Family making Music*. Canvas, 24⅝ × 31⅞ in. Haarlem, Frans Hals Museum

This excellent painting is, most obviously, a family portrait: few works of the century so strikingly anticipate the quality of a group photograph. But the ten relatives present in the room are matched by the nine further visible likenesses within the painting, presumably representing absent members. And here the resemblance to a photograph becomes totally misleading. To the seventeenth-century artist, unlike the photographer, death is the only absence that needs to be represented in this way, because he did not require all his subjects to be simultaneously present when he set to work. The entire picture is filled with hints of mortality, from the skull in the Hals-like portrait on the wall to the bubbles blown by the boy on the right, who stands before an image of Blind Justice.

51. FRANS HALS (1580?—1666): *Pieter van den Broecke*. Detail. About 1633. London, Kenwood House, Iveagh Bequest

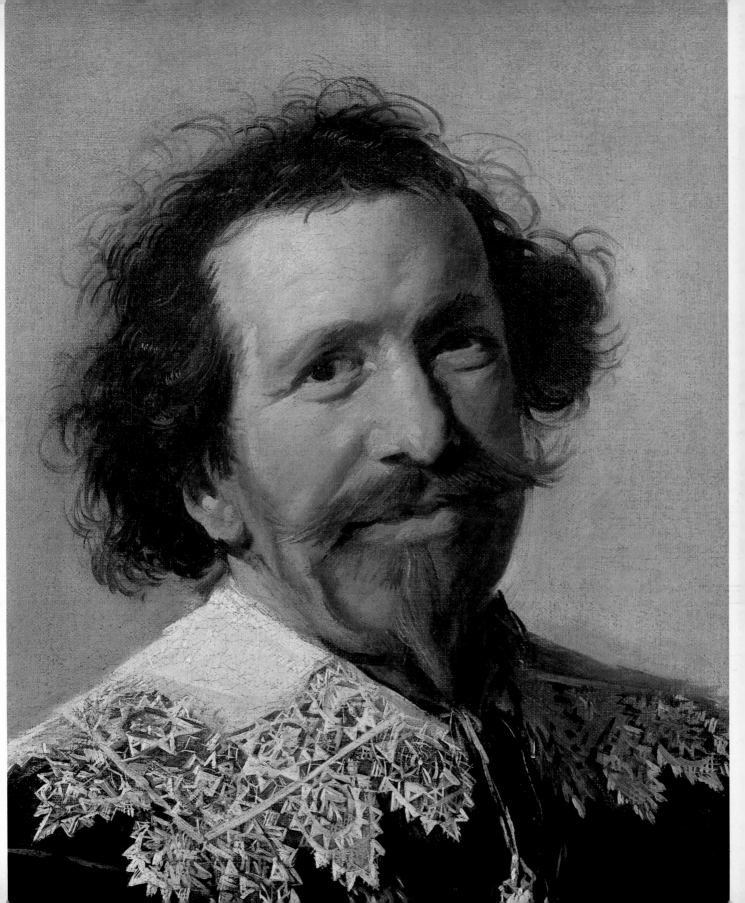

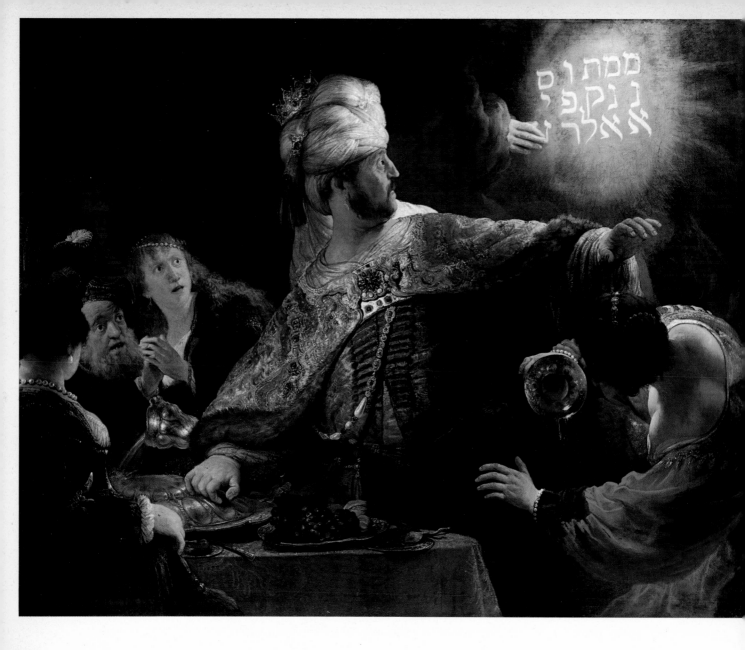

52, 53. REMBRANDT (1606—69): *The Feast of Belshazzar : The Writing on the Wall*. About 1635. Canvas,
65¾ × 79⅛ in. London, National Gallery

The subject is from the Book of Daniel, chapter five, in which the heathen king Belshazzar is described as holding a
feast to a thousand of his lords 'and drank wine before the thousand'. This was blasphemy because the cups from
which the king and his princes and his wives and his concubines drank had been taken from the Temple in
Jerusalem, and 'they drank wine, and praised the gods of gold, and of silver, of brass, of iron, of wood, and of stone.
In the same hour came forth fingers of a man's hand, and wrote over against the candlestick upon the plaister of the
wall of the king's palace . . . Then the king's countenance was changed, and his thoughts troubled him.'

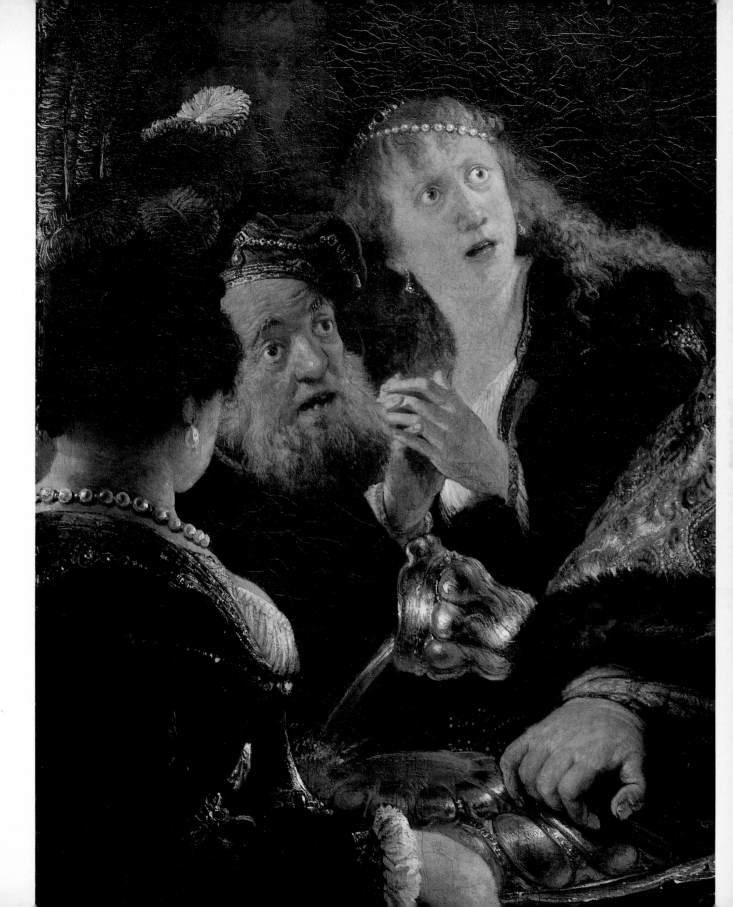

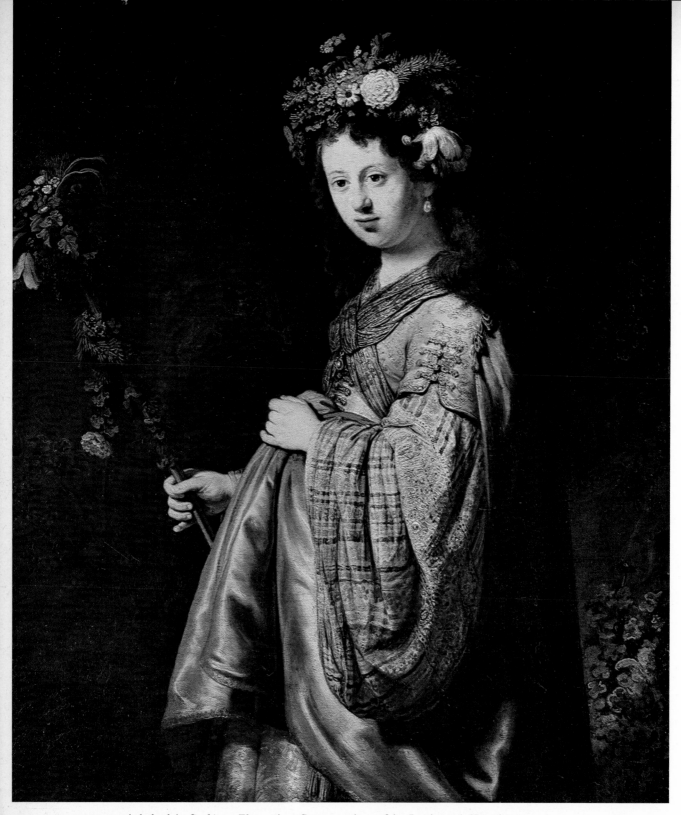

54. REMBRANDT (1606—69): *Saskia as Flora*. 1634. Canvas, 49¼ × 39¾ in. Leningrad, Hermitage

This pastoral theme was popular during the middle decades of the seventeenth century. In the following year Rembrandt painted another version, now in the National Gallery, London.

55.
REMBRANDT:
*A young
Woman in
fancy Dress.*
About 1635.
Panel,
$38\frac{5}{8} \times 27\frac{1}{2}$ in.
Château de
Pregny
(Geneva),
Baron
Edmond de
Rothschild

A wonderful
work, which,
when com-
pared with
the plate
opposite,
demon-
strates
Rembrandt's
range of
expression.
At different
times, both
have been
called por-
traits of his
wife, Saskia.

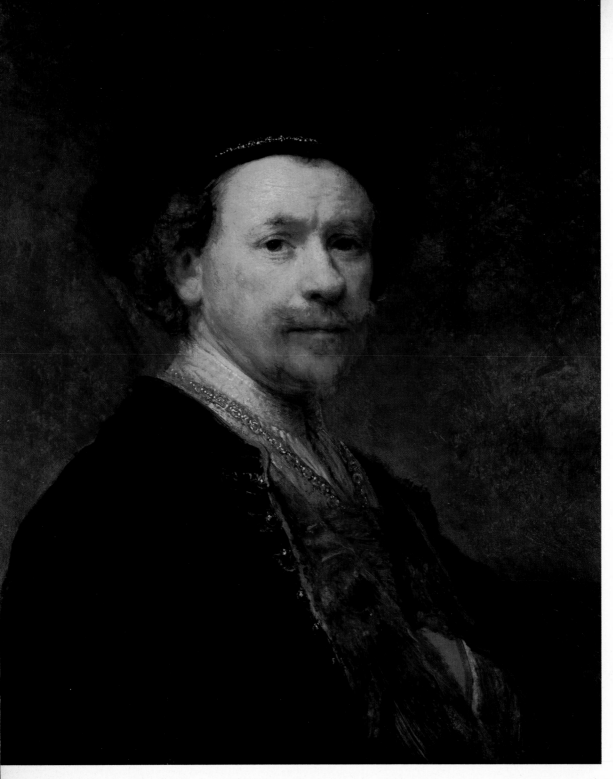

57 (*opposite*).
REMBRANDT:
*A young Girl
leaning on a
Window-Sill*.
1645. Canvas,
$30\frac{1}{2} \times 24\frac{5}{8}$ in.
London,
Dulwich College
Picture Gallery

The figure leaning
out of the picture
frame was a popular
motif with the
Utrecht School (see
pages 31–2). Typi-
cally, Rembrandt
takes up the theme
to re-create it in
more subtle terms.

56. REMBRANDT (1606–69): *Self-Portrait*. About 1639. Panel, 25 × 20 in. U.S.A., Norton Simon Collection

In his youth, Rembrandt used to paint himself in fancy costume, but here, and in other portraits of these
years, the rich clothing and aloof expression seem as if they are meant to establish his public image as a
successful artist.

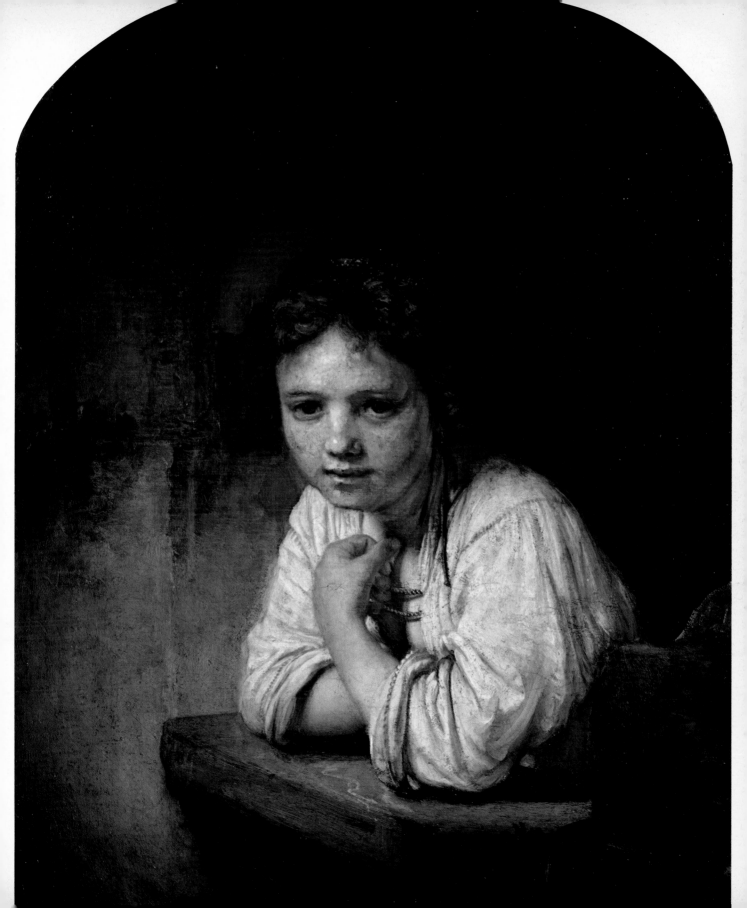

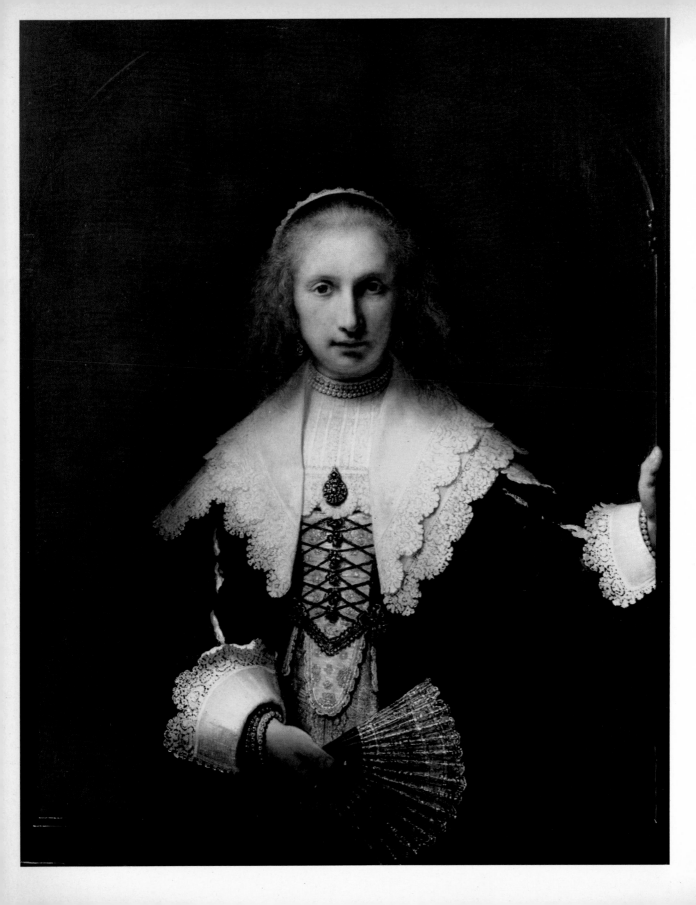

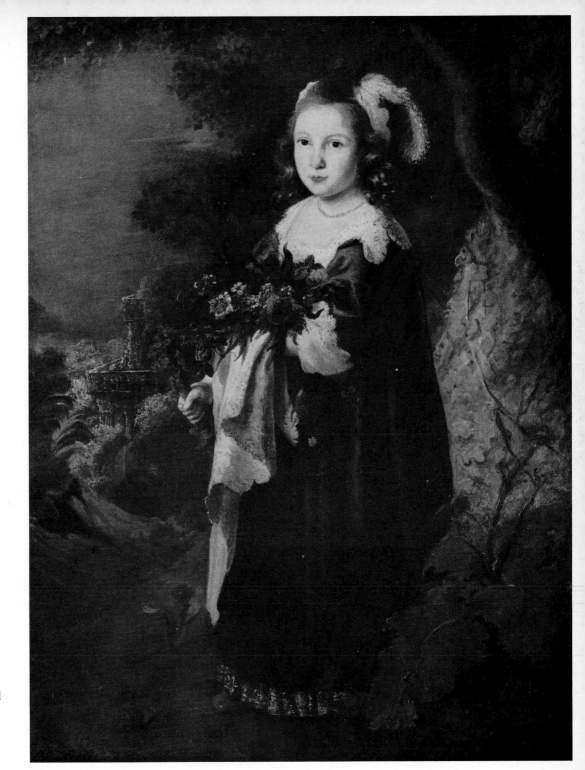

58 (*opposite*).

REMBRANDT (1606—69):
Agatha Bas. 1641.
Canvas, 41½ × 33 in.
London, Royal Collection
(reproduced by gracious
permission of Her Majesty
The Queen)

Here, in a commissioned
portrait, Rembrandt intro-
duces a simulated picture
frame through which his
sitter can pass. But her dig-
nified stance and unfocused
gaze make it clear that she
will withdraw from, not
advance towards, the spec-
tator (see also Plate 57).

59. GOVERT FLINCK (1615—60): *Portrait of a little Girl.* About 1640. Canvas, 46 × 35⅜ in. Nantes, Musée des Beaux-Arts

Flinck was one of the best of the painters trained by Rembrandt. This portrait is a re-creation of one of the latter's early compositions,
Saskia as Flora, now in the National Gallery, London. Flinck is thus able simultaneously to flatter his sitter by presenting her in
allegorical guise—a familiar form in his day—and to pay homage to his master.

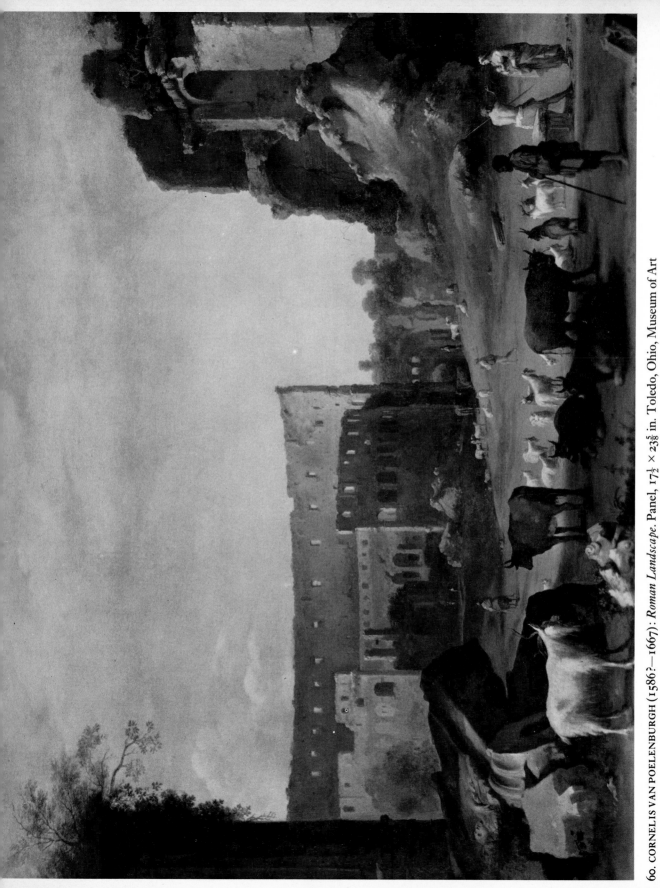

60. CORNELIS VAN POELENBURGH (1586?–1667): *Roman Landscape*. Panel, $17\frac{1}{2} \times 23\frac{5}{8}$ in. Toledo, Ohio, Museum of Art

Until recently this canvas was attributed to Poelenburgh's follower, Bartholomeus Breenbergh. Both artists worked in Rome and were influenced by the German painter Adam Elsheimer (1578–1610). Many of Poelenburgh's works are akin to the landscapes of the Flemish Mannerists, into which he introduced small, skilfully painted nudes. Here, however, he anticipates later taste, if not style, by combining a view of classical ruins with pastoral characters. It is the arcadian vision which was painted most convincingly by Claude (1600–82) but which also captured the imaginations of following generations of artists.

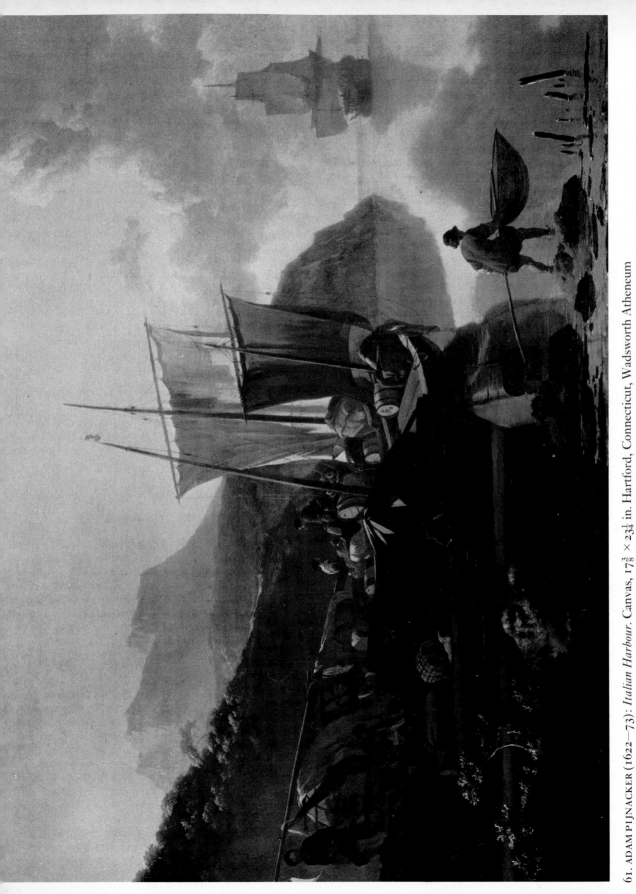

61. ADAM PIJNACKER (1622–73): *Italian Harbour*. Canvas, $17\frac{7}{8} \times 23\frac{1}{4}$ in. Hartford, Connecticut, Wadsworth Atheneum

Though he was in Italy for only a short time, Pijnacker, like Jan Both and Nicolaes Berchem, was profoundly impressed by his visit. The golden glow of the Roman Campagna or, perhaps it would be more correct to say, of the canvases of Claude remained an abiding influence. But though he painted Italian scenes in an Italianate manner, he avoided classical subjects—and here again he was like the majority of his countrymen who visited or settled in Rome. Instead he chose to show peasants or wandering people, so foreshadowing the Romantic movement in his preferred subjects as well as in the attitude he showed towards landscape. The golden haze enveloping this scene permeates even the shadows, embraces even the carefree vagabonds on the boats.

62. KAREL DU JARDIN (1621/2?—1678): *The Minstrel*. Canvas, 18½ × 17⅛ in. Kassel, Staatliche Kunstsammlungen

63. PIETER QUAST (1605/6—1647): *Comedians dancing*. About 1635. Panel, 16⅛ × 21⅞ in. Paris, Musée de la Comédie Française

Paintings of the street life of Italian towns, and principally Rome, were first popularized among the Netherlandish painters working in Italy by a Haarlem painter called Pieter van Laer, who arrived in Rome about 1625. Because of his deformed body van Laer was nicknamed 'Il Bamboccio', which means a simpleton or puppet. And because of their choice of subject-matter, the name 'Bamboccianti' was given to his imitators and followers. These were most of the painters from the United Provinces who, on arrival in Rome, joined the *schildersbent*, or painters' club, organized by Netherlandish painters there in 1623. The *bentvueghels* (birds of a flock), as they called themselves, were notorious for the wild and dissolute rites and orgies with which new members were initiated. Du Jardin's canvas is a typical *bambocciata*, while Quast's panel shows that the *commedia dell'arte* was popular even in the North.

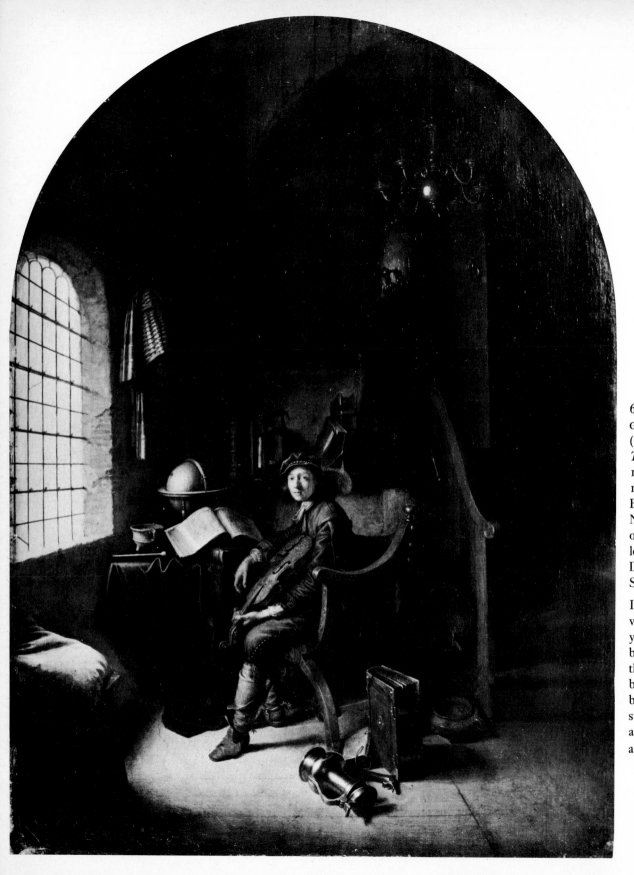

64.
GERRIT DOU
(1613—75):
The Violinist.
1637. Panel,
$12\frac{1}{4} \times 9\frac{1}{4}$ in.
Edinburgh,
National Gallery
of Scotland (on
loan from the
Duke of
Sutherland)

In addition to the
violin that the
young man holds
but does not play,
the sword,
barrel, jug, pipe,
books and globe
suggest an
allegory, probably
a *Vanitas* image.

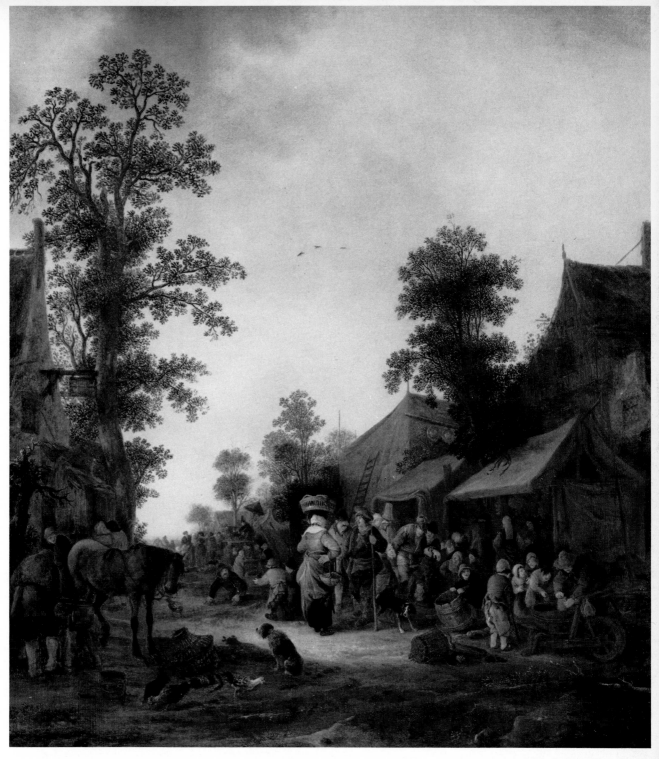

65. ISACK VAN OSTADE (1621—49): *A Village Fair*. About 1649. Panel, 31 × 28½ in. Ascott (Buckinghamshire),
The National Trust

A condescending view of low life and peasant ways provided a tradition of comic art adapted from the quite
unfrivolous compositions of Pieter Bruegel the Elder. Like his older brother Adriaen and, to a much less
extent, Jan Steen, Isack van Ostade painted many peasant scenes filled with comic details, like the small boys
jeering at the cripple and the quack doctor selling his wares to the gullible peasants.

66, 67. REMBRANDT (1606—69): *The Militia Company of Captain Frans Banning Cocq* ('*The Night Watch*'). 1642. Canvas, 144 × 172½ in. Amsterdam, Rijksmuseum

In the family album of Captain Frans Banning Cocq there is a watercolour sketch of this group portrait inscribed: 'Sketch of the picture in the Great room of the Civic Guard House, wherein the young Seigneur of Purmerlandt [Banning Cocq] as captain gives orders to the Lieutenant, the Seigneur of Vlaerdingen [Willem van Ruytenburgh] to have his company of citizens march out.' There is no mention of the artist's name. The picture, which shows eighteen officers and other ranks of a company of militia and at least thirteen other figures and a dog, was hung in the new 'Kloveniersdoelen' (i.e. the Guild Hall of the harquebusiers), together with group portraits of other militia companies by van der Helst, Backer, Flinck, Elias and Sandrart. Each of the members of the company paid 'approximately the sum of one hundred guilders, more for one person and less for another, depending on the place they had in it.' The picture's fame travelled round Europe.

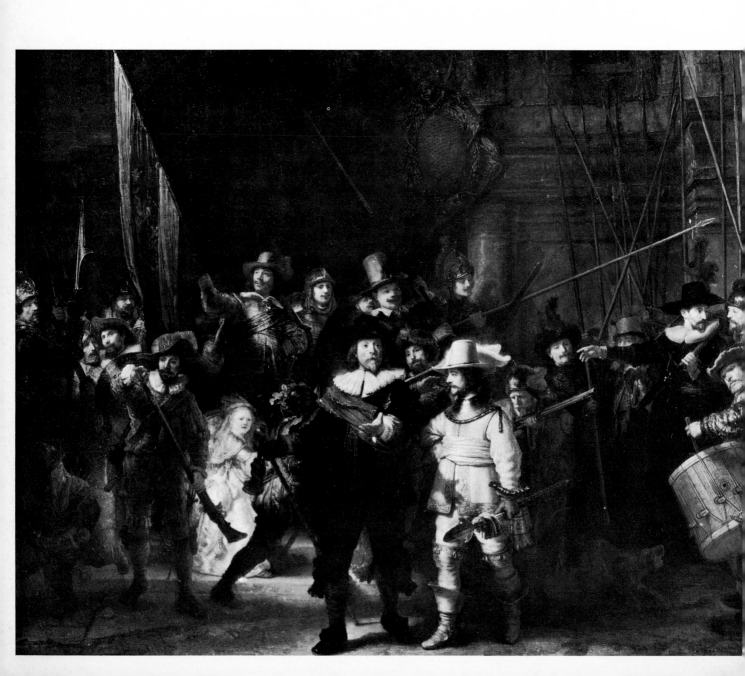

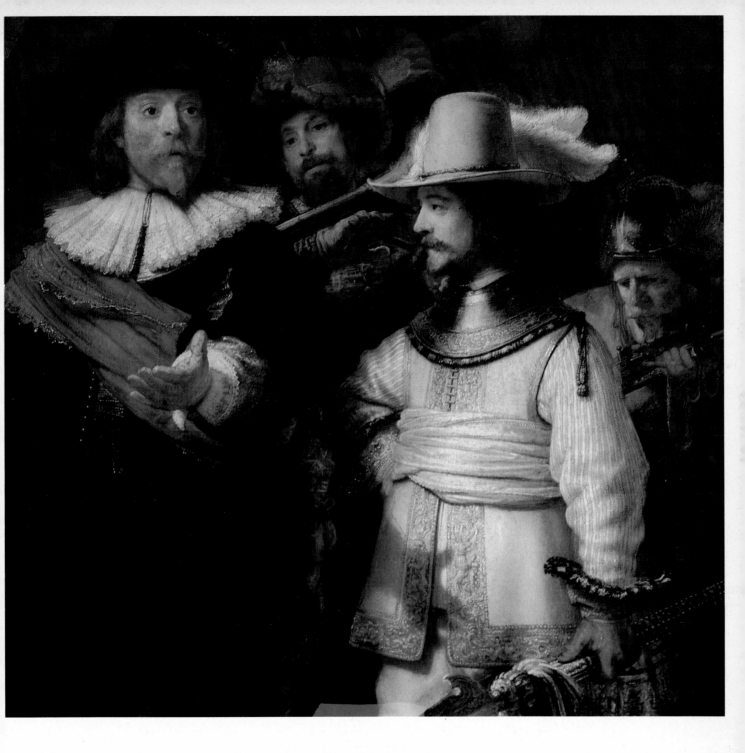

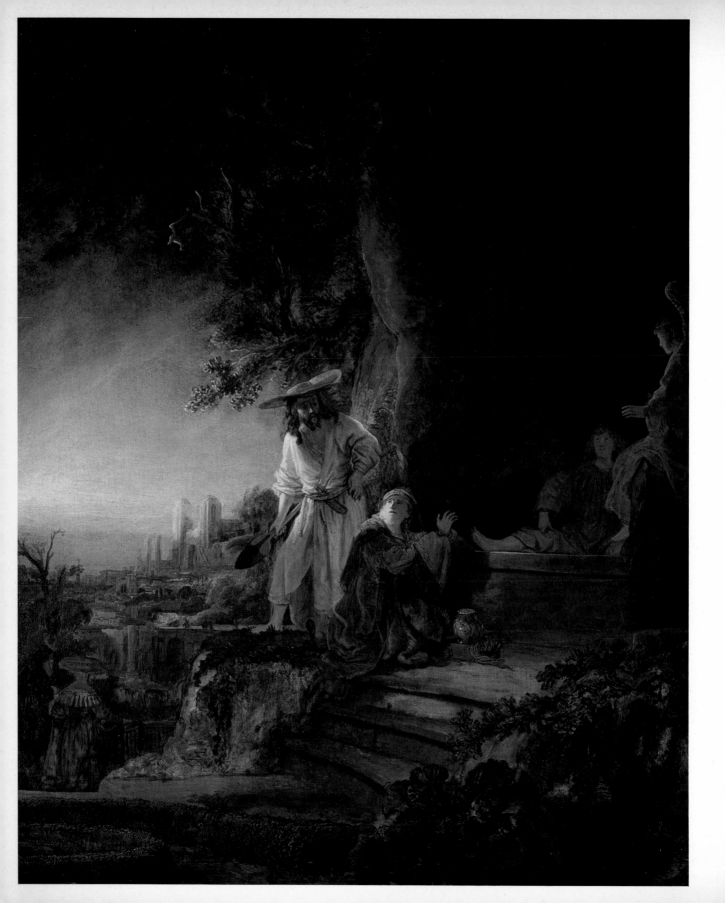

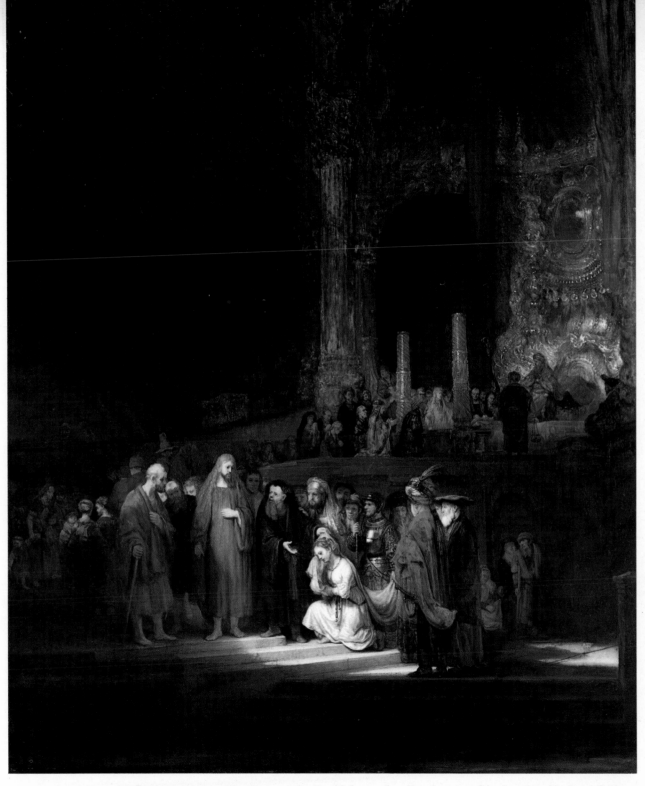

69. REMBRANDT: *The Woman taken in Adultery*. 1644. Panel, 33 × 25¾ in. London, National Gallery

68 (*opposite*). REMBRANDT (1606—69): *Christ and the Magdalen at the Tomb*. 1638. Panel, 24 × 19½ in.
London, Royal Collection (reproduced by gracious permission of Her Majesty The Queen)

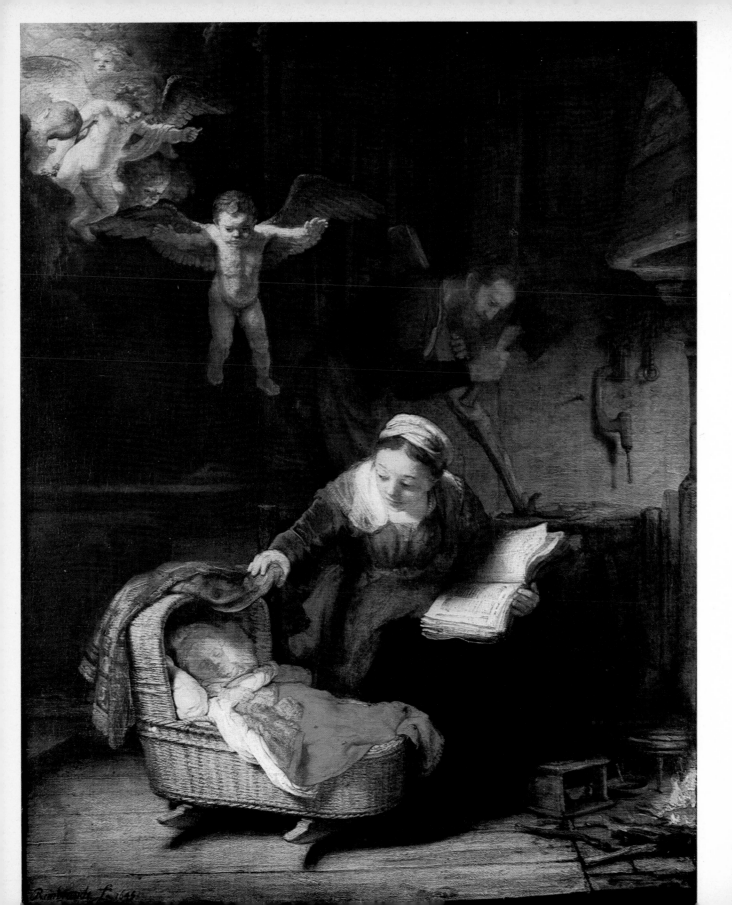

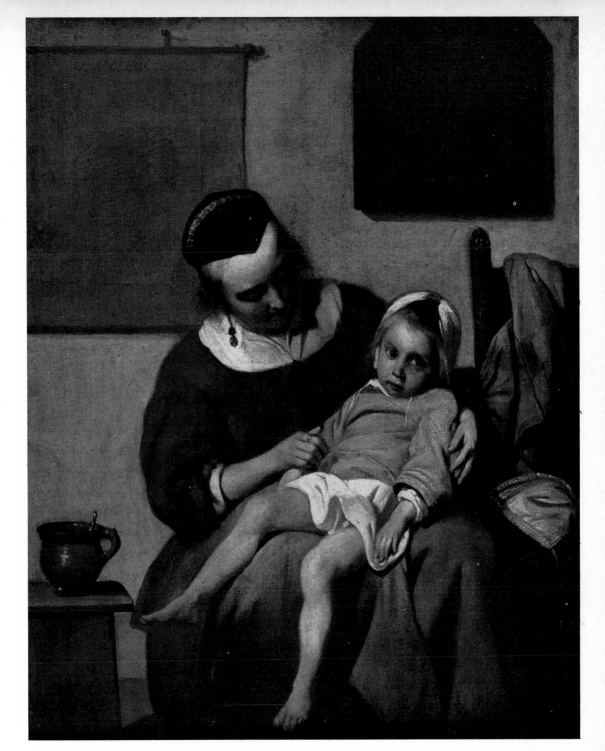

70 (*opposite*).
REMBRANDT
(1606—69):
*The Holy Family
with Angels*.
1645. Canvas,
46 × 36 in.
Leningrad,
Hermitage

71. GABRIEL METSU (1629—67): *The sick Child*. About 1660. Canvas, 13⅛ × 10¾ in.
Amsterdam, Rijksmuseum

These works demonstrate the way that for Dutch artists the sacred and the secular were
inseparable. Rembrandt shows the Holy Family as that of a seventeenth-century
Netherlandish carpenter, suddenly visited by angels. Metsu shows an unidentified child,
but the framed *Crucifixion* on the wall calls to mind the image of the dead Christ across
his Mother's lap, and so casts the shadow of mortality across the domestic scene.

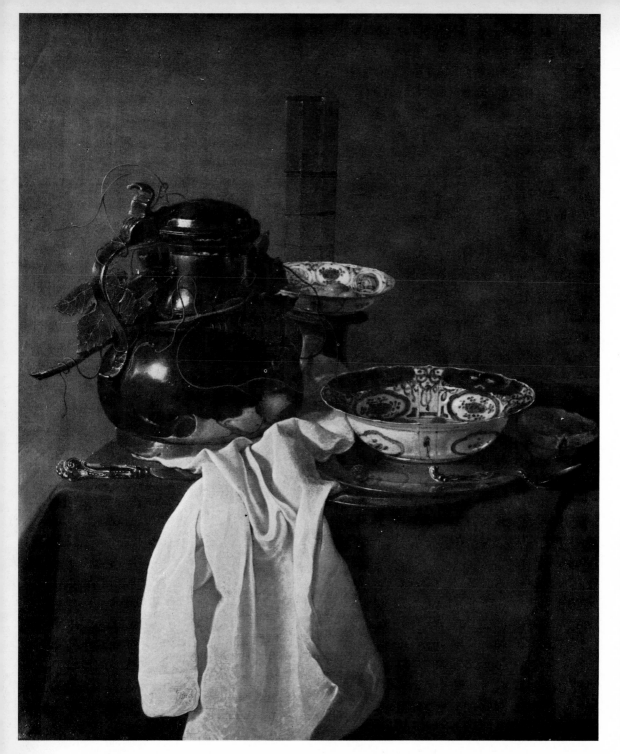

73 (*opposite*). WILLEM
KALF (1619—93):
Still-Life. 1663.
Canvas, $23\frac{3}{4} \times 19\frac{3}{4}$ in.
Cleveland, Ohio,
Museum of Art

Kalf was the Dutch
master of the *pronk
stilleven*, as they were
called, or the showy
still-life. He delighted
in rendering luxurious
objects in a restrained
manner.

72. JAN TRECK (about 1606—52?): *Still-Life with a Pewter Flagon and two Ming Bowls*. 1649.
Canvas, $30\frac{1}{8} \times 25\frac{1}{8}$ in. London, National Gallery

In Amsterdam, Treck continued the tradition of the Haarlem painters of still-life, though his
selection of precious objects (Ming bowls had only recently been imported) is distinctive here.

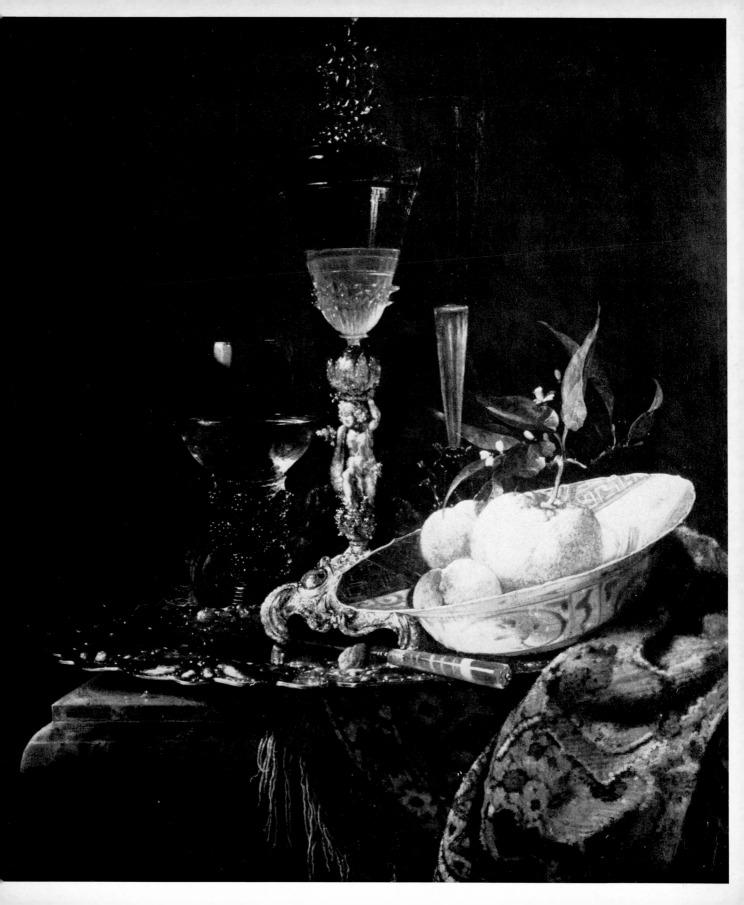

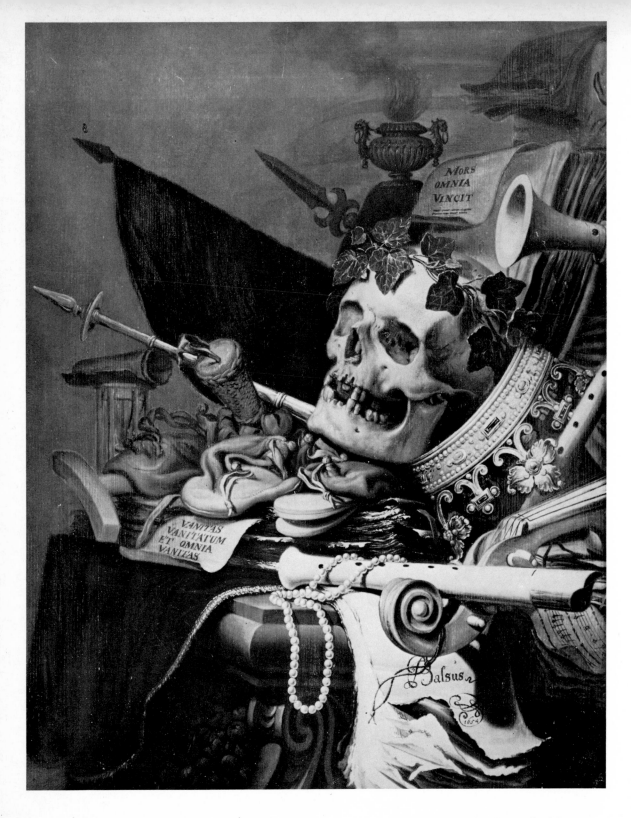

Within the painting:

MORS OMNIA VINCIT

VANITAS VANITATUM ET OMNIA VANITAS

Falsus 1654

74. JAN VERMEULEN (active 1638—74): *Vanitas.* 1654. Panel, 29 × 22½ in. Ponce, Puerto Rico, Ponce Art Museum

'Death conquers all' and 'Vanity of vanities; all is vanity'—the familiar quotations are hardly necessary, as emblems of the main human ambitions are grouped round the skull.

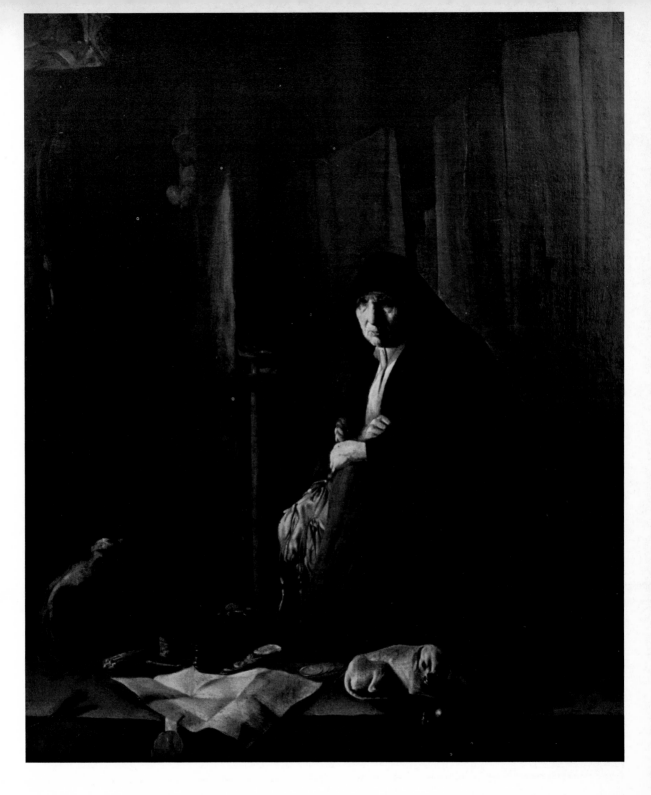

75. PAULUS BOR (about 1600—69): *Avarice* (*The Miserly Woman*). Canvas, 48 × 39⅜ in. Jacksonville, Florida, Cummer Gallery of Art

This old woman personifies the deadly sin of Avarice. The motif of the old miser, man or woman, was popular in the early part of the century.

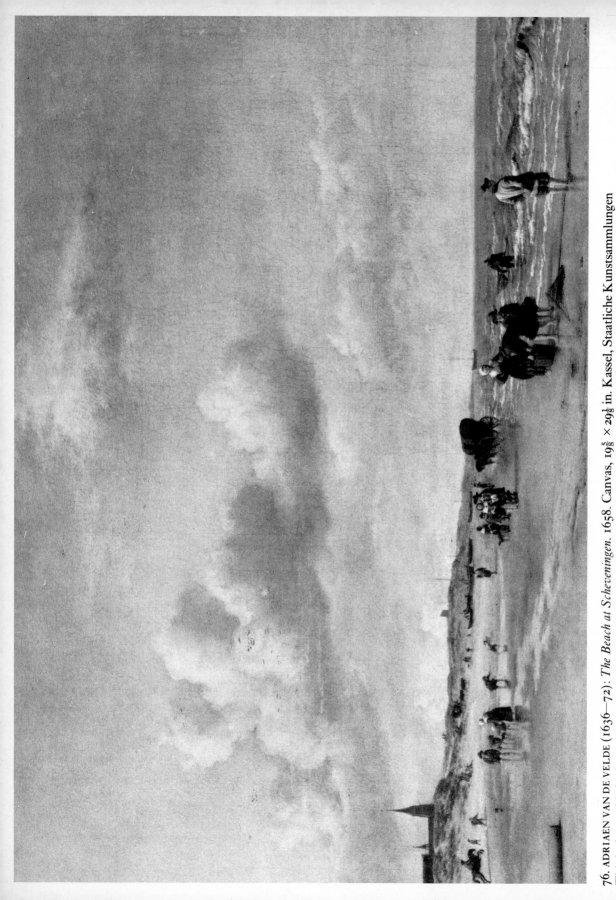

76. ADRIAEN VAN DE VELDE (1636—72): *The Beach at Scheveningen*. 1658. Canvas, 19⅝ × 29⅛ in. Kassel, Staatliche Kunstsammlungen

This is the seaside in the seventeenth century. The scene has a surprisingly familiar air and it is easy to overlook the odd clothing of the small figures, as they promenade along the beach, taking the air. Scheveningen is still a popular resort, and the face it presents in this small canvas will be recognizable to anyone who has visited a holiday resort on either side of the North Sea. The canvas is familiar for another reason. It was this type of small Dutch landscape which formed a model for so much English painting between the time of Constable and the arrival of Impressionism.

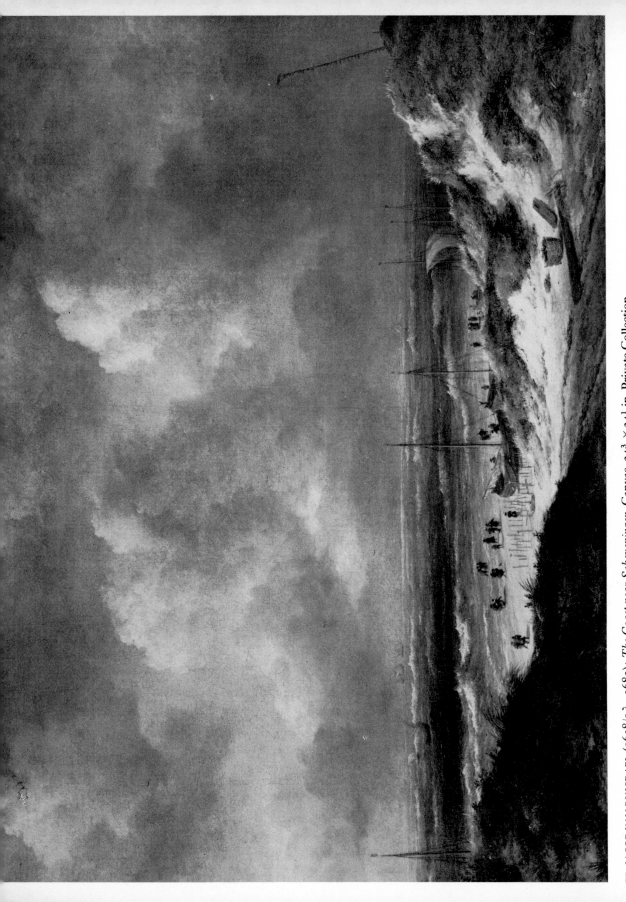

77. JACOB VAN RUISDAEL (1628/9?–1682): *The Coast near Scheveningen.* Canvas, $24\frac{3}{4} \times 34\frac{1}{2}$ in. Private Collection

Until the nineteenth century, Ruisdael was admired for his more grandiose and dramatic inventions (see Plates 143 and 144). But now it is recognized that his quieter ones, more directly based upon observation of his native landscape, have their own virtues. The comparison between this vision of the seaside and that of Adriaen van de Velde (opposite) is perhaps not most easily made in black and white, but it is interesting all the same. It is certainly easy to see the fundamental shifts in vision and procedure which separate this generation of landscape painters from that which preceded it (see Plates 31, 32, 33 and 48).

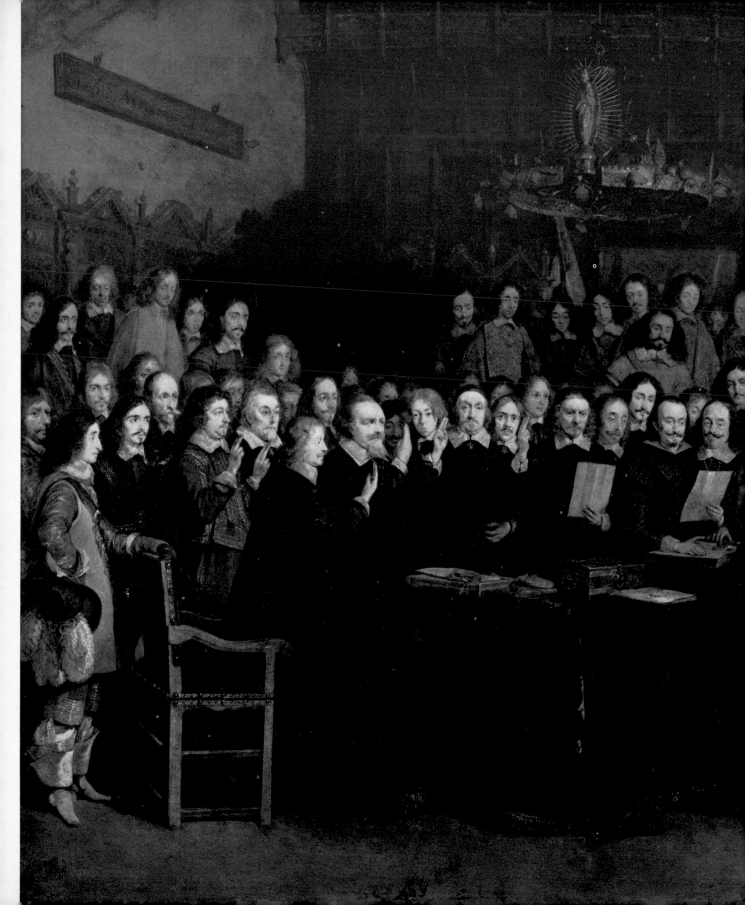

78. GERARD TER BORCH (1617—81): *The Ratification of the Treaty of Münster, 15 May 1648*. 1648. Copper, $17\frac{7}{8} \times 23$ in. London, National Gallery

The Ratification of the Treaty of Münster was a momentous occasion in the history of the Netherlands, because it marked the final legal and public recognition by Spain and the rest of the world that the war of independence that the United Provinces had been waging since 1568 against Spain was over. Spain renounced for ever her claim to sovereignty and recognized the United Provinces as free and independent. After two years of negotiations, the final swearing of the oath of confirmation took place at the town hall of Münster on 15 May 1648. An eye witness described how the six Dutch delegates and the two Spanish plenipotentiaries seated themselves at a round table covered in green, on which stood two caskets containing the treaty documents. The oath was sworn before some of the Münster magistrature and many members of the suites of the plenipotentiaries. Ter Borch's painting agrees closely with this account, and he took pains to render his setting accurately. All eight principals have been identified from portrait engravings. It is not known who commissioned this marvellous small work, but it remained in the artist's possession until his death.

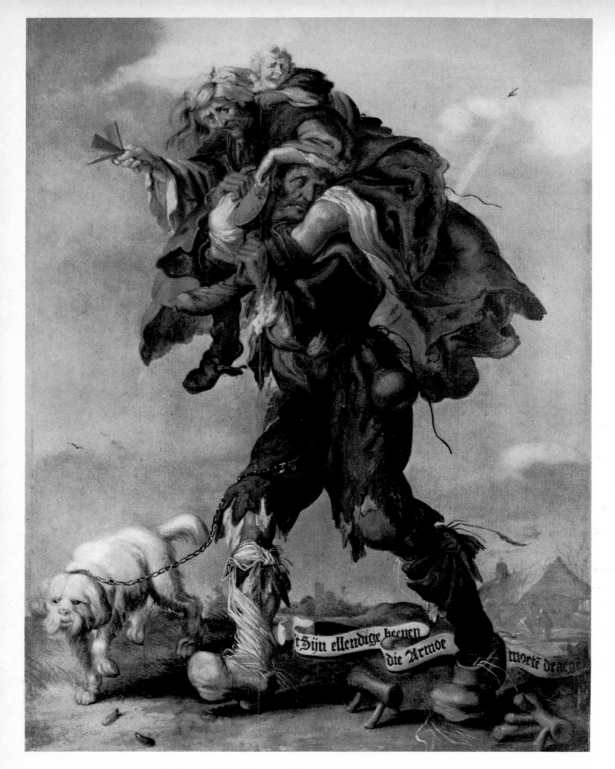

79. ADRIAEN VAN DE VENNE (1589—1662): *Allegory of Poverty*.
 Panel, 21½ × 16⅝ in. Oberlin, Ohio, Allen Memorial Art Museum

The scroll announces that it is its own miserable bones that Poverty must carry about. It was unusual for a Dutch artist of this period to paint such an openly symbolic image as this. It is the more odd in that when van der Venne provided images for Jacob Cats's emblem books they were simple scenes of daily life, given special significance only by Cats's moralizing verses.

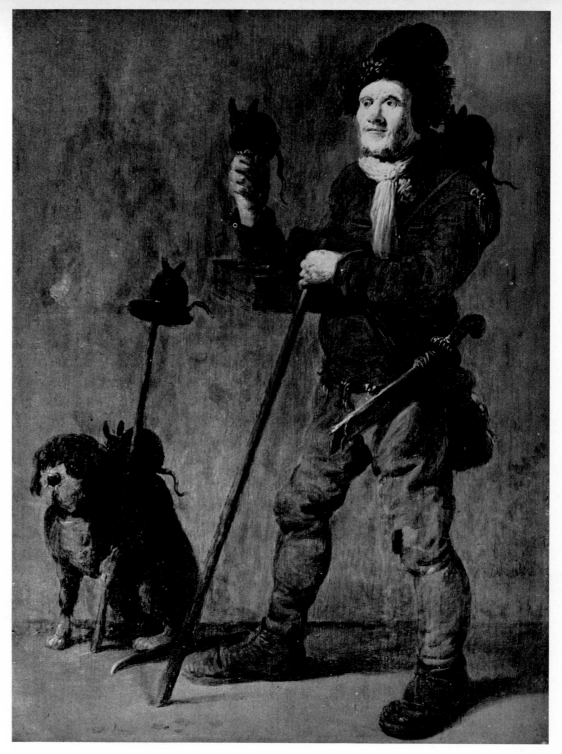

80. PIETER DE BLOOT (1601—58): *A Rat-Catcher with his Dog*. Panel, 10½ × 8 in. Los Angeles,
 County Museum of Art

The rat-catcher may well have been understood to have a specific significance, but, unlike
van de Venne's *Allegory* (opposite), this is not indicated. Clearly this is intended as a comic
figure, a grotesque. The rat-catcher, like the pancake woman, was a frequently represented
type and the most memorable version is an etching made by Rembrandt in 1632, when he was
only twenty-six.

81. MICHIEL SWEERTS (1624—64): *The Drawing Class.* Canvas, 30⅛ × 43¼ in. Haarlem, Frans Hals Museum

Sweerts, who was born in Brussels, lived a varied life. He was in Amsterdam for only a short time, perhaps between 1658 and 1661. This painting is particularly interesting because it is one of the earliest representations of a life-drawing class. The number and age of the students suggest that it is a school or academy for drawing rather than a group of apprentices in their master's workshop. Sweerts had planned to start his own academy in Brussels shortly before he moved to Amsterdam. It has been suggested that the Bohemian figure of the artist, talking to a client or parent on the right, is Rembrandt, who is known to have taken on large numbers of pupils at one period in his career.

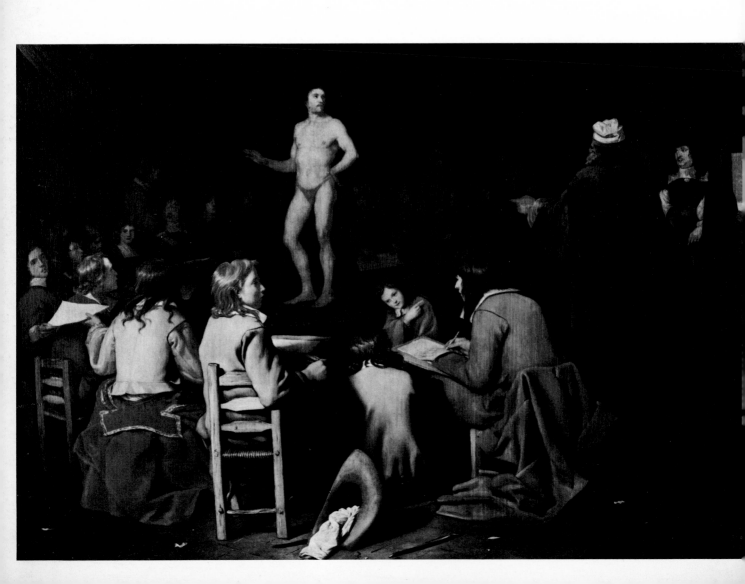

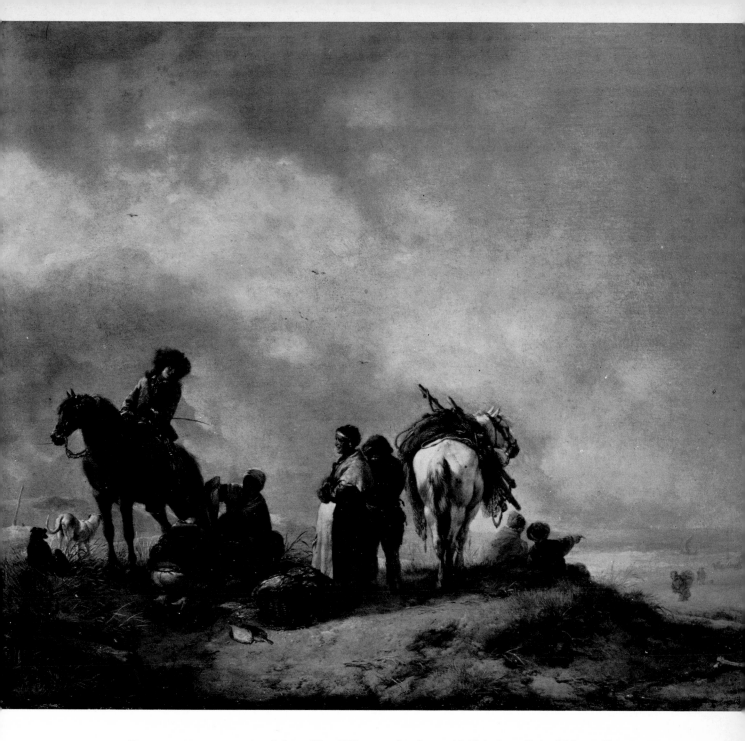

82. PHILIPS WOUWERMANS (1619–68): *A View on a Seashore, with Fishwives offering Fish to a Horseman.* Probably after 1660. Panel, $13\frac{7}{8} \times 16\frac{1}{4}$ in. London, National Gallery

Wouwermans was immensely popular in nineteenth-century England. He preferred to paint horses, and his special skills were the representation of textures and the graduation of colour and tone to create depth. These qualities can be seen in this example of his work. The foreground figures stand out boldly against a lighter, silvery distance. The deployment of this technique is most obvious in the painting of the two dogs on the left. The nearer dog is shown to have a darker coat than the other, but it is also painted in darker, more contrasting tones, whereas the standing dog, though equally sharply defined, is in lighter tones.

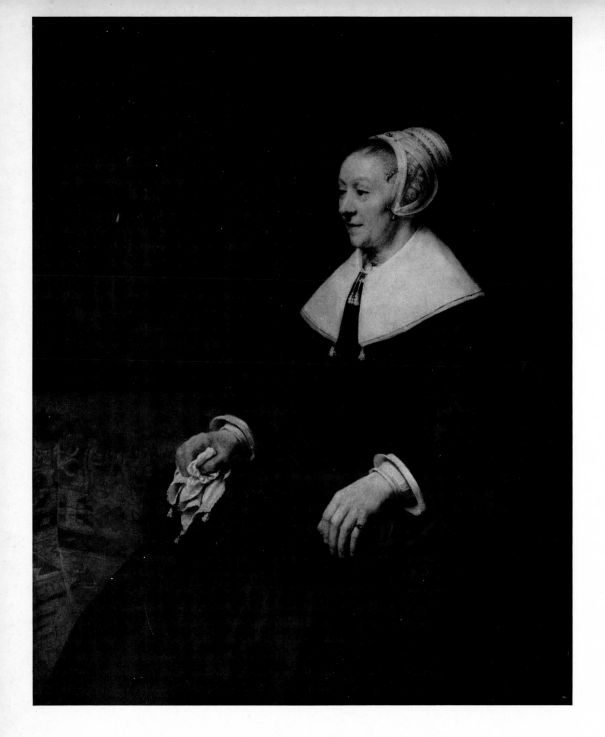

83, 84. REMBRANDT (1606–69): *Catharina Hooghsaet.* 1657. Canvas, 48⅝ × 37¾ in.
Private Collection (on loan to the National Museum of Wales, Cardiff)

Rembrandt's ability and willingness to modify his treatment according to his subject is
shown by the brilliant, commissioned portraits of his later years. This clearly lit and finely
defined portrait is three years later than the brooding image of Rembrandt's friend, Jan Six
(Plate 88). Catharina Hooghsaet and her husband, Hendrick Jacobsz. Rooleeuw, were
Mennonites. The way she is presented suggests that the canvas was one of a pair showing
husband and wife, but no portrait of Rooleeuw has survived.

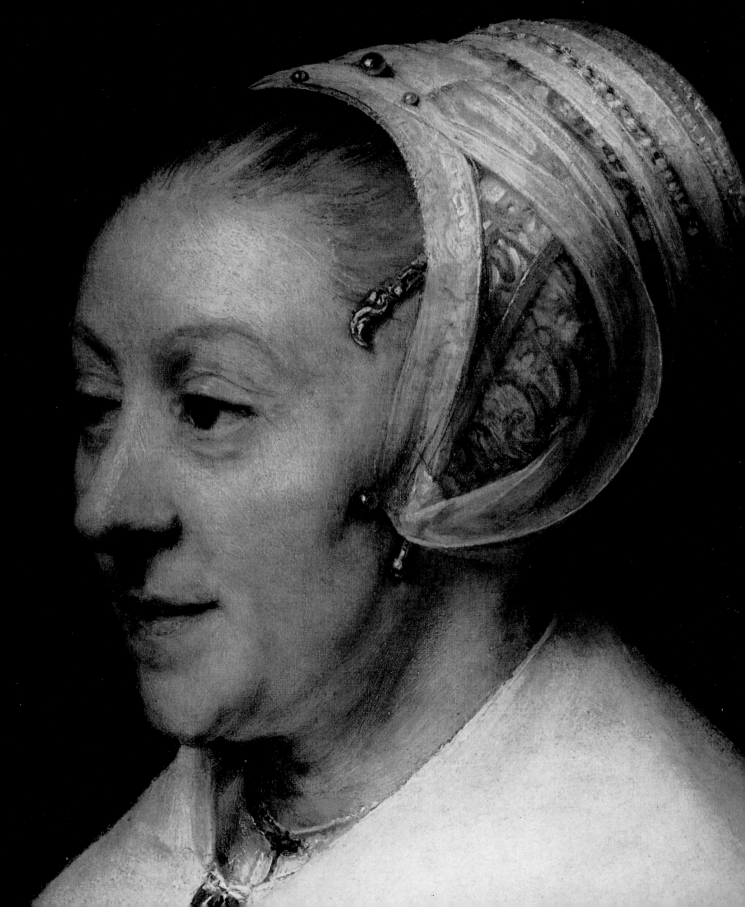

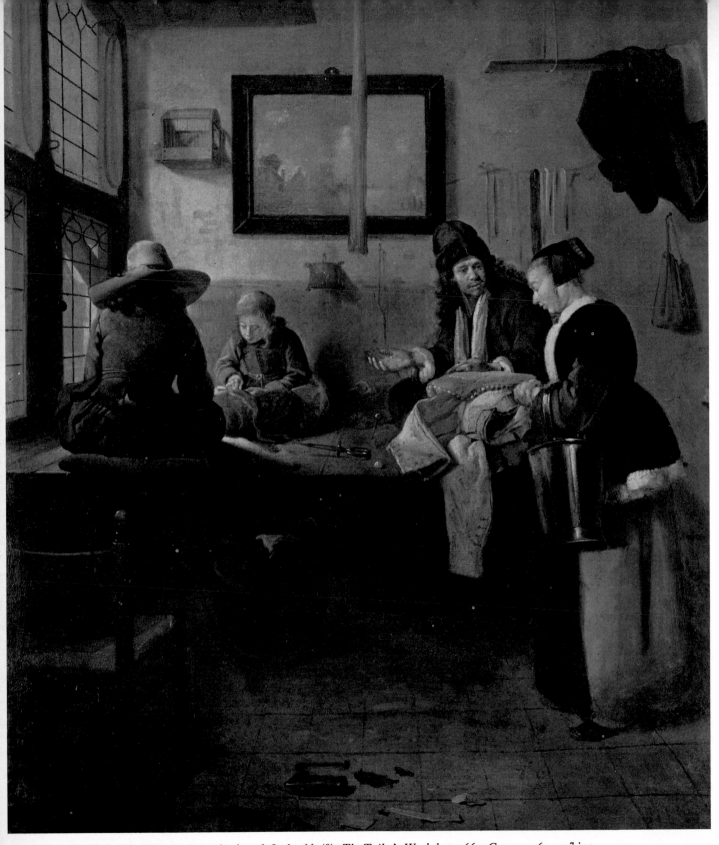

85. QUIRINGH VAN BREKELENKAM (active 1648; d. 1667/8): *The Tailor's Workshop*. 1661. Canvas, 26 × 20⅞ in.
Amsterdam, Rijksmuseum

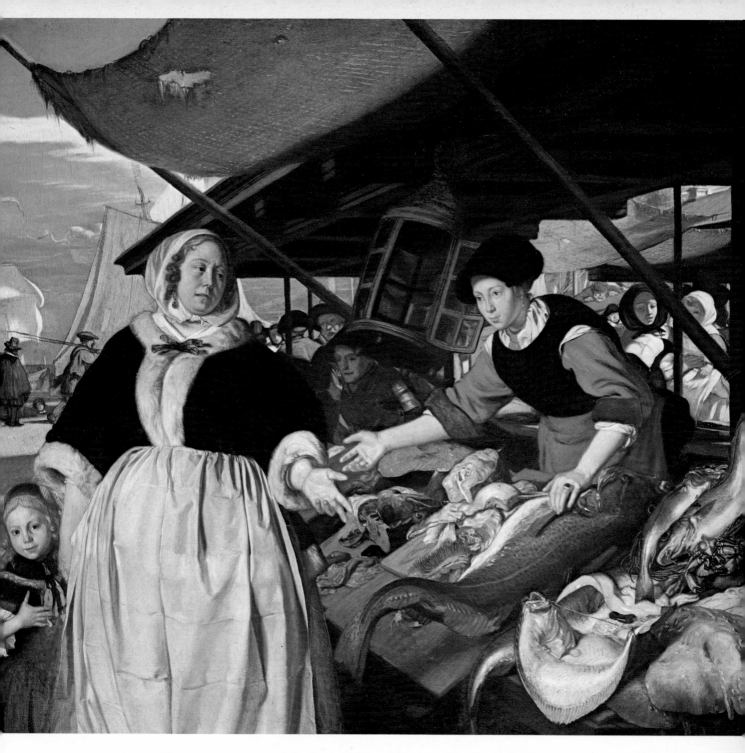

86. EMANUEL DE WITTE (1615/17—1691/2): *Adriana van Heusden and her Daughter at the New Fishmarket in Amsterdam* (?). About 1661—3. Canvas, 22½ × 25¼ in. London, National Gallery

Two representations of contemporary trades: are they merely typical, or are they also portraits? De Witte's painting is certainly a portrait. It shows the wife and daughter of an Amsterdam notary, Joris de Wijs, who, in 1658, contracted to feed and lodge the artist and pay him 800 guilders a year in return for his entire output. Fishmarkets were painted in the sixteenth century, by such Flemish artists as Pieter Aertsen, as a foreground to the New Testament scene of the Miraculous Draught of Fishes.

87. REMBRANDT (1606—69): '*The Polish Rider*'. Detail. About 1655. Canvas. New York, Frick Collection

The subject of this haunting picture has caused endless debate. The costume has been shown to be truly Polish, but whether this young man was a Polish exile known to Rembrandt, or whether he is a personification of the Christian Soldier marching East against the Infidel, is unknown. It has also been suggested that it may represent the Prodigal Son setting out from his father's house.

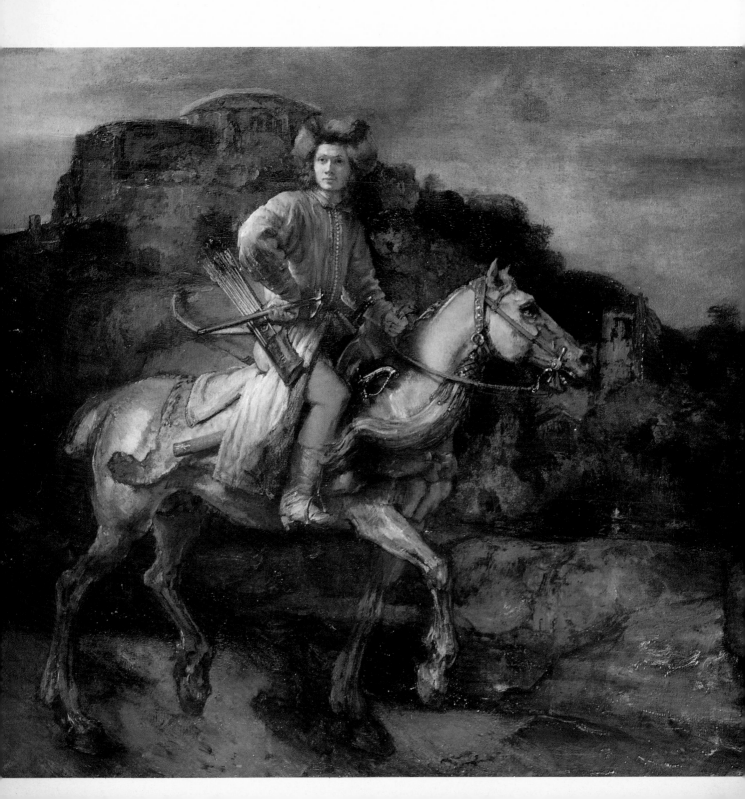

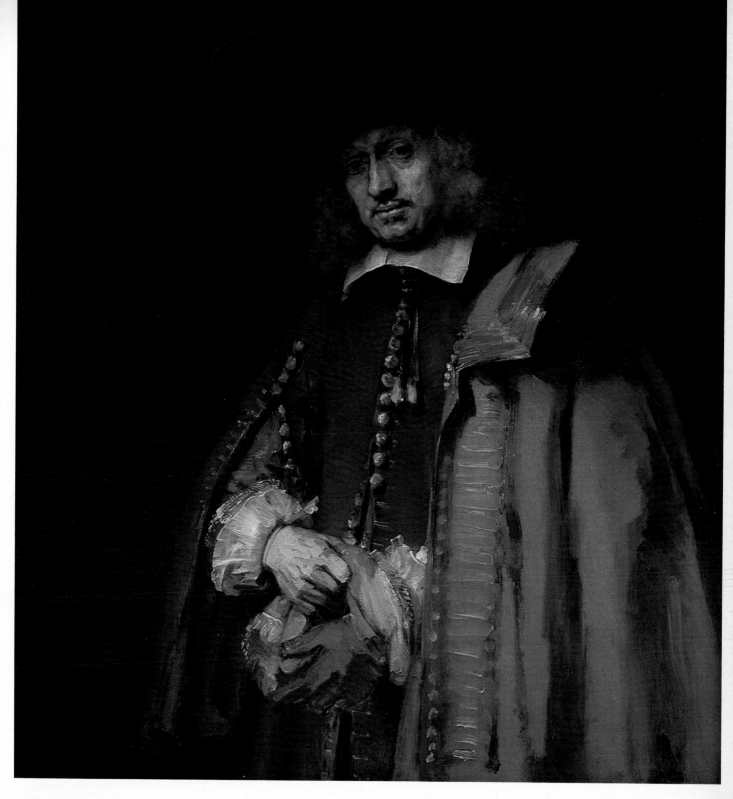

88. REMBRANDT: *Jan Six*. 1654. Canvas, 44⅛ × 40⅛ in. Amsterdam, Six Collection

Between 1647 and the date of this canvas, Six and Rembrandt were on close terms. Rembrandt made a portrait etching of Six and another illustrating his play *Medea*. Six was the son-in-law of Dr Tulp (see Plate 42).

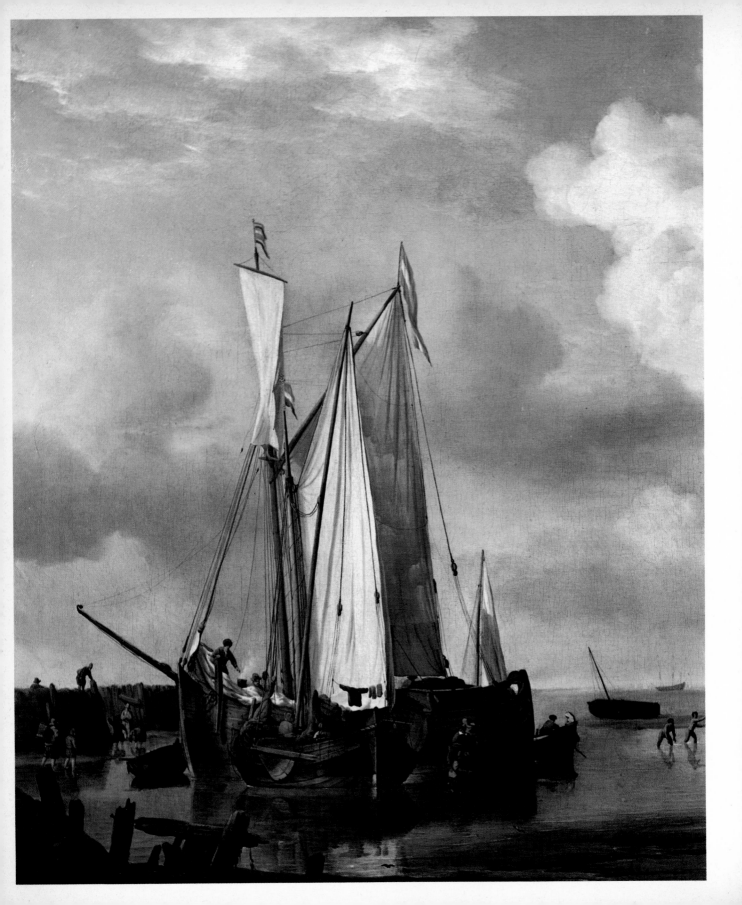

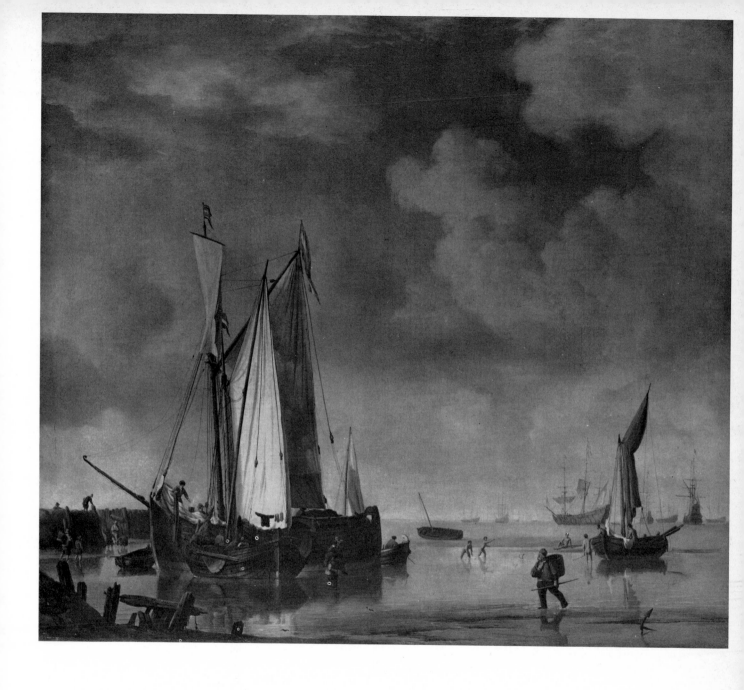

89, 90. WILLEM VAN DE VELDE THE YOUNGER (1633—1707): *Dutch Vessels close inshore at low Tide*. 1661.
Canvas, $24\frac{7}{8} \times 28\frac{3}{8}$ in. London, National Gallery

The quantity of exact detail that the marine artist had to dispose in making his compositions is easy to overlook. In addition to the two vessels in the left foreground, each with its individual rig, Willem van de Velde shows a fleet of Dutch men-of-war in the distance. One of these, broadside on, flies from the mainmast the flag and pennant of the Commander-in-Chief: to its right another ship is firing a salute. But all this detail is subordinate to the atmosphere, which is so typical of this artist's work.

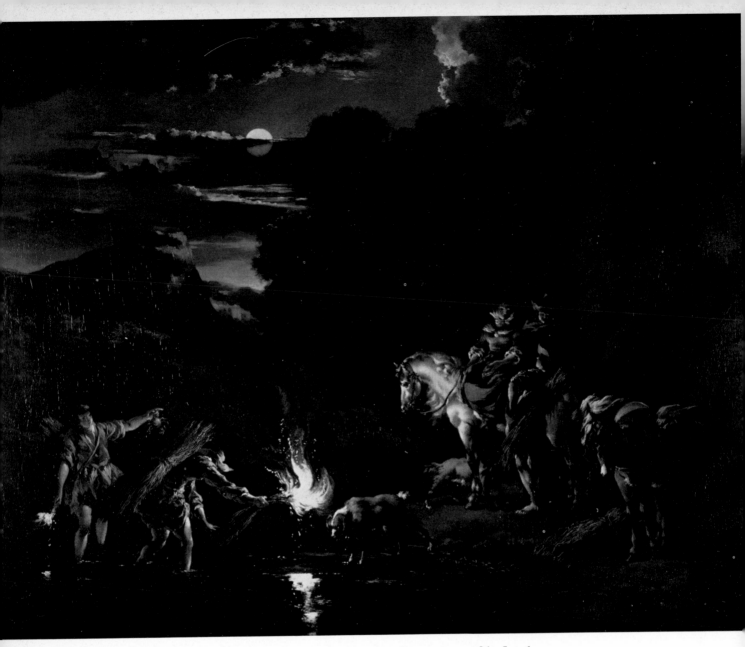

91. NICOLAES BERCHEM (1620—83): *Crab Fishing by Moonlight*. 1645. Canvas, 23 × 30¾ in. London,
Private Collection

92. AERT VAN DER NEER (1603/4—1677): *A Landscape with a River at Evening*. About 1650—5. Canvas,
31⅛ × 25⅝ in. London, National Gallery

Both these subjects were precisely defined and specialized, in their time. Berchem takes up a long-standing
Netherlandish tradition of representing fire at night. More than a hundred years earlier, in 1535, Federigo
Gonzaga, Duke of Mantua, had bought twenty Flemish paintings 'which represent nothing but landscapes
on fire which seem to burn one's hands if one goes near to touch them'. Representations of the Four
Elements, in which *Fire* was shown as a night scene of some kind, also had a long tradition. Aert van der Neer
specialized in moonlight and twilight scenes such as that illustrated opposite. Although very repetitive, at
their best, as here, his canvases are excellent.

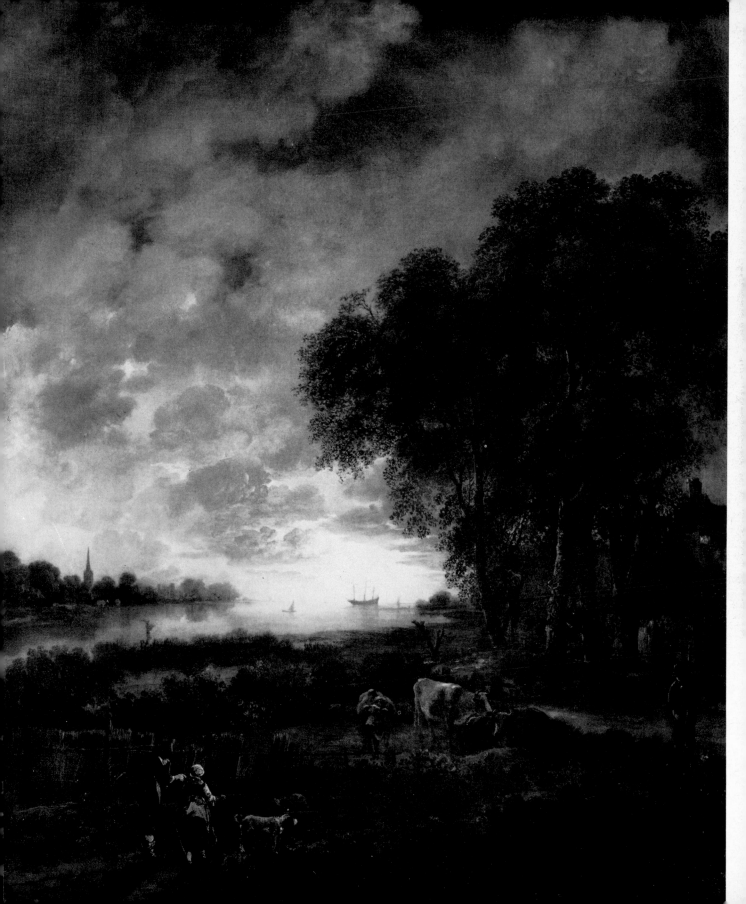

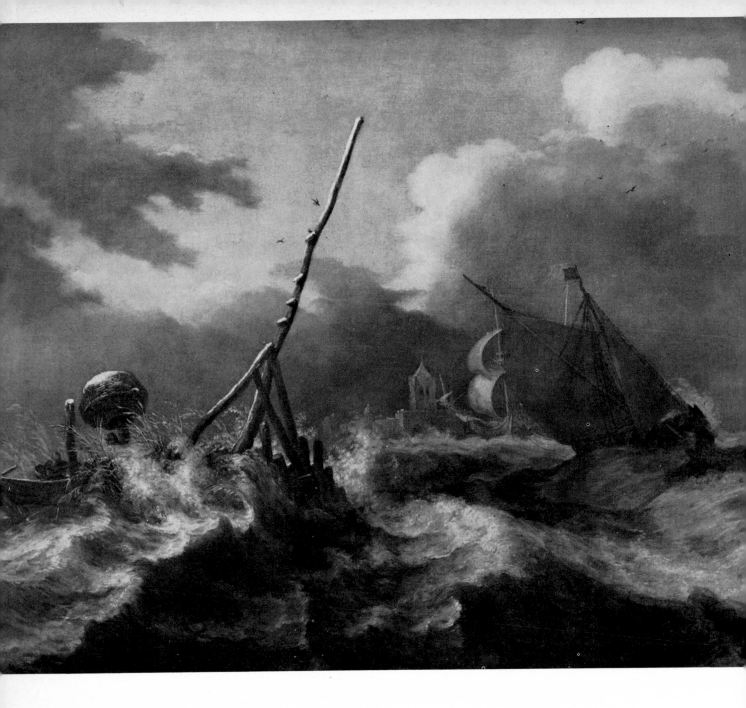

93. ALLART VAN EVERDINGEN (1621—75): *Snowstorm at Sea*. Canvas, 38 × 47½ in. Chantilly, Musée Condé

These images, which appear to be based directly upon the experiences they evoke so movingly, have behind them long traditions. When Asselijn showed hunters in the snow, he cannot have been unaware of the tradition of *Occupations of the Months*, and notably the unforgettable canvas by Pieter Bruegel the Elder, in which hunters in the snow are included in the *Month of December*. Van Everdingen develops another traditional image, taken from representations of Virtues and Vices. The virtue of *Hope* was represented, again by Bruegel, as a castle enduring the storms of fate. Here, van Everdingen shows a church withstanding the gales of adversity, and appears to present an analogy between the church and the beacon post in the foreground. The calendar and moral traditions often coincided, and Bruegel had included this emblem of *Hope* in his *Month of February*.

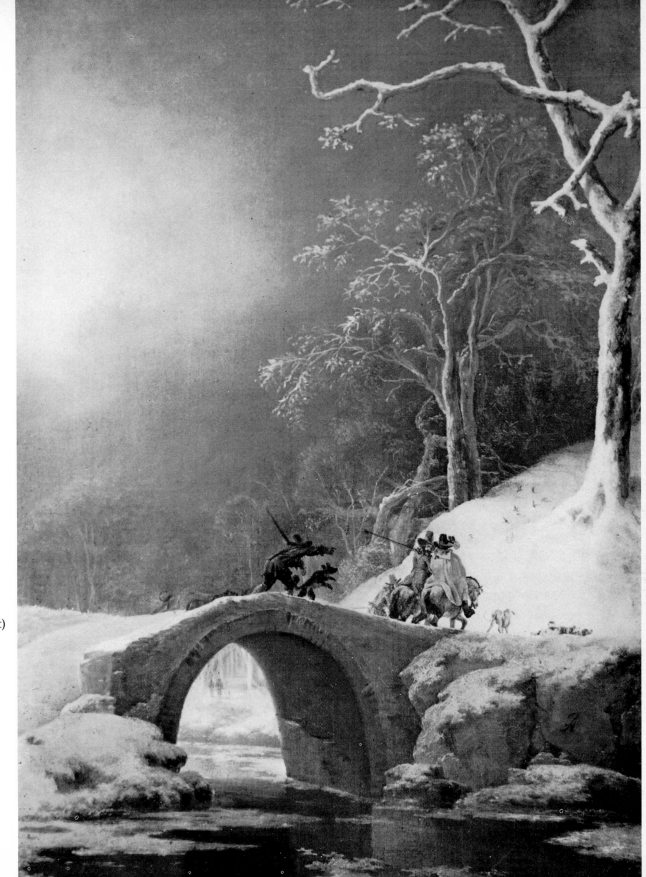

94.
JAN ASSELIJN
(1610—52):
The Bridge.
Canvas,
$19\frac{1}{2} \times 14$ in.
Paris, Fonda-
tion Custodia
(Coll. F. Lugt)
Institut
Néerlandais

95. JAN VAN DE CAPPELLE (about 1624—1679): *A Dutch Yacht firing a Salute as a Barge pulls away, and many small Vessels at Anchor*. 1650. Panel, $33\frac{5}{8} \times 45$ in. London, National Gallery

It is not known whether van de Cappelle or Cuyp first discovered the magic of calm waters, luminous skies and hanging sails. From the work of painters returned from Rome, Cuyp had learned the secret of the Claudian vision of the Campagna (see Plate 61). But however it happened, Cuyp, in Dordrecht, and van de Cappelle, in Amsterdam, both began to paint, about 1650, works such as those shown here. Van de Cappelle's scenes have a febrile air: note how, in this example, a dark cloud at the top of the canvas appears to hover menacingly over the spectator. By contrast Cuyp presents a golden vision, at once ideal and credible. Other than this group of marine painters, no Dutch artist had found such abstract harmonies in his vision of the real world. As the small illustration (Plate 96) shows, they were the inspiration of the greatest of English artists, J. M. W. Turner.

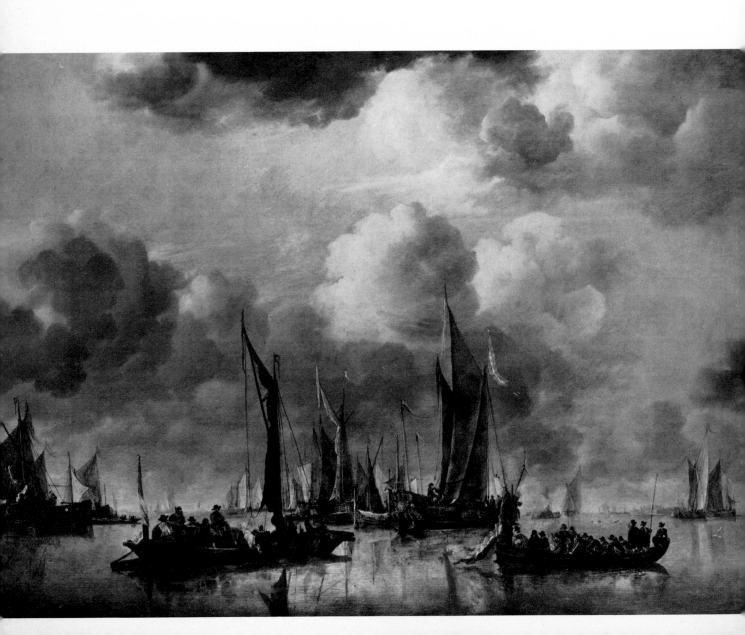

96. J. M. W. TURNER,
(1775—1851): *The
Dordrecht Packet-Boat
from Rotterdam becalmed.*
1818. Canvas, 62 × 92 in.
From the Collection of
Mr and Mrs Paul Mellon

97. AELBERT CUYP
(1620—91): *The Maas at
Dordrecht.* About 1660.
Canvas, 45¼ × 67 in.
Washington, D.C.,
National Gallery of Art
(Mellon Collection)

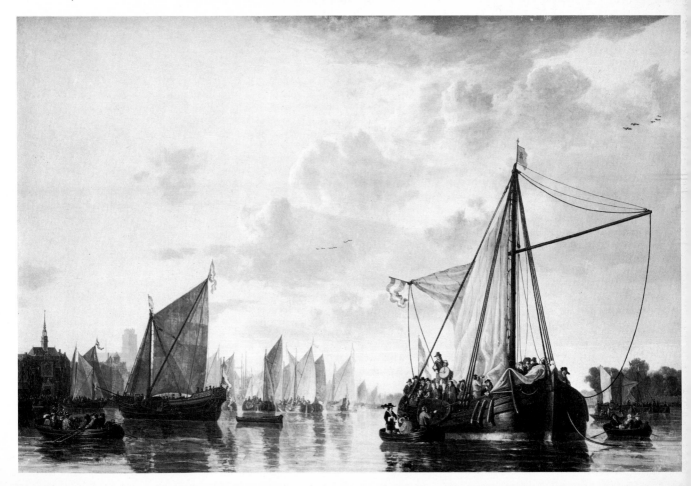

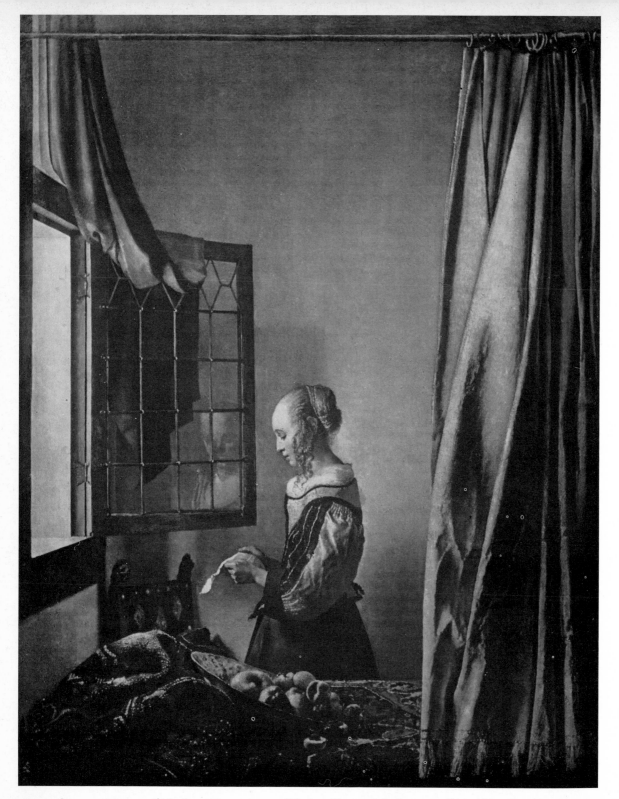

98, 99. VERMEER (1632—75): *Lady reading at an open Window*. About 1658. Canvas, $33\frac{3}{4} \times 25\frac{3}{8}$ in. Dresden, Gemäldegalerie

The curtain in this delicate work presents a problem. Is it in the room or in front of the picture? Pictures were commonly protected by curtains in seventeenth-century Holland (see Plate 117). Other artists, including Rembrandt and Gerrit Houckgeest, painted canvases apparently protected by curtains.

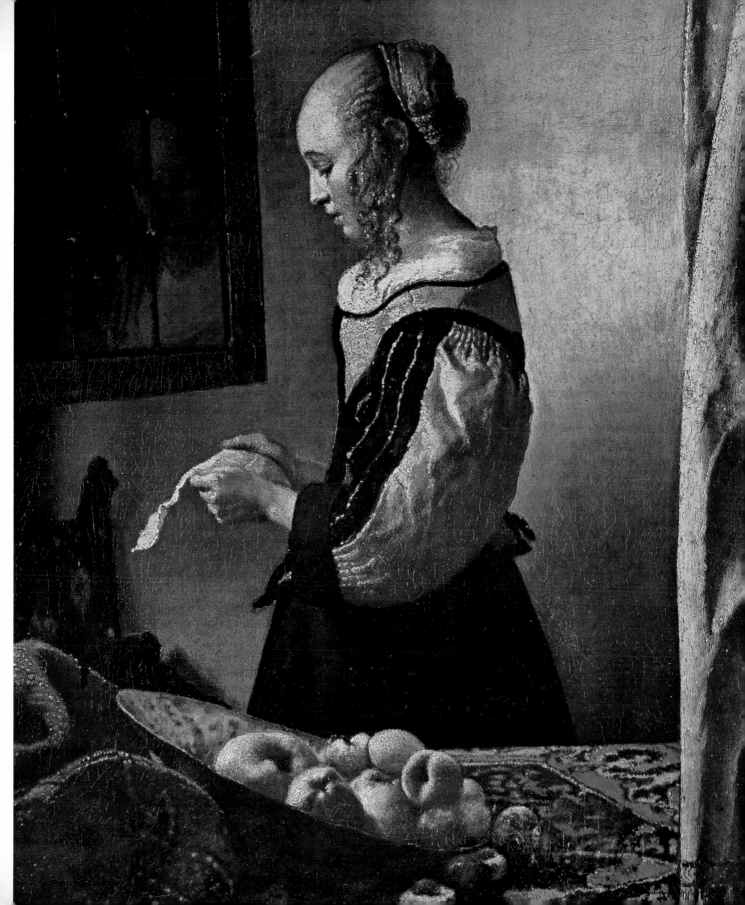

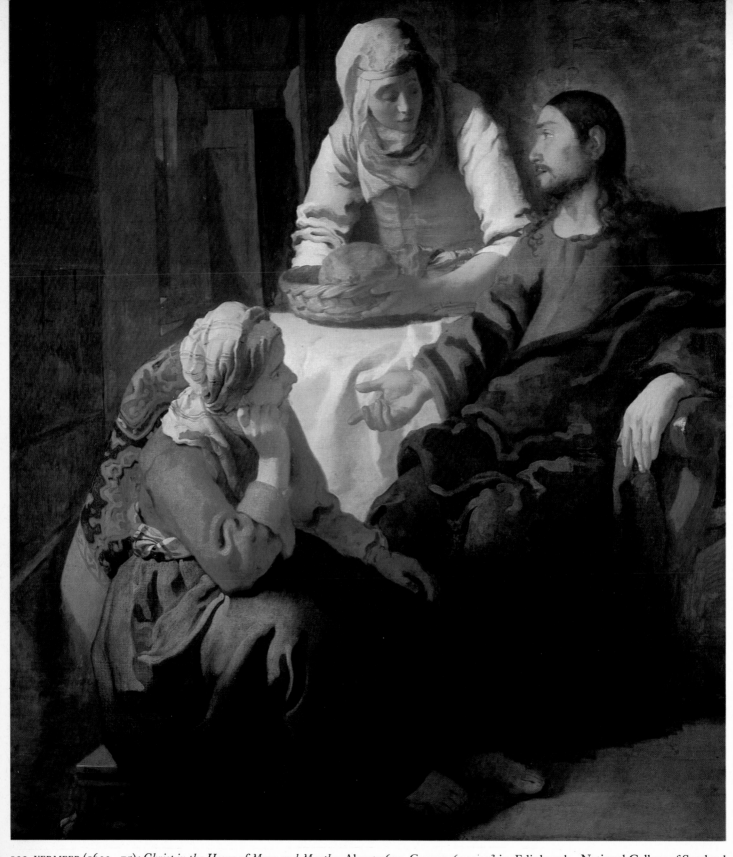

100. VERMEER (1632–75): *Christ in the House of Mary and Martha*. About 1654. Canvas, 63 × 55¾ in. Edinburgh, National Gallery of Scotland

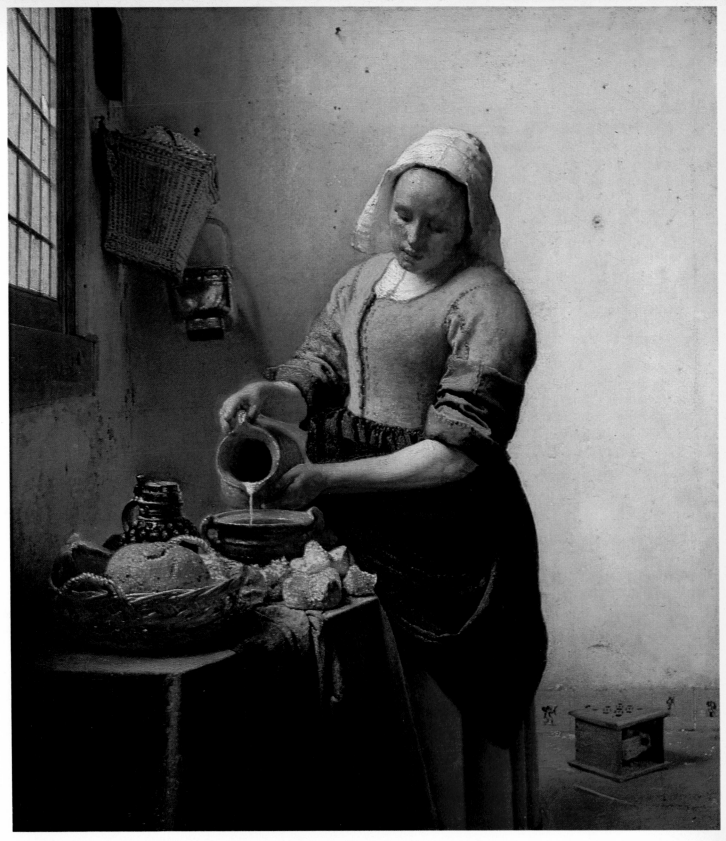

101. VERMEER: *Maid servant pouring Milk*. About 1660. Canvas, 18 × 16¼ in. Amsterdam, Rijksmuseum

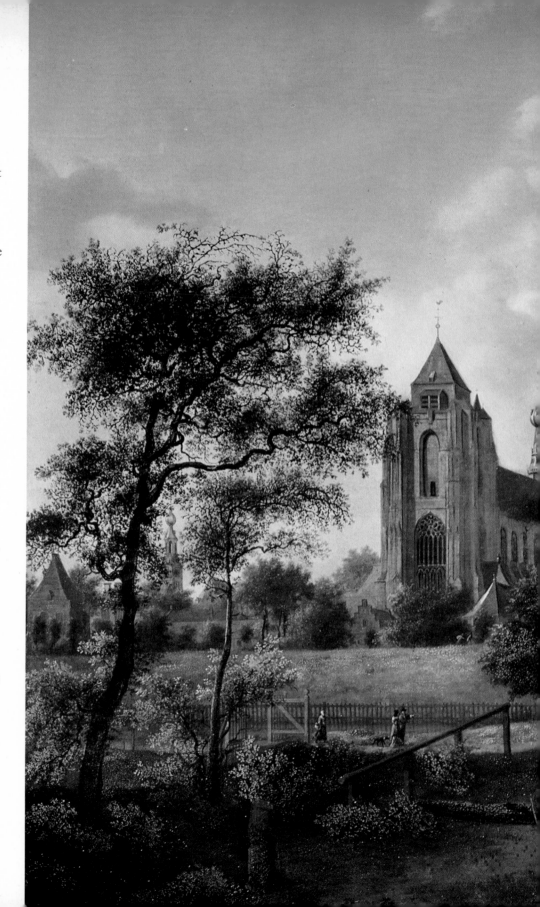

102. JAN VAN DER HEYDEN (1637—1712): *The Approach to the Town of Veere*. Detail. About 1665. Panel. London, Royal Collection (reproduced by gracious permission of Her Majesty The Queen)

Townscapes—that is, scenes where architecture is dominant but where mere topography appears subordinate to pictorial imagination—were an invention of the Delft painters of the 1650s, and there is little doubt that Carel Fabritius played a leading role in the establishment of this type of painting (see Plates 119, 120 and 121). Van der Heyden was the greatest of the few artists who specialized in townscapes. Although it is not known who taught him, there can be little doubt that he was familiar with the work of de Hoogh. Despite the great care and skill with which van der Heyden presents the detail of his subjects, and though he probably used a form of camera obscura with which, like Vermeer, he could study a projected image of a motif on a small screen, most of his pictures are inventions. Even when he is representing a particular building or group of buildings, he was capable of considerable deviation from the facts. Here, the Great Church of Veere, in Zeeland, is a striking feature.

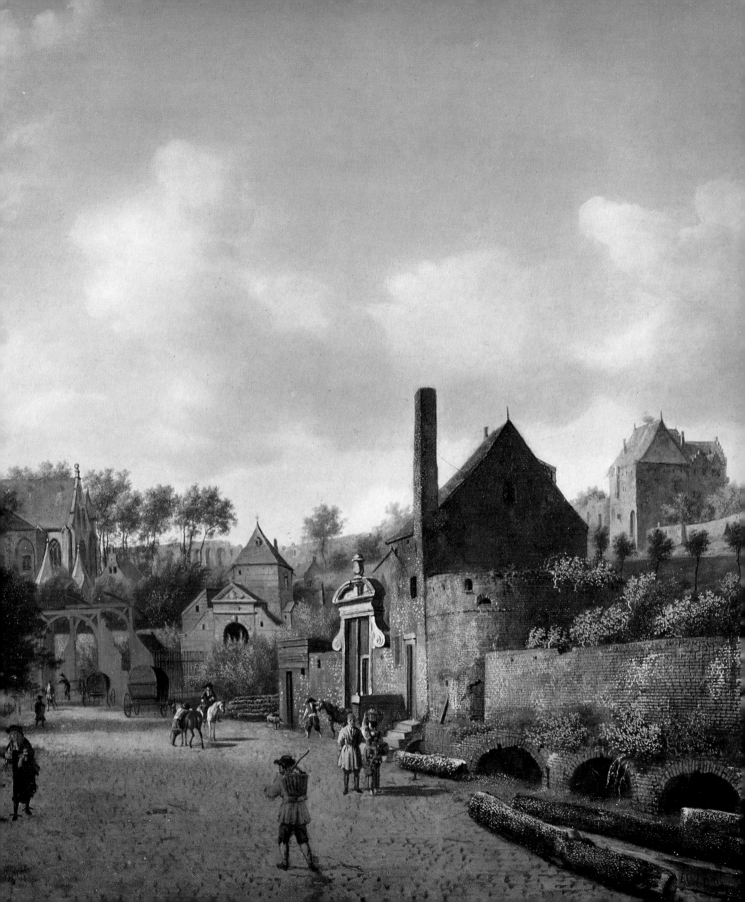

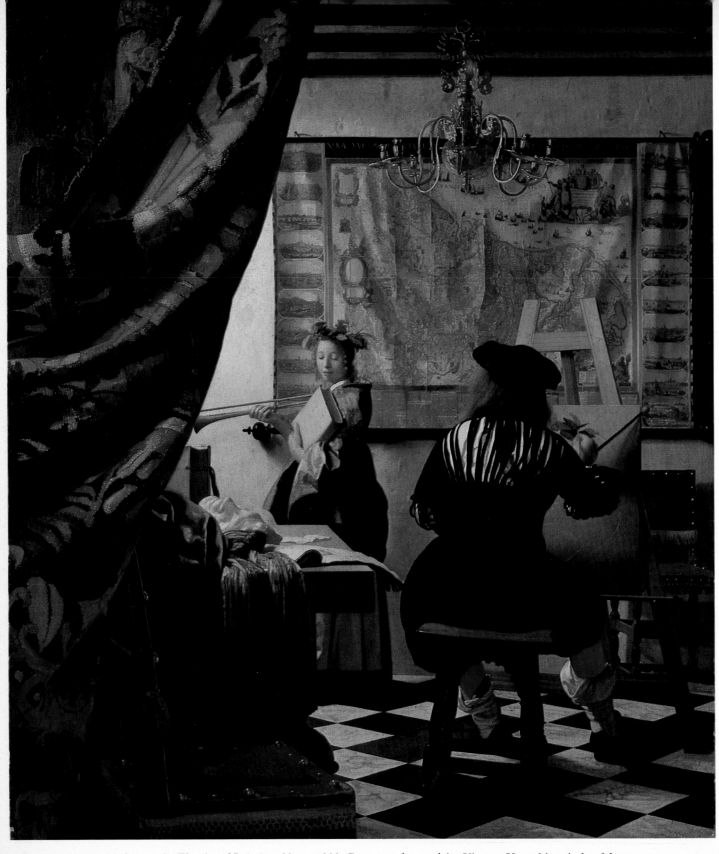

103. VERMEER (1632—75): *The Art of Painting*. About 1666. Canvas, 51¼ × 43¾ in. Vienna, Kunsthistorisches Museum

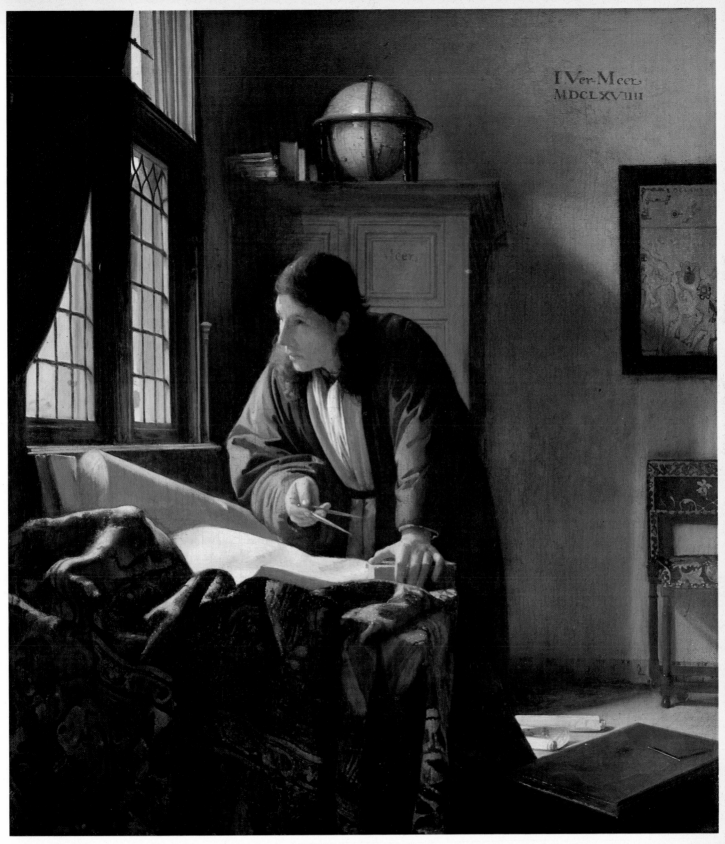

104. VERMEER: *The Geographer*. 1669. Canvas, $20\frac{7}{8} \times 18\frac{1}{4}$ in. Frankfurt, Städelsches Kunstinstitut

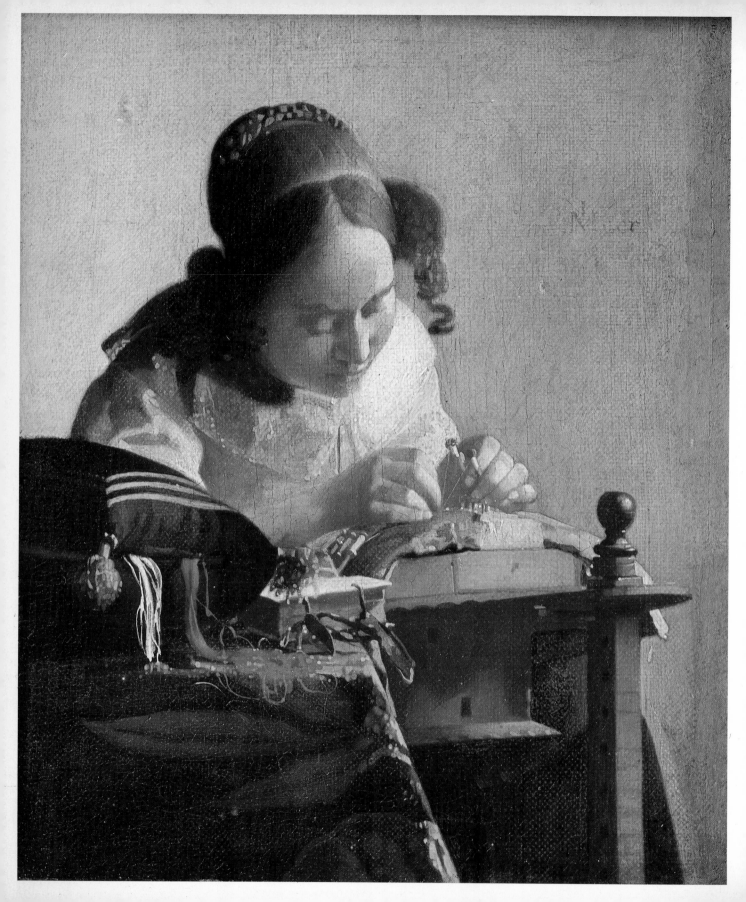

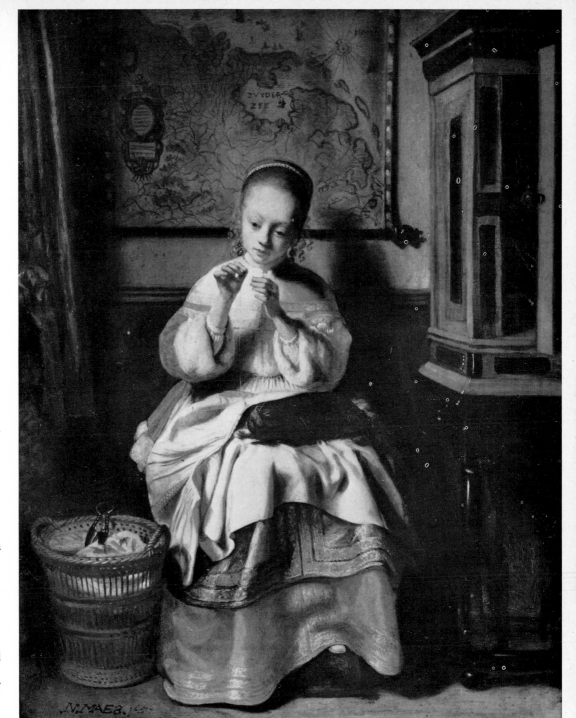

105 (*opposite*).
VERMEER (1632—75):
The Lace-Maker. About 1665.
Canvas, $9\frac{1}{2} \times 8\frac{1}{4}$ in. Paris,
Louvre

There can be few pictures
which reveal so little of the
physical structure of their
subjects as this. Vermeer
includes in this simple scene a
mass of objects, each with its
distinctive form and texture,
but he makes no attempt to
display them distinctly or to
discriminate those textures.
Out of juxtapositions of
abstract patches of colour and
tone, the spectator must
elaborate an intimate scene of
great delicacy and domestic
beauty.

106. NICOLAES MAES (1634—93): *Girl threading her Needle*. About 1655. Panel, $16 \times 12\frac{1}{2}$ in.
Mertoun House, Berwickshire, Duke of Sutherland

Maes, who was taught by Rembrandt, began painting small domestic interiors about 1654.
There seems to be a connection between his work and that of the Delft school, though Maes
was working in Dordrecht between 1654 and 1673, the very years in which this type of small
painting was being developed. Maes's work deteriorated as he crudely exaggerated certain
mannerisms he discovered in Rembrandt's art.

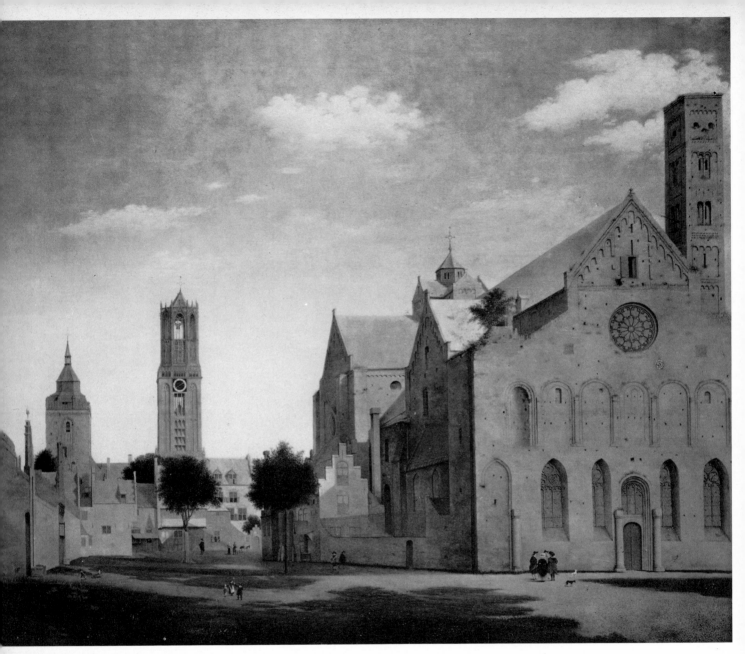

107. PIETER SAENREDAM (1597—1665): *The Mariaplaats with the Mariakerk, Utrecht.* 1663. Panel,
43½ × 54¾ in. Rotterdam, Museum Boymans—van Beuningen

Saenredam visited Utrecht once, in the summer of 1636, but from the drawings he made then he continued to work for the rest of his life. The painting above, showing the exterior of the Mariakerk, is one of the very few paintings of open-air subjects by Saenredam. It was made after a drawing dated twenty-seven years earlier— 18 September 1636. The painting opposite is closely based on the right half of a drawing dated 16 August 1636, now in the municipal archives in Utrecht. (There is also a painting based on the left side of that same drawing and dated 1645.) As he often did, Saenredam has modified the perspective construction to increase the sense of height. The odd drawing on the column shows the four sons of Aymon on the magic horse, Bayard, from a thirteenth-century legend still popular in Saenredam's day.

108. PIETER SAENREDAM: *The Interior of the Buurkerk, Utrecht.* Detail. 1644. Panel. London, National Gallery

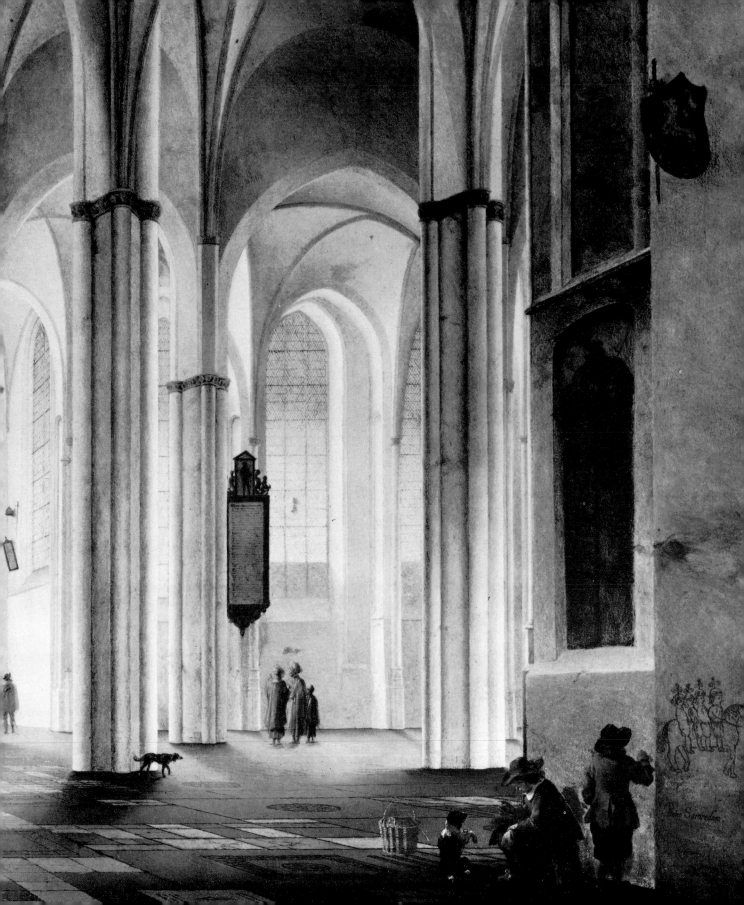

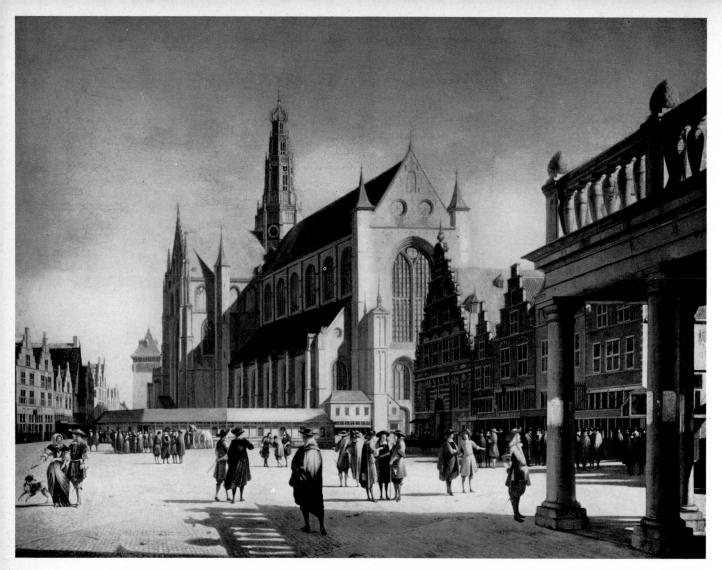

109. GERRIT BERCKHEYDE (1638—98): *The Market Place and the Grote Kerk, Haarlem.* 1674. Canvas, 20⅜ × 26⅜ in. London, National Gallery

Gerrit Berckheyde, in Haarlem, like Jan van der Heyden in Amsterdam (Plate 102), specialized in townscapes and, like him, must have learned from the painters of Delft (see Plates 119–121). But he also owed a debt of inspiration to the Haarlem painter Pieter Saenredam. Although Saenredam painted few exteriors, he did draw the Market Place of Haarlem and an engraving after his design was published in 1628 in Samuel Ampzing's history of Haarlem. Berckheyde takes a different view from Saenredam in these canvases, but this is because he is seeking elegant variations on his single theme. In a canvas of 1671, still in Haarlem (now in the Frans Hals Museum, a variant being in the National Gallery, London), he took a view based very closely on Saenredam's design. To paint the canvas illustrated above, he walked across the square and looked in the opposite direction; for the Fitzwilliam panel (opposite), he took a few paces to the right to look out from the Town Hall portico. Berckheyde was also indebted to Saenredam for this development of variations on a single theme.

110. GERRIT BERCKHEYDE: *The Market Place and the Grote Kerk, Haarlem.* Detail. 1674. Panel. Cambridge, Fitzwilliam Museum

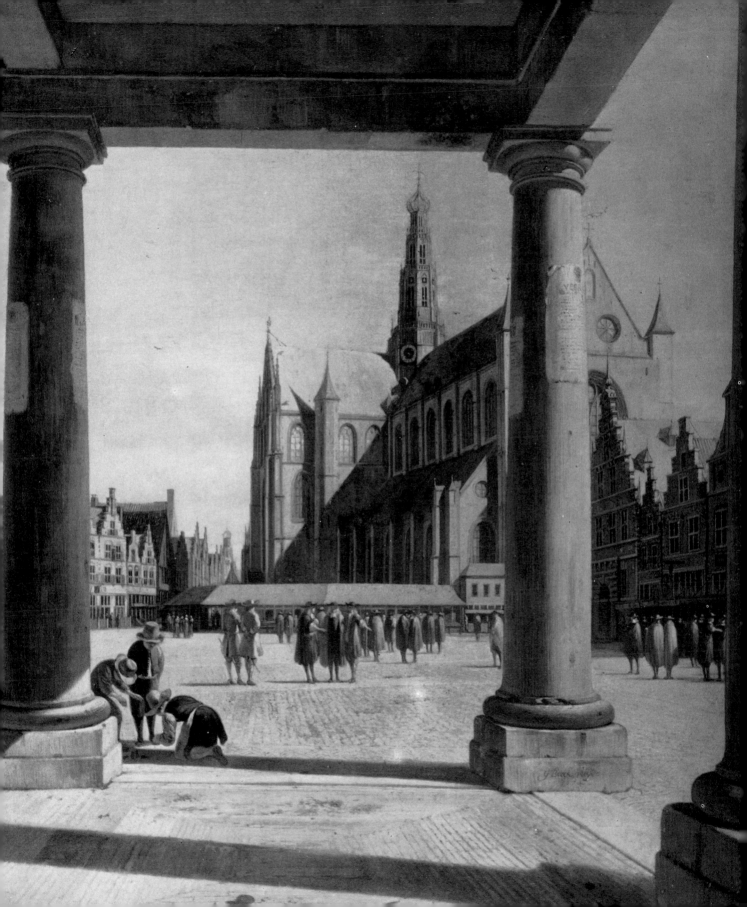

111. GERRIT BERCKHEYDE (1638—98): *View of Haarlem from the River Spaarne.* 1667. Panel, $17\frac{3}{8} \times 20\frac{7}{8}$ in.
 Douai, Musée de Douai

Berckheyde appears to have set out to do for the exterior of the Great Church of St Bavo what Saenredam did
for its interior (Plates 14, 15). In each of these three paintings (see also Plates 109 and 110) he has discovered
a new view of the famous bell-tower. Of these and the other views he painted, this is perhaps the finest. The
curious structure on the quay is a mobile crane for handling cargo.

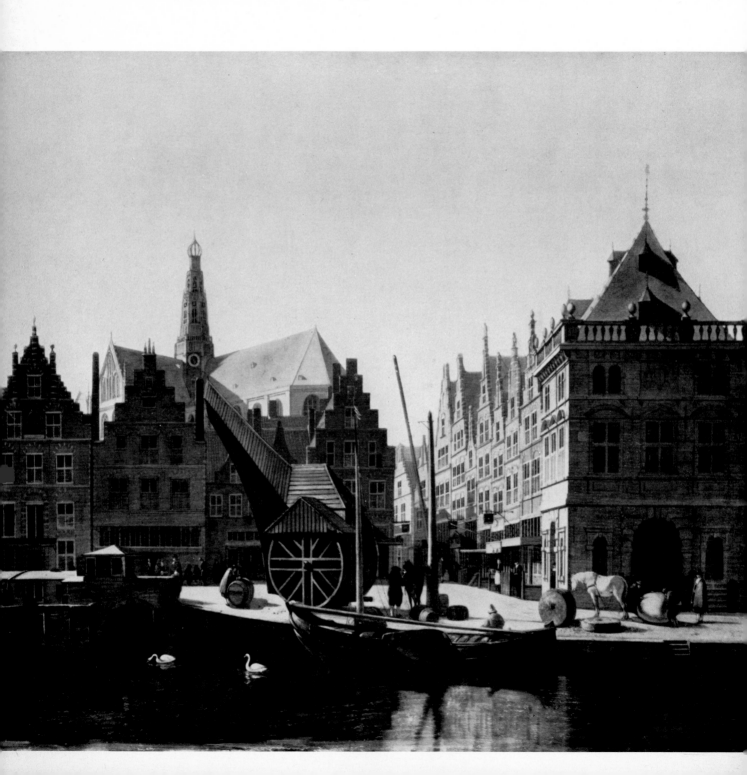

112. AELBERT CUYP (1620—91): *The Avenue at Meerdervoort, Dordrecht*. About 1660—5. Canvas, 28¼ × 39⅜ in.
London, Wallace Collection

Inevitably, but rather unfairly, this charming work has been neglected for the better-known *Avenue* by
Meyndert Hobbema, in the National Gallery, London. The painting reproduced above is not typical of
Cuyp. The bold perspective offered by the parallel lines of trees did not have much appeal for the Dutch
painters of the time: both here and in the case of Hobbema's *Avenue, Middelharnis*, the demands of topo-
graphical accuracy may have directed the artist's choice of viewpoint. Unlike Hobbema, Cuyp did not risk
showing the road receding to the horizon uninterrupted, and has carefully blocked it with as many obstacles
as possible. On the horizon, to the right, is the Grote Kerk of Dordrecht, also to be seen in the view of the
Maas at Dordrecht (Plate 97), and in many of Cuyp's other canvases.

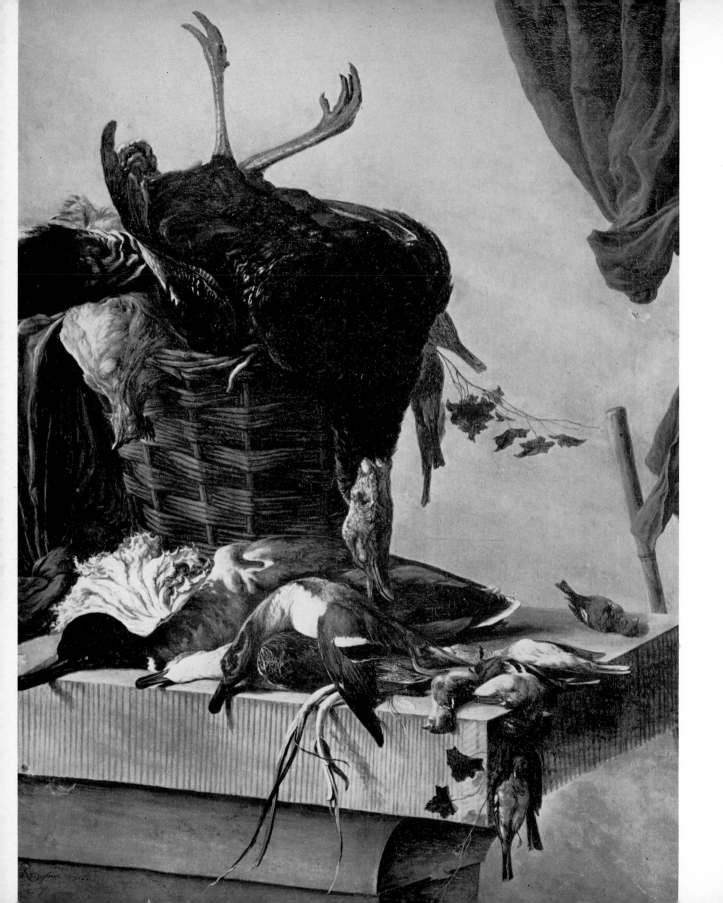

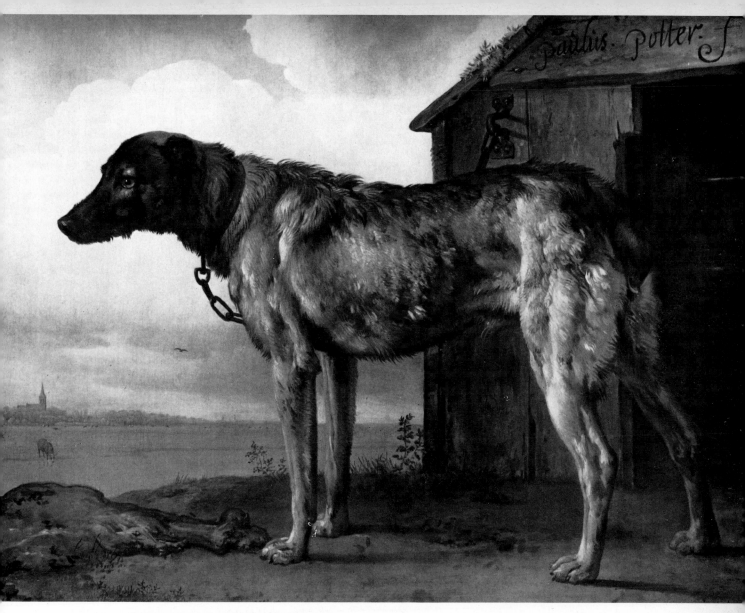

114. PAULUS POTTER (1625—54): *Wolfhound*. Canvas, 38½ × 52½ in. Leningrad, Hermitage

Although an artist of limited talents and sensibility, Potter painted one great canvas which has become known throughout the world, the *Young Bull*, of 1647, now in the Mauritshuis, The Hague. This painting of a *Wolfhound*, though smaller and less well known, is a work of a very similar kind. The animal, painted large but not quite life-size, is placed in profile in the foreground. The low viewpoint provides a clear outline against the sky and allows a small and almost separate landscape in one corner. But whereas the landscape in the *Young Bull* is itself interesting and also, by showing a herd of cows, appropriate, here it is no more than a compositional device.

113 (*opposite*). SALOMON VAN RUYSDAEL (1600/3—1670): *Still-Life with Turkey*. 1661. Canvas, 44⅛ × 33½ in.
 Paris, Louvre

Usually a landscape artist (Plate 48), Ruysdael reveals another aspect of his talent in this brilliant, late still-life.

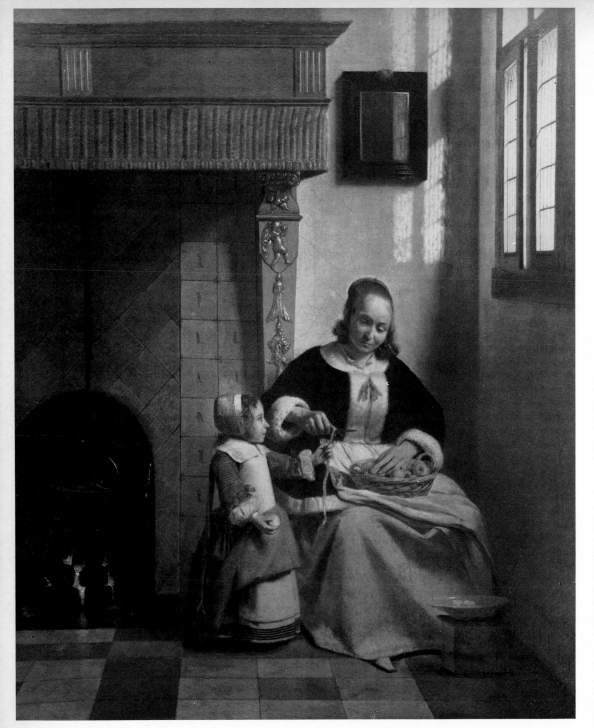

116 (*opposite*). FRANS
VAN MIERIS THE ELDER
(1635—81): *Lady playing
with Lap-Dog*. Panel,
20¼ × 15¾ in. Leningrad,
Hermitage

Immediately recognizing
that here was a seven-
teenth-century Venus at
her toilet—as the mirror,
the jewels, the lap-dog
and the maidservant all
indicated—a contempor-
ary must have responded
with heightened aware-
ness to the sensuous
warmth with which the
sun flooded the bedroom.
Wondering at the lady's
playfulness, he might
have looked for a cause,
such as a lover's letter.

115. PIETER DE HOOGH (1629—after 1684): *A Woman peeling Apples*. About 1663. Canvas,
27¾ × 21⅜ in. London, Wallace Collection

Unlike most painters of contemporary life, de Hoogh celebrated the quiet virtues of domestic
trivia. He frequently treated the theme of Mother and Child engaged in some unimportant
activity. In this picture, his composition is unusually simple, being entirely without those
views through doors and windows in which he delighted (see Plate 122). In its concentration
on the play of light over surfaces in a limited space, it recalls Vermeer, to whom, though, the
careful discrimination of textures and contours is totally alien.

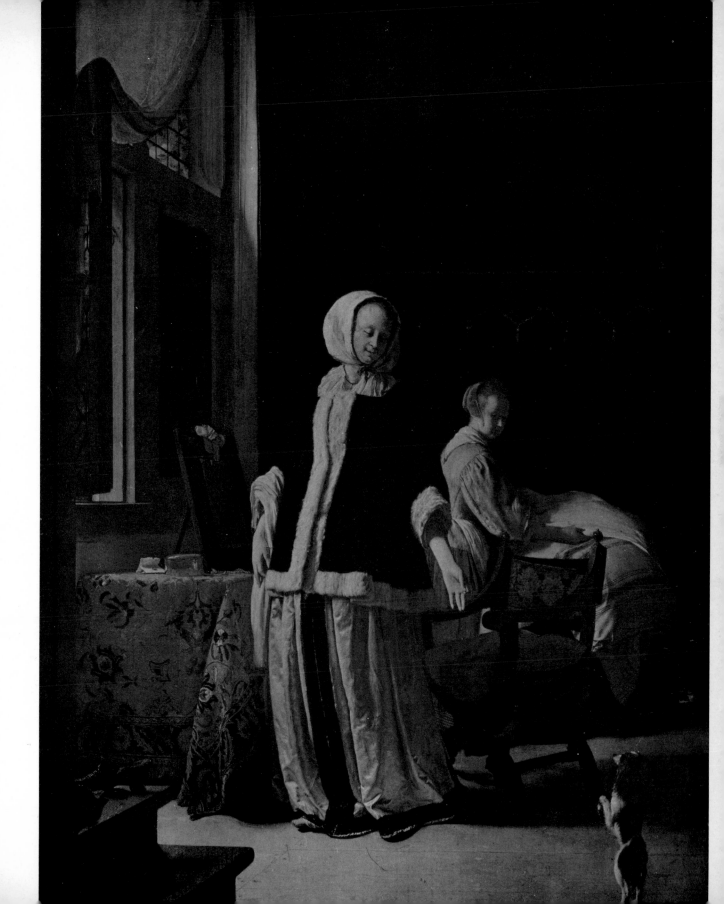

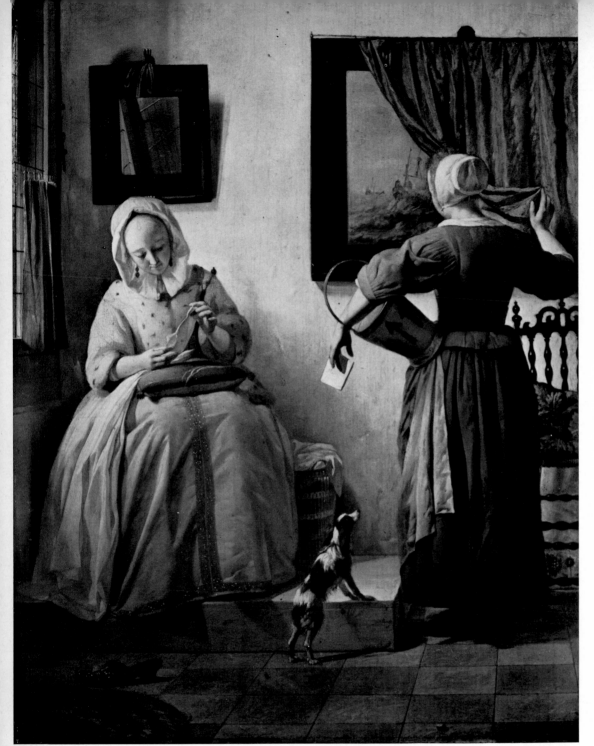

118 (*opposite*).
VERMEER (1632—75):
The Love Letter. About
1670. Canvas, $17\frac{1}{4} \times 15\frac{1}{4}$
in. Amsterdam, Rijks-
museum

Another letter, another
marine painting on the
wall: a letter from one
tossed on the sea of
Love. The lute is a
common indication of
love and affection, and
slippers are frequently
shown to mark the
presence of sexual
passion.

117. GABRIEL METSU (1629—67): *The Letter-Reader*. About 1662—5. Panel, $20\frac{1}{2} \times 16$ in.
 Blessington, Ireland, Sir Alfred Beit, Bt.

Marine paintings appear with surprising frequency in rooms in which letters are read, and
letters are read in a remarkable number of paintings of this period—two enigmas that held no
secrets from contemporary viewers. That the painting is curtained and that painting and
mirror are in identical ebony frames are two further intriguing features of this fine work.
See also Plate 98 and note.

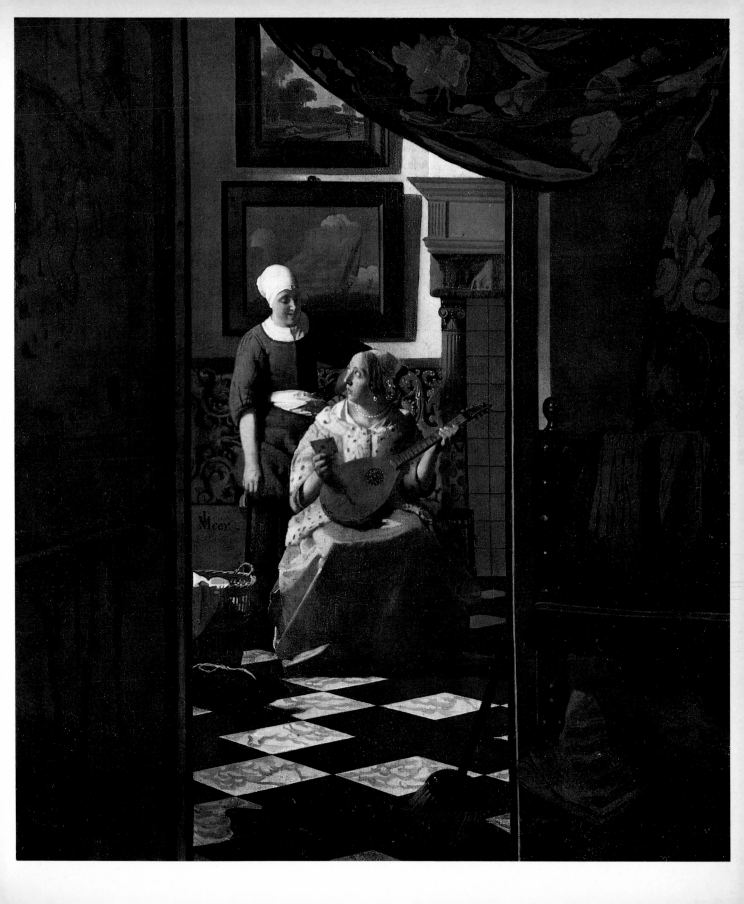

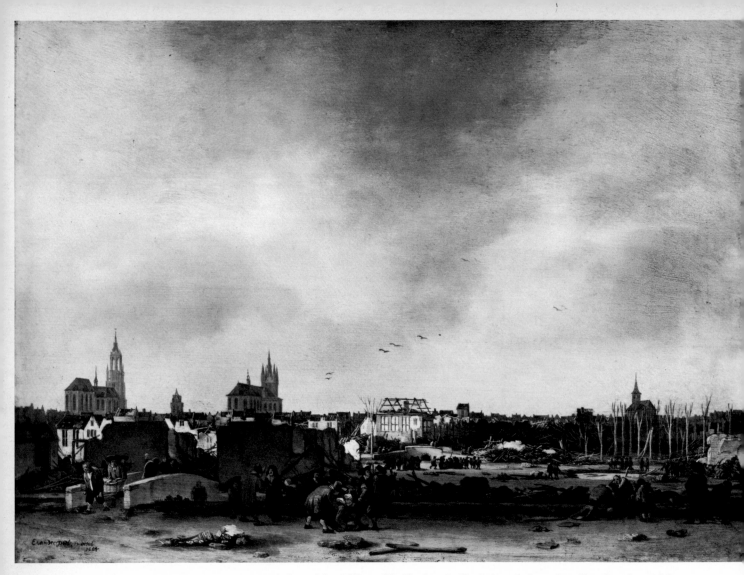

119. EGBERT VAN DER POEL (1621–64): *A View of Delft after the Explosion of 1654.* 1654. Panel, $14\frac{1}{4} \times 19\frac{1}{2}$ in.
 London, National Gallery

On Monday, 12 October 1654, at 10.30 a.m., a powder magazine in Delft blew up. A large part of the town was completely destroyed, and much of the rest of it was damaged. The terrible disaster left a deep impression on the people of Delft and the area of complete devastation was never rebuilt. It also led van der Poel and Vosmaer to produce a great many paintings of the disaster, some of them long after the event. But the loss to art was greater than the gain, for one of the many killed in the explosion (and the exact number was never known) was the painter Carel Fabritius, at the age of thirty-two. Fabritius, who had been one of the most gifted of Rembrandt's pupils, had moved to Delft some time before 1650. Little of his work has survived, but it seems that he made his impression on the painters of Delft with his illusionistic pictures such as this *View of Delft* (Plate 120), which, judging by its extreme perspective, was intended to be viewed through a peep-hole in a perspective box.

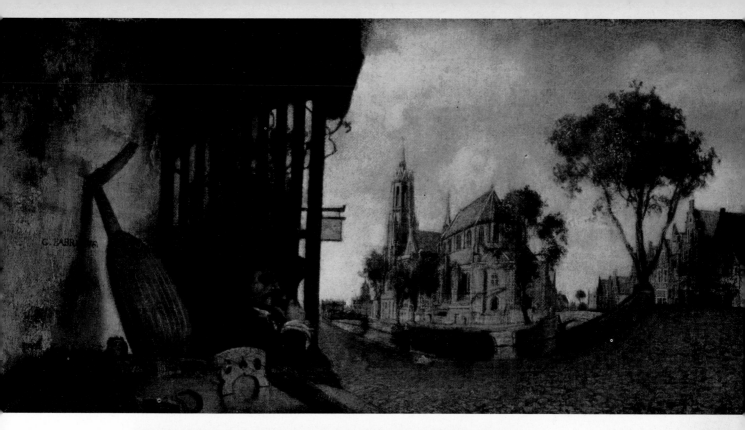

120.
CAREL FABRITIUS
(1622—54): *A View in Delft, with a Musical Instrument Seller's Stall.* 1652. Canvas, 6 × 12½ in. London, National Gallery

121.
DANIEL VOSMAER
(second half of the 17th century): *View of Delft.* 1665. Canvas, 35½ × 44½ in. Delft, Stedelijk Museum 'Het Prinsenhof'

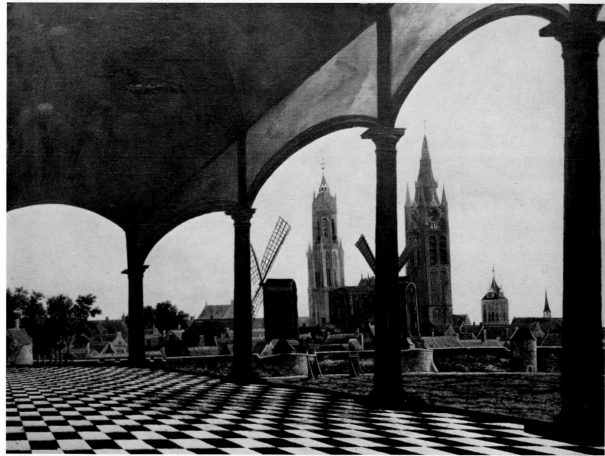

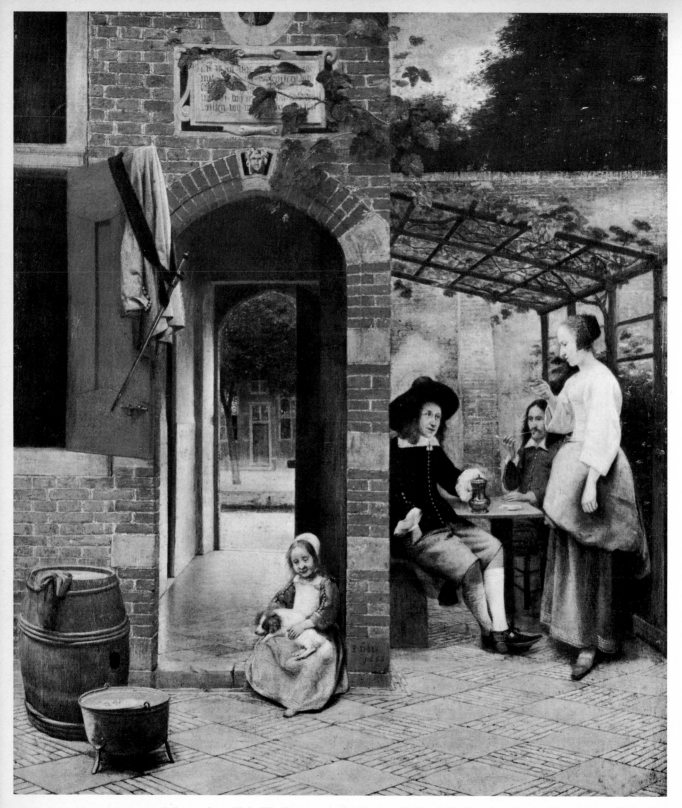

122. PIETER DE HOOGH (1629—after 1684): *The Courtyard of a House in Delft*. 1658. Canvas, 26⅛ × 22¼ in. Private Collection (on loan to the National Gallery of Scotland, Edinburgh)

123 (*opposite*). VERMEER (1632—75): *The Little Street in Delft*. About 1659. Canvas, 21⅜ × 17¼ in. Amsterdam, Rijksmuseum

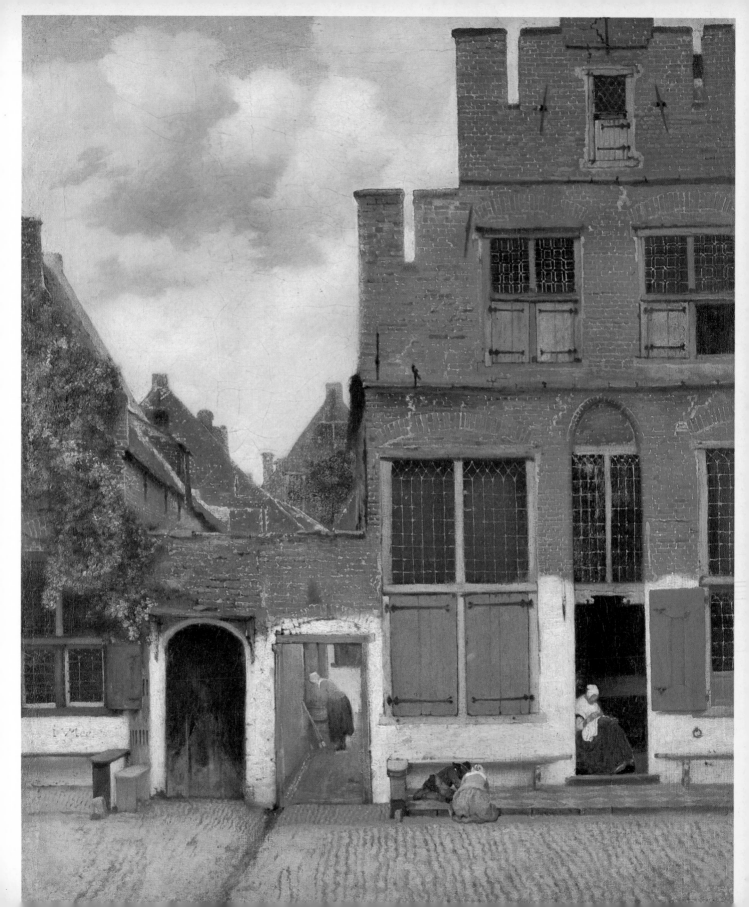

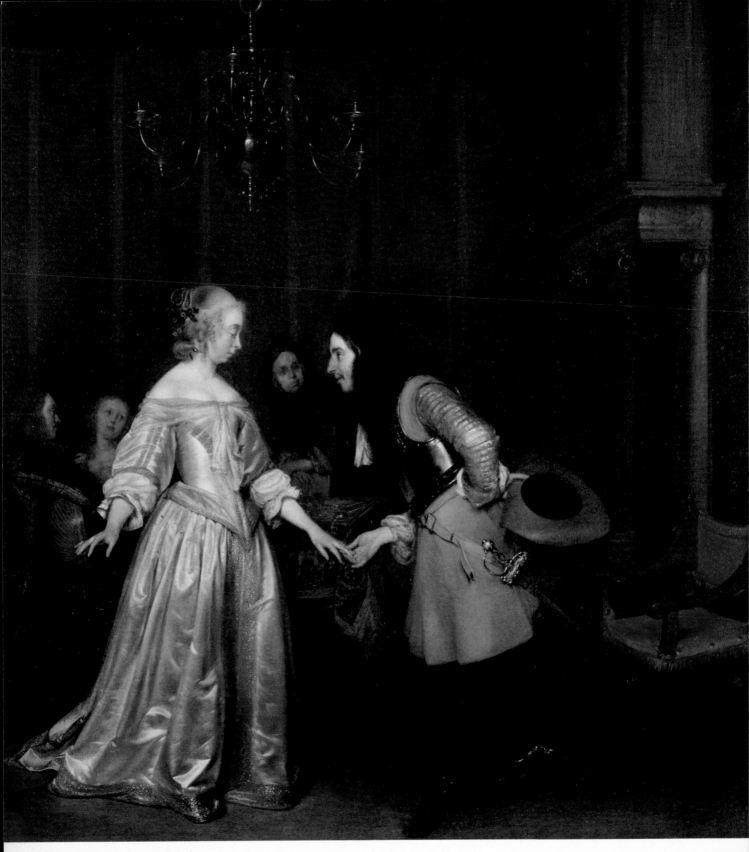

124. GERARD TER BORCH (1617—81): *The Introduction*. About 1662. Canvas, 30×26¾ in. Polesden Lacey (Surrey), The National Trust

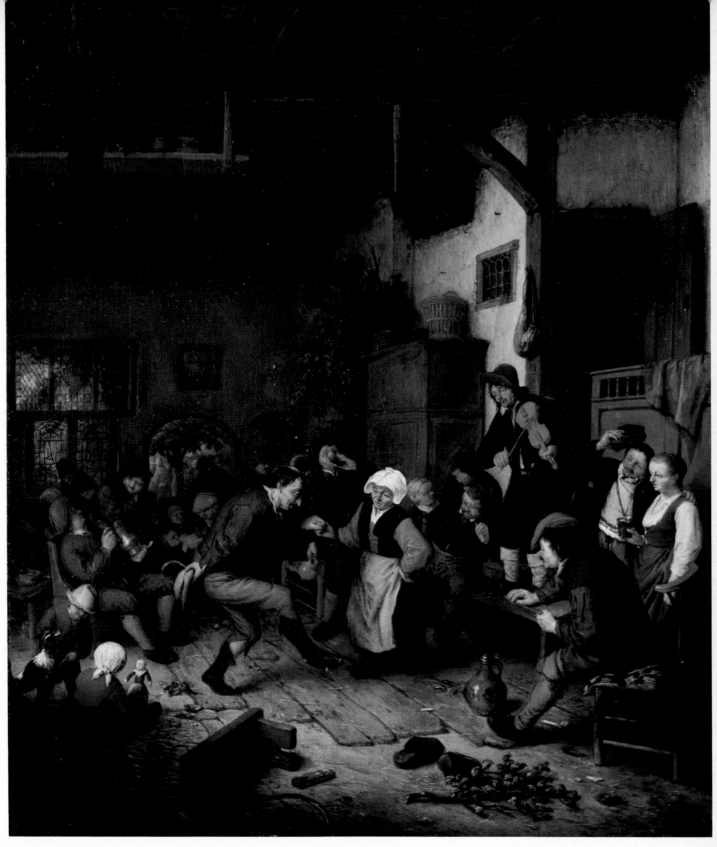

125. ADRIAEN VAN OSTADE (1610—85): *The Golden Wedding*. 1674. Panel, 17½ × 15⅝ in. Chicago, Art Institute of Chicago

126. MEYNDERT HOBBEMA (1638—1709): *Road on a Dyke*. 1663. Canvas, $36\frac{1}{2} \times 50\frac{1}{2}$ in. Blessington, Ireland, Sir Alfred Beit, Bt.

Hobbema typifies the central paradox of much of seventeenth-century Dutch painting. His paintings are repetitive, even monotonous, when seen in quantity; he may have even been bored with painting them himself, for, after he obtained a sinecure as a wine-gauger in 1668, he appears to have painted little for thirty years. Yet almost every single painting reveals him as a major master, one of the half-dozen outstanding Dutch painters of his century. Like his teacher, Ruisdael (see Plates 143 and 144), he was a superb inventor of compositions. Ruisdael had much the wider range of skills, but in their best works both depend on subtlety and variation within the framework of a familiar and even conventional compositional schema. Unlike Ruisdael, Hobbema used his brush with the skills of a virtuoso draughtsman: where the older man usually dabbed his paint on in heavy lumps, his pupil flicked it into its precise place with a rhythmical force which recalls the painters of Haarlem and the tradition derived from Elsheimer.

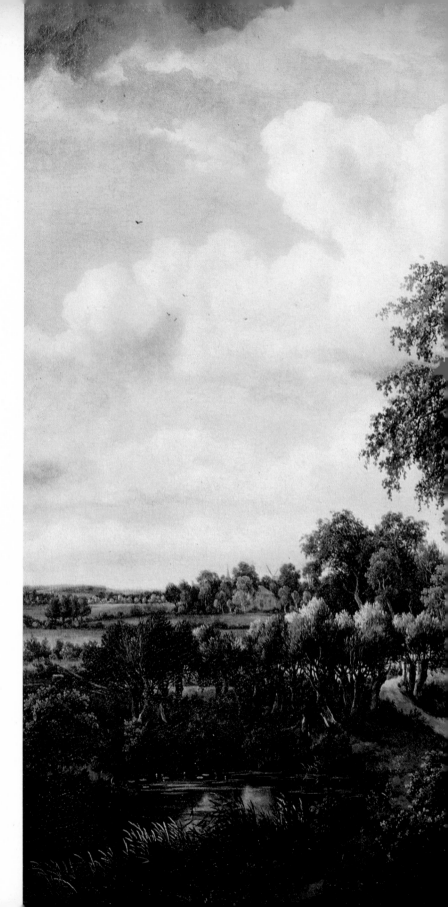

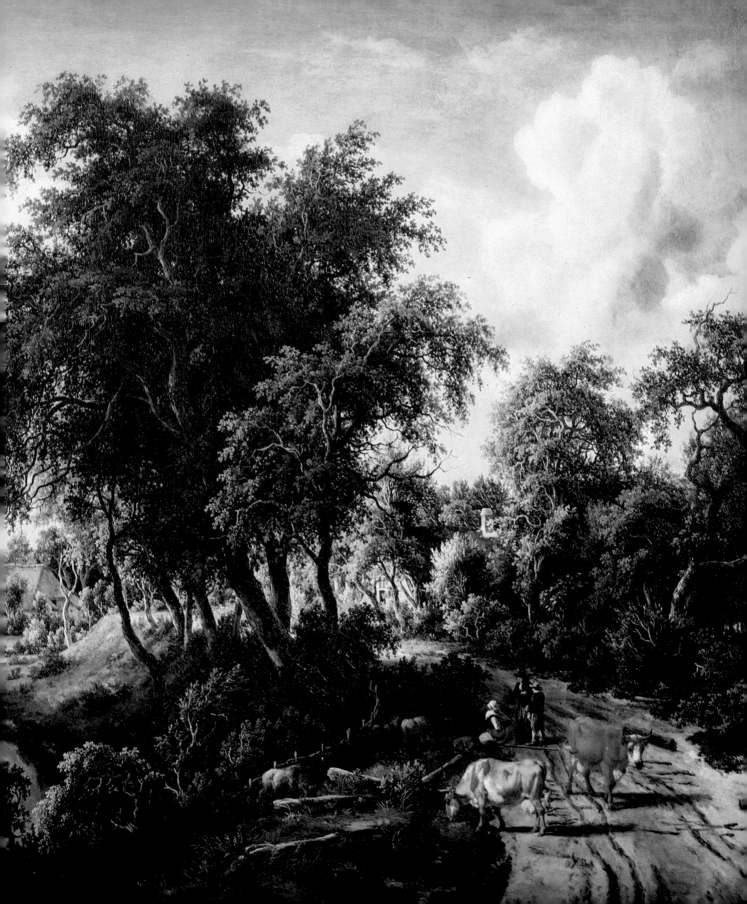

127. VERMEER (1632—75): *The Music Lesson.* Detail. About 1662. London, Royal Collection (reproduced by gracious permission of Her Majesty The Queen)

Reflected in the mirror, above and behind the musician's head, is the edge of that table we can see in the foreground, and, above that, an indistinct object which is the foot of the painter's easel.

128. (*opposite*) JAN STEEN (1625/6—1679): *The Morning Toilet.* 1663. Panel, $25\frac{7}{8} \times 20\frac{7}{8}$ in. London, Royal Collection (reproduced by gracious permission of Her Majesty The Queen)

As in Plate 130, Steen uses still-life and accessories to throw light on otherwise commonplace or enigmatic events, here contrasting the attractions of the young woman with the *memento mori* on the threshold. In '*The Physician's Visit*', the pictures on the wall (*Venus and Adonis* and Hals's *Peeckelhaering* (see Plate 22)), the old husband in the distance, the cupid-like boy and the doctor's knowing look—all spell out the woman's sickness.

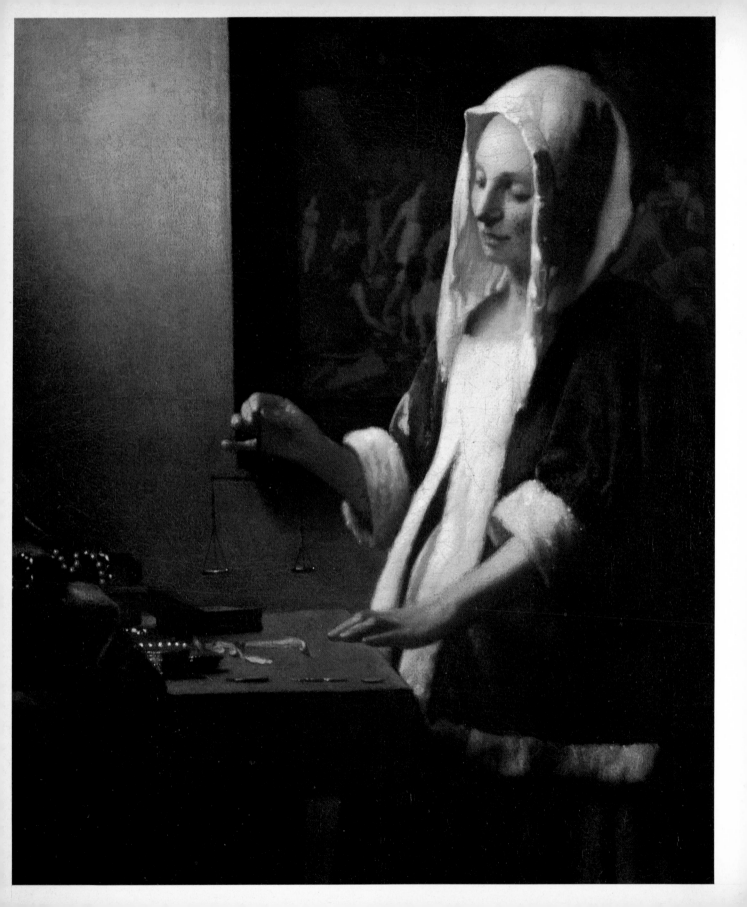

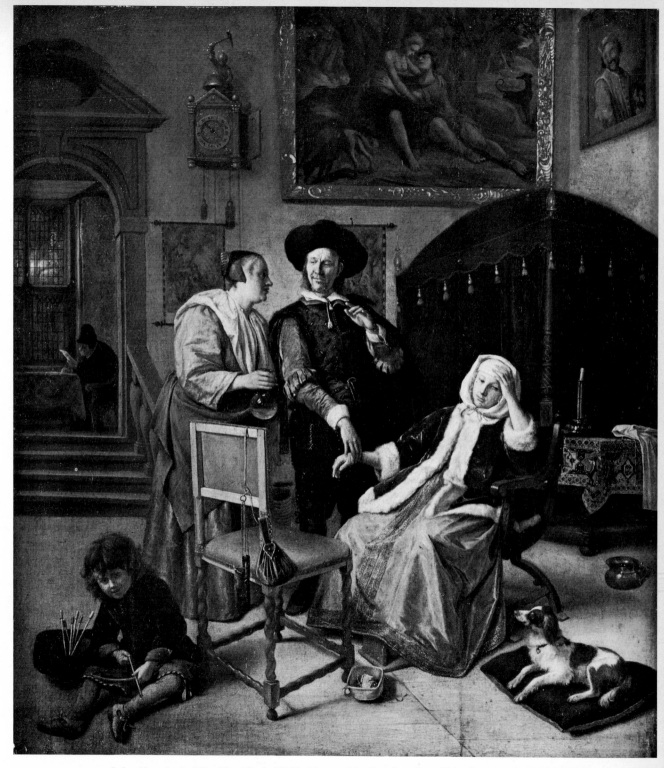

130. JAN STEEN (1625/6—1679): '*The Physician's Visit*'. About 1665. Panel, 19⅛ × 16½ in. London, Wellington Museum (Apsley House). See also notes to Plates 22 and 128

129 (*opposite*). VERMEER : (1632—75): *Lady weighing Gold*. Detail. About 1665. Canvas. Washington, D.C., National Gallery of Art (Widener Collection)

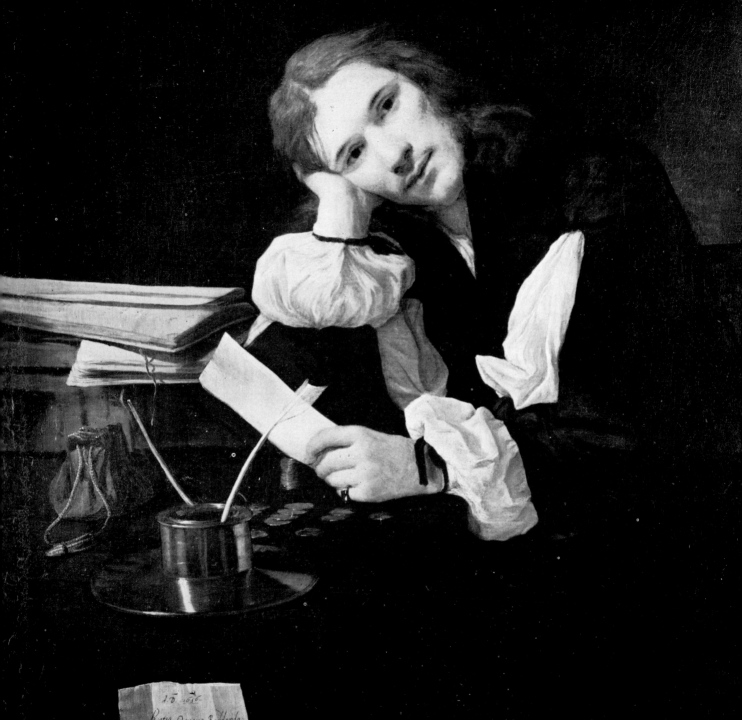

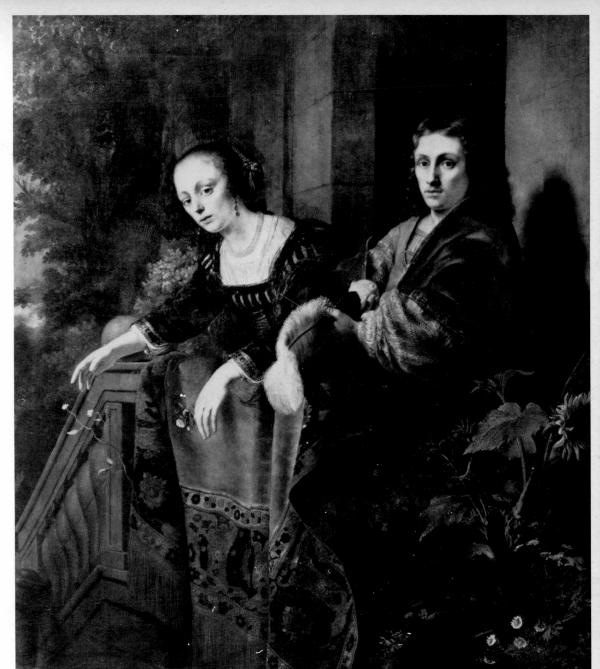

131.
MICHIEL SWEERTS
(1624—64): *Portrait
of an honest Man*.
Detail. 1656. Canvas.
Leningrad, Hermitage

That the sitter con-
sidered himself to be
honest is indicated by
the coins on the table
and the motto in-
scribed on the sheet of
paper: 'To each what
is owing to him.'

132. FERDINAND BOL (1616—80): *Ferdinand Bol and his Wife, Elisabeth Dell*. 1654. Canvas, $80\frac{3}{4} \times 70\frac{7}{8}$ in. Paris, Louvre

Few of Rembrandt's pupils were able to extract from his highly personal style a technique that they could adapt to their own temperament. Pupils of his later years often reacted against his art after they left his shadow. Bol was one of the exceptions. A skilled and successful portrait-painter, he perfected a style which combined the material tangibility of Rembrandt's painting of the early 1640s (see Plate 58) and something of the elegance that had become desirable since the success of van Dyck. This double portrait is a fine example of Bol's painting at its best.

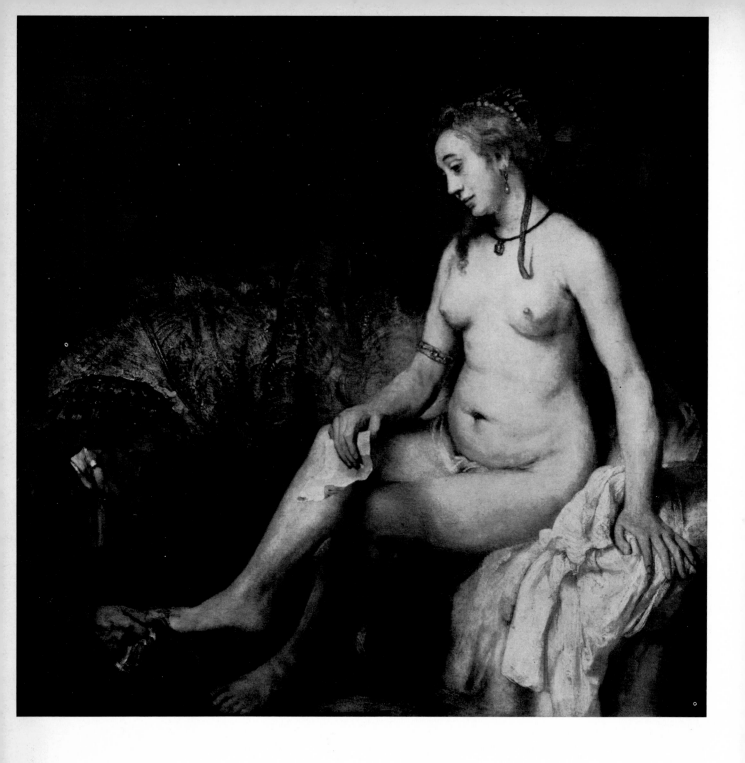

133, 134. REMBRANDT (1606—69): *Bathsheba with King David's Letter*. 1654. Canvas, 56 × 56 in. Paris, Louvre

When King David accidentally saw Bathsheba, the wife of one of his soldiers, bathing, he sent a letter summoning her to his bed. (The story is told in the second book of Samuel, chapters 11 and 12.)

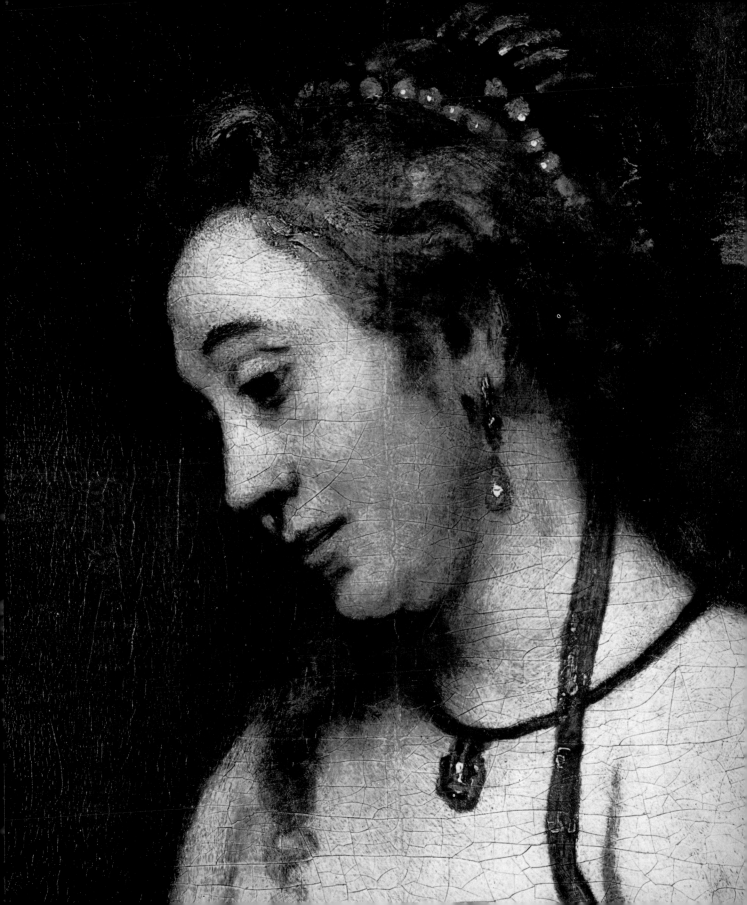

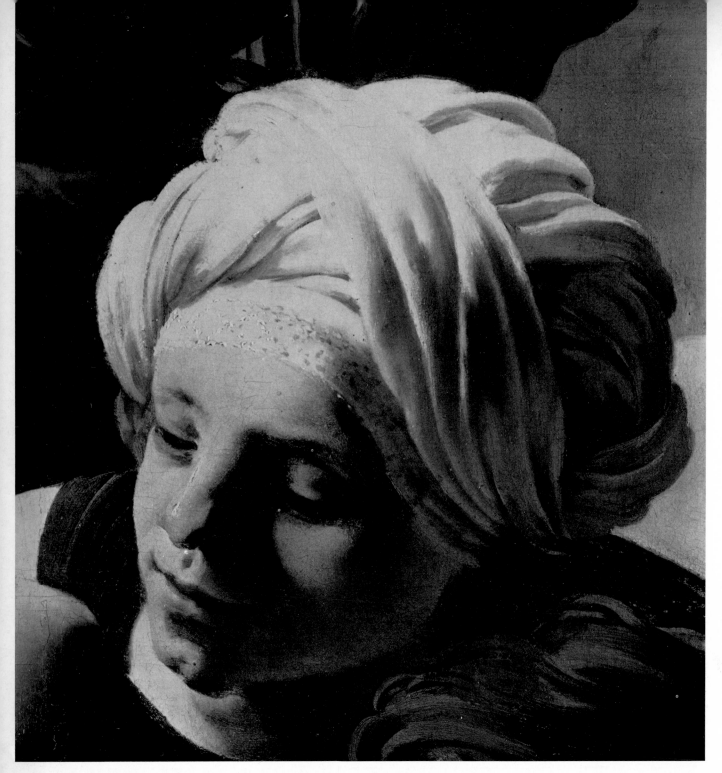

135. HENDRICK TER BRUGGHEN (1588?–1629): *St Irene*. Detail from Plate 25

A comparison of the head of the Saint by ter Brugghen and that of the model (probably posing as Clio, the muse of history) by Vermeer reveals interesting similarities and differences in the treatment of light and the modelling of forms. Despite the differences, ter Brugghen anticipates Vermeer's achievement more directly than other artists.

136. VERMEER (1632–75): Detail, enlarged, from *The Art of Painting* (Plate 103)

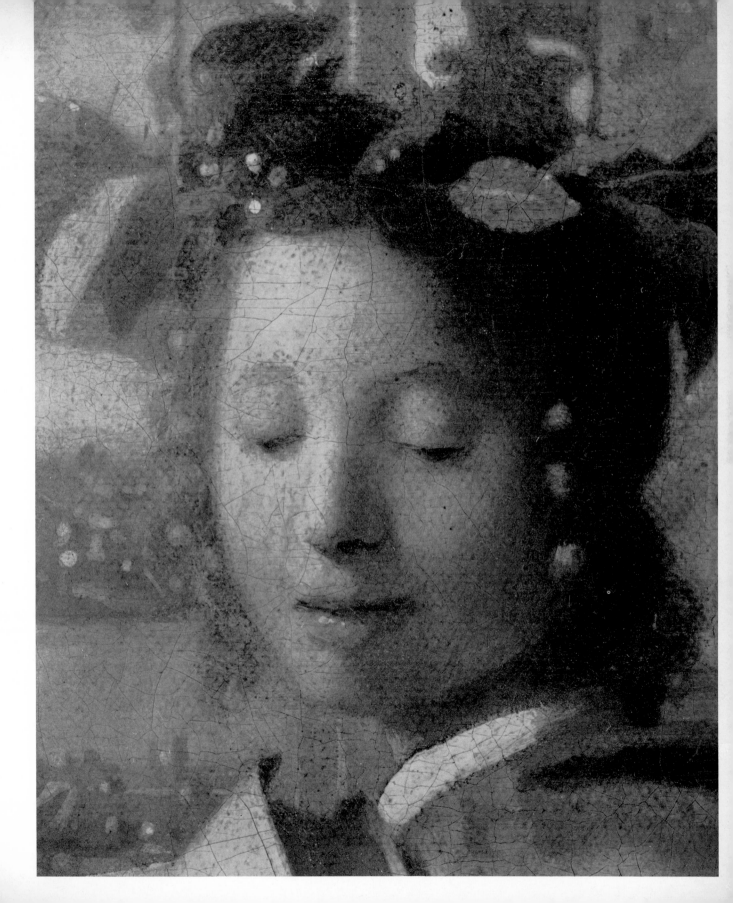

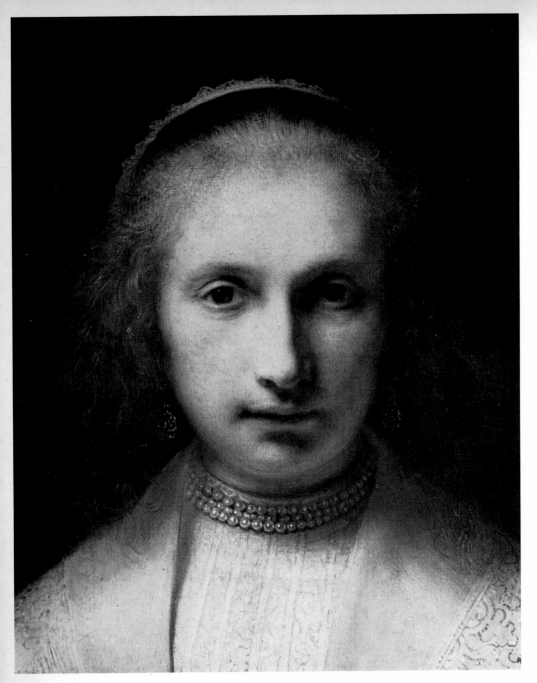

In no other surviving portrait does
Hals combine charm and brilliance
so completely. His sitter is more
appealing than many who commis-
sioned him, but the genius lies in
the subtle balance of formality and
spontaneity with which he captures
her shy, yet warm, personality.

137. REMBRANDT (1606—69): Detail from *Agatha Bas* (Plate 58)

In this commissioned work, Rembrandt was at the height of his powers and he
appears capable of showing the *mind* of his sitter by representing the volume and
textures of his or her *body* with infinite delicacy and subtlety. Note the refinement
with which brow and hair are rendered.

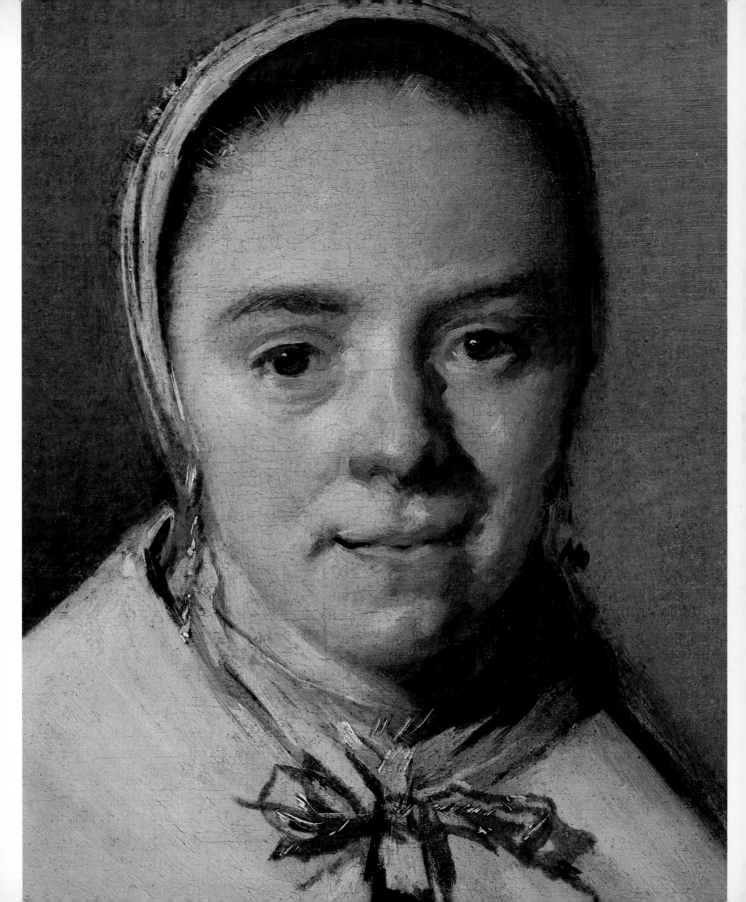

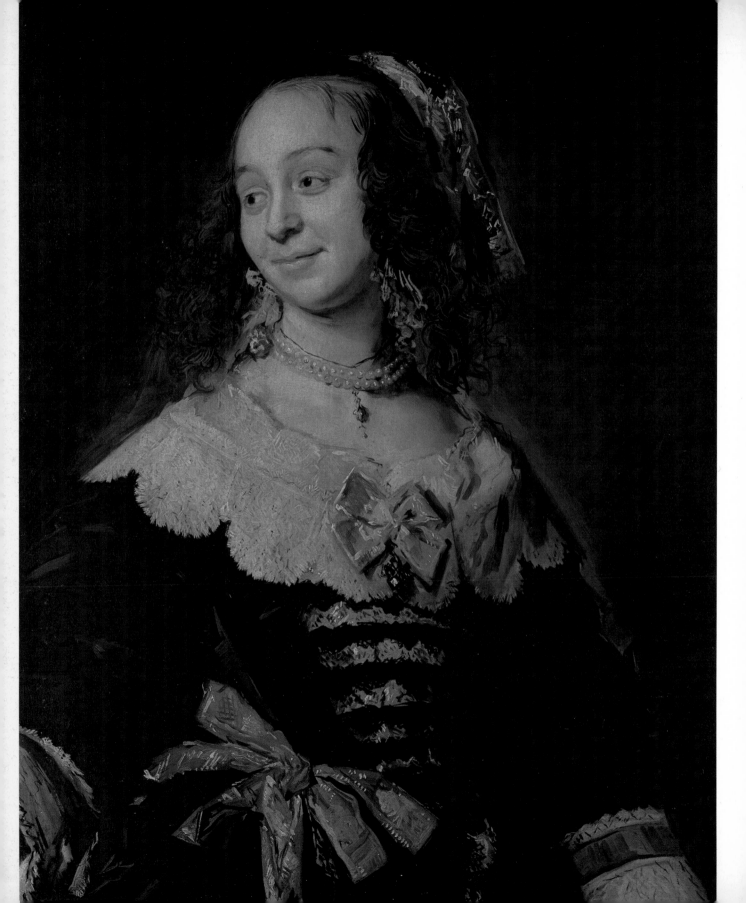

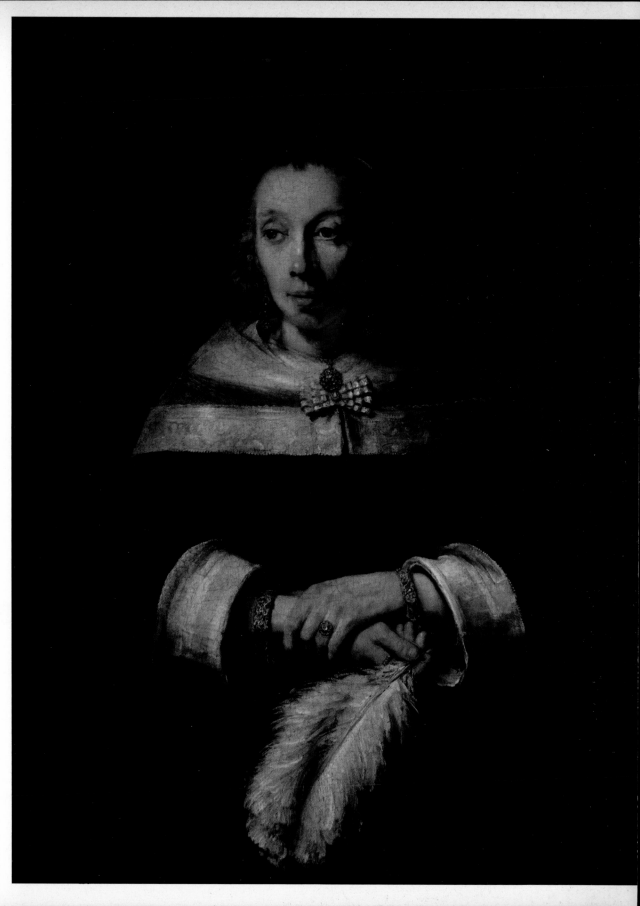

139.
(opposite).
FRANS HALS
(1580?—
1666):
Isabella
Coymans.
Detail.
About
1650—2.
Canvas.
Paris,
Baronne
Edouard de
Rothschild

140.
REMBRANDT
(1606—69):
Portrait of a
Woman
holding an
Ostrich-
Feather Fan.
1665—8.
Canvas,
$38\frac{1}{2} \times 32\frac{1}{4}$ in.
Washington, D.C.,
National
Gallery of Art
(Widener
Collection)

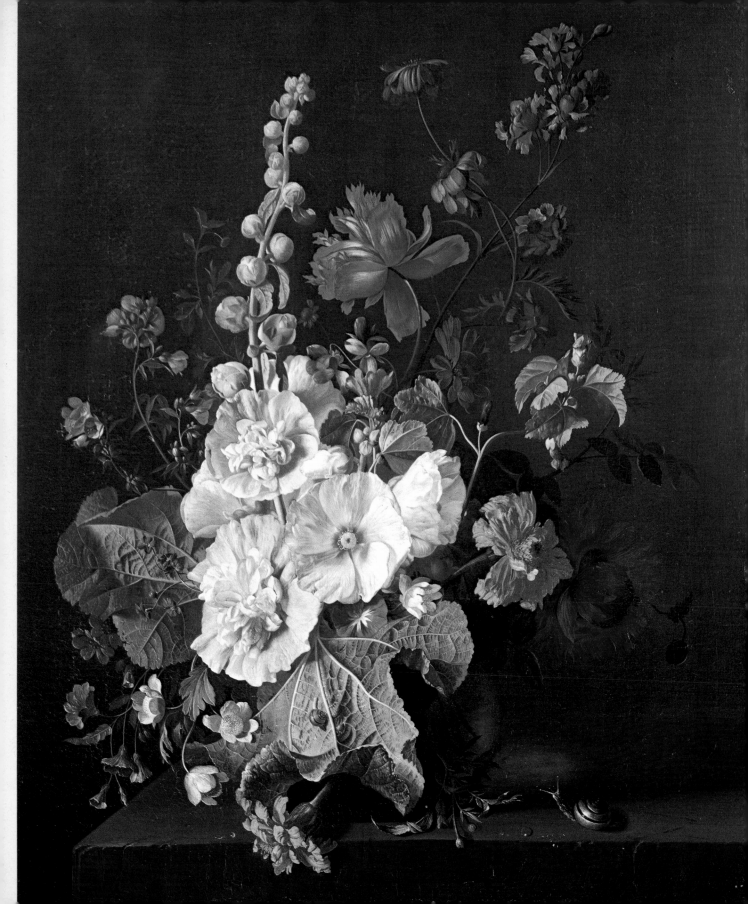

141.
JAN VAN HUIJSUM
(1682—1749):
*Hollyhocks and other
Flowers in a Vase*.
Canvas, 24½ × 20½ in.
London, National
Gallery

According to Neil
MacLaren, this fine
painting is from the
earlier years of the
artist's career, that is,
before the early
1720s, when he began
to paint more elabor-
ate and artificial
pieces with light
backgrounds.

142. GERARD TER BORCH (1617—81): *Portrait of a Man*. About 1665—8. Canvas, 26½ × 21½ in.
Saint-Omer, Musée de l'Hôtel Sandelin

Ter Borch worked on a scale only slightly larger than miniature, but he was one of the three
great Dutch portraitists of his age. His format was simple and almost unvaried, as may be seen
here: a bare room, in shadow, a table on the right, possibly a chair to the left, and the sitter, erect
and aloof, isolated in clear light.

143. JACOB VAN RUISDAEL (1628/9—1682): *Rocky Landscape*. Canvas, 41⅛ × 50 in. London, Wallace Collection

Although Ruisdael did visit Bentheim, over the German border, in 1650, and later produced a splendid version of *Bentheim Castle* (Beit Collection), the inspiration for his many superb rocky landscapes and waterfalls—even the view of Bentheim Castle itself—owes less to personal experience than to the works of Allart van Everdingen, who visited Scandinavia, probably in 1644, and certainly painted rocky landscapes before Ruisdael adopted the motif. Some of Ruisdael's most brilliant, complex and original inventions grew out of these motifs taken from another artist, and this is one of the finest.

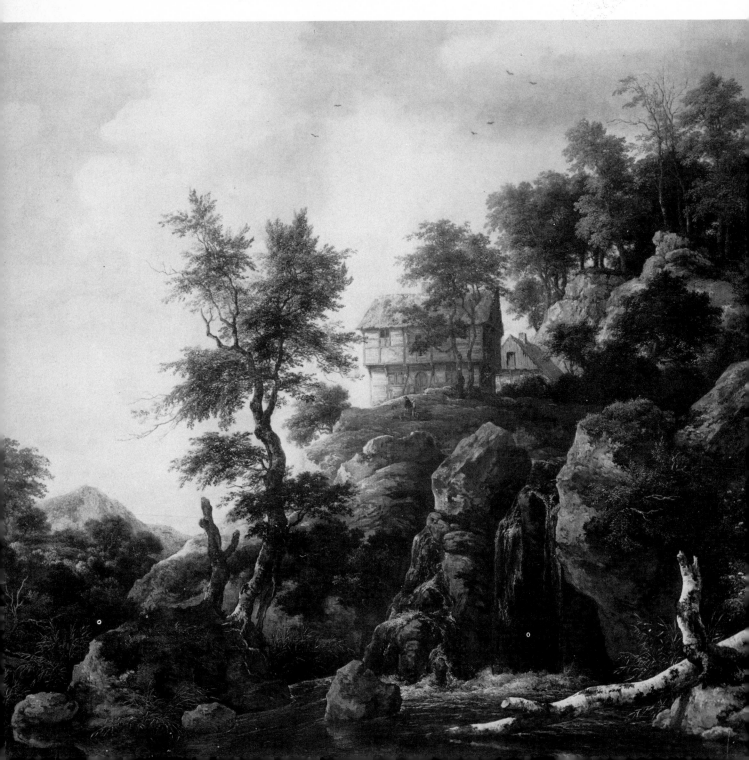

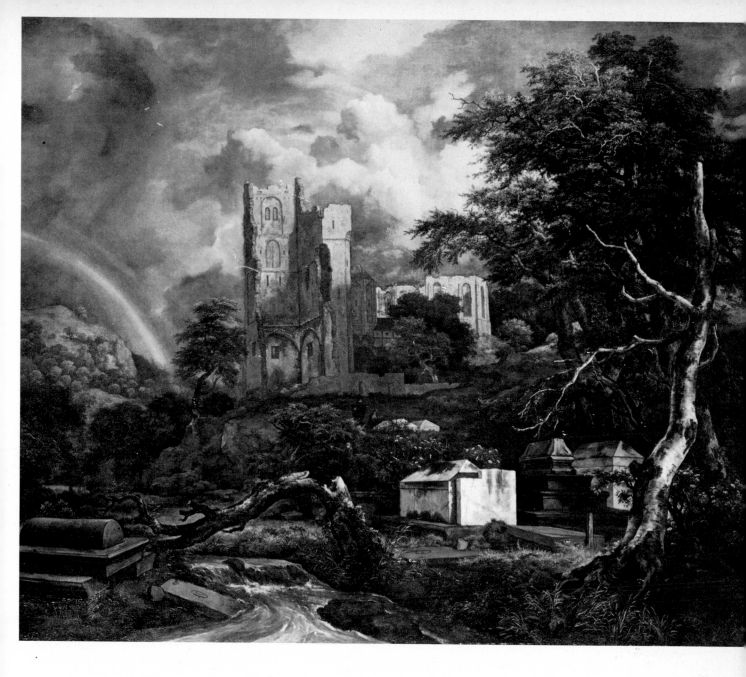

144. JACOB VAN RUISDAEL: *The Cemetery*. Canvas, 56 × 74½ in. Detroit, Detroit Institute of Arts

Ruisdael painted two versions of the Jewish burial-ground at Ouderkerk, near Amsterdam, and they are both magnificent and deservedly famous works. But, as comparison of them (the other is in Dresden) immediately reveals, they cannot both be based equally closely on the original motif. Many details differ slightly, but the principal feature (other than the tombs)—the ruin—is totally different in the two versions. Two drawings by Ruisdael, now in the Teyler Museum, Haarlem, confirm the suspicion that the artist has simply used the tomb architecture as the central element in a profound allegory. Against the evidence of decay, human, architectural (which is to say social and cultural—for it is a Romanesque building), and natural (the dead tree), he has set the promise of the rainbow.

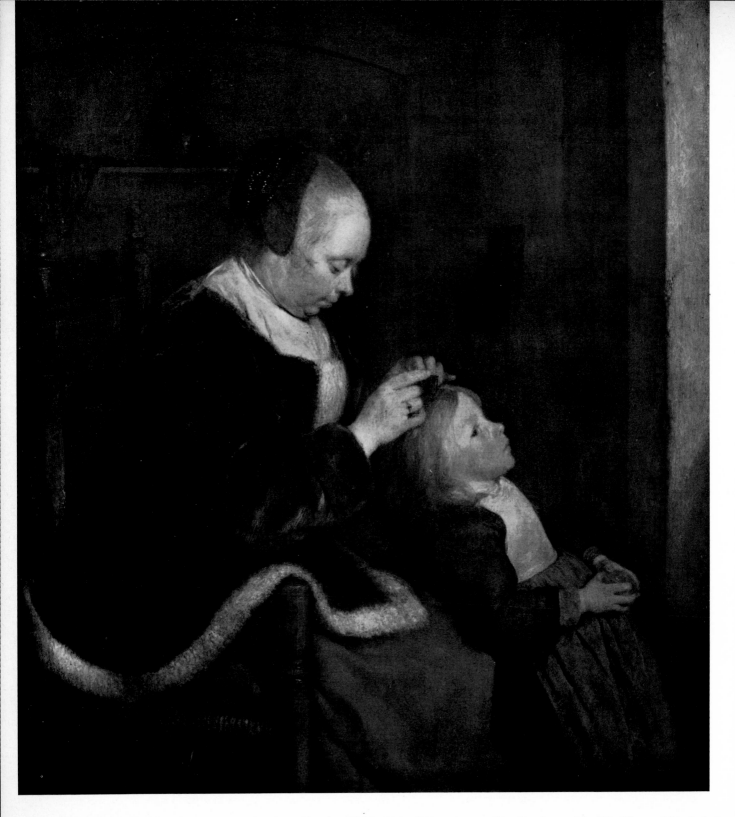

145. GERARD TER BORCH (1617—81): *A Mother ridding her Child's Hair of Lice*. 1650—3. Panel, 13¼ × 11⅜ in. The Hague, Mauritshuis

The mother ridding her child's hair of lice was an image of maternal solicitude and a homely personification of good government. Pieter de Hoogh also painted this subject.

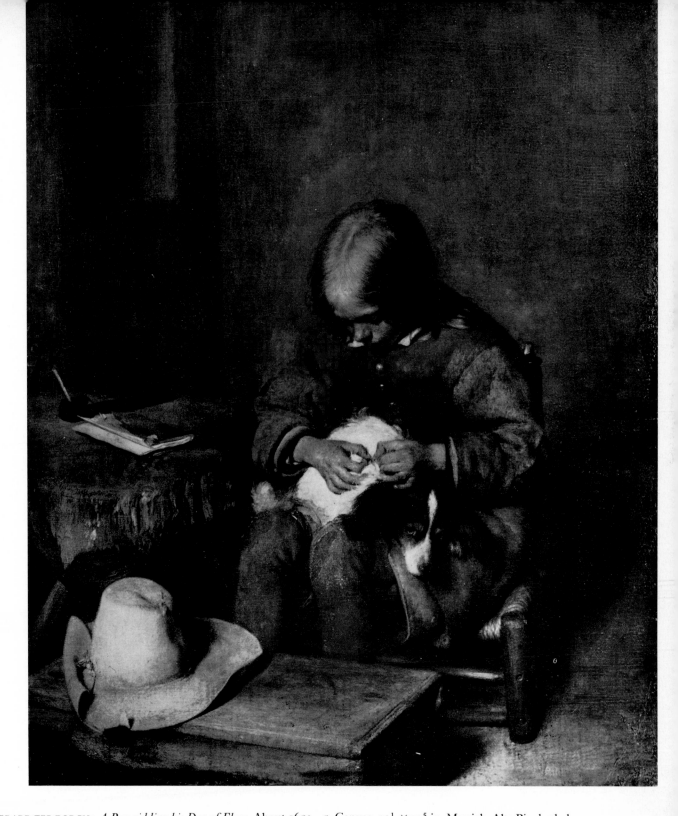

146. GERARD TER BORCH: *A Boy ridding his Dog of Fleas*. About 1653—5. Canvas, $13\frac{1}{2} \times 10\frac{5}{8}$ in. Munich, Alte Pinakothek

The search for fleas was a popular subject in poetry and painting of the sixteenth and seventeenth centuries. This is probably one of the *Five Senses*: the Sense of Touch.

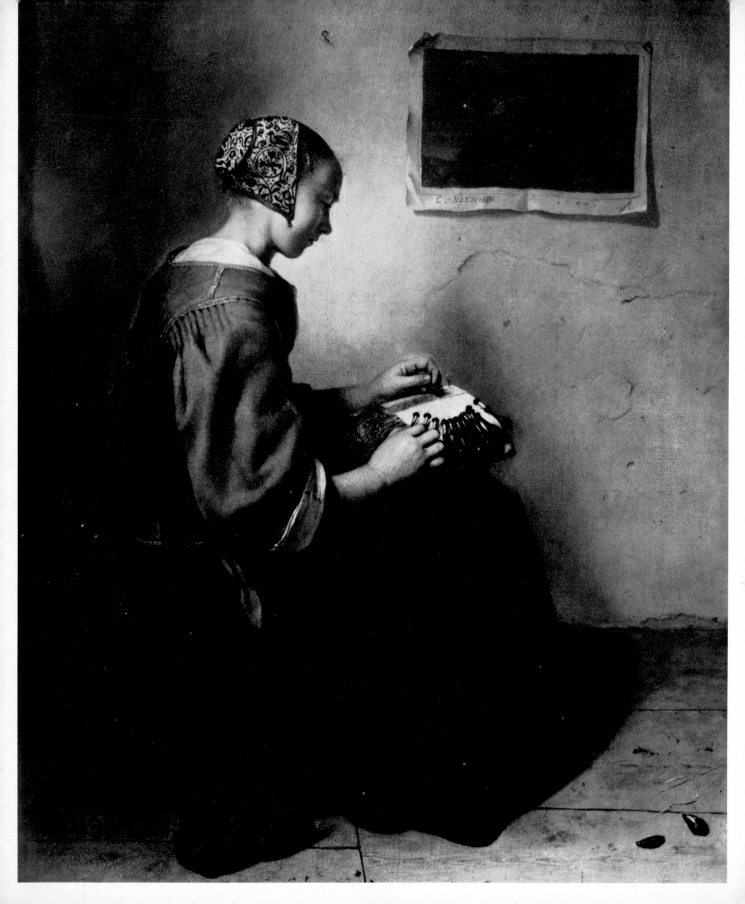

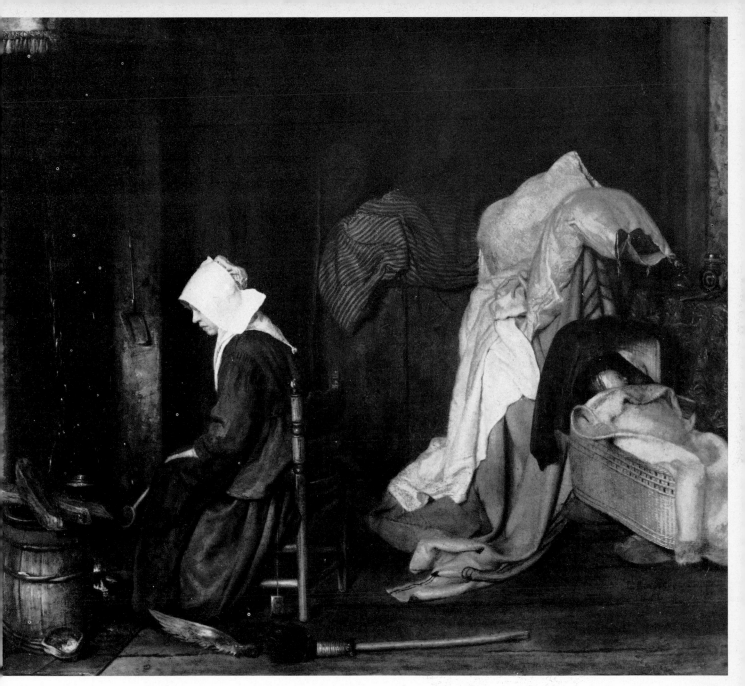

148. ESSIAS BOURSSE (1631—72): *Interior: Woman cooking*. 1656(?). Canvas, 20⅜ × 23 in. London, Wallace Collection

Two enigmatic works. The representation by Boursse is so exquisitely meticulous that it is easy to overlook the unusual disorder of this household, though it is quite at odds with contemporary representations such as those by de Hoogh. The severe simplicity of Netscher's canvas, the tranquility of the lace-maker and her absorption in her intricate task are at odds with the two mussel shells, usually found in tavern scenes. Odder still: the slippers and broom, behind the lace-maker, are attributes of the harlot. The broom was used to sweep out the spent-up lover (see Plates 116, 117, 118, 128, and 178). Compare with Vermeer's treatment of the lace-maker (Plate 105).

147 (*opposite*). CASPAR NETSCHER (1635/6—1684): *The Lace-Maker*. 1664. Canvas, 13½ × 11⅛ in. London, Wallace Collection

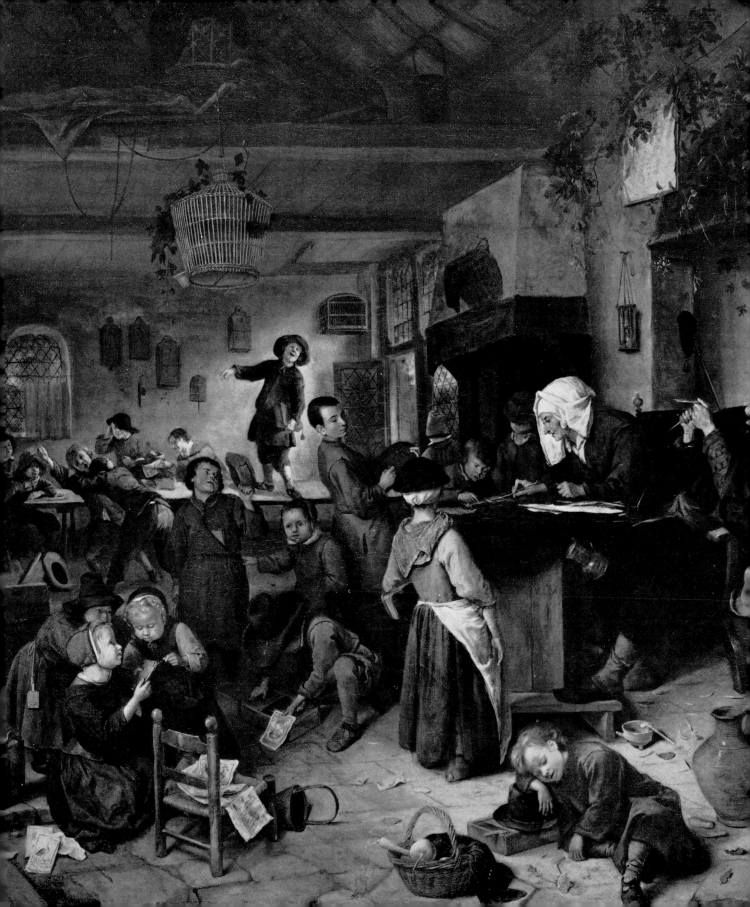

149. JAN STEEN (1625/6—1679): *Village School*. About 1670. Canvas, 33 × 43 in. Edinburgh, National Gallery of Scotland (on loan from the Duke of Sutherland)

In spirit, this teeming and amusing canvas recalls *Children's Games* by Pieter Bruegel. The key to its meaning is the owl on its perch beside a bunch of keys on the right. The owl, the bird of Minerva, is widely held to be wise, but not in the Netherlands, where it has long been an image of stupidity and drunkenness. To call a person an owl ('t is een uil') is the equivalent of calling him an ass in English. Another saying, appropriate to this scene is 'elk meent zijn uil een valk te zijn' (everyone thinks his owl to be a hawk), the equivalent of 'everyone thinks his geese are swans.' But why is one of the silly owls offering the feathered owl a pair of spectacles? This recalls another proverb: 'What use are candles and spectacles if the owl refuses to see?' The only other wearer of spectacles here is the biggest owl of them all, the school-master himself, who should be the source of wisdom for the little ones, but who in his complacency is utterly blind to the chaos around him.

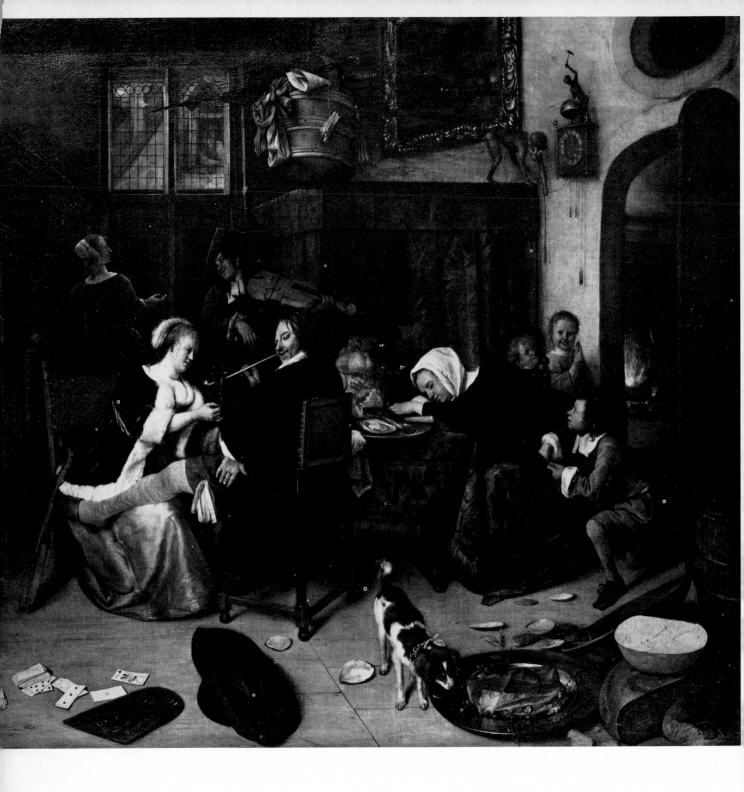

150, 151. JAN STEEN (1625/6—1679): *The dissolute Household*. Canvas, $30\frac{5}{8} \times 34\frac{1}{2}$ in. London, Wellington Museum
(Apsley House)

Nowhere in Britain is there a more representative collection of works by Steen than in the Wellington Museum. In addition to the typical and exquisite *Physician's Visit* (Plate 130), there is the spiralling, grand composition of the *Egg Dance*, the luminous and haunting *Wedding Party* (Plate 45) and this version of the *Dissolute Household*. More probably an inn or a brothel than a private household, or so the tally board in the bottom left-hand corner suggests, it is related to the 'merry company' paintings of the first half of the century (see Plate 34). This work is typical in another and fundamental way: the curious wide-angle composition which embraces a wide sweep of the interior in a small compass and within which Steen held together a staggering diversity of significant details. It was Steen's special genius as a painter that he could include details that ter Borch or van Mieris might have been proud of, yet keep them subordinated to a larger scheme that was quite beyond the invention of his rivals.

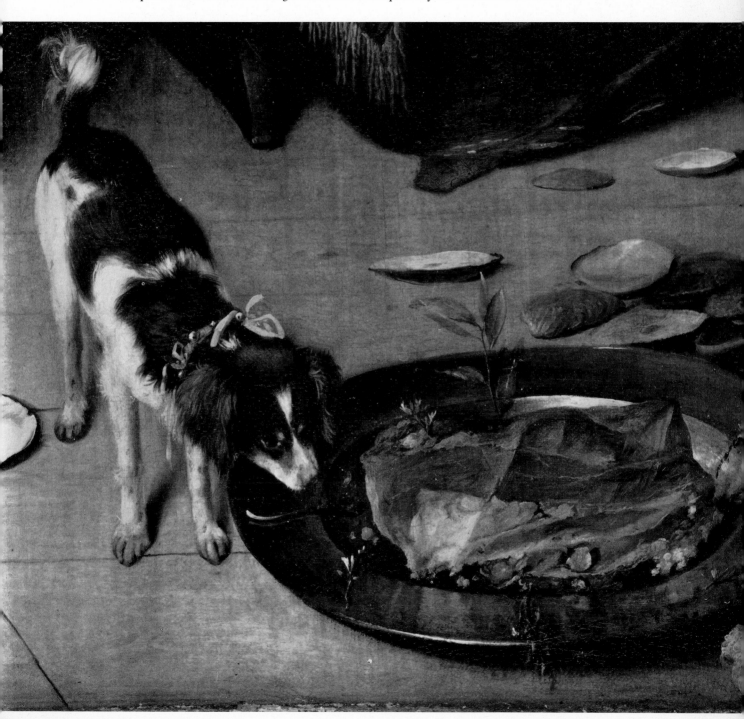

152. JACQUES DE CLAEUW (also known as Jacques Grief) (d. after 1676): *Vanitas*. Canvas, 37 × 49¾ in.
Jacksonville, Florida, Cummer Gallery of Art

153. JAN STEEN (1625/6—1679): *The Drawing-Master*. Panel, 18 × 15 in. Denmark, Private Collection

Again two canvases which use similar properties with quite different meanings (see Plates 36 and 37). The still-life (above) appears at first to be no more than the bric-à-brac of the studio heaped on a table, and indeed it must have been that. But numerous details—the hourglass, the pipe and the overblown roses, in particular—suggest that this too is a *Vanitas*, though less obvious than that reproduced as Plate 74. Steen's delightful picture (opposite) is far more enigmatic, and he appears to have used the necessary tools of the artist's trade to obscure rather than to clarify his meaning. In his other canvases (e.g. Plate 130) a cupid or cupid-like figure certainly signifies sexual love, but here the plaster figure suspended from the ceiling seems merely incidental. Intrigued, the eye returns to the expressions of the three characters.

These two canvases and that on the following page (Rembrandt's *Conspiracy of Julius Civilis*), all painted within a couple of years, demonstrate the problems that faced the ambitious painter in Holland in the second half of the seventeenth century. While Rembrandt painted as well as he knew and had his commission rejected, Adriaen van de Velde and Karel du Jardin sought radically differing solutions. That they did seek solutions is clear from their earlier works, which had developed after the example established in Haarlem by Berchem and Wouwermans. But in the paintings shown here van de Velde has gone back to a model that would not have astonished Poelenburgh (Plate 60), while du Jardin has been strongly influenced by more recent Italian and French examples, and in this way anticipates the achievement of van der Werff (Plate 177).

154. ADRIAEN VAN DE VELDE (1636—72): *The Migration of Jacob*. 1663. Canvas, 53½ × 71¼ in. London, Wallace Collection

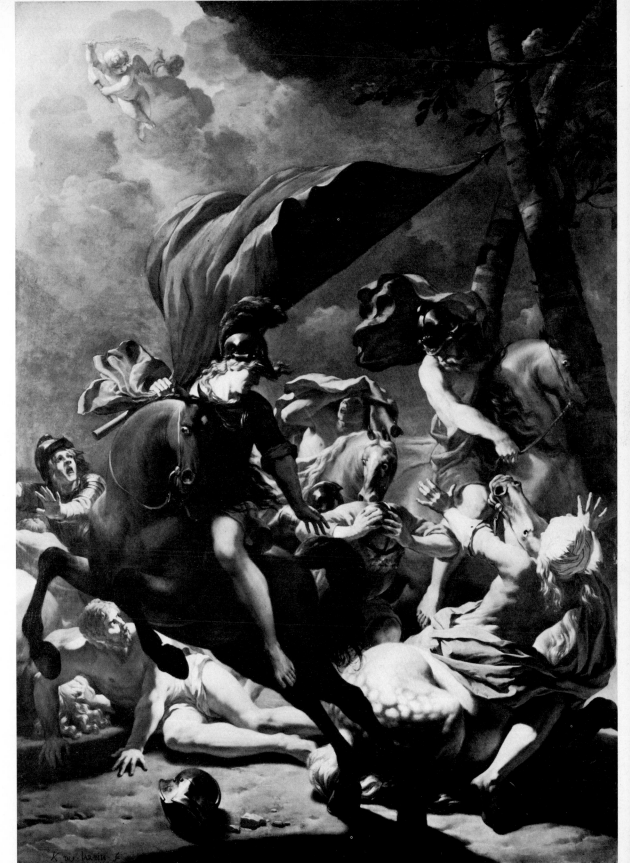

155
KAREL DU JARDIN
(1621/2?—1678):
*The Conversion of
St Paul.* 1662.
Canvas, $73\frac{1}{2} \times 53$
in. London,
National Gallery

156, 157. REMBRANDT (1606—69): *The Conspiracy of Julius Civilis: The Oath.* 1661. Fragment. Canvas, 77 × 121 in. Stockholm, Nationalmuseum

In 1659, Rembrandt's pupil, Govert Flinck, was given the commission to decorate the Great Gallery of the new Amsterdam Town Hall with eight or twelve paintings of stories of the Batavian war of liberation against the Romans, a struggle that prefigured that of the United Provinces against Spain. But Flinck died before he could make more than preliminary sketches, and the commission was divided between several painters, including Jan Lievensz. and Jacob Jordaens. When Rembrandt received his commission is not known, but the only surviving preliminary study, a pen drawing now in the Munich Print Room, is on the back of an obituary notice of a Rebecca de Vos, dated 25 October 1661. This small sketch is the only indication of the original scope of Rembrandt's imagination. According to the historian Tacitus, whose account Rembrandt followed, Julius or Claudius Civilis, an old one-eyed warrior, had called the Batavians to a midnight banquet in a sacred grove, where they made a solemn pledge of conspiracy against their foreign overlords, the Romans. Rembrandt's sketch shows that his composition was of a great vaulted hall, echoing the scale and proportions of Raphael's *School of Athens*. But for some reason the vast canvas, some 18 foot square, was returned to the artist for alterations, some time in 1662. Apparently he never made them satisfactorily; instead he must have cut the picture down to its present size and disposed of this fragment to a dealer.

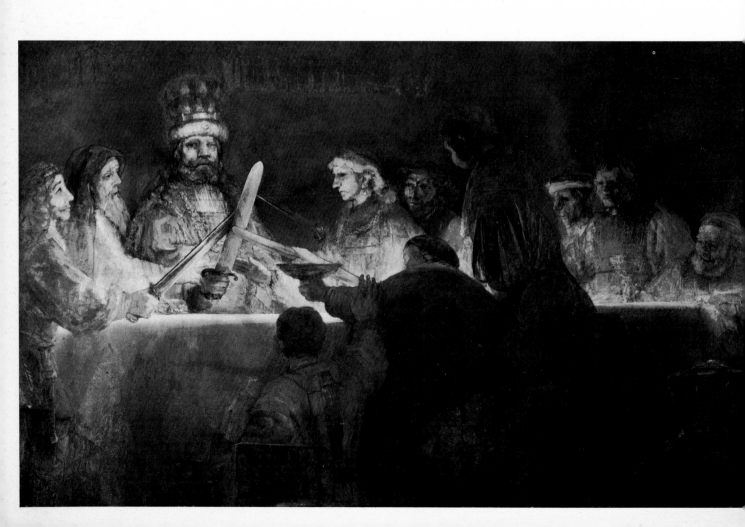

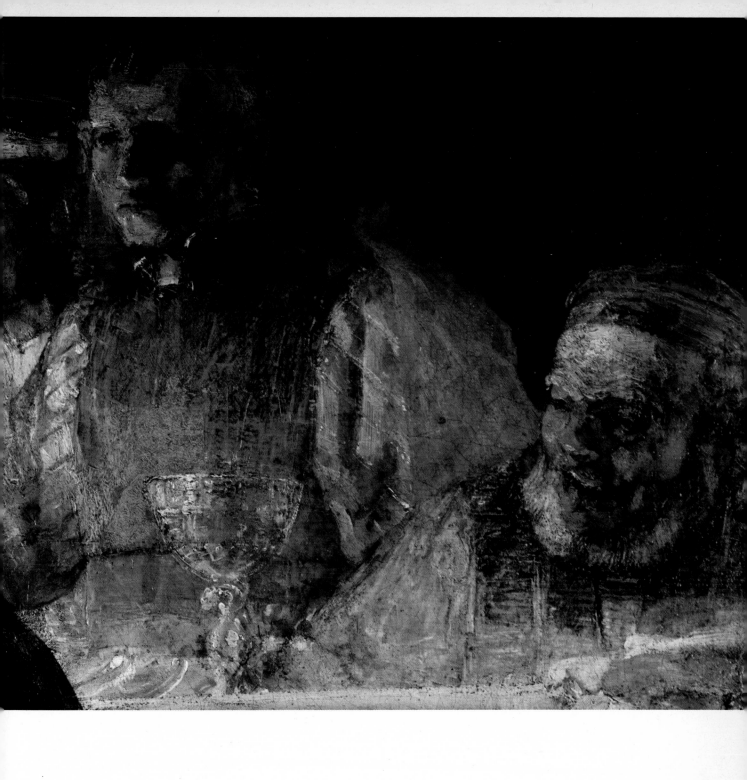

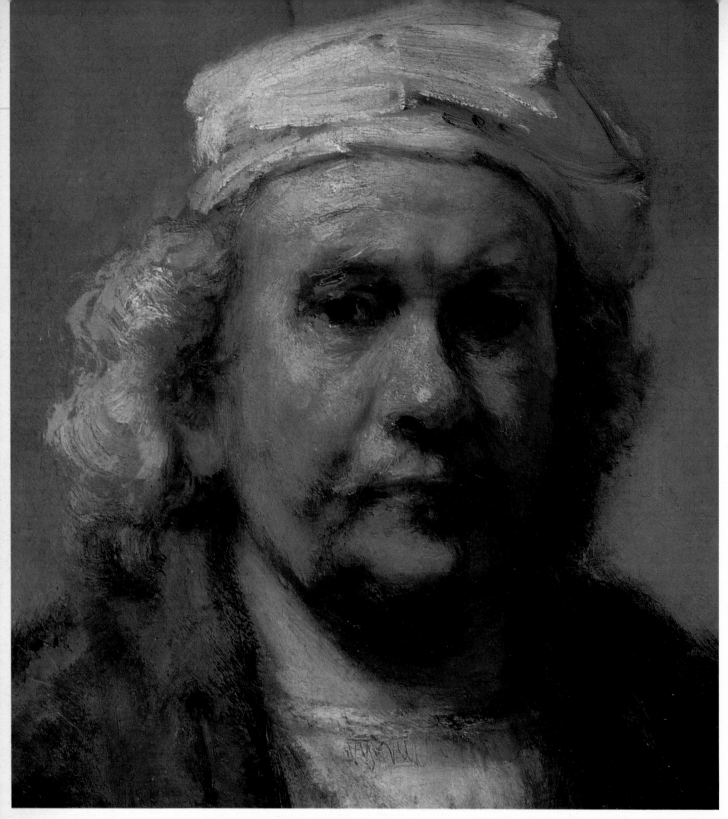

158. REMBRANDT (1606—69): *Self-Portrait with Palette and Brushes*. Detail. About 1660. Canvas. London, Kenwood House, Iveagh Bequest

159. FRANS HALS (1580?—1666): *Portrait of a Man*. Detail. About 1655—60. Canvas. Copenhagen, Royal Museum of Fine Arts

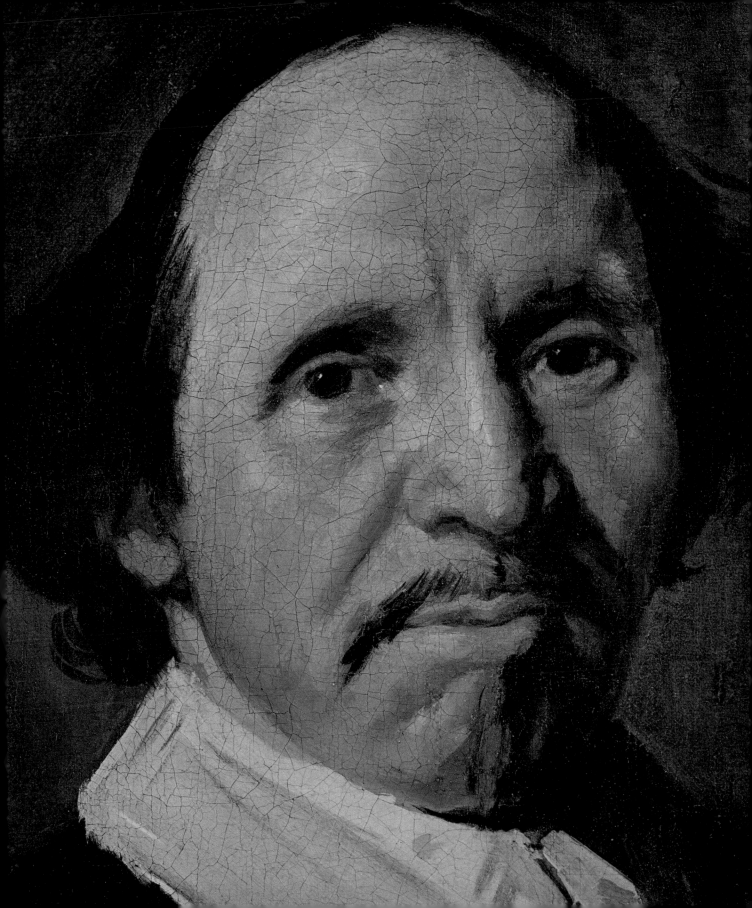

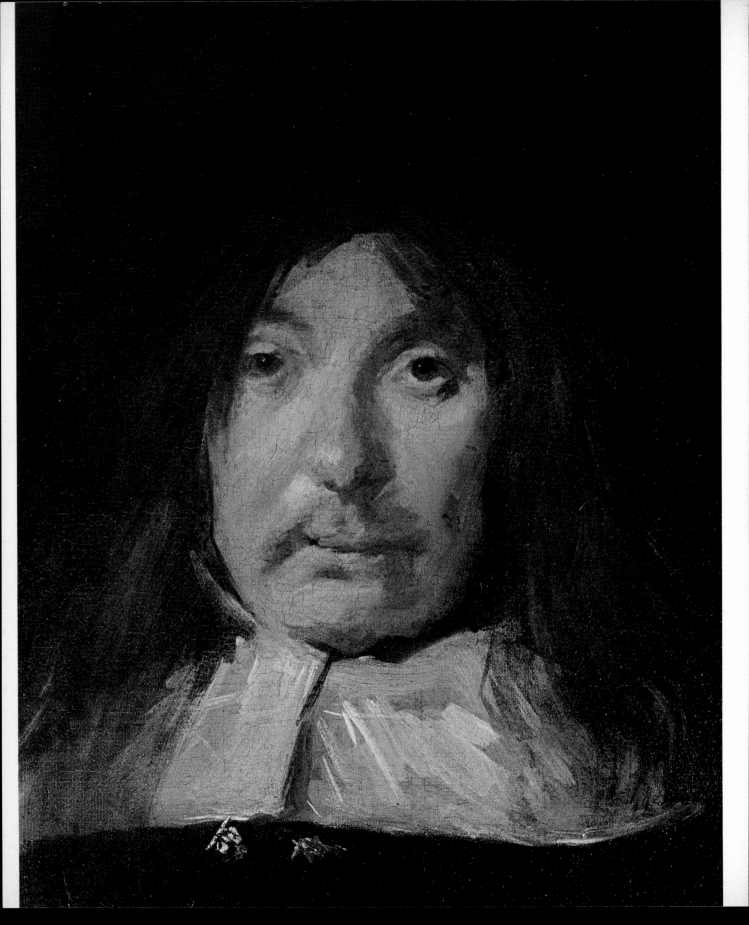

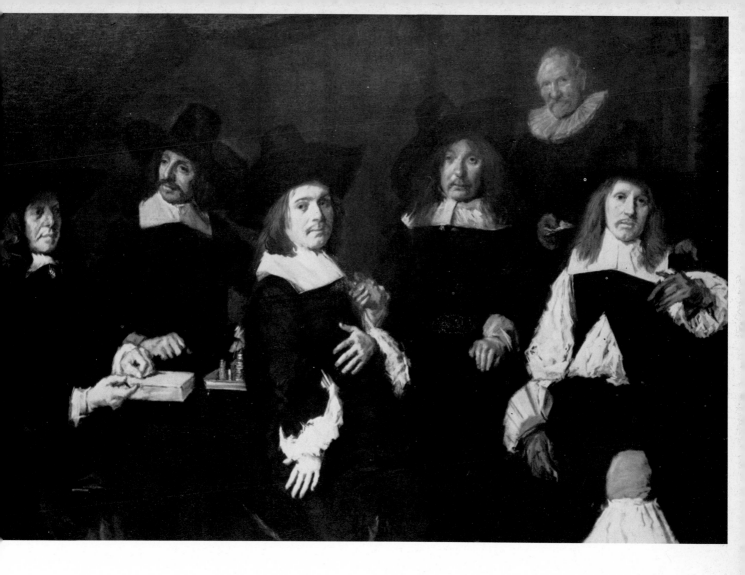

160, 161. FRANS HALS (1580?—1666): *Regents of the Old Men's Alms House*. About 1664. Canvas, 69½ × 100¾ in. Haarlem, Frans Hals Museum

About a year before he died, Frans Hals, perhaps eighty-four years old and chronically in debt, was commissioned to paint two portraits for the Regents of the Old Men's Alms House in Haarlem. These two canvases —one of the *Men Regents* and one of the *Women Regents*—were the last, and arguably the greatest, of his group portraits. The pattern of regent portraits, which had been painted in Amsterdam since the end of the sixteenth century, was fairly stereotyped. In Amsterdam there was a taste for full-length portraits and for a dramatic focus, such as the entry of a messenger. But Hals simply represented the Regents and their servant grouped round a table, on which lie ink-stand and account book, emblems of their duties. As Seymour Slive has pointed out in his monograph on Hals, there is no indication that the artist has treated his subject satirically. If they had not been satisfied with the first they need not have allowed him to finish the second, as there was living in Haarlem at the time another very competent painter of groups, Jan de Bray.

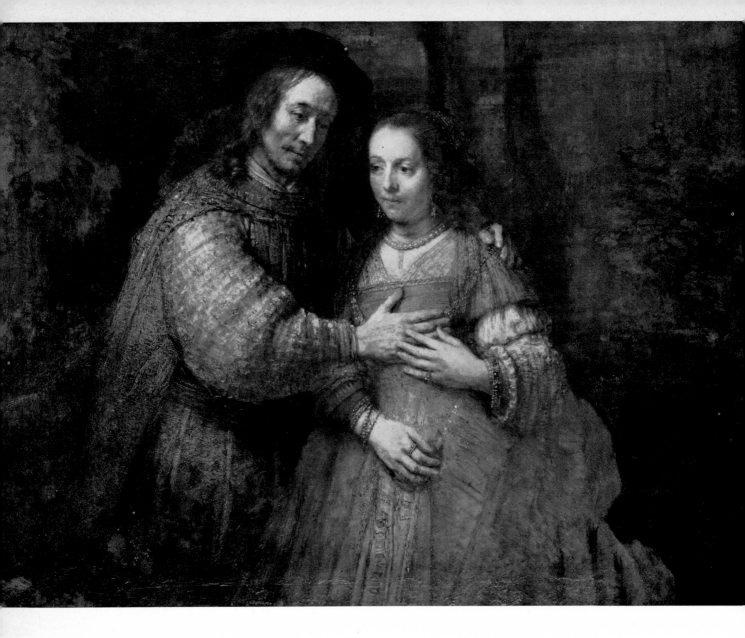

162. REMBRANDT (1606—69): 'The Jewish Bride'. After 1665. Canvas, 48 × 65½ in. Amsterdam, Rijksmuseum

There is a drawing in the Kramarski Collection, New York, representing *Isaac and Rebecca* (Genesis 26:8), which closely resembles this painting. As the X-rays of the canvas show that originally the figures were seated (as they are in the drawing) it is likely that there is a relation between the picture and the bible story, in which Isaac pretends that his wife, Rebecca, is his sister so that the king, Abimelech, shall not kill him to obtain her. Whether Rembrandt was concerned primarily to portray 'Isaac and Rebecca' and found two suitable models or whether he was commissioned to portray a husband and wife in the appropriate guise of Isaac and Rebecca cannot be determined, but in either case he created a profoundly moving image of human love in this, perhaps the greatest of his works.

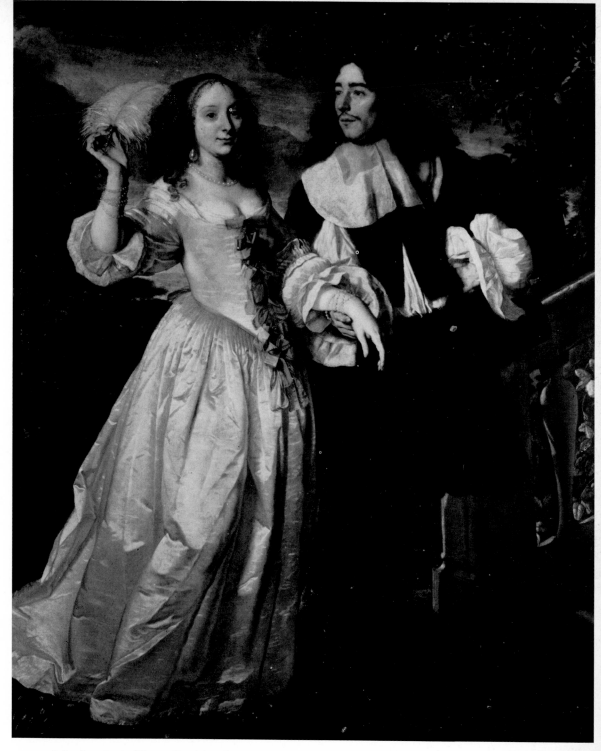

163. BARTHOLOMEUS VAN DER HELST (1613?—1670): *Young Patrician Couple*. 1661. Canvas, 73¼ × 58½ in. Karlsruhe, Staatliche Kunsthalle

When van der Helst moved to Amsterdam from Haarlem in 1636, he became Rembrandt's most important rival as a portrait-painter. It was also about that time that the elegant style of the Flemish painter van Dyck became known and admired and van der Helst was able to offer a Dutch version. Though his most important commissions were undoubtedly two militia groups painted in 1639 and 1648, the present work gives a clear idea of his strengths and weaknesses.

164. BARTHOLOMEUS VAN DER HELST (1613?–1670): Detail from *Young Patrician Couple* (Plate 163)

The detail shown here gives a much more favourable and accurate impression of van der Helst's skills than is possible in the small scale reproduction of Plate 163. The painting of the hands has a firmness and delicacy that only the genius of Rembrandt could overshadow.

165. REMBRANDT (1606–69): Detail from '*The Jewish Bride*' (Plate 162)

166. REMBRANDT (1606—69): Detail from *Jan Six* (Plate 88). 1654.

The similarities and differences between the mature styles of Hals and Rembrandt are vividly displayed in these details. As the hands of *Jan Six* reveal, Rembrandt was never closer to the manner of Hals than in the early 1650s, and it is not impossible that he was influenced by the older artist at the very time that he was broadening his own technique. But as this comparison shows, the differences were more important than the similarities. Hals's brushwork (which has real if coincidental similarities to that of the Spanish painter, Velazquez) is impressionistic, his concern being to draw with a deliberately ostentatious virtuosity the appearance of his model as he saw it. Rembrandt's brushwork was far more variable than Hals's. He manipulated it in a variety of ways until it *felt* like his model. (Isabella Coymans was Dorothea Berck's daughter.)

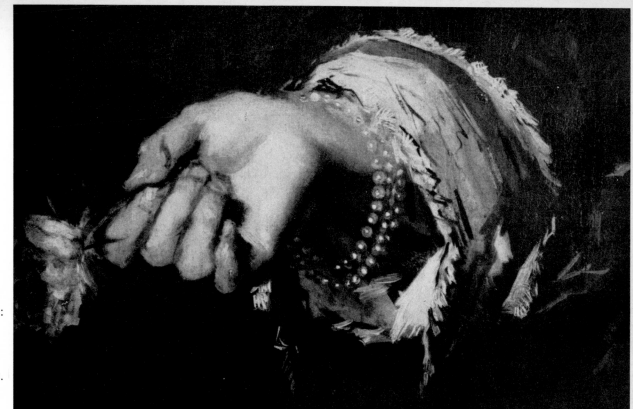

167.
FRANS HALS
(1580?— 1666):
Detail from
*Isabella
Coymans.*
About 1650— 2.
See also
Plate 139

168.
FRANS HALS:
Detail from
*Dorothea
Berck.* 1644.
Baltimore,
Maryland,
Museum of Art
(not reproduced)

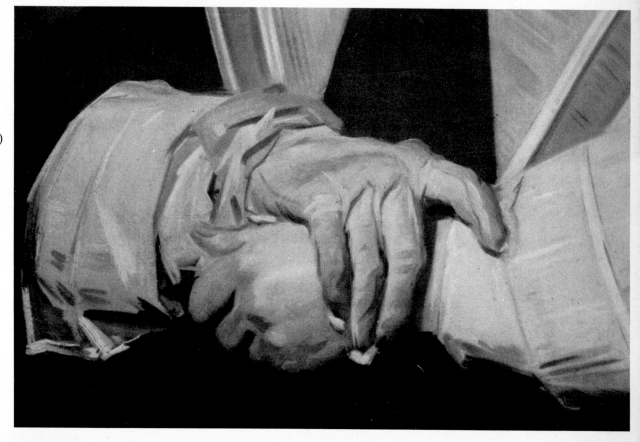

169, 170. REMBRANDT (1606—69): *The Return of the Prodigal Son*. About 1668—9. Canvas, 103 × 81 in. Leningrad, Hermitage

The Prodigal Son, abandoning himself to the pleasures of the senses, heedless of eternity and judgement, was a recurrent theme of Netherlandish art, being the original subject behind many of the motifs taken, superficially, from daily life. When, at the end of his life, Rembrandt treated the subject, he chose the theme of repentance and forgiveness by which the son's sins were taken away. In a timeless and unforgettable image, he shows the father take back his child to his shadowy bosom. It is remarkable that, as in so many of his works, Rembrandt expresses the meeting of two souls not with an exchange of looks but by an embrace: here it is especially poignant, as the son renounces his embrace of 'riotious living' for the innocence of a return to his parent's arms. This, which is unmistakably a history painting, may be compared to the more problematic '*Jewish Bride*' (Plate 162).

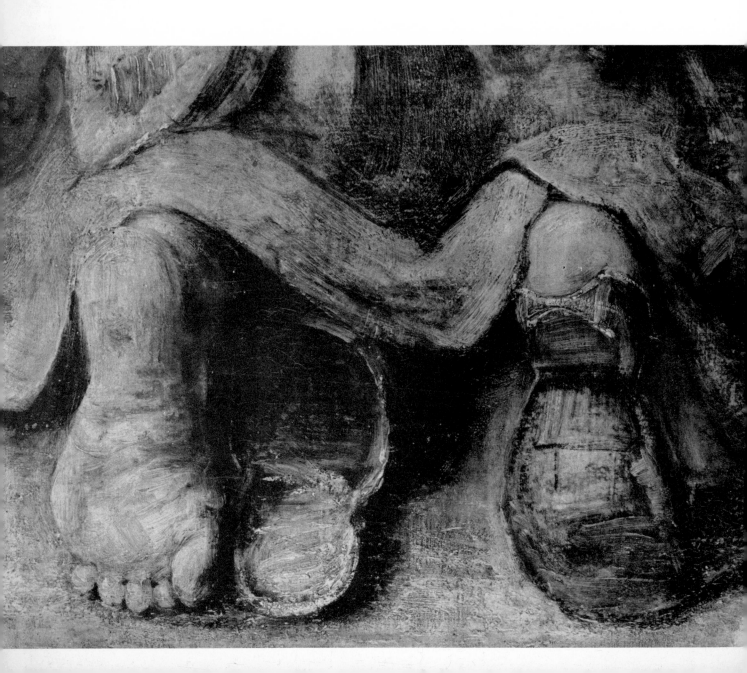

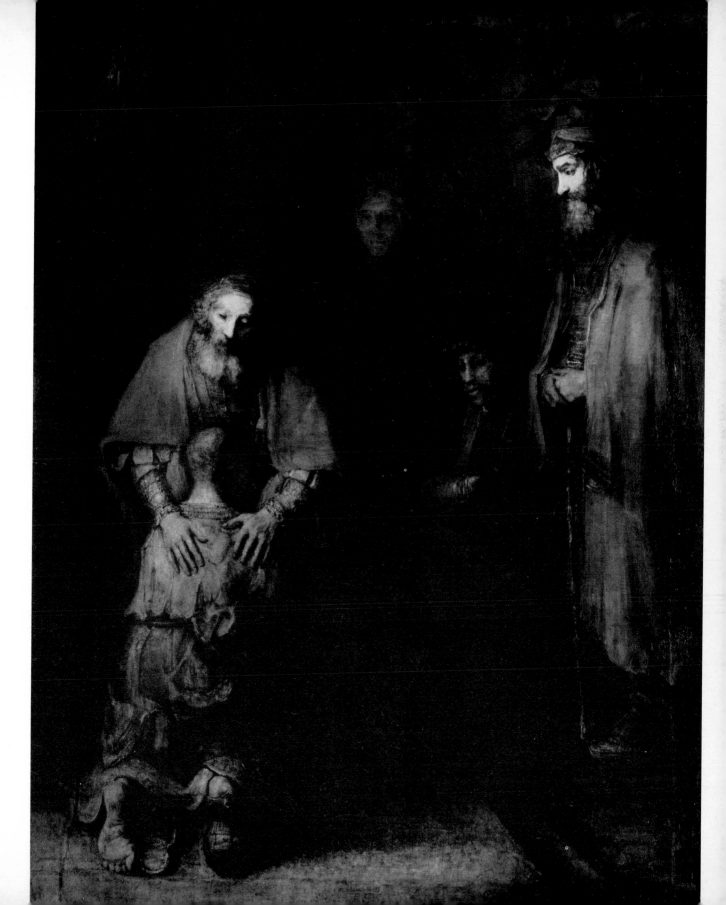

171. JAN WIJNANTS (1620/5–1684): *Landscape with Huntsmen*. 1666. Canvas, $33\frac{1}{2} \times 40\frac{3}{4}$ in. Bonn, Rheinisches Landesmuseum

The blond tonality, the open, fragmented composition, and the exaggerated decay of the rustic fence, are all features that were admired and copied in the following century by the landscape painters of Rococo France. This, just as much as the landscape of Hobbema or Ruisdael, was the origin of the taste for the picturesque which grew up during the eighteenth century. Wijnants, the son of an art dealer, exhibited a knowledge of current taste in the formation of a style which can be compared with the calculation shown by Jan Weenix in the invention of the *Merry Company* shown opposite.

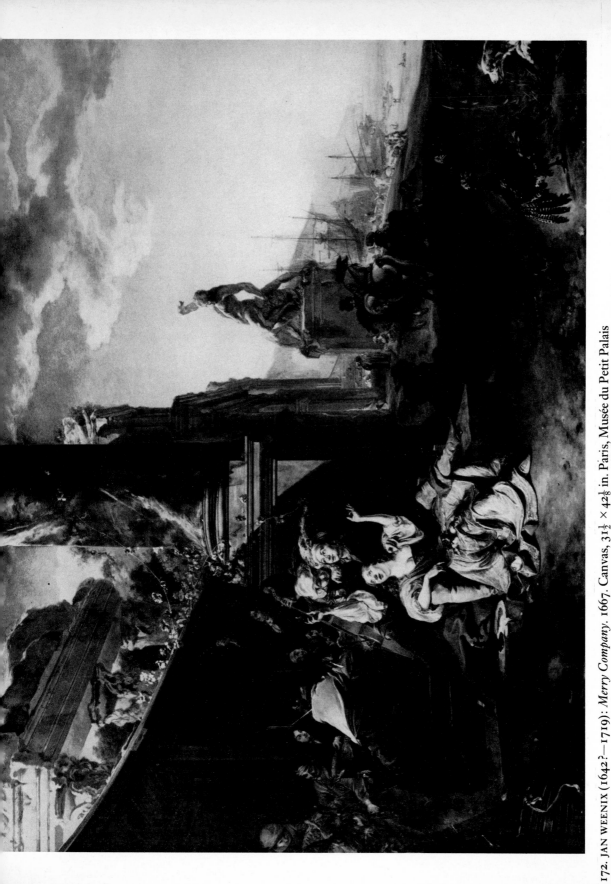

172. JAN WEENIX (1642?–1719): *Merry Company*. 1667. Canvas, $31\frac{1}{2} \times 42\frac{1}{8}$ in. Paris, Musée du Petit Palais

In this *tour de force* of popular motifs, Jan Weenix follows most closely the example of his father, Jan Baptist, who painted a very similar composition, of virtually the same dimensions, eighteen years earlier (now in the Wallace Collection, London). Jan Weenix includes every conceivable device here. There is a merry company in the left foreground which includes lovers, a musical party, figures reminiscent of Steen and the 'Bamboccianti' (see note to Plate 63) and a candle–lit interior dimly glimpsed through the doorway. There are picturesque classical ruins and a Renaissance statue, a harbour recalling Claude and the better works of Both and Pijnacker, horsemen in the manner of Wouwermans, and turkeys and a spaniel which were at least his own speciality. With more than thirty years to run, the seventeenth century appears to have finished and the art of eighteenth–century France to have arrived.

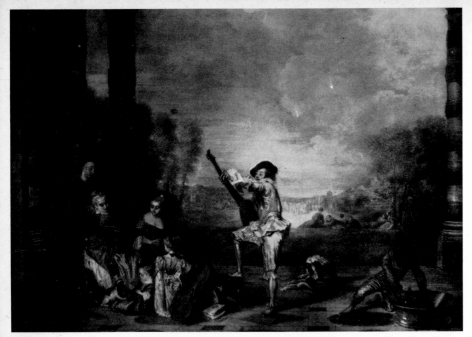

173. ANTOINE WATTEAU (1684—1721): *The Music Party*. Canvas, 27 × 33⅝ in. London, Wallace Collection

174. JAN STEEN (1625/6—1679): *A Party in the open Air* (*The Prodigal Son*). 1677. Canvas, 26 × 34½ in. Private Collection

175. JACOB VAN LOO (about 1614—70): *Concert*. Canvas, 30 × 25½ in. Leningrad, Hermitage

The music party, a form of 'merry company' (see pp. 28–30 and Plate 34), was a major theme of Dutch painting in the seventeenth century. It could be given a wide range of interpretations and soon after the beginning of the eighteenth century it provided the inspiration from which the Flemish-born Watteau created a new French art.

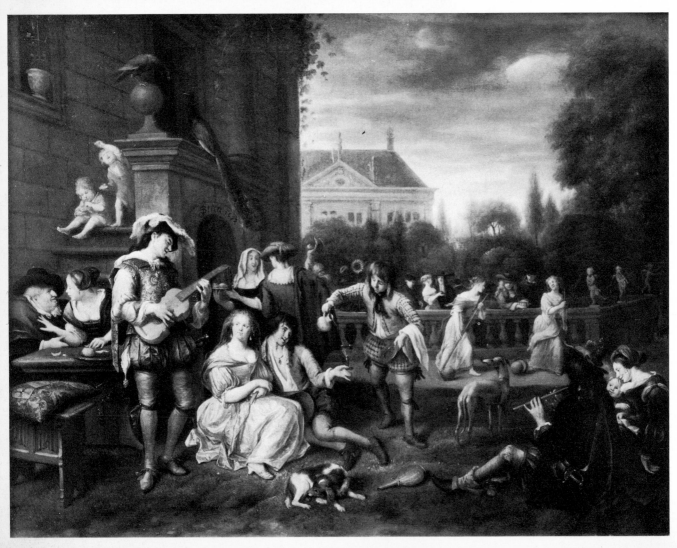

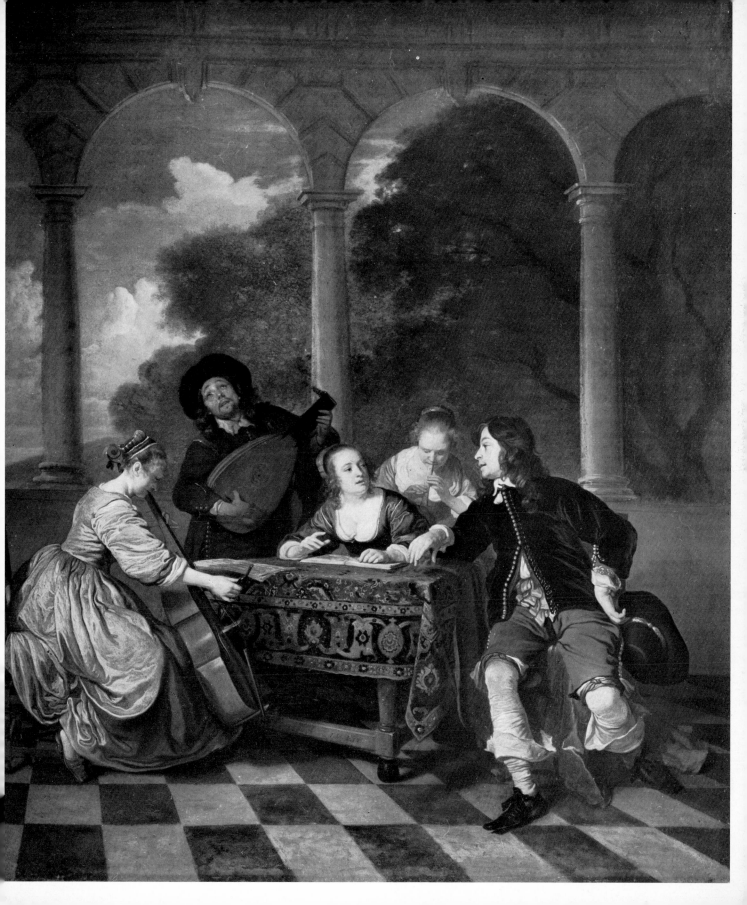

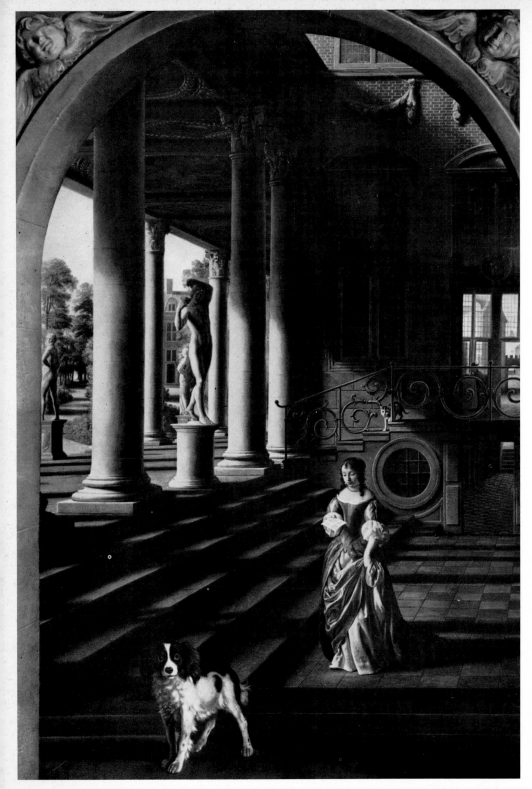

177. ADRIAEN VAN DER WERFF (1659—1722): *The Rest on the Flight into Egypt*. Detail. 1701. Panel. London, National Gallery

Although he was 41 when the new century began, van der Werff had already abandoned the ideals of the seventeenth century. Though he uses a technique adopted from the fine painters of Leyden, his Madonna with a pink marble breast and totally sculpted Christ child is far more artificial than even the prettiest of Dou's works (Plate 64). A comparison with Rembrandt's *Holy Family* (Plate 70) reveals the enormous changes that Dutch taste had undergone in fifty years.

176. SAMUEL VAN HOOGSTRATEN (1627—78): *Young Lady in a Vestibule*. Canvas, $95\frac{1}{8} \times 70\frac{1}{2}$ in. The Hague, Mauritshuis

Hoogstraten painted many perspective scenes in which geometrical precision and visual illusion appear to have been his main concerns. He may have been influenced by Carel Fabritius (Plate 120), whom he met while they were both studying with Rembrandt. In this work, the letter theme is lost among the vistas.

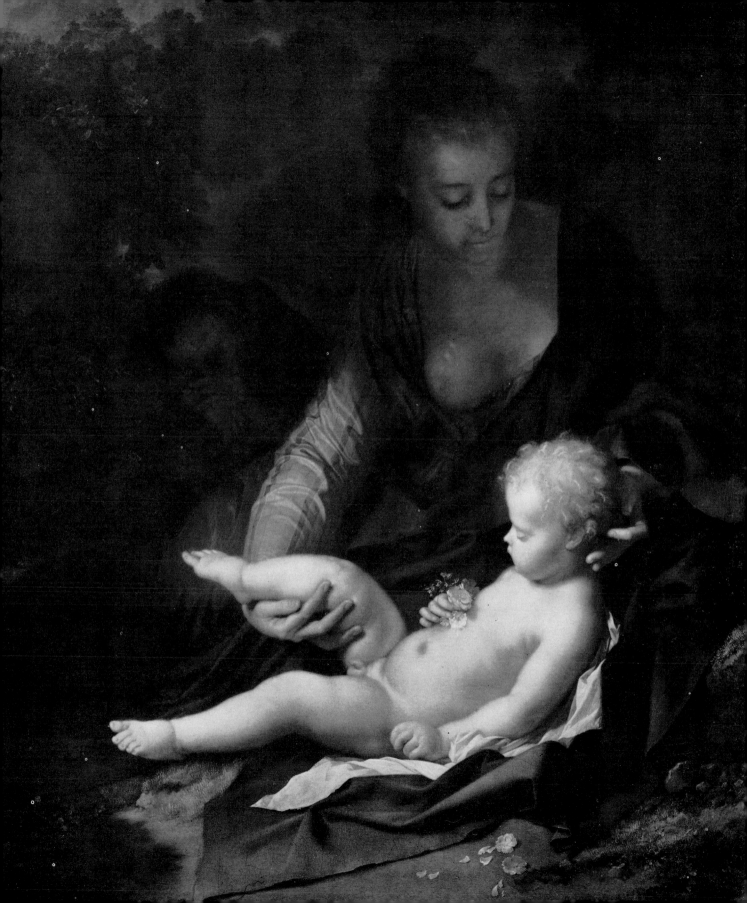

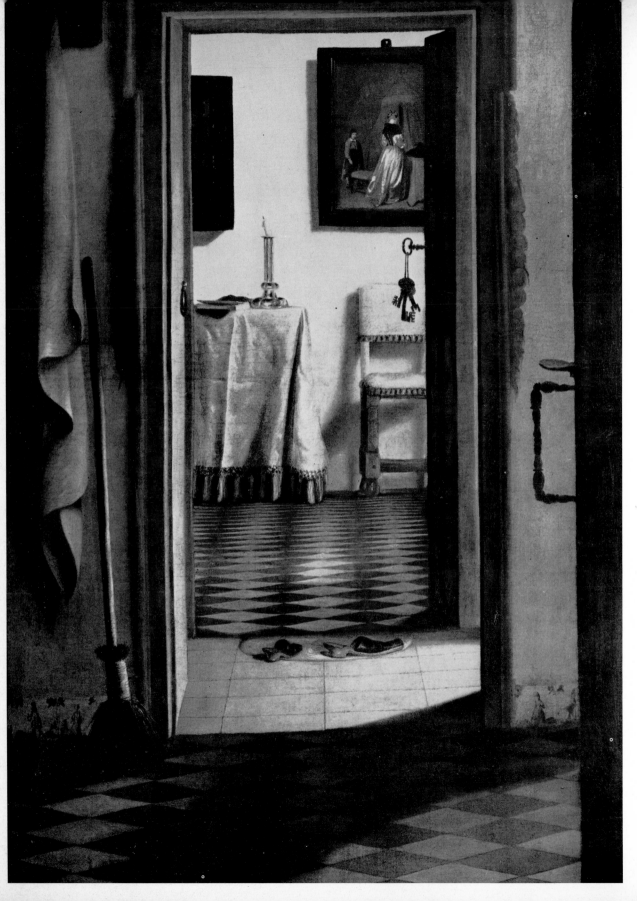

178.
Attributed to
SAMUEL VAN
HOOGSTRATEN
(1627—78):
'*Les Pantoufles*'.
About 1654—
62. Canvas,
$40\frac{1}{2} \times 28$ in.
Paris, Louvre

The broom,
the pair of
slippers, the
extinguished
candle, and
the bunch of
keys, insignifi-
cant in them-
selves, awake
echoes and
reminiscences.
On the wall is
a *Courtesan*,
which appears
to be by ter
Borch, as he
painted several
pictures con-
taining a similar
figure.

ASSELIJN, *Jan*

Born in 1610, Jan Asselijn was a landscape-painter who passed much of his life in Rome, where he was given the nickname of 'Crabbetje' (little crab) because of the crab-like deformity of one hand. He painted Italianate landscapes showing large ruins, and was said by Houbraken to have brought the pure and light manner of Claude, the French landscape-painter, to Holland. His return there was in 1645, and he seems to have become the friend of Rembrandt, who etched a brilliant portrait of him shortly after that date. Despite his reputation as a landscape-painter, his most famous work is the *Angry Swan* (Amsterdam, Rijskmuseum) defending her nest against a maurauding dog. Asselijn died in 1652.

AVERCAMP, *Hendrick*

Baptized in Amsterdam on 27 January 1585, Avercamp was taken the next year to Kampen, a small town by the Zuider Zee. He was called 'de stomme van Kampen' (the mute of Kampen) because he was dumb. His art was devoted to winter scenes of outdoor sport and leisure. Initially his style was based on that of the Flemish followers of Pieter Bruegel the Elder. He composed his scenes— which show the bare, flat, spaces of the frozen Zuider Zee become busy with a multitude of small animated figures— using careful preparatory drawings, and the same figures recur in several works. His nephew, Barent Avercamp, followed his style, and another artist, Arent Arentsz., called Cabel (about 1585–1653), painted similar subjects. Avercamp died in Kampen and was buried there on 15 May 1634.

BERCHEM, *Nicolaes*

The son of Pieter Claesz., the still-life painter, Berchem was baptized in Haarlem on 1 October 1620. According to the historian Arnold Houbraken, he studied under numerous masters. The surname Berchem was his own choice and he spelt it variously during his career. He entered the Guild of St Luke in Haarlem in June 1642 and soon had pupils. But the important period in his development was a visit to Italy with his cousin Jan Bap-tist Weenix between 1643 and 1645. The landscape studies he produced then served throughout his life. He was one of the most successful, influential, and well-paid artists of his day and did much to establish the popularity of Italianate landscape in Holland. He died in Amsterdam in 1683.

BERCKHEYDE, *Gerrit*

Baptized in Haarlem on 6 June 1638, Berckheyde was apparently taught painting by his elder brother, Job. After travelling through Germany with his brother, and working for a time for the Elector Palatine, he settled in Haarlem and joined the Haarlem guild of painters in 1660. Though he painted a few landscapes and interiors of churches, which were more in the manner of Emanuel de Witte than of Saenredam, Berckheyde specialized in views of towns, notably Amsterdam, The Hague and Haarlem. He painted Haarlem market place many times —a subject first represented by Saenredam in an etching. Berckheyde died in Haarlem in 1698.

BLOEMAERT, *Abraham*

Born in Utrecht in 1564, Abraham Bloemaert was trained as a painter by his father, Cornelis, and by Joos de Beer, who also taught Wtewael. Though he spent time in Paris and Amsterdam, Bloemaert passed most of his life in his native town of Utrecht. For almost sixty years, he taught the young painters of Utrecht. These included the Utrecht Caravaggists ter Brugghen and Honthorst and the Italianate landscape-painters Poelenburgh, Jan Both and Jan Baptist Weenix. It is remarkable that so many of his pupils travelled to Italy though Bloemaert never went there himself. He was a gifted rather than an original artist, working in many styles, but his best paintings were made under the influence of his best-known pupils, ter Brugghen and Honthorst. He died in 1651.

BLOOT, *Pieter de*

Pieter de Bloot was born in Rotterdam in 1601, but little else is known of his career. He was a versatile painter of peasant scenes and landscapes. His peasant scenes show

the influence of Adriaen Brouwer, and his landscapes reflect the influence of the Haarlem school of Esaias van de Velde and Jan van Goyen. De Bloot died in Rotterdam in 1658.

BOL, *Ferdinand*

Bol was baptized in Dordrecht on 24 June 1616. While still young, he moved to Amsterdam and became a pupil of Rembrandt, probably some time between 1632 and 1637, though his earliest known works, a painting and an etching, are both dated 1642. Bol was one of Rembrandt's ablest and most successful pupils and received commissions for portraits, group portraits and historical pictures for public buildings in Amsterdam, Leyden and elsewhere. After 1650, he followed more closely the style of the fashionable Bartholomeus van der Helst in his portraits. After his second marriage—in 1669 to a wealthy widow—he appears to have painted little. He was buried in Amsterdam on 24 July 1680.

BOR, *Paulus*

Bor was born at Amersfoort, Holland, probably about 1600, and went to Rome in the 1620s, where, with such artists as Poelenburgh, he founded the Netherlandish artists' club, the *schildersbent*. He returned to Amersfoort in 1628 with a personal version of the current Italianate style, influenced by Caravaggio and by Caravaggio's follower, Orazio Gentileschi, but shortly after his return his work reveals more awareness of Rembrandt's art. The second half of his life showed an unexpected change of direction. He was one of the artists employed to decorate the new palaces at Honselersdijk and Rijswick that the Stadholder Prince Frederik Hendrik had recently had built. Bor died in 1669.

BOURSSE, *Esaias*

Born in Amsterdam on 3 March 1631, Esaias Boursse is a relatively unknown figure, a minor artist who occasionally achieved paintings of great beauty. He visited Italy in his youth but none of his work from that time is now identified. He returned to Amsterdam about 1653. There is evidence that he painted history subjects and still-lifes as well as domestic interiors, but none have been identified. His works have, in the past, been confused with those of de Hoogh and Vermeer. He entered the service of the East India Company and made several voyages to India. He died at sea on 16 November 1672.

BREKELENKAM, *Quiringh van*

The first documentary record of Brekelenkam is that of his entry into the Leyden Guild of St Luke, in March 1648, from which it has been conjectured that he was born about 1620. Brekelenkam's sister is recorded to have been born at Zwammerdam, which is about twelve miles from Leyden, and this may have been the family home. He was influenced by Dou's subjects, but his style is perhaps closer to that of Metsu. His best painting is undoubtedly the *Tailor's Workshop* (Plate 85), and he produced several versions of this motif which are now in London (the National Gallery); Worcester, Massachusetts; and the J. G. Johnson Collection, Philadelphia. He lived and married in Leyden and died there some time in 1667 or 1668.

BROUWER, *Adriaen*

There is no known record of Brouwer's birth or baptism: according to a tradition recorded in 1682 he was born at Oudenaarde and died in Antwerp aged 32. As the date of his burial is known to have been 1 February 1638, he was probably born about 1606, the same year as Rembrandt. The places of his birth and death have usually caused Brouwer to be considered a Flemish painter. However, the first certain record of him is in Amsterdam, in 1626, and in another record of the following year he is called a painter from Haarlem. All in all—and in view of both his style and his influence on later Dutch painters, in particular Jan Steen—it seems likely that he trained in Haarlem, some time between 1620 and 1624, and may have been a pupil of Frans Hals, making him, in everything except birth, a painter of the Dutch school. He did, however, become a master in the Antwerp Guild of St Luke in 1631/2. In 1633 he was imprisoned in the Kasteel

in Antwerp, but it is not known why. According to Houbraken, he was imprisoned for suspected spying, only being released when Rubens came and identified him and guaranteed his character.

CAPPELLE, *Jan van de*

Van de Cappelle was born in Amsterdam, probably about 1624, because in 1666 he was said to be about forty-two. He was the son of a master-dyer, whose business he later took over himself. He was therefore a man of some wealth. An inventory drawn up on his death shows that he spent a part of this wealth on works of art. He owned ten pictures and over 400 drawings by Jan van Goyen, nearly 900 drawings by Hendrick Avercamp, some 500 drawings by Rembrandt and many works by other contemporaries. Most important, though, were the nine paintings and 1,300 drawings by the marine painter Simon de Vlieger and the sixteen paintings by another marine painter, Jan Porcellis, for this wealthy amateur, described by a contemporary as self-taught, was one of the most gifted of all the great seventeenth-century painters of ships and the sea. He died in Amsterdam on 22 December 1679.

CLAEUW, *Jacques de* (also known as Jacques Grief)

Few records of the life of Jacques de Claeuw have been discovered. He was a painter of still-life—principally of *vanitas* motifs—active in Dordrecht, The Hague and Leyden. He was born in Dordrecht, where, in 1642, he was one of the founders of the guild. In 1646 he joined the painters' guild in The Hague, and there, in 1649, he married one of van Goyen's daughters, thus becoming the brother-in-law of Jan Steen (q.v.). In 1651 he is re-recorded as having been in Leyden. His last dated work is of 1676.

CODDE, *Pieter*

Born in Amsterdam and baptized on 11 December 1599, Codde was an artist of great talent but less originality. The events of his life were unremarkable and he has left few traces in the records. He married in Amsterdam in 1623 and appears to have lived there throughout his life.

He painted portraits, merry company subjects and barrack-room scenes. His most challenging task, which he fulfilled admirably, was to complete the large militia company portrait, the so-called *Meagre Company*, left incomplete by Frans Hals in 1636. Codde skilfully painted half-a-dozen life-size figures to match the ten by Hals and worked over the entire composition to bring it to completion. Though he lived until 1678 (he was buried in Amsterdam on 12 October 1678), Codde never emulated the painters of the Delft or Leyden schools.

CUYP, *Aelbert*

Born in Dordrecht in October 1620, Aelbert Cuyp (properly spelt 'Cuijp') was the son and pupil of the painter Jacob Gerritsz. Cuijp. Though a skilled portraitist like his father, Aelbert Cuyp was a landscape-painter throughout his life; he was indeed one of the three great landscape-painters of the middle decades of the century, and in his diversity second only to the great Jacob van Ruisdael. His development is not too easy to follow as he seldom dated his canvases, but is not hard to deduce that those are his early paintings that most closely emulate the long, low, monochrome landscapes of Jan van Goyen. Living in Dordrecht throughout his life, Cuyp can never have visited Italy, but some time after 1640, when such artists as Asselijn had begun to return from Rome, he discovered in their work the magical light of the Roman Campagna. After 1646, Cuyp developed a pure, clear, architectural style of painting, which treated the lowlands, the estuaries and the waters round Dordrecht with the light of Claude and which, nevertheless, seldom give the impression of being contrived. Although the motif most readily associated with his name is a group of ruminating cows, painted as if they were mountains gilded by the setting sun, Cuyp's range of subjects was wide. He travelled about his own land of the United Provinces, especially exploring the great rivers—the Rhine, the Maas and the Waal—which made Dordrecht so important and wealthy a town. Cuyp was one of the well-off and respected members of the community. He had married well, in 1658, and he owned a fine house in Dordrecht

as well as a country seat near by. He died in Dordrecht in November 1691.

DOU, *Gerrit*

Born in Leyden on 7 April 1613, Dou was the son of a glass-engraver, Douwe Jansz., and was himself trained as a glass-engraver. He worked in his father's shop and was a member of the glaziers' guild at the age of twelve. On 14 February 1628, when he was not yet fifteen, he became a pupil of the twenty-one-year-old Rembrandt, with whom he probably stayed until Rembrandt moved to Amsterdam in 1631 or 1632. Dou was one of the first members of the Leyden painters' guild when it was founded in 1648 and quickly became enormously successful with his small, highly detailed paintings, which recalled the tradition of the van Eycks as much as the early work of Rembrandt. He is reputed to have spent five days on the under-painting of one hand of a woman who sat for a portrait. High prices were paid for his work, and he was invited to visit England by Charles II. However, he refused to leave Leyden. Dou had many pupils and followers and the tradition of the so-called *fijnschilders* (fine painters) of Leyden continued until the nineteenth century. Dou died in Leyden in 1675.

DUCK, *Jacob*

Born about 1600, Jacob Duck was the Utrecht specialist in guardroom subjects. Little is known of his career. He was inscribed as an apprentice in Utrecht in 1621, and became a master there in 1632. He was still in Utrecht in 1646, but between 1656 and 1660 he moved to The Hague. Nothing is known of him after 1660.

DU JARDIN, *Karel*

Occasionally signing himself 'du Gardin', du Jardin was probably the son of a painter, Guilliam du Gardin, and may have been born in Amsterdam about 1622 (in 1672 his age is said to be about 50). His master is said to have been Nicolaes Berchem. He went to Rome and joined the *schildersbent* or Netherlandish painters' society, where he was given the nickname of 'Bokkebaart' (goat's beard). He

was in Amsterdam in 1650, travelled to Lyons, where he married, and was once more in Amsterdam in 1652. In October 1655 he moved to The Hague, where he joined the newly formed painters' society 'Pictura'. After another move to Amsterdam, he returned to Italy in 1675 and died in Venice in November 1678. Most of his work was of landscape in Berchem's manner, but he painted occasional classical and religious subjects.

EVERDINGEN, *Allart van*

Born at Alkmaar and baptized on 18 June 1621, Everdingen was the younger brother of Cesar van Everdingen, who was also a painter. He was a pupil of Roelandt Savery, the Flemish landscape-painter, and, later, of Pieter de Molijn. He travelled to Sweden with a patron in 1644, and when he returned, introduced a repertory of Scandinavian motifs, mountains, waterfalls and log cabins, which became popular and influenced the greater landscape-painter, Jacob van Ruisdael. In February 1645 he married in Haarlem and he joined the guild there later that year. He finally moved to Amsterdam, where he died in 1675.

FABRITIUS, *Carel*

Born at Midden-Beemster and baptized on 27 February 1622, Carel Pietersz., was the son of a schoolmaster. He seems to have adopted the surname Fabritius because his first training was as a carpenter (*faber* is Latin for a worker in hard materials). It was probably in the early 1640s (while the painter and historian Samuel van Hoogstraten was also a pupil) that Fabritius became a pupil of Rembrandt, though no doubt he had already had some training from his father, who used to paint in his spare time. His earliest works certainly show a dependence on Rembrandt's history paintings, particularly the *Night Watch*. His career throughout is obscure and at no time more so than in these early years. Between 1641 and 1643, he was married, had two children, both of which he lost, and was widowed, but whether he was living in Midden-Beemster or Amsterdam is uncertain. In 1650 his betrothal to a second wife is recorded in his native town,

but the couple is said to be already living in Delft. Certainly it was in Delft that he spent his few remaining years and it was there that he made his important and original contribution to art. He was fascinated by perspective constructions, as his painting (Plate 120) in the National Gallery, London, demonstrates. His concern for light effects and for the representation of scenes from daily life had a powerful influence on the art of Johannes Vermeer. Fabritius died as a result of injuries received in the great Delft explosion of 12 October 1654 (see note to Plates 119, 120 and 121).

FLINCK, *Govert*

Born at Cleves on 25 January 1615, Flinck is said to have been sent to Leeuwarden in Friesland to study with Lambert Jacobsz., and from there to have travelled to Amsterdam with his fellow pupil, Jacob Backer, where he studied with Rembrandt. Flinck passed the rest of his life in Amsterdam, where he met with considerable success. In 1642 and 1643, he painted groups to hang in the same grand hall of the Kloveniersdoelen as Rembrandt's *Night Watch*, and thereafter it was to Flinck rather than to his master that the civic authorities and other public bodies turned when giving commissions. In 1656 he painted a *Solomon praying for Wisdom*, and soon afterwards a *Marcus Curius Dentatus* for the new Amsterdam Town Hall, for which he was well paid. In 1659 he was commissioned to paint an important series of twelve compositions for the Great Gallery of the Town Hall—eight of the struggle between the Batavians and the Romans and four of patriots of the ancient world—at 1,000 guilders each. Before he could do more than sketch the designs, he died in Amsterdam on 2 February 1660.

GOYEN, *Jan van*

Born in Leyden on 15 January 1596, van Goyen (who frequently spelt his name 'Goien' before 1627) is reported to have been the pupil of many masters. He studied first in Leyden and then at Hoorn. After working for a time in Leyden, he travelled in France for a year before arriving in Haarlem for the decisive period of his education, about 1617. He was then taught for a year by Esaias van de Velde. By the time he was 21 years old, van Goyen must have acquired the insight which, in the course of the following decade, led to a renovation of landscape painting. The developments of that decade are obscure. Esaias van de Velde was at The Hague after 1618, van Goyen appears to have returned to his native Leyden the same year, when he is recorded as marrying there, and Pieter de Molijn and Salomon van Ruysdael were living in Haarlem. Initially inspired by Esaias van de Velde, these artists developed in parallel, as it were, the new landscape art of the 1620s. There is no doubt, though, of van Goyen's power and originality; his art continued to develop throughout his life. It is tempting to relate the fluency and bravura of his pictorial style with his restless spirit as it was manifested in his career. He was a picture dealer and valuer, arranging auction sales and speculating in land, houses and tulip bulbs. Shortly after Esaias van de Velde had died there, he moved to The Hague in 1631, where he remained for the rest of his life, acquiring citizenship in 1634. In 1649 his daughter Margaretha married Jan Steen (q.v.), and the same year another daughter married Jacques de Claeuw (q.v.). In 1651 he painted a panoramic view of the town for the Burgomaster's room at the Stadhuis in The Hague. He died in The Hague on 27 April 1656.

HALS, *Frans*

There is no known record of the time and place of Frans Hals's birth. His father was a cloth-worker from Mechelen and his mother came from Antwerp. According to one tradition Frans was 85 when he died, which would make the year of his birth 1580 or 1581; another report states that he was born in 1584. As his parents moved from Mechelen to Antwerp about 1581, his beginnings are quite obscure. They continue in obscurity for a good many years. His parents were in Antwerp in 1585 and in Haarlem by 1591, where Frans's younger brother, Dirck (who also became a painter), was baptized on 19 March. Theirs was one of the more than 600 families of Flemish

textile workers who left the South for Haarlem after 1585. Nothing certain is known, either, about Hals's training or his early work. He is reputed to have been the pupil of the painter, historian and poet, Carel van Mander, but this is not confirmed in any second source, and there seems to be no trace of van Mander's influence on Hals's style. But then, no work can be attributed to him with any certainty before 1611, when he was not younger than twenty-six and probably nearer thirty. He joined the Guild of St Luke in Haarlem in 1610 and married about the same time. His first child, Harmen, who also grew up to be a painter, was born in 1611 and in 1615 his wife died, leaving him with two children. She was buried in a pauper's grave, which is the first evidence of what has become established as Hals's financial condition. In 1617, Hals remarried. The banns were published on 15 January, the ceremony was on 12 February and a daughter, Sara, was baptized on 21 February. Hals's second wife, who was illiterate, bore him at least eight children and lived to be over eighty, surviving him by eight years. Three of Hals's sons by this marriage became painters, Frans Fransz. Hals the Younger, Reynier Fransz. Hals and Nicolaes Fransz. Hals. There was also Johannes Fransz. Hals (who was also a painter), but it is not certain whether he was of the first or second marriage. Counting sons, brothers and a nephew, there were nine members of the family, all named Hals, who were painters. Frans Hals began to make his reputation as a portrait-painter in 1616, when he was commissioned to paint the *Banquet of the Officers of the St George Militia Company*. But portrait-painters were not held in very high esteem in Hals's day. Although he received commissions and trained apprentices or pupils, he was never widely famed and his finances were always precarious. His refusal to travel to Amsterdam to finish a group portrait of a militia company in the 1630s suggests that his frequent money troubles were of his own making. (The nineteenth-century tradition that he was also a drunkard and wife-beater was, however, a case of mistaken identity. The document probably referred to a Haarlem weaver of the same name.) Bills were unpaid: in 1635 he failed to pay his guild dues.

Other troubles followed. In 1642 his son Pieter was committed to an institution because he was dangerous, and in the same year his daughter Sara had an illegitimate child. In 1654 a baker seized his property to settle a bad debt. In 1661 the Guild exempted him from payment of the annual dues. In 1663 and in the years that followed he received a grant from the municipality. In 1664, at his request, he was given three cartloads of peat. He died on 29 August 1666 in his mid-eighties and on 1 September was buried in the choir of St Bavo's Church in Haarlem.

HEEM, *Jan de*

Born in Utrecht in 1605 or 1606, Jan de Heem was the best-known of a family of still-life and flower painters. It was in his youth, in Leyden, where he worked from about 1625 to about 1629, that he painted still-lifes in the Dutch tradition. In those years his favourite theme was a pile of worn and torn books, which were an emblem of the futility of earthly knowledge and one of the *vanitas* motifs popular in Leyden at the time. In 1636 he moved south to Antwerp and became a citizen there the following year. He became the outstanding exponent of the flamboyant table-piece, popular in the southern Netherlands, showing tables overflowing with fruit, game and other luxuries. He died between October 1683 and May 1684.

HELST, *Bartholomeus van der*

The son of an innkeeper in Haarlem, Bartholomeus van der Helst was probably born in 1613, though his age as given in later documents would place his birth either a year earlier or a year later. His early pictures recall the style of Nicolaes Eliasz. of Amsterdam and suggest that he was a pupil of Eliasz., as he was in Amsterdam by 1636. His earliest dated work is of 1637. Van der Helst became the most fashionable portrait-painter of his day, bringing a little of van Dyck's elegance to his representations of regents and naval officers. He painted two major militia group portraits and also some other guild group portraits. He was buried in Amsterdam on 16 December 1670.

HEYDEN, *Jan van der*

Born at Gorinchem in 1637, van der Heyden had moved with his family to Amsterdam by 1650. He was said to have been the pupil of a glass-painter. His preferred subject was architecture or townscape and many of his works were topographical, but he was also capable of architectural fantasies. As can be seen from his works, although he lived in Amsterdam all his life, he travelled in the southern Netherlands and Germany. In addition to painting, he organized Amsterdam's street-lighting and its fire brigade. He is said to have invented the fire hose and he published a monograph on it in 1690. He died in Amsterdam on 28 March 1712.

HOBBEMA, *Meyndert*

Born in 1638 in Amsterdam, Meyndert Lubbertsz. adopted the name Hobbema as a young man, though it does not appear to have been used by his father. He was a pupil of Jacob van Ruisdael, who testified in 1660 that Hobbema 'served and learned with me for a few years'. Though he learned from the example of other landscape artists, Hobbema was very close to his master for several years, even on one occasion basing a painting on an etching by Ruisdael. By the time he was twenty-five, Hobbema was at the height of his powers and the rival of his master. Though he never achieved the range or profundity of Ruisdael, he was a much more fluent painter and his sparkling, tightly wrought, and well-wooded landscapes, though repetitious, are approaching perfection. Then, in 1668, his thirtieth year, he married the kitchen-maid of an Amsterdam burgomaster and became one of the wine-gaugers of the Amsterdam octroi, a form of customs and excise officer. The post was well-paid and he held it to the end of his long life, a further forty-one years. And for forty-one years, he appears to have painted little. Until recently it was believed by art historians that he had stopped painting altogether after 1668. For a long time the date on the famous *Avenue, Middelharnis* in the National Gallery, London, was read as 1669 because it appeared incredible that this masterpiece had been painted long after Hobbema's other major works. But as a result of recent cleaning the date has been shown to be 1689, and now more paintings—though still relatively few—have been related to those later years. Hobbema died in Amsterdam on 7 December 1709.

HONTHORST, *Gerrit van*

Born in Utrecht on 4 November 1590, Honthorst, the son of a painter of tapestry cartoons, was first trained by Abraham Bloemaert in Utrecht and later went to Rome. Influenced strongly by the work of Caravaggio, Honthorst soon became much in demand in Rome. He was patronized by the Marchese Vincenzo Giustiniani and by Cardinal Scipione Borghese, who was later also the patron of the sculptor Bernini. On his return to Utrecht, in 1620, Honthorst came to play a leading role in the civic life of the town, being dean of the painters' guild on four occasions between 1625 and 1629. In 1628 he spent six busy and profitable months in England at the invitation of Charles I. After his return to Utrecht he remained an internationally admired figure. His later works—especially those painted for the Court of Denmark and for the Stadholder in Holland—were dryly classicist. Honthorst died, still successful, in Utrecht in 1656.

HOOGH, *Pieter de*

Baptized in Rotterdam on 20 December 1629, Pieter de Hoogh (who often spelled his name 'de Hooch' in his earlier days) was the son of a stonemason. He was probably the pupil of Nicolaes Berchem, the landscape-painter, in Haarlem, though his own earliest pieces are barrack-room scenes recalling those of Codde and ter Borch. In 1653 he is recorded in the service of a cloth-merchant who lived in Delft; de Hoogh is called a servant and painter. In May 1654 he married and settled in Delft, and in September the following year he entered the Delft guild. Which of the Delft painters he knew well is not recorded: he may have become acquainted with Carel Fabritius before the fateful explosion of October 1654 in which the latter was killed. It was in those years in Delft that de Hoogh painted his best works, works that establish him as the great poet of the Dutch domestic interior,

the rival of that other great painter from Delft, Johannes Vermeer. Unlike Vermeer, whose preferred subject was a solitary woman in the corner of a room, de Hoogh did show family life. Though men seldom intrude, his interiors are occupied with the activities of the home; his women are wives and mothers, mistresses of the household, accompanied by children and servants. The true subject of de Hoogh's Delft paintings, however, is the Dutch house itself, its spaces and vistas, its open doors and windows through which the world is seen. These canvases offer a microcosm of Holland in the seventeenth century. At some time between 1660 and 1663, de Hoogh moved to Amsterdam, and his work, perhaps under the influence of work by Maes and de Witte, began to deteriorate. There is evidence that he continued to live in Amsterdam until 1670, and there are paintings dated as late as 1684, but the year and place of his death are not known.

HOOGSTRATEN, *Samuel van*

Born in Dordrecht on 2 August 1627, Hoogstraten was first the pupil of his father, then, some time after his father's death in 1640, he entered Rembrandt's studio, where a fellow pupil was Carel Fabritius. The two young painters probably influenced each other: certainly both showed great interest in geometrical perspective, and Hoogstraten constructed peep-shows with *tromp l'oeil* scenes inside. Hoogstraten travelled widely, visiting Rome and Vienna, where he was patronized by the Emperor. He was in London in 1666, at the time of the Great Fire. He finally settled in his native town where he was made a Provost of the Mint. His major contribution to art was a book, *Inleyding tot de Hooge Schoole der Schilderkonst*, an introduction to the art of painting, and one of the few handbooks on painting published in Holland in that century. He died in Dordrecht on 19 October 1678.

HUIJSUM, *Jan van*

Born in Amsterdam on 15 April 1682, Huijsum was first taught by his father, Justus van Huijsum the Elder, who was a flower painter. Jan grew up to be perhaps the best

and most famous of all flower painters; called by his contemporaries in the early years of the eighteenth century 'the phoenix of all flower painters', he could command high prices. Collectors often paid more than 1,000 guilders for a single work. Huijsum's life was uneventful. He lived and died in Amsterdam, and had only one pupil, Margaretha Haverman, though his younger brother, Jacobus, and many other painters imitated him. He died on 8 February 1749.

KALF, *Willem*

Born in Rotterdam in 1619, Willem Kalf was the greatest still-life painter of his generation. Occasionally, throughout his life, he painted small scenes of kitchens and barns, but his most typical and most popular works were the so-called *pronken* (ostentatious) still-lifes that showed costly artifacts of metal, glass and porcelain. Kalf was in Paris between 1642 and 1646. In 1651 he married, at Hoorn, a talented woman, Cornelia Fluvier, who was a diamond-engraver, calligrapher and poet. In 1653 he settled in Amsterdam, where he worked until his death in 1693.

KEYSER, *Thomas de*

Born in Amsterdam in 1596 or 1597, the son of the Amsterdam sculptor and architect Hendrick de Keyser, Thomas de Keyser was one of the two most successful portrait-painters of his native town before the arrival of Rembrandt. He was his father's pupil from 1616 to 1618. His earliest surviving dated work is a group portrait of Amsterdam surgeons of 1619. He married in 1626. In 1640 he entered the Amsterdam stonemasons' guild and from then on, for a number of years, he was active as a stone merchant and painted less. In 1662 he was appointed stonemason to the town of Amsterdam. He died there in 1667 and was buried on 7 June.

KONINCK, *Philips*

Born in Amsterdam on 5 November 1619, Koninck was chiefly known as a painter of portraits and contemporary life, but today his landscapes are most admired. In 1629 he was the pupil of his elder brother, Jacob, in Rotter-

dam. He moved to Amsterdam, where, according to one source, he was a pupil of Rembrandt. This has not been corroborated, but Koninck's earlier work shows Rembrandtesque features. His landscapes are unmistakably evolved from those of Hercules Seghers. Koninck's life was uneventful. He died in Amsterdam and was buried there on 6 October 1688.

LASTMAN, *Pieter*

Probably born in Amsterdam in 1583, Lastman is best known today as the teacher of Rembrandt. This is to underestimate his real abilities as a painter. In 1604 he was in Italy, whence rumours of his great promise were brought to Carel van Mander writing in Haarlem. In Rome, Lastman was influenced by the work of Caravaggio and Elsheimer, both of whom he may have met. He arrived back in Amsterdam between 1605 and 1607 and lived there for the rest of his life. He was one of the most influential painters of his day in Holland and one of the very few to practice the high art of history painting. He was also the teacher of Rembrandt's contemporary, Jan Lievensz., of Leyden. Lastman died in 1633.

LEYSTER, *Judith*

Born in Haarlem and baptized on 28 July 1609, Judith Leyster was the daughter of a Flemish-born brewer, who took his surname from his brewery in Haarlem, the *Leysterre* (or Lodestar). One of Frans Hals's most talented followers, she was also precocious; when only eighteen she was mentioned as one of Haarlem's artists by Samuel Ampzing. The following year, 1628, her parents moved to Vreeland, near Utrecht, where she seems to have discovered the work of ter Brugghen. She was a member of the Haarlem guild by 1633 and soon had pupils. In 1636 she married the painter Jan Molenaer (q.v.), and the following year they moved to Amsterdam. In 1648 they moved to Heemstede, near Haarlem, where she eventually died in 1660, eight years before her husband.

LOO, *Jacob van*

Born at Sluys about 1614, Jacob van Loo was a pupil of his father, Johannes. After 1642, he lived in Amsterdam, where he acquired a high reputation. Following a murder committed in 1660, he was banished and went to Paris, where he was accepted as a member of the Académie Royale in 1663. He painted in various styles, and in his years in Paris modified the manners acquired from ter Borch and Maes under the influence of French academicism. He died in Paris in 1670.

MAES, *Nicolaes*

Born in Dordrecht in January 1634, Maes was probably a pupil of Rembrandt about 1650. His earliest surviving works are religious subjects in Rembrandt's manner of the later 1640s, but he soon developed a style of his own, when he returned to Dordrecht some time before 1654. There he began to paint small scenes of daily life, usually of servants and the kitchen. The best of these are delicately handled, with a concern for light effects which may have influenced de Hoogh. But many canvases are repetitions of early motifs executed in a coarsened chiaroscuro only vaguely reminiscent of Rembrandt. He was also in demand as a portraitist. He is said to have visited Antwerp in the 1660s and in 1673 he settled in Amsterdam, where he died in 1693.

METSU, *Gabriel*

Born in Leyden in 1629, Metsu is said to have been a pupil of Gerrit Dou, though his work only occasionally shows traces of Dou's detailed manner. Metsu's art is very uneven, both in style and quality. Though he paints the motifs of the Leyden and Delft schools, his manner is more reminiscent of contemporary Flemish painting. But he also produced paintings that recall ter Borch and others that resemble earlier works by Maes and later works by de Hoogh. The best-known of his pictures, the *Sick Child* (Plate 71), suggests a knowledge of the art of Emanuel de Witte. Metsu was, all the same, a gifted painter, and his works are often delightful. He lived in Leyden, off and on, until after 1654, but by 1657 he had settled in Amsterdam. He married there in 1658 and lived there until his death in 1667.

MIERIS, *Frans van, the Elder*
Born in Leyden on 16 April 1635, Frans Jansz. van Mieris the Elder was the son of a goldsmith, said by his parents to be one of the last of twenty-three children. He studied painting with Gerrit Dou, who called him the 'Prince of my pupils'. Certainly van Mieris's technique is worthy of comparison with that of his master, but his subjects more often recall those of ter Borch, Jan Steen or Metsu. Van Mieris entered the Leyden guild in May 1658 and became dean in 1665. He was extremely popular with the collectors of his day. He was called on by the Grand Duke Cosimo III of Tuscany, who visited the United Provinces in 1667, and the Archduke Leopold Wilhelm invited him to work at the court in Vienna. Van Mieris refused and stayed in Leyden until his death on 12 March 1681.

MOLENAER, *Jan*
Born in Haarlem about 1609 or 1610, Jan Miensz. Molenaer was one of the first painters of the new commonwealth of the United Provinces to specialize in scenes of contemporary life. He painted a variety of subjects. Some of his merry company pictures recall those of the Haarlem painters of his generation; others—the majority—of his works show peasant revels, in the manner of that other contemporary, Adriaen van Ostade. He is said to have been a pupil of Frans Hals, but this has never been documented, and his canvases more closely resemble those of Hals's brother Dirck. In 1636 Molenaer married Judith Leyster (q.v.). By 1637 they had moved to Amsterdam, and in 1648 they moved to Heemstede, near Haarlem. He was buried in Haarlem on 19 September 1668, having survived his wife by eight years.

NEER, *Aernout (Aert) van der*
Although he was probably born in 1603 or 1604, Aernout van der Neer came to painting late. According to Houbraken, he was a steward (*majoor*) with a family at Gorinchem in his earlier days and only became a professional painter when he moved to Amsterdam in the early 1630s. The earliest known dated canvas by him is of 1635. He specialized in winter and moonlit landscapes. His work is highly repetitive, although his best canvases are suberb, showing great richness and subtlety. Between 1659 and 1662, he kept an inn in Amsterdam, but by December 1662 he was declared bankrupt. He died in Amsterdam on 9 November 1677.

NETSCHER, *Caspar*
The date and place of Netscher's birth is not certain, but most probably it was in Prague in 1635 or 1636. According to one report he was taken, as a child, to Arnhem, where he first began his training as a painter with Herman Coster, and then went to Deventer, to study with Gerard ter Borch. He certainly painted small genre scenes in the manner of ter Borch. At the age of twenty-one he left for Rome but got no further than Bordeaux, where he married in 1659. By 1662 he had moved to The Hague, where he spent the rest of his life. From then on he specialized in small, elegant, half-length protraits of the aristocracy. He died in The Hague on 15 January 1684.

OSTADE, *Adriaen van*
Born in Haarlem and baptized on 10 December 1610, Adriaen van Ostade is said to have been a pupil of Frans Hals. But his earlier works more strikingly resemble those of Adriaen Brouwer while his later ones show the influence of Rembrandt. He specialized in scenes of peasant life, often comical, occasionally grotesque, but in principle intended to show, like Bruegel's canvases, the condition of mankind. By the middle of the century, his work became more respectable. Van Ostade's output was vast, and he was well-to-do and respected in his community. He was dean of the Haarlem guild in 1662. In 1657 he was converted to Catholicism and married a wealthy Catholic woman from Amsterdam. He died in Haarlem and was buried there on 2 May 1685.

OSTADE, *Isack van*
Born in Haarlem and baptized on 2 June 1621, Isack van Ostade was the younger brother and pupil of Adriaen van Ostade. His first works bear a strong resemblance to those of his brother but he quickly developed a style of

his own. His preferred motif was a delicate combination of genre and landscape, showing crowds of people, usually peasants in the open air. His earliest known dated picture is of 1639 so he was active for perhaps only a decade before he died, but in that time he showed a talent which even outshone his brother's. He died in Haarlem in 1649, aged 28, and was buried on 16 October.

PIJNACKER, *Adam*
Born in 1622, Pijnacker was a Delft painter. He is said to have spent three years in Italy, and his works confirm this. He was of the second generation of Italianate painters, and less concerned than his predecessors with classical motifs or with the art of Claude. He was strongly influenced by the example of his own compatriot, Jan Both. His early pieces, although infrequently dated, can be identified by the golden lighting. Later, his light becomes more silvery and he picks out details of texture in, for example, the bark of a tree which are almost surrealist in effect. He also produced large decorative wall hangings for the richer burghers of Amsterdam, but most of these are now forgotten and inaccessible. He died in 1673.

POEL, *Egbert van der*
Born in Delft and baptized on 9 March 1621, van der Poel began by painting interiors of stables and cottages, canal and winter landscapes and coast scenes. He entered the Delft guild in October 1650. He married at Maasluis, near Rotterdam, in 1651 and settled there permanently in 1655. But he was almost certainly in Delft on 12 October 1654 when a powder magazine blew up, taking part of the town and a good many citizens with it (see Plate 119 and note). Van der Poel witnessed the disaster and painted at least a dozen versions of the scene. For the last decade of his life he specialized in nocturnal scenes, frequently showing fires. He was buried in Rotterdam on 19 June 1664.

POELENBURGH, *Cornelis van*
Probably born in Utrecht in 1586, Poelenburgh may have been a pupil of Abraham Bloemaert. He was in Rome by 1617, and was one of the first members of the *schildersbent* (the club formed by Netherlandish painters in Rome), being given the nickname of 'Satyr'. His works were principally, though by no means entirely, landscapes of a classical type. He was especially admired for arcadian scenes inhabited by plump nudes. It was a kind of justice that when Rubens visited Utrecht in 1627, Poelenburgh was chosen to be his guide. Ten years later, in 1637, he went to England at the invitation of Charles I. He was dean of the Utrecht painters' college in 1657 and 1658. He was buried in Utrecht on 12 August 1667.

POTTER, *Paulus*
Baptized at Enkhuizen on 20 November 1625, Potter was a specialist painter of limited talent who nevertheless gained great fame both in his life and in the centuries following. His special skill was for animals. His most famous work is the life-size *Young Bull* of 1647, now in the Mauritshuis, The Hague. His style was of an earlier generation, and though he often showed great perception in his observation of animal behaviour, his work is seldom totally successful. At The Hague by 1649, he worked for the House of Orange, and in 1653 Dr Nicolaes Tulp (see Plate 42) persuaded him to visit Amsterdam to paint an equestrian portrait of his son. Potter died young in Amsterdam and was buried there on 17 January 1654.

QUAST, *Pieter*
Born in Amsterdam, probably in 1605 or 1606, Quast was a painter of low life and satyrical subjects. He also painted military subjects, in the tradition of the Amsterdam painters Duyster and Codde, and illustrated proverbs in the manner of Adriaen van de Venne. In 1634 he joined the guild at The Hague, but by 1644 he had returned to Amsterdam, where he remained until his death in 1647.

REMBRANDT
Born in Leyden on 15 July 1606, Rembrandt van Rijn was the son of a miller, Harmen Gerritsz. van Rijn. On 20 May 1620, he was inscribed as a student of Leyden

University, when his age was given as already fourteen. He appears not to have attended the university for long, if at all, and was put as a pupil with a Leyden painter, Jacob Isaacksz. van Swanenburgh. In 1624 or 1625 he was sent to Amsterdam to the celebrated painter Pieter Lastman, with whom he stayed for six months. He is said also to have studied with Jacob Pynas, from whom he learned to paint in grisaille. About this time he seems to have met Jan Lievensz. and when he returned to Leyden, probably in 1625, to become a professional artist, they often collaborated and may have shared a studio. By 1628, Rembrandt, aged twenty-one, had his first pupil, Gerrit Dou, who was with him for about three years. It was about this time that he was discovered by Constantijn Huygens (see Plate 29), who, as secretary to the Stadholder, later obtained for Rembrandt a commission for five scenes of the *Passion of Christ*, which were painted for the Prince of Orange between 1633 and 1639. Between June 1631 and July 1632, Rembrandt moved to Amsterdam, where he painted his first successful group portrait, *Dr Nicolaes Tulp demonstrating the Anatomy of the Arm* (Plate 43). On moving to Amsterdam, he lodged with an art-dealer, Hendrick van Uylenburgh, and Uylenburgh must have introduced him to his niece, Saskia van Uylenburgh, whom Rembrandt married on 22 June 1634. During the following decade, Rembrandt was very successful. He was in demand as a portrait-painter, he had many pupils, and he bought works of art himself. His only sorrows must have been the deaths of three children, each soon after birth. Otherwise Rembrandt and Saskia lived in the grand style. In 1638 they were accused by members of Saskia's family of squandering her dowry in a 'flaunting and ostentatious manner'. In 1639 they moved into a grand house in the Breestraat, for which the price was 13,000 florins. Then the tide turned. In 1642, the year of his greatest professional success, the painting of the *Night Watch* (Plate 66), Saskia died, leaving Rembrandt with their only surviving child, Titus, still less than a year old. Rembrandt's professional reputation did not immediately or dramatically decline. His works were still sought after by amateurs. A Sicilian nobleman, Don

Antonio Ruffo, commissioned three canvases from him between 1652 and 1663. Rembrandt still received portrait commissions, too. For a number of years a friend and patron was Nicolaes Tulp's son-in-law, Jan Six (Plate 88). After 1660, Rembrandt was given a commission for a decoration for the new Amsterdam Town Hall. And in 1667, on a visit to Amsterdam, the Grand Duke of Tuscany went to Rembrandt's studio, where he bought two self-portraits. But from the moment of his purchase of the house in Breestraat (1639) Rembrandt was never out of debt. For sixteen years he struggled, constantly borrowing from new creditors to satisfy the old. In 1656, to avoid bankruptcy, he applied for the liquidation of his property. An inventory was drawn up, and the following year the first sale of his enormous collection of paintings and curios took place. In 1660 Rembrandt had moved to rooms in a suburb of Amsterdam, and on 15 December of that year, in order to protect him further from creditors, Hendrickje Stoffels, who had lived with him since about 1645, and his nineteen-year-old son, Titus, formed a company for art dealing of which he was the nominal employee. Rembrandt died in Amsterdam on 4 October 1669, in the deepest poverty, survived only by his illegitimate daughter, Cornelia, his recently widowed daughter-in-law and a seven-month-old granddaughter, Titia.

RUISDAEL, *Jacob van*
Born in Haarlem, possibly in 1628 or 1629, Jacob Isaacksz. Ruisdael was the single outstanding landscape-painter of the second half of the seventeenth century: though Cuyp and Hobbema may be put alongside him, they are not his equal, either in range or in profundity. Ruisdael's father was a frame-maker who dealt in works of art and also painted landscapes, though no works by him have been identified. Jacob's uncle was Salomon van Ruysdael, and his influence can be seen in Jacob's earliest works. But Jacob matured early and was an independent master by 1646, when he was probably only eighteen. He was a member of the Haarlem Guild of St Luke in 1648. Some time about 1650, he travelled to the German bor-

der, perhaps with Nicolaes Berchem, who is said to have been a great friend. That rolling, wooded country made a lasting impression on him, and one of his greatest inventions was his painting of *Bentheim Castle*. But Ruisdael was not limited to landscapes based on his own experience. Shortly after 1660, he was inspired by the landscape paintings made by Allart van Everdingen after visiting Scandinavia in the 1640s. By June 1657 Ruisdael had settled in Amsterdam, though his works suggest he occasionally travelled about the country. There is also the possibility that he took a degree in medicine at Caen, in France, in 1676 and was inscribed in (and later scored out of) the list of Amsterdam doctors. The probability, though, is slight, and it is more likely that there was another Ruisdael in Amsterdam at that time. Similarly, it was not he but his cousin, Jacob Salomonsz. van Ruysdael, who died in the Haarlem poorhouse on 13 November 1681. Jacob Isaacksz. continued to live and work in Amsterdam for the rest of his life, though he apparently painted less in his later years. He seems to have died in Amsterdam, but was buried in Haarlem on 14 March 1682.

RUYSDAEL, *Salomon van*

Born at Naarden in Gooiland, some time between 1600 and 1603, Ruysdael was known originally as Salomon de Gooyer (i.e. from Gooiland), as his father had been known as Jacob de Gooyer. He lived in Haarlem all his life and was one of the leading landscape-painters of the new generation that established the quality and ideals of native Dutch landscape painting between 1612 and 1640. His earliest works are in the manner of Esaias van de Velde and there are affinities in his early style with that of Jan van Goyen. But his mature work is quite individual while being, unmistakably, the triumphant climax of a generation's search for a style. Although it is as a landscape-painter that he is best known, he occasionally painted still-life pictures as well. He was the uncle of Jacob van Ruisdael and the father of another painter, Jacob Salomonsz. van Ruysdael. He was buried in Haarlem on 3 November 1670.

SAENREDAM, *Pieter*

Born at Assendelft on 9 June 1597, Pieter Jansz. Saenredam was the son of an engraver, Jan Pietersz. Saenredam, who made engravings after many of the most famous artists of the day, including Goltzius and Bloemaert. Jan Saenredam died in 1607, and two years later, Pieter and his mother moved to Haarlem. In May 1612 Pieter was apprenticed to Frans Pietersz. de Grebber, a painter of history paintings and portraits. Saenredam seems to have been a slow developer, for he remained with de Grebber for ten years, until 1622. In 1623 he entered the painters' guild in Haarlem, but of the work of the preceding or immediately following years, only two sheets of drawings have survived. Then, in 1626, he was given the commission to make illustrations, including maps, for the history of Haarlem by the Reverend Samuel Ampzing, published in 1628. It was for this history that he made his first drawing of the interior of the great church of St Bavo in Haarlem, a building that provided him with motifs throughout his life, as from then on he devoted himself almost exclusively to painting the interiors of churches. It is likely that his friendship with the architect Jacob van Campen was not unconnected with his grasp of the geometry of perspective that he used throughout his career. Saenredam lived and died in Haarlem, though in order to obtain material he made brief excursions to 's Hertogenbosch (in 1632) Assendelft (1633), Alkmaar (on three occasions), Utrecht (1636), Amsterdam (1641) and Rhenen (1644). He was able to hoard drawings made on these trips and use them for paintings many years later. Saenredam was a respected member of the Guild of St Luke in Haarlem, of which he was secretary, steward and even dean, during his life. He was buried in Haarlem on 31 May 1665.

SEGHERS, *Hercules*

Born in Haarlem, probably in 1589 or 1590, Seghers became the most inventive and influential landscape-painter of Holland. He was probably a pupil of Gillis van Coninxloo in Amsterdam for a couple of years before the latter's death in 1607. He entered the Haarlem guild in

1612, the same year as Esaias van de Velde, but probably returned to Amsterdam two years later, in 1614, staying there until he moved to The Hague, some time between 1629 and 1633. After January 1633, there is no further record of him. Though he painted relatively few paintings, the extent of his influence is inestimable. All later Dutch landscape owed a debt to his example.

STEEN, *Jan*

Born in Leyden, probably in 1625 or 1626, Jan Steen must be placed among the first half-dozen painters of seventeenth-century Holland. His comic gift, which is itself of the highest order, should not obscure his amazing genius as a painter and draughtsman. Steen was inscribed as a student at Leyden University in November 1646, when he was said to be twenty. His teachers are said to have been Adriaen van Ostade in Haarlem and Jan van Goyen in The Hague. In October 1649 Steen married van Goyen's daughter Margaretha. Having spent most of his life in Leyden before his marriage, he then moved to The Hague, where he stayed for five years, until 1654. His father, who was a brewer, then leased a brewery for him in Delft from 1654 until 1657, though there is no evidence that he ever stayed long there. In 1661, he entered the Guild of St Luke in Haarlem, where he stayed until 1670, returning to Leyden after he had inherited a house there. During all these movements, Steen kept a sharp eye on the work of his contemporaries. He must have seen Metsu's art in Leyden, and de Hoogh's and Vermeer's in Delft. Above all, in Haarlem, he discovered and admired the work of Hals. Hals's *Peeckelhaering* (Plate 22) is shown in two of Steen's interiors, one of which is '*The Physician's Visit*' (Plate 130). But Steen's art is unique. With some debt to his teacher, Adriaen van Ostade, he developed a compositional genius which none of his generation could equal and which few artists anywhere have surpassed. He died in Leyden and was buried on 3 February 1679.

SWEERTS, *Michiel*

Born in Brussels in 1624, Michiel Sweerts had a chequered career. He spent about ten years in Rome, between about 1646 and 1656, where he was a member of the Academy with the task of collecting dues owed to the Guild by artists of the Netherlandish community. Back in Brussels by 1656, he planned to open a drawing academy. In 1661 he was in Amsterdam, though there is no record of his arrival there or of his departure, which must have been almost immediate, for the same year he left for the East, travelling as a lay brother with a group of missionaries. He died in Goa in 1664.

TER BORCH, *Gerard*

Born at Zwolle, in the province of Overijssel, at the end of 1617, Gerard (or, as he often signed it, Geraert) ter Borch was the son of a painter of the same name who was undoubtedly his first teacher. Ter Borch's other recorded master was Pieter de Molijn, at Haarlem, in 1634. It was probably for this reason that ter Borch's earliest known paintings are of aspects of military life in peacetime, in the manner of Molijn, Codde and other painters of barrack-room scenes active at that time. Arnold Houbraken says that after leaving Haarlem, ter Borch visited Germany, Italy, England, France, Spain and the Netherlands: there is slight evidence that he was in Rome in 1640 or 1641. It was during these years of the 1640s that he developed his ability and reputation as a painter of small portraits. These full-length figures, despite, or perhaps because of, the monotonous similarity of pose, are brilliant pieces of painting and convincing as excellent likenesses (Plate 142). Ter Borch's *tour de force* of portraiture, made after his visit to Münster, in 1648, was the portrayal, on a small copper panel (Plate 78), of over fifty plenipotentiaries and their retinues at *The Swearing of the Oath of Ratification of the Treaty of Münster*. It is not known who commissioned this masterpiece, but it remained in the artist's possession until his death. In February 1654, at the age of 36, he settled in Deventer, in Overijssel, where he married and lived out the rest of his life, away from the main centres of Dutch painting. It was in those years, without any recorded contact with Delft, that he developed his unique form of drama of

contemporary life, which is comparable with, but very different from, the work of de Hoogh and Vermeer. Ter Borch died in Deventer on 8 December 1681.

TER BRUGGHEN, *Hendrick*

The early years of ter Brugghen's career are shrouded in obscurity. The first reliable record of him is in Milan in the summer of 1614, when he was on his way back from a stay in Rome. From less reliable evidence, it seems likely that he was born in Deventer, in Overijssel, probably in 1588, and that his family moved to Utrecht about 1591. He is said to have been a pupil of Abraham Bloemaert and to have spent ten years in Italy. All this is surmise, for little attention was paid to his work until very recently, and the first dated picture is of 1620. It is, however, clear that he did visit Rome and was very impressed with the art of Caravaggio. Indeed it is just possible that if he did spend ten years in Italy he actually knew Caravaggio personally. It is equally likely that he arrived only after Caravaggio's departure in 1606. In either case, the new art made a profound impact on him. Ter Brugghen was a rare type of artist: although strongly influenced by Caravaggio's style, he was able to combine it with odd, earlier northern motifs, from Dürer, Lucas van Leyden, Massys and Marinus van Reymerswaele—the very sources Caravaggio himself had been so influenced by. Ter Brugghen joined the Utrecht guild in 1616, married in the same year, and apparently passed the rest of his life there. Of the Utrecht followers of Caravaggio, ter Brugghen was the only one to continue painting religious works in any number after his return to the North. He also took up different subjects—notably of arcadian shepherds—but especially important are his half-length figures. These again recall Caravaggio's canvases, though this time his early ones, in which a half-length, life-size figure fills the frame. Ter Brugghen died in Utrecht on 9 November 1629.

TRECK, *Jan*

Born in Amsterdam about 1606, Jan Jansz. Treck is first mentioned as a painter in 1623 and is referred to in documents fairly often from 1631 to 1650, but comparatively few of his works are known to have survived. This is because his work is sound rather than idiosyncratic. Most of his paintings are close in style to those of his much more original and inventive brother-in-law, Jan Jansz. den Uyl the elder, who may also have been his teacher. The works are in the tradition of the Haarlem still-life painters, Heda and Pieter Claesz. Treck is thought to have died in 1652.

VELDE, *Adriaen van de*

Born in Amsterdam and baptized on 30 November 1636, the son of the marine painter Willem van de Velde the Elder and brother of the marine painter Willem van de Velde the Younger (q.v.), Adriaen van de Velde was one of the most talented and versatile artists of his age, and yet, like many of his contemporaries, he painted few canvases which are distinctive or memorable. He was probably a pupil of his father and possibly also of Jan Wijnants in Haarlem. Certainly he was influenced by another Haarlem painter, Philips Wouwermans. Many of his works suggest that he went to Italy, but there is no other evidence for the journey. In addition to painting his own, often exquisite, landscapes, he painted the figures and animals in the landscapes of other artists, including those of Jacob van Ruisdael and Philips Koninck. He was buried in Amsterdam on 21 January 1672, aged 35.

VELDE, *Esaias van de*

Born in Amsterdam, probably about 1590, and the son of a painter from Antwerp, Esaias was one of the inventors of true Dutch landscape painting. He may have been the pupil of Gillis van Coninxloo, in Amsterdam, and had certainly seen the landscapes of Adam Elsheimer, even if only in engraved copies. He moved to Haarlem in 1610 and joined the painters' guild there in 1612. Although both Willem Buytewech and Esaias's cousin, the engraver Jan van de Velde, made landscapes which may have influenced him, he was the one who, with unprecedented freedom, discovered the open, low compositions of the new style. Just before he left Haarlem for

The Hague, in 1618, Jan van Goyen, the other great landscape-painter of the time, was his pupil. Esaias van de Velde died in The Hague in 1630.

VELDE, *Willem van de, the Younger*
Born in Leyden and baptized on 18 December 1633, Willem van de Velde was the son of the marine painter, Willem van de Velde the Elder and the brother of Adriaen van de Velde (q.v.). Willem the younger studied with his father and possibly with Simon de Vlieger and became the best-known sea-painter of his day, not only in the United Provinces, but in England. Both the Willem van de Veldes, father and son, were working in Amsterdam when, in 1672, the war with France affected their trade, and they moved to England. After a couple of years, they were taken into the service of Charles II, staying in royal service for the rest of their lives. They had a studio in the Queen's House at Greenwich. Willem van de Velde the Elder died at Westminster in 1693 and his son died there on 6 April 1707.

VENNE, *Adriaen van de*
Born in Delft in 1589, Adriaen van de Venne painted mainly in grisaille (i.e. shades of grey or brown). His principal manner was satirical and moralizing, in the tradition of Bruegel. He moved to The Hague, where he joined the Guild of St Luke in 1625. In 1637 he was made dean of the guild. In 1656 he became a founder-member of 'Pictura', the artists' confraternity established in that year. He was best-known for his illustrations to Jacob Cats's emblem books, published in 1618 and 1627, Van de Venne's engravings placing Cats's abstraction in the contemporary world. Van de Venne died in The Hague in 1662.

VERMEER, *Johannes*
Born in Delft and baptized on 31 October 1632, Vermeer became famous in his lifetime, yet his activities are largely unrecorded. His father was a silk-weaver and innkeeper who may have also dealt in works of art. It is not known when or by whom he was taught, and despite the Italian influences to be seen in his early work, there is no evidence that he visited Italy. It is known that he married in Delft in 1653 and entered the guild there in the same year, a familiar pattern in the lives of Dutch painters of the time. Vermeer married a woman from a Catholic family and may himself have been converted at that time. He was certainly a Catholic later in life, when he painted the *Allegory of the Faith*, now in the Metropolitan Museum of Art, New York. He joined the Delft guild in December 1653. His first known dated work is of three years later. This is the *Procuress*, dated 1656, now in the Gemäldegalerie, Dresden. There, and in only two other surviving works, Vermeer revealed a close knowledge of, and interest in, the painting of the Utrecht Caravaggists. A more important influence and one that was closer to him was, however, that of Carel Fabritius. The name of Fabritius is linked with that of Vermeer in the only significant contemporary reference. In a history of Delft, published in 1667, the death of Carel Fabritius, snatched from life and fame by the 'Delft Thunderclap' (i.e. the powder-magazine explosion of 1654), was described, but, the author added, Delft was fortunate that Vermeer had arisen, Phoenix-like, and was following the same path. There is too little evidence about either painter to establish a close relationship between them, but there is little doubt that Fabritius did play a seminal role in the establishing of Vermeer's art. Unfortunately, the only other known dated work by Vermeer is of 1668, twelve years later, and towards the close of his short career. That, too, is an atypical work, the *Astronomer*, now in a private collection in Paris. But Vermeer was far from unrecognized by his contemporaries. Not only did he serve as an official of his guild, like so many of his contemporaries, on four occasions, but in 1663 a French amateur visiting Delft took care to call at Vermeer's house. The amateur, Balthazar de Monconys, found Vermeer absent and not a single work by him in the house. The only painting by Vermeer that he was able to see belonged to a local baker, who had paid what de Monconys thought was the ridiculous price of 600 guilders. Vermeer seems to have worked slowly (fewer than forty paintings can be

attributed to him today) and he was often in debt. Two further reasons for Vermeer's financial difficulties, in addition to his slow rate of production of paintings, were his large family of eleven children, and, according to his widow, the war with France, which for several years had prevented him from earning much. Like other artists, at other times and places, Vermeer may have been largely dependent on the patronage of a single man. In 1696 twenty-one of his paintings were sold at auction. They came from one collection, and the owner was not named, but he may have been the Delft publisher and book-seller Jacobus Abrahamsz. Dissius. It was from that collection that the majority of the surviving forty are known to have come. Vermeer died in 1675, aged 43, and was buried in Delft on 15 December. He died in debt, leaving, among other effects, three paintings by Carel Fabritius.

VERMEULEN, *Jan*
There were a number of painters of this name, but little has been discovered of the activities of Jan. He belonged to the circle of still-life painters, active in Haarlem in the middle years of the seventeenth century, that included Pieter van Steenwijck and Jan de Heem. Vermeulen was active between 1638 and 1674.

VOSMAER, *Daniel*
Daniel Vosmaer was one of a family of artists living in Delft. He was active from about 1642. His father, Arent, was a goldsmith and his brother was Nicolaes Vosmaer. He is recorded as being a member of the Delft guild in 1650. He may have originated the composition of the pictures showing the great explosion in Delft of 1654 that both he and Egbert van der Poel (q.v.) painted repeatedly. His perspective *View of Delft* (Plate 121) is his masterpiece. He is last recorded in 1666.

VROOM, *Hendrick*
Born in Haarlem in 1566, Vroom was perhaps the first of the Dutch tradition of marine painters. He did not specialize in the subject until he was twenty-four, having first travelled Europe working as a decorator of pottery. His art was closely dependent on the drawings and paintings of ships by Pieter Bruegel the Elder, which were widely distributed in engraved copies. Vroom was also a successful tapestry designer, and his ten designs representing the *Defeat of the Spanish Armada by the English Fleet* decorated the old House of Lords in London until the building was burned down in 1834. Vroom died in Haarlem in 1640.

WEENIX, *Jan*
Born in Amsterdam, probably in 1642, Jan Weenix was the pupil of his father, Jan Baptist Weenix. While still a child he moved with his father to Utrecht, where he lived at least until 1668, although he returned to Amsterdam for the second half of his life. Although he painted a number of Italianate scenes in the style of his father, Jan Weenix was essentially a specialist in large-scale still-lifes of dead game. These oppressive mountains of carcasses set in parks were very popular, and between 1702 and 1712 Weenix was appointed court painter to the Elector Palatine Johann Wilhelm and commissioned to decorate the Elector's palace at Bensberg with such works. He was buried in Amsterdam in September 1719.

WERFF, *Adriaen van der*
Born at Kralingen, just outside Rotterdam, on 21 January 1659, van der Werff was one of the most successful painters of his age. He became a professional artist at the age of seventeen and from that time on poured out a steady succession of skilfully executed works. In 1696 he started working for the Elector Palatine, who the following year appointed him court painter with the salary of 4,000 guilders a year, with the condition that he worked for the Elector for six months of each year. In 1703 the Elector made him a knight, and in 1712 gave him 6,000 ducats for a single work. Van der Werff's highly finished and elegant paintings were also sought after by the King of Poland, the Duke of Brunswick and the French Regent. Besides painting, he dabbled in architecture. He died in Rotterdam on 12 November 1722.

WIJNANTS, *Jan*

Wijnants's early life is shrouded in oblivion. His earliest date work is of 1643, which might suggest that he was born about twenty years earlier. He seems to have been a native of Haarlem (according to his declaration at his betrothal in Amsterdam in 1660) and may have been the son of an art-dealer of the same name mentioned in the records of the Haarlem guild for 1642. However that may be, Jan Wijnants the painter worked in Haarlem until some time between mid-1659 and 1660, when he was betrothed in Amsterdam. In 1672 he is recorded as a 'painter and innkeeper'. His paintings are all landscapes. He died in Amsterdam in 1684.

WITTE, *Emanuel de*

Born at Alkmaar, perhaps between 1615 and 1617, de Witte joined the Alkmaar guild in 1636. Later he moved to Rotterdam and in 1642 he joined the guild in Delft. According to one source, he was trained by a still-life painter in Delft, but his earliest known work is a *Vertumnus and Pomona*, dated 1644. About 1651, he moved to Amsterdam where he seems to have spent the rest of his life. It was about the time of his removal that he began to specialize in church interiors (the earliest dated piece is of 1651), though he never confined himself exclusively to a single motif. After 1658 de Witte began to contract himself to paint for various patrons in return for bed and board. He was often in debt through drink and gambling. At the age of seventy he was charged and fined for unruly behaviour. Eventually he disappeared and was found eleven weeks later in a frozen Amsterdam canal, suspected of having committed suicide. He was buried in Amsterdam in 1692.

WOUWERMANS, *Philips*

Born in Haarlem and baptized on 24 May 1619, the son of a painter, Philips Wouwermans was one of the most prolific and successful painters of his century. He specialized in small paintings of horses in landscapes, especially on dunes and beaches. He is said to have been the pupil of Frans Hals, but his works do not confirm this. His style was much more influenced by the Italianate painter Pieter van Laer, who returned to Haarlem in 1638. Wouwermans is said to have run away to Hamburg to marry when he was nineteen. However, he became a member of the guild in Haarlem a year or two later, in 1640, and appears to have spent the rest of his life there. He was very successful and left his daughter a dowry of 20,000 guilders. He died in Haarlem on 19 May 1668.

WTEWAEL, *Joachim*

Born about 1566 in Utrecht, Wtewael was, like Bloemaert, a pupil of the Utrecht artist, Joos de Beer. In 1586 Wtewael went to Italy, where he lived in Padua for two years. Then he returned to Utrecht by way of France, spending two years in St Malo, from 1588 to 1590. He painted a variety of subjects, including portraits and kitchen scenes. Unlike most of his contemporaries, he kept to the Mannerist style of his youth throughout his life. He died in 1638.

List of collections

Amsterdam, Rijksmuseum

BREKELENKAM, *The Tailor's Workshop*, 85
METSU, *The sick Child*, 71
REMBRANDT, *Anna accused by Tobit*, 19 (on loan)
 Self-Portrait, 21
 '*The Night Watch*', 66, 67
 '*The Jewish Bride*', 162, 165
SAENREDAM, *Old Town Hall, Amsterdam*, 16
VERMEER, *Maidservant pouring Milk*, 101
 The Love Letter, 118
 The little Street in Delft, 123
VROOM, *Battle of Gibraltar*, 6

Amsterdam, Six Collection

REMBRANDT, *Jan Six*, 88, 166

Ascott (Buckinghamshire),
The National Trust

ISACK VAN OSTADE, *A Village Fair*, 65

Baltimore, Maryland, Museum of Art

HALS, *Dorothea Berck* (detail), 168

Berlin–Dahlem, Staatliche Museen

HALS, *Nurse and Child*, 9, 10

Bonn, Rheinisches Landesmuseum

WIJNANTS, *Landscape with Huntsmen*, 171

Boston, Massachusetts,
Museum of Fine Arts

REMBRANDT, *An Artist in his Studio*, 18

Brunswick, Herzog Anton Ulrich
Museum

GOYEN, *Street in Bilt, with Troops*, 5
LASTMAN, *David in the Temple*, 3

Cambridge, Fitzwilliam Museum

BERCKHEYDE, *The Market Place, Haarlem* (detail), 110

Cardiff, National Museum of Wales

REMBRANDT, *Catharina Hooghsaet*, 83, 84 (on loan)

Chantilly, Musée Condé

EVERDINGEN, *Snowstorm at Sea*, 93

Chicago, Art Institute of Chicago

ADRIAEN VAN OSTADE, *The Golden Wedding*, 125

Cleveland, Ohio, Museum of Art

KALF, *Still-Life*, 73

Copenhagen, Royal Museum of
Fine Arts

HALS, *Portrait of a Man* (detail), 159

Delft, Stedelijk Museum 'Het Prinsenhof'	VOSMAER, *View of Delft*, 121
Detroit, Michigan, Detroit Institute of Arts	RUISDAEL, *The Cemetery*, 144
Douai, Musée de Douai	BERCKHEYDE, *View of Haarlem from the River Spaarne*, 111
Dresden, Gemäldegalerie	VERMEER, *Lady reading at an open Window*, 98, 99
Edinburgh, National Gallery of Scotland	DOU, *The Violinist*, 64 (on loan) HOOGH, *Courtyard of a House in Delft*, 122 (on loan) STEEN, *Village School*, 149 (on loan) VERMEER, *Christ in the House of Mary and Martha*, 100
Florence, Uffizi	HONTHORST, *A Banquet*, 12
Frankfurt, Städelsches Kunstinstitut	VERMEER, *The Geographer*, 104
Haarlem, Frans Hals Museum	HALS, *Banquet of the Officers of the St George Civic Guard Company*, 8 *Regents of the Old Men's Alms House*, 160, 161 MOLENAUER, *Family making Music*, 50 SWEERTS, *The Drawing Class*, 81 VROOM, *The Arrival of Frederick V, Elector Palatine, at Flushing* (detail), 7
Haarlem, Municipal Archives	SAENREDAM, *St Bavo, Haarlem, Interior*, 15
The Hague, Mauritshuis	HEEM, *Still-Life with Books*, 36 HOOGSTRATEN, *Young Lady in a Vestibule*, 136 REMBRANDT, *The Presentation of Jesus in the Temple*, 41 *Dr Tulp demonstrating the Anatomy of the Arm*, 42, 43 TER BORCH, *Mother ridding her Child's Hair of Lice*, 145
Hartford, Connecticut, Wadsworth Atheneum	PIJNACKER, *Italian Harbour*, 61
Hull, Ferens Art Gallery	HALS, *Portrait of a Woman* (detail), 138

Short bibliography

General

All the Paintings of the Rijksmuseum in Amsterdam, Amsterdam, 1976

Art in Seventeenth Century Holland, London, 1976. [Exhibition Catalogue by C. Brown]

Dutch Pictures from the Royal Collection, London, 1971. [Exhibition Catalogue by O. Millar]

HOFSTEDE DE GROOT, C. *Catalogue raisonné of the works of the most eminent Dutch painters . . .*, 8 vols., London, 1907–27

MACLAREN, NEIL. *National Gallery Catalogues: The Dutch School*, London, 1960

NICOLSON, B. *The International Caravaggesque Movement*, Oxford and New York: Phaidon, 1979

ROSENBERG, J., SLIVE, S., and TER KUILE, E. H. *Dutch Art and Architecture 1600–1800*, Harmondsworth and Baltimore, 1966

STECHOW, W. *Dutch Landscape Painting of the Seventeenth Century*, London and New York: Phaidon, 1966

Monographs

BAUCH, K. *Rembrandt: Gemälde*, Berlin, 1966

BECK, H. U. *Jan van Goyen*, 2 vols., London, 1973

BLANKERT, A. *Vermeer of Delft*, London and New York: Phaidon, 1978

BREDIUS, A. *The Paintings of Rembrandt*, 3rd ed., London and New York: Phaidon, 1969

CLARK, K. *Rembrandt and the Italian Renaissance*, London, 1966

FREISE, K. *Pieter Lastman*, Leipzig, 1911

GERSON, H. *Philips Koninck*, Berlin, 1936

GOLDSCHEIDER, L. *Jan Vermeer*, London and New York: Phaidon, 1958

GOWING, L. *Vermeer*, 2nd ed., London, 1970

GRANT, M. H. *Jan van Huysum*, Leigh-on-Sea, 1954

GRISEBACH, L. *Willem Kalf*, Berlin, 1974

GUDLAUGSSON, S. J. *Geraert ter Borch*, 2 vols., The Hague, 1959–60

JUDSON, J. R. *Gerrit van Honthorst*, 's-Gravenhage, 1959

KIRSCHENBAUM, B. D. *The Religious and Historical Paintings of Jan Steen*, New York, 1976, and Oxford, 1977

MANKE, I. *Emanuel de Witte*, Amsterdam, 1963

MARTIN, W. *Gerard Dou*, London, 1902

MARTIN, W. *Jan Steen*, Amsterdam, 1954

MOLTKE, J. W. VON. *Govaert Flinck*, Amsterdam, 1965

NICOLSON, B. *Hendrick Terbrugghen*, London, 1958

REISS, S. *Aelbert Cuyp*, London and New York, 1975

ROBINSON, F. W. *Gabriel Metsu*, New York, 1974

ROSENBERG, J. *Rembrandt*, 3rd ed., London and New York: Phaidon, 1968

ROSENBERG, J. *Jacob van Ruisdael*, Berlin, 1928

RUSSELL, M. *Jan van de Cappelle*, Leigh-on-Sea, 1975

SCHNEIDER, H. *Jan Lievens*, Haarlem, 1932

SCHUURMAN, K. E. *Carel Fabritius*, Amsterdam, 1947

SLIVE, S. *Frans Hals*, 2 vols., London and New York: Phaidon, 1970

STECHOW, W. *Salomon van Ruysdael*, Berlin, 1938

SWILLENS, P. T. A. *Pieter Jansoon Saenredam*, Amsterdam, 1935

VALENTINER, W. R. *Klassiker der Kunst: Pieter de Hooch*, London, 1930

VALENTINER, W. R. *Nicolaes Maes*, Stuttgart, 1924

WAGNER, HELGA. *Jan van der Heyden*, Amsterdam, 1971

WELCKER, C. J. *Hendrick Avercamp en Barent Avercamp*, Zwolle, 1933

Acknowledgements

The author gratefully acknowledges the collaboration of Keith Roberts in the choice of the illustrations.

Plates 58, 68, 102, 115, 127, 128 and 137 are reproduced by gracious permission of Her Majesty The Queen. Grateful acknowledgement is also made to the following for permission to reproduce works in their collections: *Rijksmuseum, Amsterdam* (6, 16, 21, 66, 67, 71, 85, 101, 118, 123, 162, 165); *Six Collection, Amsterdam* (88, 166); *The Baltimore Museum of Art* (168); *Sir Alfred Beit, Bt.* (117, 126); *Staatliche Museen, Berlin-Dahlem* (9, 10); *Rheinisches Landesmuseum, Bonn* (171); *Boston Museum of Fine Arts* (18); *Herzon Anton Ulrich Museum, Brunswick* (3, 5); *The Trustees of Mr and Mrs Julian Byng's Marriage Settlement—from the collection at Wrotham Park* (122); *The Syndics of the Fitzwilliam Museum, Cambridge* (110); *Musée Condé, Chantilly* (93); *Art Institute of Chicago* (125); *The Cleveland Museum of Art* (73); *Royal Museum of Fine Arts, Copenhagen* (159); *Stedelijk Museum 'Het Prinsenhof'* (121); *The Detroit Institute of Arts* (144); *Musée de Douai* (111); *Gemäldegalerie, Dresden* (98, 99); *The Governors of the Dulwich College Picture Gallery* (57); *The Trustees of the National Galleries of Scotland, Edinburgh* (100); *Uffizi, Florence* (12); *Städelsches Kunstinstitut, Frankfurt* (104); *Frans Hals Museum, Haarlem* (7, 8, 50, 81, 160, 161); *Municipal Archives, Haarlem* (15); *Mauritshuis, The Hague* (36, 41, 42, 43, 136, 145); *Wadsworth Atheneum, Hartford, Connecticut* (61); *Ferens Art Gallery, Hull* (138); *The Greater London Council as Trustees of the Iveagh Bequest* (51, 158); *Cummer Gallery of Art, Jacksonville, Florida* (75, 152); *Staatliche Kunsthalle, Karlsruhe* (163, 164); *Staatliche Kunstsammlungen, Kassel* (62, 76); *Hessisches Landesmuseum, Kassel* (22); *Hermitage, Leningrad* (54, 70, 114, 116, 131, 169, 170, 175); *Musée des Beaux-Arts, Lille* (17); *Trustees of the National Gallery, London* (1, 2, 13, 26, 29, 31, 48, 49, 52, 53, 69, 72, 78, 82, 86, 89, 90, 92, 95, 108, 109, 119, 120, 141, 155, 177); *Victoria and Albert Museum, London* (32, 44, 45, 130, 150, 151); *The Trustees of the Wallace Collection, London* (15, 38, 39, 47, 112, 143, 147, 148, 173); *Los Angeles County Museum of Art* (80); *National Gallery of Victoria, Melbourne* (37, 40); *Mr and Mrs Paul Mellon* (96); *Alte Pinakothek, Munich* (146); *Musée des Beaux-Arts, Nancy* (4); *Musée des Beaux-Arts, Nantes* (59); *The National Trust* (65, 124); *Musée des Beaux-Arts, Nîmes* (34); *Frick Collection, New York* (87); *Metropolitan Museum of Art, New York* (23); *Allen Memorial Art Museum, Oberlin College, Ohio* (25, 28, 135); *Musée National du Louvre, Paris* (105, 113, 132, 133, 134, 178); *Fondation Custodia (Coll. F. Lugt) Institut Néerlandais, Paris* (14, 94); *Musée de la Comédie Française, Paris* (63); *Musée du Petit-Palais, Paris* (33, 172); *Ponce Art Museum, Ponce, Puerto Rico* (74); *Baron Edmund de Rothschild* (55); *Baronne Edouard de Rothschild* (139, 167); *Museum Boymans-van Beuningen, Rotterdam* (46, 107); *Musée de l'Hôtel Sandelin, Saint-Omer* (142); *Nationalmuseum, Stockholm* (35, 156, 157); *The Duke of Sutherland* (64, 106, 149); *Museum of Art, Toledo, Ohio* (60); *Baroness Bentinck-Thyssen* (19); *Centraal Museum, Utrecht* (11); *Kunsthistorisches Museum, Vienna* (103, 136); *National Gallery of Art, Washington, D.C.* (97, 129, 140).

The publishers are also grateful to those private owners who have given permission for works in their possession to be reproduced but who wish to remain anonymous.

For biographical material the author has drawn upon *The Dutch School*, by Neil MacLaren, in the series of catalogues produced by the National Gallery, London, and upon Thieme–Becker, *Allgemeines Lexikon der bildenden Künstler*, Leipzig 1908–50. The map on page 6 was drawn by Gillian D. March.

Index of persons and places

Porcellis, Jan 49, 243
Pot, Hendrick 29
Potter, Paulus 56, 251
Poussin, Nicolas 47
Prague 250
Pynas, Jacob 252

Quast, Pieter 251

Raphael 13, 55
Rembrandt van Rijn 24, 30, 32, 33–
39, 43, 45, 46, 49, 51, 52–54, 55,
241, 242, 243, 244, 245, 248, 249,
250, 251–52
Reymerswaele, Marinus van 13, 31,
255
Reynolds, Sir Joshua 42, 51, 52
Rhenen 253
Richardson, Jonathan 51
Rijn, Harmen Gerritsz., 251
Rijn, Titus van 252
Rijswick 242
Rome 11, 13, 15, 31, 33, 36, 241, 242,
243, 244, 247, 248, 249, 250, 251,
254, 255
Rotterdam 29, 241, 242, 247, 248,
251, 257, 258
Rouen 14
Rubens, Peter Paul 7, 30, 31, 35, 37,
243, 251
Ruffo, Don Antonio 36, 37, 252
Ruisdael, Jacob Issacksz. van 11, 46,
47, 49, 54, 243, 244, 247, 252, 253
Ruskin, John 57
Ruysdael, Jacob Salomonsz. van 253
Ruysdael, Salomon van 24, 47, 245,
252, 253

Saenredam, Jan 8, 253

Saenredam, Pieter Janzoon 8, 9, 10,
11, 12, 17, 20, 241, 253
Savery, Roelandt 23, 46, 244
Schade van Westrum, Jaspar 17
Schalken, Godfried 49
Scorel, Jan van 13
Scriverius, Peter 9
Seghers, Hercules 24, 25, 29, 46, 47,
249, 253
Six, Jan 36, 252
Slive, Seymour 19
Sluys 249
Spranger, Bartholomeus 14
Steen, Jan 27, 31, 42, 43, 46, 52, 54,
242, 243, 245, 250, 254
Steenwijck, Pieter van 257
Stoffels, Hendrickje 252
Swaneburgh, Jacob Isaacksz. 252
Sweerts, Michiel 254

Ter Borch, Gerard 41, 43, 44, 247,
249, 250, 254, 255
Ter Brugghen, Hendrick, 31, 32, 241,
249, 255
Tintoretto, Jacopo 21
Titian 13, 20, 37, 43
Treck, Jan Jansz. 27, 255
Treck, Pieter Claesz. 255
Tulp, Dr Nicolaes 36, 251, 252

Utrecht 11, 13, 14, 31, 32, 36, 241,
244, 246, 247, 249, 251, 253, 255,
256, 257, 258
Uyl, Jan Jansz., den 255
Uylenburgh, Hendrick van 252
Uylenburgh, Saskia van 252

Vasari, Giorgio 14, 34
Velde, Adriaen van de 49, 255, 256

Velde, Esaias van de 24, 29, 46, 242,
245, 253, 254, 255, 256
Velde, Jan van de 255
Velde, Willem van de, the Elder
255, 256
Velde, Willem van de, the Younger
49, 51, 255, 256
Venice 13, 15, 36, 244
Venne, Adriaen van de 251, 256
Vermeer, Johannes 32, 40–45, 46, 49,
242, 245, 248, 254, 255, 256, 257
Vermeulen, Jan 257
Veronese 20, 21
Vienna 248, 250
Vinckboons, David 23, 29
Visscher, Claes Jansz. 42
Visscher, Roemer 42
Vlieger, Simon de 243, 256
Vosmaer, Arent 257
Vosmaer, Daniel 257
Vosmaer, Nicolaes 257
Vreeland 249
Vroom, Hendrick, 257

Weenix, Jan 49, 257
Weenix, Jan Baptist 241, 257
Werff, Adriaen van der 49, 257
Westminster 256
Wijnants, Jan 49, 255, 258
William the Silent, Prince of Orange
7, 9, 10, 14, 39
Witte, Emanuel de 12, 49, 241, 248,
249, 258
Wouwermans, Philips 255, 258
Wtewael, Joachim 14, 28, 241, 258

Zeeland 13, 24, 241
Zwammerdam 242
Zwolle 254